W9-BHG-425

AVANT-GARDE, INTERNATIONALISM, AND POLITICS

A book in the series

Latin America Otherwise: Languages, Empires, Nations

Series editors:

Walter D. Mignolo, Duke University

Irene Silverblatt, Duke University

Sonia Saldívar-Hull, University of Texas, San Antonio

AVANT-GARDE, INTERNATIONALISM, AND POLITICS

Argentine Art in the Sixties

ANDREA GIUNTA

Translated by Peter Kahn

DUKE UNIVERSITY PRESS

DURHAM & LONDON 2007

N
6635
.G5713
2007

© *2007 Duke University Press*
All rights reserved
Printed in the United States of America
on acid-free paper ∞
Designed by Katy Clove
Typeset in Carter & Cone Galliard
by Tseng Information Systems, Inc.
Library of Congress Cataloging-in-
Publication Data appear on the last
printed page of this book.

Avant-Garde, Internationalism, and Politics: Argentine Art in the Sixties
was originally published as *Vanguardia, internacionalismo y política:*
Arte argentino en los años sesenta (Buenos Aires: Editorial Paidós SAICF, 2001).

Vanguardia, Internacionalismo y Política received the 2002 Award for the Best Scholarly
Book on the art of Latin America from the Pre-Columbian era to the present from the
Association of Latin American Art (an affiliate of the College Art Association), funded by
the Arvey Foundation.

The correspondence of Alfred H. Barr is reprinted by permission of the Museum
Archives of the Museum of Modern Art, New York.

Publication of this book has been aided by a grant from the Millard Meiss Publication
Fund of the College Art Association.

Translation of the book was funded by a grant from the Fundación Antorchas,
Buenos Aires.

To Violeta, Olga, and Rob

CONTENTS

List of Illustrations

PLATES (between pages 140 and 141)

About the Series

Latin America Otherwise: Languages, Empires, Nations is a critical series. It aims to explore the emergence and consequences of concepts used to define "Latin America" while at the same time exploring the broad interplay of political, economic, and cultural practices that have shaped Latin American worlds. Latin America, at the crossroads of competing imperial designs and local responses, has been construed as a geocultural and geopolitical entity since the nineteenth century. This series provides a starting point to redefine Latin America as a configuration of political, linguistic, cultural, and economic intersections that demands a continuous reappraisal of the role of the Americas in history, and of the ongoing process of globalization and the relocation of people and cultures that have characterized Latin America's experience. Latin America Otherwise: Languages, Empires, Nations is a forum that confronts established geocultural constructions, rethinks area studies and disciplinary boundaries, assesses convictions of the academy and of public policy, and correspondingly demands that the practices through which we produce knowledge and understanding about and from Latin America be subject to rigorous and critical scrutiny.

Andrea Giunta's *Avant-Garde, Internationalism, and Politics* is a tour-de-force that refigures art history without falling into some of the traps of cultural studies. It brings together art, politics, and international relations by examining projects developed by U.S. foundations to "support the arts" and "diffuse knowledge and understanding" in Latin America. Andrea Giunta does this by shifting the politics of knowledge; placing

the problem at the forefront, she moves in the domain of transdisciplinarity—beyond disciplinary and interdisciplinary research—to uncover the problem's underpinning.

Giunta is an art historian and critic who knows how to analyze artistic works and to trace artistic genealogies and their social motivations. But she is also an astute social and cultural critic with a piercing eye that sees beyond and behind institutional projects (museums and art galleries) and the artistic and political enthusiasm of the Argentine (and Latin American) avant-garde of the 1960s. Giunta reveals the underlying political entanglements of institutions and artists with the Cold War and the Cuban Revolution on the one hand, and with the Kaiser Industry's organizing of the American Art Biennials and the Rockefeller Foundation's promoting of artistic creativity in Latin America on the other. International and state programs aimed at developing and modernizing Argentina and Latin America—the Alliance for Progress—were all part and parcel of a package that created the conditions for neoliberalism to emerge in Argentina, and for dependency theory and the philosophy of liberation to develop as critical symptoms of the time. Giunta's book masterfully shows the blind spots of the artistic avant-garde, the vested interest of museums, and the clear imperial designs of the U.S. foundations that supported and promoted the arts.

Preface and Acknowledgments

The subject of this book responds to a twofold concern. On the one hand, to reconsider those years of Argentine culture which have been celebrated as its peak moment of glory. Without a doubt, to write about the art of this period—when there was a pervasive certainty that anything was possible—is a great pleasure. However, my argument also originates from a concern regarding certain agreements that were made at the time and to explore the tensions that permeated society at various levels. In general, books on art history that classify individual biographies and artistic schools tend to respond to an implicit desire to present the facts as if they conformed to a natural order, ruled by an evolutionary logic that treats artistic works as explanatory pieces in a greater narrative: the history of modern art and, similarly, the evolution of Argentine art. This cumulative version of the processes, viewed in relation to the idea of progress, tends to ignore other significant features that may help us understand the degree to which specific projects were rewritten, repeatedly breaking the supposed intransigence and purity proposed by the very programs to which they belonged. In this book I hope to establish the significance of various pacts and dissensions of the period, to examine those moments in which artists, institutions, and critics formed a single front, organized to achieve a single mission (in this case, to promote an identity for Argentine art, to situate it in the world, and to secure its long-anticipated recognition), in addition to reviewing the circumstances under which all these commitments came to be broken.

The need to adopt a different approach to the art of this period also

originates from my reading of other books and my contact over the years with colleagues, friends, and students while working on the writing and researching of this book, all of whom provided valuable conversations, criticism, and constant inspiration for the progress of my work. These critiques arose from discussions during seminars, the exchange of ideas in classes, debates by e-mail, and long conversations in the bars of Buenos Aires.

To pursue my research, the support of the grant system of the University of Buenos Aires was fundamental, offering me a unique opportunity to dedicate almost all my time to this project. I was able to peruse the Archives of American Art, the archives of the Organization of American States in Washington, and those of the Museum of Modern Art in New York thanks to a grant for advanced study from the Association of Research Institutes in Art History, subsidized by the J. Paul Getty Grant Program, the Fundación Lampadia, and the Andrew W. Mellon Foundation. The research I conducted in the Kaiser archives in the city of Córdoba was supported by a subsidy from the University of Buenos Aires, granted to the group Arte, Cultura y política en los '60, which for several years operated out of the "Gino Germani" Institute of Social Sciences at the College of Social Sciences under the generous direction of Enrique Oteiza. The translation of this book was supported by a subsidy from the Fundación Antorchas, and a grant for the reproduction of color images was provided by the College Art Association.

I am profoundly grateful to Elsa Flores Ballesteros and Beatriz Sarlo, readers and generous advisors, whose comments were invaluable during the revision of the manuscript. I am also deeply grateful to María Teresa Gramuglio and José Emilio Burucúa for their crucial support.

Mexico provided a special atmosphere for the debate of several sections of this book. There I presented early versions of the book in colloquiums and seminars organized by the Instituto de Investigaciones Estéticas of the Universidad Autónoma de México under the direction of Rita Eder. I am especially grateful to her for the debates she made possible—particularly during the seminar on the history of art in Latin America that she directed beginning in 1996—as well as for her friendship. In those seminars the contributions of Serge Guilbaut were vital.

Walter Mignolo, Gabriela Nouzeilles, Mari Carmen Ramirez, and Florencia Bazzano-Nelson created magnificent contexts for teaching and learning about the various debates on Latin American art in the United States. Similarly, my thanks go to Shifra Goldman, Beverly Adams, and

Charles Merewether. Anne Milne and Jacobo Ojito generously offered me their friendship while I was conducting my research in New York.

In Buenos Aires I am indebted to my colleagues Laura Malosetti Costa, Lía Munilla, Gabriela Siracusano, Diana Wechsler, Marta Penhos, and Marina Aguerre, all of whom, for several years, have formed part of our seminar on the theory of symbolic exchange. I also want to thank Roberto Amigo, Claudia Gilman, Miguel Angel Muñoz, and Adrián Gorelik.

Many people assisted me with my research in various archives: María José Herrera and Alejandra Grimberg in the Museo Nacional de Bellas Artes (the National Museum of Fine Arts in Buenos Aires), Carlos Plutman in the Kaiser archives in the city of Córdoba, Ricardo Rodríguez Pereyra in the archives of the Torcuato Di Tella Institute, Martita Romero Brest in the archives of Jorge Romero Brest, which she generously donated to the Instituto de Teoría e Historia del Arte "Julio E. Payró." I am also thankful to Héctor H. Schenone, director of the institute, for the institutional support and interest he always expressed for the research I was carrying out.

I am also deeply grateful to all the artists and actors of the period who generously offered me their time in successive interviews and provided me with access to their personal archives, especially Luis Felipe Noé, Kenneth Kemble, Rafael Squirru, Julio Llinás, and Luis Wells. Special thanks go to León Ferrari for the materials he made available to me, for his invaluable and warm friendship, and for all that he has generated in Argentine art from the 1960s to the present. My gratitude also goes to the collectors who provided me with access to many works of art and authorized their reproductions in this book.

Regarding the production of this book, I am grateful to María Amelia García, Fabiana Serviddio, Florencia Battiti, Verónica Tell, Cristina Rossi, and Laura Azcoaga for their collaboration. I am also grateful to Guillermo Schavelzon for his support of the publication of this book.

Finally, my heartfelt thanks go to Olga Carnero, for her unconditional affection, to Rob for his support, as well as to my daughter, Violeta, who added her feelings to my work: the best aspects of this book were fed by her passion and inexhaustible enthusiasm.

Translator's Note

For this English-language edition, all text and quotations originally in Spanish have been translated into English by the translator. For quotations originally in languages other than Spanish, an effort has been made to use previously published English translations, as indicated in the bibliography; whenever this was not possible, all translations are the translator's own.

Abbreviations

AAA: Archives of American Art
ABAA: Archives Bienales Americanas de Arte
AHB: Alfred H. Barr
CACC: Centro de Arte Contemporáneo, Córdoba
CAV: Centro de Artes Visuales
CGTA: General Workers' Union of Argentina
ITDT: Instituto Torcuato Di Tella
IKA: Industries Kaiser Argentina
IAFA: The Inter-American Foundation for the Arts
IAC: Inter-American Committee
JRB: Jorge Romero Brest
MNBA: Museo Nacional de Bellas Artes
MAM: Museo de Arte Moderno
MOMA: Museum of Modern Art, New York
RAC: Rockefeller Archives Center
RBF: Rockefeller Brothers Foundation

Introduction

In 1964 the artistic milieu of Buenos Aires appeared to be very close to completing the ambitious project into which artists, institutions, critics, and gallery directors had invested such an extraordinary amount of energy. The goal was to transform Buenos Aires into an international artistic center and to obtain, at the same time, international recognition for "new" Argentine art. Clement Greenberg, the critic who championed the value of postwar North American art and contributed to its recognition in the rest of the world, arrived in Buenos Aires for the first time to participate as a juror in the Torcuato Di Tella National and International Prize Competition. That same year, the exhibition New Art of Argentina brought together a selection of works by Argentine painters and sculptors, touring several museums in the United States. Unlike previous shows that had so often linked the artists with the art of a continent, this exhibition identified them specifically with their country.[1] Both of these events, though of undeniable importance, only added to a whole body of information and facts that fueled the conviction that the international art world had turned an attentive eye toward Latin America, with special interest in Argentina, at a time when the art of this country showed signs of entering an intense and unprecedented period of renovation.

The purpose of this book is to analyze the forms of the projects that were specifically designed to internationalize Argentine art and its avant-garde during the 1960s. This book examines the conditions that made the conception of these projects possible, the strategies formulated to promote them, the images that best represented them, and the antagonistic

and opposing discourses that defined the rhythm of the continuing debates that characterized artistic development during this period. It was in this atmosphere that the tension between art and politics was inscribed in terms that would then fuel the cultural debate in Latin America, imbuing it with a constantly increasing radicalism over the course of the decade. Overall, this text will attempt to penetrate to the heart of this complex plot from the perspectives of the various actors, taking into consideration the ways and degrees to which their intentions were expressed in words and images.

This study focuses on a postwar era, the 1960s, so brilliant that no adjectives seem sufficient to describe all of its characteristics. On the subject of 1960s culture all the analyses (from Marshall Berman to Daniel Bell)[2] emphasize the enthusiasm and contradictions of the period. The need to eliminate the barriers between art and life, to fuse art and politics, to express anti-intellectualism, anti-institutionalism, to redesign and broaden the traditional concept of the "work of art" (happenings, collages, assemblages), to search for a new public, all of these were recurring features in the culture of the decade. It was a period that, as Fredric Jameson maintains, may be analyzed beyond the national frame of reference, through the rhythm established in the context of philosophy, culture, revolution, and economics. The culmination of existentialism in its various strains, the development of structuralism, the Cuban Revolution, Fanon's representation of colonialism, the rupture of the modernist canon, the liberation movements—all are frames of reference that had an immense impact on the general configuration of the period. That the 1960s were characterized by ebullient confidence in the modernist view of progressive social transformation in history, and that this hegemony was consistently mined by a critical—but no less modernist—discourse of opposition, is a characterization that is not exclusive to the Argentine process.[3] In this sense, and with respect to leftist Latin American culture, Claudia Gilman proposes that the period be considered as an "era" whose characteristics permit an analysis that transcends national borders.[4] Why, then, propose a study of the visual arts of this period in national terms and not exclusively in regional terms? My view is that although the 1960s, without a doubt, present us with shared features that allow us to study this period as an epoch whose formational matrices may be found throughout Latin America, the United States, and Europe, in the case of Argentine art there are certain differences within the Latin American context. These distinctions involve the condensation and radicalization of common fea-

tures rather than the formulation of an entirely different model. I am interested in analyzing the degree of commitment on the part of both artists and institutions to various projects of the period, as well as the extent to which they influenced discourses on artistic development at the time and endowed it with unique characteristics relative to the artistic processes taking place in other countries of Latin America during those same years.

By considering achievements in the Argentine intellectual field of the 1960s it is possible to gain perspective on a variety of problems related to the limits of this period, and on the positions of various public figures and formations in the complex debates that animated those years. In this sense, the works of Oscar Terán and Silvia Sigal are fundamental.[5] The discussion on the limits of the "decade," implicit in Terán's and Sigal's texts, also calls for a reconsideration of the framework that I propose in this book. Without denying that 1966 constituted an important rupture in the artistic milieu, a "parting of the waters" on the symbolic plane as indicated by Terán,[6] it is 1968 that makes it possible to clearly visualize a process of slippage whereby the artist's commitment to art shifted to a commitment to politics. Considering the accelerated and radical way in which it took place, an examination of this shift offers a unique view of a process that also took place in other cultural spaces. It was during these years that the debate concerning the relation between intellectuals and politics filtered into the debate on art and politics so irrevocably and one-sidedly, normalizing a perceived disjuncture between art and politics. However, this dynamic was not only attributable to Argentine art. The early revisionist work of Barbara Rose, as well as that of Lucy R. Lippard,[7] both focused on the evolution of this debate in the United States. Nor were the discussions on the "disappearance of art," articulated after 1968, exclusively pertinent to the local art scene: one example among many is the colloquium that took place in 1969 at the Guggenheim Museum in New York, organized for the purpose of discussing the future of art.[8]

Studies of Argentine art of the 1960s may be characterized, in terms of their dominant traits, as descriptive and biographical, or as attempting to find order based on the emergence of schools and styles. This is the case, for example, in the works of Córdova Iturburu and Aldo Pellegrini.[9] Jorge López Anaya also focuses on the formation of styles but, in addition, in-

troduces into his analysis considerations on the complex assimilation of international models.[10] Although the study of 1960s art has formed part of numerous general works on Argentine art history, no documented and exhaustive study can be cited, nor have there been any critical revisions regarding the processes that evolved at that time.

Certain studies may serve as primary examples of and sources for interpreting the period. In this sense, Jorge Romero Brest's book, published in 1969,[11] is significant because it is a document that offers an initial evaluation of the decade by an author who was also a central actor at the time. Guided by the clear intention to focus only on those artists who were "innovative," Romero Brest differentiates between the "new" artists and "those that did not advance," and he establishes a value system that enables an analysis of many of the decisions that he made during his directorship of the Center for Visual Arts (CAV) which was part of the Institute Torcuato Di Tella (ITDT), a pivotal institution for Argentine art of the 1960s. His claim that 1963 was a decisive year, when the ITDT moved on to the fashionable Florida Street and he became director of the CAV, grants significant centrality to his own actions, but ignores crucial years at the beginning of the decade. These early years are also important to consider for the ideas that would either be explored in greater depth or discarded over the ensuing decade. This was a period of great excitement and possibility that requires careful analysis in light of the period's contradictions and convergences in order to understand the risks that were taken and why they succeeded or failed to bring about the desired results.

Among the various texts that historically reconstruct the artistic circuits of the 1960s, John King's study is preeminent. He focuses his analysis on the ITDT, an institution that, as indicated by the author, "microscopically reflected the tensions of Argentine society during the 1960s."[12] King's study is the first documented analysis of the activities that took place at the different centers of the Di Tella Institute, but it lacks a critical reading of the time.

The intention of my study is not to reconstruct Argentina's artistic movements or the group, individual, or institutional careers that existed in the artistic scene during this period of time. More precisely, my objective is to analyze the projects that both the artists and the institutions formulated during this period; to examine how opposing programs and actors created networks of negotiation in order to unite forces and accomplish

what, over a relatively long period of time, succeeded in diminishing their conflicts: the recognition of Argentine art and securing Buenos Aires's place as one of the important centers for international art.[13] As the projects of artists and institutions became increasingly radical, the contradictions underlying their alliances became increasingly volatile. Rather than biographies and artistic movements, what I am interested in analyzing are the conflicts of interest among institutional policies, artistic programs, and critical discourses, as well as their short-term agreements. On this battlefield, both national and international political histories were of critical importance, but not because transformations in the artistic milieu or in poetics could be deduced or even explained by the political situation. There are at least two other reasons why politics became a relevant factor to this analysis: the constant friction between the political and cultural spheres, which became one of the dominant features of the period, and the fact that politics became unavoidable for artists not only as a theme in their work, but also as a problem that had to be resolved with the creation of new art forms. This politicization of the cultural milieu was affected as much by the national situation—which was viewed by many as a budding revolution—as by international conditions. With respect to the latter, both the Cuban Revolution and the policies of the Alliance for Progress had an impact on the politicization of intellectuals and artists, while also inaugurating a new era in relations between Latin America and the United States.

Few studies of the visual arts during this period consider the relations between economic development, society, and the artistic milieu. Practically the only work done in this area is that of Néstor García Canclini on the symbolic strategies of economic development.[14] His analysis is a starting point for the study proposed here. García Canclini presents a perspective not considered by other researchers: he grants relevance to the material organization of the "artistic field," to the spaces where images were placed, and the emerging relation between the artistic avant-garde and popular culture toward the end of the 1960s. He seeks to establish new relations between artistic production and technological and industrial development in Argentina during the 1960s and to see how these transformations affected the visual arts field. García Canclini's study examines the institutional network established by the internationalist project (the International Council of the MOMA, the Pan-American Union, the CIA, and transnational corporations) and considers that the purpose of its politically motivated policies was to disseminate a formal experiment that was

supposedly depoliticized, offering abstract expressionism as an alternative to social realism.[15] From this perspective, Argentina's receptiveness to North American penetration stands out, but what this analysis doesn't reveal is how the project of internationalization was also articulated from within Argentina.

The purpose of this book is also to tell a story. Thus, the arguments are presented in diachronic order much in the same way as a narrative. At the same time, however, there is an element of recurrence—a circular quality—by means of which I repeatedly return to artistic and institutional programs in an attempt to reconstruct for the reader the place each actor occupied in the artistic scene with respect to these programs. From this perspective, a synchronic look at the events is also important.

"Avant-garde," "internationalism," and "politics"—terms which may be used to designate the dominant projects of the period—were much more than mere words: they were arguments, conditions for legitimacy, as well as plunder. That is to say, they were notions whose significance, use, and authority were in constant dispute. Tensions surrounded the use of these terms that were decisive for the art of the period: they implied a degree of hope and plans for the future, they projected a new era and, at the same time, coexisted in a relation of concurrence, superimposition, and competition.

By proposing these terms as focal points for an analysis of the problems I would like to consider in this study, I do not intend, by any means, to establish new values or to consolidate existing ones. I am not interested in analyzing whether Argentine art should be considered international, whether there ever existed an avant-garde, or whether art should be involved with politics. What concerns me is to observe how and why all these necessities—to produce avant-garde, international, or political art—which at times concurred and at other times operated independently, came to be viewed as urgent for Argentine art. Why did these notions have such recurrence in the artistic debates of the 1960s? Why, in short, was it almost impossible to discuss art independent of the values and justifications established by these notions, in the face of which the artists could scarcely remain indifferent?

During these years, such words as "avant-garde," "internationalism," "commitment," "politicization," and "revolutionary art" were charged with a multitude of meanings. I propose that, rather than the true and

original meaning of these terms, what we need to explore are the different moments of rupture and the many ways in which the significance of these moments have been reinscribed—in other words, the forms of *positivity* that have characterized them.[16]

During the 1960s, these words served as *highly disposable verbal artifacts* that were stamped on any individual who chose to be active in the artistic and cultural field of the period. Their significance was constantly being reformulated, constantly employed in the process of convergence between institutions and activities. In this context they were institutionalized, received, recycled, and combined; they were objects of desire, interest, and they posed questions related to power.[17] With respect to the problematicization of recurrent terms associated with the period, the ideas of Michel Foucault have been central to my analysis. Such notions as discursive constellation, positivity threshold, formulation contexts, transformation, and dispersion have been very helpful for the problem of addressing a set of recurrences that characterize the discourses on art and culture during this period. In this sense, Foucault's considerations on the possibility of establishing a correlation between discourses and nondiscursive domains (institutions, political events, practices, and economic processes) have served as a basis for delimiting the period and the internal scope of this book.[18]

The problematicization of the internationalist project may be found in several texts on Argentine art of the 1960s. For the perspective I have chosen for this analysis, the research of Beverly Adams has been especially important. Specifically, I have drawn upon an article in which she "maps out" the internationalist strategies of Argentine institutions between 1956 and 1965 (fundamentally through the activities of the Museum of Modern Art of Buenos Aires and the Torcuato Di Tella Institute).[19] In addition to contributing an analysis of the semantic field of the term "internationalism," her work considers the exhibitions that brought Argentine art into contact with the rest of the world, the criteria adopted by Argentine organizations, and the critical reception of these shows in the United States. However, what her analysis dilutes is the political use to which these exhibitions were put and the conflictive political context, both nationally and internationally, in which they circulated.

In his book on the Di Tella Institute,[20] John King also refers to the "internationalist strategy" and considers two questions: to what extent it implied an "art of submission," as affirmed by Marta Traba,[21] and to what degree internationalism was either possible or just an "illusory" oppor-

tunity. King describes the international network that makes it possible to analyze this project. However, he does not consider its motives or its complicated formulation, which involved a web of institutions organized in the United States as part of the proposed inter-American dialogue generated in relation to the Alliance for Progress program.

From the evidence, it seems clear that in discussing the question of internationalism, rather than a style characterized by a homogeneity of the language, or a group of artists formed on the basis of socially revolutionary precepts (something that was characteristic of the early avant-garde and that, in some measure, was relived by artists of the 1960s),[22] there was a double sense of urgency to implement a set of complementary policies. On one hand, there was a compelling need to elevate Argentine art, considered "backward" with respect to international standards. Thus, to internationalize, in this sense, was to advance and update. On the other hand, and at the same time, there was also the perceived urgency to earn recognition of Argentine art in the major art centers. From this perspective, the internationalist project was a quest for success.

All these imperatives were clearly defined during the early years of the Revolución Libertadora (The Liberating Revolution). They were impelled by a desire to rescue Argentine art from the "annihilation" of the spirit and the "suicidal isolation" that, according to Romero Brest, had characterized the years under Peronism.[23] The policies were primarily developed through a network of public and private institutions and involved the "importation" of exhibitions of contemporary international artists; the sending of grant recipients abroad to study, to "improve," and ultimately to "elevate" the local art scene; the organization of prize competitions involving prestigious international art critics; and, finally, the "exportation" of exhibitions of Argentine art to Europe and, most importantly, to the United States. Once the required level had been attained, internationalization would imply both "exporting" culture as well as converting Buenos Aires into an international center, that is, a reception center for important exhibitions, recognized artists, and influential critics.

Sectors of high culture had clearly perceived that, in the postwar era, Western artistic hegemony was no longer exerted from Paris.[24] However, rather than weep over the death of what had until then been the cultural and artistic wet nurse of Buenos Aires, the central concerns were how to produce from the vacuum left by Paris's fading and how to gain recognition from the new center now located in the city of New York.

Internationalism was, then, a recurring term, whose meaning was rewritten in new discursive constellations as the projects to which it was applied were constantly being modified. At the risk of simplification, in a schematic way we could say that whereas in 1956 internationalization meant, above all, breaking out of isolation, in 1958 it implied joining an international artistic front; in 1960 it meant elevating Argentine art to a level of quality that would enable it to challenge international spaces; in 1962 attracting European and North American artists to Argentine competitions; in 1964 it brought the "new Argentine art" to international centers, in 1965 it brandished the "worldwide" success of Argentine artists before the local public; and, finally, after 1966, internationalism became increasingly synonymous with "imperialism" and "dependence," upsetting its previous positivity.

All these interpretations of the word "internationalism" indicate the distance that lay between its original meaning and that which it came to assume during the 1960s. Perry Anderson analyzes the radical change in meaning that the term underwent following the second world war.[25] Until then it had been used by the left as a stance in opposition to nationalism and, thus, defined the Second and Third Internationals, which went on to identify with the communist international backed by Russia. However, this historic cycle of the use of the word would end when Stalin, searching for conditions that would favor an alliance with England and the United States, announced the dissolution of the Third International. With the end of the war, radical transformations affected both nationalism and internationalism. Whereas nationalism came to be identified with popular anticolonial and anti-imperialist causes, internationalism came to be associated increasingly with spaces pertaining to capital and its restructuring, a process that shifted the United States into a position of power that no other nation had previously occupied.

This substitution for the original meaning of the term international not only pointed to the processes of restructuring capital, but also served as an ideologem for the legitimization of artistic expressions in opposition to the national character. This feature is particularly significant in the case of Latin American art and its circulation in the United States where, after the Cuban Revolution and the program of the Alliance for Progress, Latin America became a priority. Following the revolution in Cuba, during what might be considered the second important period of the Cold War, the need to promote good-neighbor policies with respect to Latin America also gave rise to artistic exchange. Exhibitions of Latin Ameri-

can art circulated through the United States at an unprecedented rate. Whereas in the 1930s the national character of Mexican muralism did not hinder Orozco, Siqueiros, and Rivera from painting their murals in the United States, in the 1960s art critics viewed nationalism as anathema and only recognized as valid art that could be expressed through an "international" style.

The internationalist project not only compromised Argentine art, but also the entire Latin American circuit. An article published by Shifra M. Goldman in 1978 was one of the first to call attention to this issue.[26] Referring to the case of Mexico, Goldman analyzed the internationalist aperture of the 1950s and the role of North American institutions, particularly that of the International Council of the MOMA in New York and its ties to the Rockefeller family. Goldman's work drew upon the articles that Eva Cockcroft and Max Kozloff had published in *Artforum* during the 1970s, examining the propagandistic use of abstract expressionism by the United States during the Cold War.[27] Goldman asserts that, in addition to economic penetration, art was also an instrument of neocolonialism in Latin America. What I intend to show here is that cultural policy implemented by North American institutions in attempts to halt the advance of communism over the continent did not exclusively consist of sending exhibitions of North American artists abroad. This policy, which indeed existed, was the visible aspect of a much more complex and subtle strategy. Its activities also consisted of bringing Latin American artists and intellectuals to the United States in order to prove to them that there was an incipient interest there, and to demonstrate the extent to which new conditions existed for true exchange. This recognition of their existence, together with the need to proclaim it at every given opportunity, enriched Cold War rhetoric with a new approach. The purpose was to hinder Latin American intellectuals from identifying with the Cuban Revolution.

Eva Cockcroft also considered relations between the United States and Latin America in the artistic sphere. In her view, the resolute promotion of Latin American art in the United States after World War II formed part of the strategy designed to establish North American hegemony.[28] Cockcroft emphasizes the role played by the Organization of American States (OAS) as a space for introducing Latin American art into the United States, as well as the role played by José Gómez Sicre, visual arts director of the OAS, in defining tastes. However, what is not addressed is how this project was also formulated in such countries as Argentina and

Brazil, to cite the most notorious cases. Cockroft's scrutiny of the intense debate over abstract expressionism and the figure of Clement Greenberg, developed in the historiography of North American art during the 1970s, leads her to apply to Latin America the same interpretations of how North American hegemony was established in Europe. In contrast to Europe, abstract expressionism was not a "weapon of the Cold War" in Latin America. Until the 1960s, Argentine art was influenced considerably more by Europe than by the United States. On the other hand, although it is true that the exhibitions that took place in the galleries of the OAS tended to favor abstraction, they did not represent the only efforts made in those years to promote the internationalization of Argentine art.

Félix Angel views the Alliance for Progress as an economic and cultural strategy designed to halt the advance of communism in Latin America.[29] His analysis considers the political context and the reasons why interest in Latin American art was generated at certain moments: during the war years it was cultivated in order to assuage Latin American countries' resentment of the restrictions imposed upon them by the United States; in the 1960s it was a resource to minimize the effect of the Cuban Revolution. Angel points to the "symbiotic" relationship between museums and galleries with respect to the promotion of Latin American art, the actions taken by the Center for Inter-American Relations in New York, and the relative inability of all these activities to definitively affect the evaluation and recognition of Latin American art by the major international art centers. In his analysis, the aggressive policies that were carried out by certain Latin American institutions become blurred and the panorama he describes implies a defenseless Latin America trapped in the claws of empire. It is not that this is a total misrepresentation of the situation, but this perspective neutralizes the possibility of analyzing projects that were organized in such countries as Argentina and Brazil, which, even when subscribing to the larger context of the new internationalism, did not cease to define their own expansive strategies.

The internationalist project in Argentine art implied, in turn, a profound transformation of the artistic field. When I refer to the notion of an "artistic field" I allude to a group of institutions, forms of legitimacy, cultural arbitration, and the imposition of values, elements intensively identified and analyzed in the works of Pierre Bourdieu.[30] Intensive but not exhaustive because, as indicated by María Teresa Gramuglio, "the abso-

lute Franco-centricity of the empirical analyses on which his theoretical model is based . . . requires that particular attention be paid to Bourdieu's scant observations regarding the need to consider the different configurations and specific traditions in each case."[31] To these objections should be added those raised by Carlos Altamirano and Beatriz Sarlo with respect to the concept of "cultural field" in terms of the coercion applied by the political system to the relative "autonomy" of the cultural (and artistic) field in Latin America,[32] the permanent presence of a system of references oriented toward international artistic centers and not only toward national traditions, as well as the effects upon aesthetic and stylistic paradigms, and events celebrating awards and recognition. In light of the preceding, it is fair to wonder what the "selective tradition" is (in the sense that Raymond Williams uses the concept)[33] that is operating in each new formulation of the Argentine artistic avant-garde.

The problem implies a reconsideration of the relationship between the periphery and the center, as well as the quest for a new reversion, proposed above all because this was a moment in which avant-garde discourse aspired to embark on something new, with even greater energy than was seen in the 1920s. In many cases what appears to be central is the need to subscribe to a proper and differentiated model as a way of intervening in international repertoires and of being recognized in spaces of awards and circulation.

Identifiable within a network of simultaneous movements, the internationalist project implied establishing a new direction in the history of the national art. The force and urgency of this need were clearly outlined against the immediate past, defined in antithetical terms with respect to a present in which everything, it was felt, had to begin anew. Those were the years of post-Peronism when the country confidently charged toward a program of industrialization designed to liberate it from its postwar isolation and internal market policies that had impeded its integration into the international market. It was at this moment, basking in the glow of the inaugural moment and marked by the urgent need to establish a foundational tabula rasa, that there emerged a group of institutions determined to carry forward initiatives that would definitively elevate Argentine art to a new level, indeed, to stardom. In this sense, the institutions played such a central role in the process of modernization that it is possible to refer to an artistic field whose structure was to undergo a radical transformation driven by the project for cultural renovation and modernization.

On the other hand, it should be emphasized that the internationalist project did not have an exclusively local formulation. Just as this discourse of a promising future could not free itself from the dispute over the immediate national past, it should not be considered apart from the international situation that was so strongly influenced by the new Cold War environment. The need to activate initiatives that, following the Cuban Revolution, would halt the advance of communism over the rest of the American continent would encounter a series of measures and promise-filled slogans emanating from the assistance program of the Alliance for Progress. In this sense, I argue that the projects for the internationalization of Argentine art were not the exclusive product of a determined leadership class with a mission of messianic artistic patronage, but rather these actions took place in the context of a broader discourse that, in the cultural productions field, had the support of economic programs, publicity, and stimuli that favored the circulation of Latin American art. This redoubled and strident cultural discourse foretold of a promising future for the continent. From this perspective, my intention is to review the international circuits with a critical eye toward reconstructing the political intentions of such programs, frequently obscured by lofty philanthropic objectives expressed in the catalogue introductions for exhibitions and competitions. I sustain that the support given by a group of North American institutions to Latin American art should be also understood as a propaganda instrument oriented toward counteracting Cuban policies toward Latin American intellectuals. These intellectuals were constantly convened in Havana to discuss the culture of the revolution and their conclusions were reprinted in leftist intellectual magazines across the continent.[34] Nonetheless, in the visual arts field, it was only in the mid-1960s that avant-garde artistic groups conceived of their artistic productions as a form of supporting the revolutionary movement. For many Argentine artists at the beginning of the 1960s, the styles, galleries, critics, and museums of Paris and New York represented much more powerful points of distinction than the entrance of Fidel Castro into Havana.

For Argentine institutions, the priority was to produce an artistic avant-garde and to become involved in the international scene, and to do so they had to present an art that was different from what was already being offered as part of the repertoires of the main cultural centers—an art that

was cutting edge. As we shall see, the project was not very well defined when the time came for deciding which images should represent it. It meant offering all that could be considered new and, preferably, produced by young artists. The idea was that, out of all the forms that emerged from this climate of experimentation and adventure that had taken hold among the artists of Buenos Aires, there was something key and original and different from what was being created in the traditional art centers. This idea, perhaps for the first time, was one that the artistic institutions of Buenos Aires thought they could count on, even though they were still unable to decide which style was most representative.

In the early 1960s, the artists saw themselves producing their work in a climate similar to that described by Jürgen Habermas when characterizing the avant-garde: "invading unknown territories, exposing oneself to the danger of unexpected meetings, conquering the future, tracing tracks in a landscape no one has yet traversed."[35] These are features of prophecy and anticipation that recall other authors, ranging from Renato Poggioli to Roger Garaudy, Harold Rosenberg, Otto Hahn, and many others.[36] What interests me for this analysis are the questions of what measures were taken to this end, what the aspirations were, and why the expected success was either tenuous or not achieved at all. Why, at the beginning of the 1960s, did so many artists feel the necessity to launch innovative programs and manifestos? Finally, why did this combination of decisions, which were so institutionally well received, betray in principle the anti-institutionalism that authors such as Peter Bürger consider to be central in the definition of the avant-garde?[37]

Another aspect I analyze is the aesthetic paradox posed by the relationship between modernity and avant-garde in the 1960s. Whereas it is perhaps unquestionable that during those years the avant-garde assumed many of the characteristics of modernity (exaltation of the urban, perpetual disintegration, ambiguity, anxiety, the necessity for transformation of the individual and the world),[38] there was a general denial of a central feature in the paradigm of the modern aesthetic: formal autonomy (self-sufficiency, antinarrativity) as critical oppositional consciousness.[39] What art of the 1960s brought together as material for innovation was precisely what Greenberg had thrown into the kitsch trash-bin and was, in Thomas Crow's view,[40] the refuge from which the avant-garde reinvented itself in order to become part of the mental system of modern painting springing from the normativity of language (in both Impressionism and cubism). During the 1960s the conflict between autonomy and heteronomy ex-

ceeded the terms of exchange proposed by Crow, resulting in a crisis of the modernist paradigm that could not be measured in terms of evolution. In this context, I analyze how Argentine art was positioned relative to this question and the extent to which Romero Brest, through his criticism and actions in the artistic field, sustained throughout the 1960s the program he had championed and modified in the 1950s.

With respect to problems posed by the notion of an avant-garde, it is also of central importance to consider the various positions regarding the relationship between art and society. To this end it is crucial to analyze how the notion of autonomy is constituted,[41] and at what moment it ceases to refer to an intensification of form through abstraction in order to serve to centrally define the rupture of continuity between art and vital praxis through the creation of an autonomous institutional sphere. This is the moment that the avant-garde, in an instance of self-criticism within the artistic system, ceases to concentrate on the aesthetic project in order to take aim at the art institution as a whole (the distance between "fiction" and "praxis," between "artifact" and "useful object").[42] This is a central feature in the definition of avant-garde proposed by Peter Bürger and a dilemma that is examined every time artists question the function of art in society, an instance that, as analyzed by Raymond Williams, concludes with the need to intertwine art and politics.[43]

Therefore, for the problems examined in this book, it is relevant to consider the role of the institutions and their relationship to the projects of the avant-garde. The institutional system and the prologues and declarations, heard at every opening of prize competitions and exhibitions, acted as a form of convocation which found a broad context of receptivity and coincidence in the dynamically developing experimental art field of the mid-1950s and 1960s. While the artists of Buenos Aires were creating their work in a rarely seen climate of experimentation and innovation, they also seemed to have the support of one of the indispensable conditions for responding to the challenges of inventing a new and long-awaited art form: promotion. By focusing on this new situation, I am not making the claim that the institutions might have generated an avant-garde, but rather that at the beginning of the 1960s the relationship between both was defined by a coincidence of interests and mutual collaboration. It was a relationship that, as we will see, was continually transforming and eventually became unsustainable.

This concept of a dynamic and constantly redefined artistic avant-garde is precisely what allows us to conceive of the relationship that exists

among the projects of internationalization during this period as a variable connection, in which short-term alliances, discords, and violent confrontations played important roles. Whereas at the beginning of the 1960s the dominant challenge for avant-garde sectors had to do with an experimental attitude toward the transformation of formal structures, after 1965 it would become increasingly difficult to conceive of art and the avant-garde apart from political concerns and positions. The aesthetic and political avant-gardes gained strength in what Thomas Crow refers to as the discovery of an "energizing congruence."[44] What I will demonstrate is that the association of the avant-garde with the internationalist project, just like its violent defection, are highly significant for understanding the artistic projects of the period in question. Within this repositioning process, art was increasingly both representation and action, as well as a problem relative to ethics and power. It was a dynamic in which the story of the individual artist was replaced by that of the social artist (the abandonment of "the studios and galleries for the streets," as Marshall Berman would say)[45] and in which the distinguishing features of style and language were replaced first by the *option* and, shortly thereafter, the *imperative* of politics. This evolution, which had an impact on all cultural spaces, had a peculiar effect in the artistic production field. Its climax, the height of its articulation, also signaled the exhaustion of its options and its demise.

The artistic avant-garde project of the 1960s must be understood within the framework of the intense process of cultural modernization that characterized the "developmentalist" moment.[46] For a country that was expanding its economy so intensely, it was also necessary that transformation and development in the cultural field should take place. Such a project required extraordinary efforts by powerful directors among the booming industrial bourgeoisie as well as in the intellectual sectors. These actors were opportune allies, capable of liberating the growth and development program from exclusively economic circuits.

In addition to patronage—support emanating from foundations and the financing of mega-projects that could effectively and immediately promote such aspirations—there was also a perceived need for a program, values, and guidelines that would indicate the actions that should be prioritized in order to break onto the international scene with a unique art form of unquestionable quality. In this sense, Romero Brest was a crucial cog in the machinery. In a certain sense, his actions could be evaluated as those of a "planner of an era,"[47] a "modernizing intellectual," or, in

Bourdieu's terms, a "taste-maker"[48] who, after 1956, was situated at the center of the artistic scene as director of the National Museum of Fine Arts. In that institution he found a suitable position from which to carry forward the project he had carefully outlined during the restrictive years under Peronism.

One point I want to establish here is that the aggressiveness with which the artistic institutions pursued the quest for a "new art" cannot be understood without analyzing the ways—to some degree peripheral—that these aspirations were realized under Peronism. During those years, both Romero Brest and Julio E. Payró attempted, once again, to explain and introduce the "modernist paradigm" to Argentina,[49] seeking to establish solid bases for an art that, according to Romero Brest's claims in 1948, had not found the "metaphysical root of its existence" nor the "core of its destiny" that it could embrace as its own "universal art form."[50]

From this perspective, I propose that the form of criticism developed by Romero Brest during the Peronist years, and the activities he engaged in after 1956,[51] decisively contributed to the definition of a program that maintained a close relationship to the aspirations of a restricted sector of the modernizing bourgeoisie, inclined to support modern art, whose foremost representative was the young and cultured industrialist Guido Di Tella. The discourse expressed by Romero Brest as art critic and cultural director both fulfilled the ideological needs of these sectors and found its ideal space in the model of cultural patronage embodied by the Torcuato Di Tella Institute.

The artistic images and the decisions that were made with respect to the configuration of the formal works, as well as the political, social, and institutional dynamics, contributed to the active discourse of the cultural debates of the period. In this sense, it is my view that the analysis of the specificity of the formal expressions provides important key elements for understanding aspects of the period which are not so readily accessible through other texts. As multifaceted crystallizations of coexisting narratives, conceptual and perceptual clusters, or concepts that were condensed into "dense visual icons" (in Crow's terms),[52] the images are not only significant because of the spaces in which they operate or the debates they give rise to. Critical also are the decisions that have been made regarding the artistic forms and the visual narratives of diverse experiences that the art successfully condenses in an order that is both perceptual and, in a broad sense, ideological. These pieces are a reservoir of narratives that also provide access to the spectrum of experiences that constitute

the "structures of feeling" (in Williams's terms) of an era.[53] Some of the images that I consider, both for their contents and for their formal configuration, imply taking a position in specific situations and could even be viewed as forming part of a program, as "image-manifestos."

From the vast output of those years, I have selected my corpus according to those works that condense and amalgamate action programs in the artistic field and that reflect social expectations and political and aesthetic debates. From this perspective I analyze opposing programs, the disputes they gave rise to, their successes and failures: those artistic objects, exhibitions, individual or collective actions that implied a historically significant stance. In relation to the images and the perspective I have proposed for this analysis, together with contributions to the social history of art represented by such authors as T. J. Clark, Thomas Crow, and Serge Guilbaut, I will especially take into account W. J. T. Mitchell's contributions regarding a theory of the image and representation, particularly his studies on the relationship between image and power, between politics and aesthetics; that is, questions relative to the potential effects of (in this case visual) representations.[54]

Our story begins, strictly speaking, in 1956, with the self-proclaimed Liberating Revolution, a moment that coincided with the founding of the important institution, the Museum of Modern Art of Buenos Aires. This event signaled the reorganization of institutions as a function of a project aimed at renovating Argentine art. This process culminated in 1968 when, in a climate of repression under the government of Onganía, sectors of the artistic avant-garde confronted the institutions in which they had been carrying out their activities, thus redefining avant-garde strategies with a clear connection to the political sphere. These events, which serve as justifiable chronological milestones, are in fact almost anecdotal incidents that help characterize a process whose complexity can be seen in the system of debates and posturing that revolve around a set of central problems in the dynamics of the period. These included such questions as what the avant-garde is, how the relationship between art and politics should be, and to what degree it is possible to reformulate relations between central and peripheral nations. In this context it might be argued that the institutions and projects that came to prominence after the fall of Perón were not conceived in that moment. On the contrary, they were fringe

projects that were belatedly nurtured under Peronism when specific intellectual groups realized that it was impossible to carry them forward in the current official cultural spaces. For this reason I have dedicated the first chapter of this book to the Peronist years in order to analyze the position of Argentina in the postwar artistic debate, a moment in the country's history when many cultural sectors actually identified with the forces and ideologies that had been annihilated in the world conflict. These years are reviewed with certain key questions in mind: What connections were established with the international artistic circuits? How were relations between Peronism and the groups of abstract geometric artists characterized? What programs were developed by displaced groups—having been distanced from the official institutions—as they sought to articulate an artistic project to implement when the "dark" ages finally ended?

It is also important to review the stereotypical construction of artistic development during the Peronist years and to consider, at the same time, the program developed by anti-Peronist sectors which would become the scene and space for the realization of their work with the advent of the Liberating Revolution. To this end, I consider the activities of Romero Brest and the magazine *Ver y Estimar* (1948–55); the relationship between Peronism and abstract art through official exhibitions and submissions of Argentine art to international forums; the controversies that developed with respect to abstraction, primarily in the pages of such publications as *Sur* and *La Nación*; and the organization of institutions oriented toward promoting new artistic forms of expression, such as the Institute of Modern Art (1949).

Chapter 2 focuses on the organization of the artistic field following the fall of Peronism, a time of dynamic institutional upheaval characterized by projects whose central discursive theme placed the present in opposition to a period that was defined in negative terms. At this time the official initiative clearly seemed to open up spaces for modernizing programs that were capable of articulating the cultural image of a country that was hurtling toward the future, and longing to be incorporated into the international art scene. Here I examine the process of designing a project for renewal at the institutional level (the foundation of the Museum of Modern Art, Romero Brest's administrative activities beginning in 1956 and, later, as director of the National Museum of Fine Arts). I also analyze the positions of artists with respect to the avant-garde and tradition, as well as the strategies that certain sectors adopted in order to form an identity

that went beyond the national borders and adhered to an international artistic front with surrealist roots, represented by the Phases movement. The process of elaborating a junk aesthetic with the presentation of exhibitions by the Argentine informalist movement will also be considered.

At the beginning of the 1960s the discourse of catalogue texts, journalistic criticism, and the writings of artists themselves composed a sort of convocation for the formation of an artistic avant-garde. At this time the internationalist projects began to take on nationalist features. They considered not only the possibility of integrating with international styles, but also the necessity of generating an avant-garde that was so original and different that it could force its way into mainstream circuits. For various reasons, 1960 was a landmark year in the creation of this new scene. The celebrations of the 150th anniversary of the May Revolution inspired not only a critical review of the national artistic evolution but also the launching of programs that were open to renovation and innovation. Subsequently, in chapter 3, I analyze both the private and official policies that were formulated for the promotion of a new art form.

The aesthetics of materials was a fertile area for formal experimentation in the early 1960s. Chapter 4 considers the emergence of avant-garde programs and the implementation of diverse forms of activities (groups, manifestos, declarations) designed to gain recognition. I consider various group programs (Nueva Figuración, Arte Destructivo), as well as individual artists (Berni, Greco, Santantonín, Minujin, among others), reviewing the concept of avant-garde through the poetics and theoretical views that these figures propose. I also analyze how the so-called aesthetic paradox of the 1960s was infused into Argentine art through relations established between high and low culture in certain artistic productions.

Chapter 5 analyzes the "disruptions" that the new aesthetic proposals produced in the model that Romero Brest had so carefully designed during the 1950s and upon which he had staked the art of the future. His confidence in abstraction did not dominate 1960s art. Although at first the Argentine critic did not perceive the need to explain the change that was taking place, by the middle of the decade he could no longer avoid the task that he had come to see as his responsibility: to provide the public with guidelines for understanding new art. In this chapter I also analyze the different models the critic employed in order to explain what was happening on the art scene, as well as present a comparison with Masotta's critical theory model. In the mid-1960s, when Masotta began to give con-

ferences on the visual arts and to write on pop art, the happenings, and the relations between art and the mass communication media, he came to have a powerful influence on the analysis and interpretation of the experiences being produced at the time.[55]

Chapter 6 presents a comparative study of the models of promotion and internationalization of art that were experimented with by such Argentine institutions as the Torcuato Di Tella Institute and the American Art Biennials, organized by Kaiser Industries of Argentina in the city of Córdoba. In this context I consider the images chosen by these institutions as they entertained hopes of earning internationalist recognition. I also focus on how relations were established with North American institutions and in what ways the presence of foreign critics affected the local media. More precisely, I consider which operative models were adopted and what questions were discussed at the critical moment when prizes had to be awarded. I also analyze the impact of policies designed by successive North American institutions for the purpose of sending North American art exhibitions to Latin America and bringing Latin American culture to the United States (the Inter-American Committee, the Inter-American Honorary Sponsoring Committee of the International Council of the Museum of Modern Art, the Inter-American Foundation for the Arts, the Center for Inter-American Relations). Clearly, their intentions were to demonstrate that interest was rising in the United States and to give substance, through concrete actions, to the use of such terms as "exchange" and "friendship," which permeated the discourses on inter-American relations during the 1960s. Discussions on the values of Latin American art found, in the notion of "internationalism," a productive space for prolonging the dispute on the position that the art of this continent should occupy in the history of Western modern art. In this regard, this chapter also analyzes various moments in the critical reception of Latin American art in the United States, ranging from moments of recognition to utter rejection. "Internationalism" was, from the perspective I propose here, much more than a casually chosen word. On the contrary, in a subtle but effective way, this term was an integral part of the repertoire of Cold War rhetoric in the cultural sphere. My objective is to show that this word took on very diverse meanings and functions as relations between the United States and Latin America changed over the course of the 1960s.

Beginning in the mid-1960s, and particularly after 1968, the relationship

between art and politics became unavoidable for Argentine artists. Faced with evidence that a more balanced relationship of exchange with the artistic centers was impossible, and given the realization that the transformation would not be achieved through gradual and programmed development, artists recognized that the time had come to explore more fully the revolutionary option, so they began to commit their own activities to the demands of the situation. In the final chapter of this book I explore the relationship between the notions of the artist and the intellectual, and I consider the process through which the artistic field was politicized by examining several specific cases (León Ferrari, Juan Pablo Renzi, the *Tucumán Arde* exhibition). I also analyze how the problem of the relationship between art and society was addressed and the ways in which the issue of the autonomy of artistic institutions was reformulated.

The complex system of problems examined in this book is analyzed on the basis of many forms of documentation (verbal accounts, manifestos, declarations, programs, works of art) with the objective of reconstructing the dynamic of the period and capturing a sense of the intensity of the many discourses that accompanied the various courses of action. The magazines dedicated to culture (in addition to journalistic criticism) contributed crucial material for reconstructing the principal controversies of the period.

The oral accounts are taken from interviews I conducted from 1993 and 1998. The need to draw upon such sources for the study of art during the 1960s is not only justified because it was still possible to interview many of the figures from the period, but is also owing to the specific characteristics of art during that period. Although it is true that many works were lost simply out of carelessness, it is also true that for a "poetics of the ephemeral" and "art as event," the dissolution of artwork was an integral part of the program. Given the nonexistence of many works that were conceived to be active exclusively at the moment of their presentation, the oral testimonies constitute a fundamental source for their reconstruction. For this reason, the studies carried out in recent years by María José Herrera on art and communication media,[56] by Ana Longoni and Mariano Mestman on the process of the paradigmatic exhibition *Tucumán Arde*,[57] as well as Inés Katzenstein's publication of Oscar Masotta's texts on art are also relevant.[58] Although the oral testimonies do not provide direct contact with the experiences of the 1960s, they do offer access to the interplay of

desires, tensions, frustrations, expectations, debates, successes, and fail-
ures that accompanied the formulation and development of artistic and
cultural projects. From this perspective, it is not important to consider
these sources in order to reconstruct the "truth" of the events, but rather
to understand what these actors thought they were doing and the reasons
they believed in their actions.

1

MODERN ART ON THE MARGINS OF PERONISM

In his notes from August 23, 1944, published in the literary journal *Sur*, Jorge Luis Borges described his impressions of the celebrations in Buenos Aires following the liberation of Paris: "That day of teeming masses, I was struck by three heterogeneous forms of amazement: by extreme physical joy when I was told that Paris had been liberated, by the discovery that collective emotion is not necessarily ignoble, and by the enigmatic and notorious enthusiasm of many of Hitler's supporters."[1] In a few short pages, Borges delivered a suggestive description of a conflicted reality, laden with political, ideological, and cultural contradictions. As in the plot of a surreal story, it seemed as though Argentina was being subjected to an order from which the rest of the world was now free. Despite the complexity of those years, the history of the period was often written as if things had been clear and straightforward; this is apparent in the rhetoric of both the Peronists and the anti-Peronists.

The geometric abstract movements spearheaded by the artistic groups Madí, Arte Concreto Invención, and Perceptismo, were formed and developed during the Peronist period. They have been studied as if they could be isolated from history, ignoring the changing relations that existed between Peronism, during its first ten years in power, and the worlds of art and culture.[2] All the tensions and forged agreements between artists and government were held in suspense in what became the characteristic posture of opposition to abstract art led by the minister of culture, Oscar Ivanissevich, on behalf of the Peronist administration.[3]

Analyzed from a perspective that considers various aspects of the period, there emerge contradictions, disputes, and negotiations that shaped those confrontational years, aesthetically as well as politically. During the Peronist regime an artistic agenda took shape that was in opposition to what was recognized as the official position, despite its not having been stated explicitly. This agenda was linked in various ways to one being formulated in other cultural spaces, particularly that of the noteworthy literary circle that produced *Sur* and, in the art world, the magazine *Ver y Estimar*, under the direction of Jorge Romero Brest. Ostensibly expelled from the art world and the official institutions, what aesthetic projects did these sectors develop from the margins? What was the nature of the relations between these artistic formations and the international world of art and culture at a moment in which, despite the emerging avant-garde in the United States, the intellectual elite still identified with Europe and, particularly, with France?

Investigating this shadowy period of Peronism enables us to consider the ways in which confrontations during those years acted as a powerful force to activate initiatives suddenly taking shape in the post-Peronist period: a time, for some sectors, of historical revenge.

Postwar Chronicle

In September 1945, as the daily headlines announced the possibilities for a definitive Allied victory over the Axis powers, a situation in Argentina was emerging that, in a certain way, transported the tensions of the world conflict to home soil. The new international situation made it clear that continuing the fascist experience initiated by the Argentine colonels in 1943 would be impossible. This led to an outpouring of citizens into the streets to demand the urgent normalization of institutions and an end to Argentina's diplomatic isolation. Despite attempts to politically redirect the government, its collapse was imminent.[4] However, this did not take place all on its own. Beginning in April artistic and cultural sectors began organizing a publicity campaign that featured a series of uninterrupted rallies and demonstrations, culminating in the massively attended march for La Constitución y la Libertad (Constitution and Liberty) held in the Plaza Congreso on September 19, 1945. This demonstration was called forth by a broad political front that brought together radicals, socialists, communists, democratic progressives, conservatives, and even the military sectors.

Two days earlier in the same climate of public action, as proclamations were being delivered that shook the nation, the Salón Independiente (Independent Salon) opened its doors in a gallery space on Florida Street — graciously provided by the aristocratic Sociedad Rural Argentina (Argentine Rural Society). This new group was in clear opposition to the Salón Nacional (National Salon) which, at that transcendent moment in history, became synonymous with the government, the dictatorship, and all those forces the masses wanted to eradicate. All public statements addressed the urgent need for change and were directed at this singular, uniting objective. The artists had decided to assume civic responsibility and to call for a return to democracy: "The works on exhibit here were intended for the National Salon this year. The artists whose names appear on these works participate in this exhibit in solidarity with the democratic desires expressed by the intellectuals of this nation. With this attitude, the exhibitors wish to express that they are not indifferent to the problems affecting the activities of artists and citizens."[5] This public position, at one of the most critical and turbulent moments in Argentine history, was symptomatic of the conflictive context that characterized the relationship between the art world and Peronism until 1955.

Despite efforts to transport Europe's fate to Argentine territory, evidence quickly came to light of a new situation that some cultural sectors identified with the defeated forces and ideologies of the war. The history of Argentina was rapidly being woven against the grain of the new world order, and one part of society was consolidating its efforts to break down the barriers that prevented the country from siding with the victors. On September 18 the front page of the newspaper *La Prensa* reflected the deep-seated anxiety and sense of urgency that marked this issue: Alongside MacArthur's declarations regarding the rapid occupation of Japan and the reports of two hundred thousand deaths at Auschwitz, there appeared an article on the massive turnout for the march for the Constitution and Liberty and the inauguration of the Independent Salon. Intellectuals, artists, and some political and military sectors thus formed a transitory front determined to act, confident in the power of its weapons. And among them, the images to be offered by the art world were not to be underestimated.

The Independent Salon did not, as suggested in the printed media, represent a confrontation between artists disputing avant-garde space. The need to organize did not arise from a disagreement over the dominant aesthetic; it had more to do with an "eclectic and balanced" group to

which belonged a number of "prestigious names in the national art scene, with constructive and responsible works."[6] In large part, it was owing to the presence of these prestigious names that the painter Antonio Berni was able to uphold the importance of the salon and raise it to a level equal to the significance of the march for the Constitution and Liberty.[7] At the same time, the salon afforded Berni a magnificent opportunity to defend his opposition to aestheticism, which, in his words, was what made this collective initiative an important cause: "What is extraordinary is that against all the restrictions imposed on artists over the years to keep them within the unworkable and narrow conventional limits of a purist and romantic world, these artists have collectively broken out of their self-imposed isolation, as well as that imposed on them, in order to mix in with the mass of citizens (as well they should), fighting for the cause of Argentine democracy without which, they know, the necessary spiritual probity and opportune climate for the free expansion of human personality is impossible."[8]

Few voices were raised against this organized paintbrush militancy. The invitation to the artists from the Asociación Estímulo de Bellas Artes (Association for the Stimulation of the Fine Arts) to attend the National Salon—so that "this superior expression of the country's culture" should not remain caught in the trap of "lowly politics"—merited only a short statement from the "citizen artists" regarding the necessity of "expressing their opinion in agreement with the feelings of the democratic intellectuals of the Republic."[9] What this statement demonstrated was that the rejection of all manipulation of art, which was based on the defense of artistic autonomy, was collapsing in the face of this situation, now considered of the utmost urgency.

"Freedom" was the keyword. It represented the principle that the artists felt they were defending when they showed work that thematically referred to the end of the war and, for this very reason, they could be sure that their work was not going to please the authorities, who had associated themselves with the defeated forces in the world conflict.

At least three paintings from the salon, by artists who were very representative of the Argentine art scene, addressed the barbarity of war: *Liberación* (Liberation), by Raquel Forner (see plate 1), *Objetivo estratégico* (Strategic Objective), by Emilio Centurion, and *1945*, by Enrique Policastro. These images, denouncing the aberrations of the conflict, could be seen as challenges to the established power structures. They were, in a certain sense, "reports from the front" that spoke to the suffering caused by

a war in which the Argentine government had remained neutral until just a few months before the end; a government that, on the other hand, had not hesitated to send mounted police to disperse demonstrators celebrating the liberation of Paris in Buenos Aires. To paint the war, to denounce atrocities, could be seen in this context as a kind of manifesto.

The same need to take a position that had led Raquel Forner to express her tribute to the liberation of Paris on August 23, 1944, inspired her to paint *Liberación* in the heat of the Allied advance. As a summary, she picked up many of the themes she had begun to develop in her heartrending paintings of the war: the wounded woman, the repetition of *ni ver, ni oir, ni hablar* (see no, hear no, speak no evil), Icarus, the broken bridge, the flower. All these themes, which she developed in the series on Spain (1936–39) and Drama (1940–45), now aided her narration of victory. The same figure of a woman that Forner had painted many times as a medium for the barbarities and suffering of war,[10] now stands like a pillar in the center of the composition; she raises the blanket of death and the souls in agony, and, splitting the earth in two, she opens her eyes to the beginning of a new age.

A victim of violence, the lacerated body of the woman rises up in this painting as the great judge of all history, surrounded by an iconographic fusion that condenses elements of the Final Judgment: the separation of humanity into two groups, the torment of the condemned and the ascension of the chosen few, the Veronica with the shroud and the wounds. To this was added a kind of free-form recycling of iconography, in which the topos *see no, hear no, speak no evil* now placed beneath the earth, suggested — with this inversion of the significance of the theme in her previous works, in which she reverted to the need to lull the sensibility in order to resist the pain of the war — the recuperation of the senses or the latency of danger. In one corner, the hydra, a serpentine animal, the image of the proliferation of evil, is crushed by a hand from which a red poppy germinates, as if to represent the sublimation of human suffering and as a tribute to the anonymous dead in pursuit of an ideal. The wounded body of the woman becomes a medium, the embodiment of the voyage from the destruction to the rebirth of life.

All these elements combined to render Forner's work an effective intervention that successfully condensed and interpreted conflicts, evoking the immediacy of the international through a national context. This painting, highlighted in all of the art reviews, became the signature piece of the Independent Salon, as much for its thematic content as for the fact that it

had been withdrawn from the National Salon where, everyone agreed, it would have undoubtedly won first prize. The work was a synthesis of Forner's oeuvre, but at the same time, it upset its own iconographic sequence by proposing an interpretation of the new situation. All the elements, thematic as well as formal, rendered the work an even more powerful and comprehensive program for intervention than the statement originally issued when the artists opened the salon. The sense that this work was a painted program, a declaration of principles in this case more political than aesthetic, imbued it with the characteristics of an "image manifesto." This quality promoted an evaluation of the political situation, expressing an attitude toward it, and simultaneously attracting more followers than if the program had been expressed in written form.

The need at this time was so urgent that the artists did not hesitate to shun the official ceremonies and to utilize their works as instruments for social advance. This is what Berni had done at the tribute ceremony for Domingo Faustino Sarmiento, held by the Federation of Teachers, by painting an enormous portrait of the founding father to preside over the stage, with the famous exclamation: "Barbarians! Ideas cannot be killed!" A ceremony that, on the other hand, had been extremely controversial considering the "uproarious ovation that rose up from all sides when the loudspeakers announced the arrival of the ambassador from the United States, Mr. Braden."[11] From the moment the ambassador arrived in the country, his actions had an impact on the conflictive political, economic, and cultural relations between the United States and Argentina during the Perón administration.[12]

The collective exhibition at the Independent Salon enabled the artists to reconcile themselves with the war's victors and to that part of society with which they felt most identified. But in spite of all this optimism, there was a factor that the civilian opposition to Perón's surging power had not evaluated with due measure: the actions of the worker's organizations, which for the three previous months had tried to remain on the margins of the increasingly taut confrontation between the opposition and the government. Following the temporary victory achieved by the alliance between the opposition and the military sector that distanced Perón from the government on October 9, Perón managed to regain power a week later owing to the joint actions of the worker's movement and the masses that marched through the streets of the city.[13] In those crucial days, dominated by one of the most decisive political crises in Argentine history, every mistake and every shrewd move by the three sectors involved (mili-

tary, political, and union actors) were irreversible. The tumultuous day of October 17, culminating in Perón's 11 o'clock speech that night to the masses gathered in the Plaza de Mayo, opened a new period in Argentine history and culture.

Once the tensions of this critical situation had diminished, the artists dissolved their united front. After February 1946, considering "that the recent national elections [indicated] a return of the Constitution to the empire," the Argentine Visual Artists Association decided to discontinue its boycott of the National Salon, the awards competitions, and all of the events they had publicly renounced.[14] The conflict, however, did not disappear. During those years the National Salon was a space that remained at the center of the dispute between the government and the artists.

The North American Invasion

Relations between the Perón government and the United States were just as complicated as those between the government and sectors of the country that had traditionally held power. These relations were influenced not only by the exemplary activism of Braden, the U.S. ambassador who voiced his opposition to Perón in the elections of 1945, but also by the publication of *Libro Azul* and the repeated attempts by the United States to exclude Argentina from inter-American meetings and discussions on the new world order. Thus, good relations were at first affected by uneasiness and suspicion. Even so, Buenos Aires was still included in the continental tour by the exhibition La Acuarela—EE. UU. (The Watercolor—USA) programmed in 1945 by the Inter-American Office and the National Gallery of Art in Washington. This alliance between culture and politics, implemented in Latin America during the 1940s as a way to combat Nazi expansion on the continent,[15] was clearly visible in two exhibitions organized by the Office for the Coordination of Inter-American Affairs on the initiative of Nelson Rockefeller, forever obsessed with changing the image of the United States in Latin America. In 1941 he sent the exhibition La Pintura Contemporéana Norteamericana (Contemporary American Painting) on a tour of the entire continent.[16] As indicated by Elizabeth Cobbs, even though Nelson Rockefeller had a true passion for Hispanic and Luso-Brazilian cultures, he himself defined his activities as "psychological warfare in the Hemisphere."[17]

La Acuarela—EE. UU. included forty-five watercolors, representing nothing very new in terms of "modern art." Only the works by Feinnin-

ger, Charles Demuth, Max Weber, and Stuart Davis could be linked to transformations that, in the language of abstraction, had been introduced by the historical avant-gardists. Nonetheless, the text of the catalogue affirmed that the discoveries regarding light and color to be found in these watercolors ran parallel to those found in French Impressionism. It was even possible, according to the catalogue, that in these watercolors "the new freedom" had found "its genuine expression" for the first time.[18] If Buenos Aires spectators had taken such statements seriously, they would have had to look hard to discover the origins of modern art among those brushstrokes, something that certainly contradicted the widely held and professed view that situated the birthplace of modern art at the Paris school. But the claims of the catalogue could not be supported by the images, the arguments did not succeed in convincing the public to receive the exhibition as a representation of modern art. The policies that had guided the organization of the exhibition were not backed up by the paintings selected.

After the crisis in 1945 that linked art with the demands of politics, the illustrious sectors of Argentina no longer supported the proselytism of the image. However, the intellectual elite did not withhold judgment in matters of taste, and among the criteria applied, the rejection of all ideological contamination was a central element. What seemed to be a priority in those dark times was to keep the flame of high culture burning, and to this end it was necessary to establish, with extreme clarity, what could and could not be considered art. In this sense, a system of inclusion and exclusion operated in both the art and literary worlds. *Sur* was a powerful arbitrator, in both respects. This journal, which had been an active pro-Allies organism during the war, had taken a position during the Peronist period that coincided in various ways with the ideas upon which United States policy toward Argentina was based. As emphasized by John King, during the war, *Sur* "benefited directly from the United States' desire to stimulate the development of modern intellectual élites" in Latin American countries in order to establish a "liberal Utopia" that would expand beyond all borders.[19] Nationalism and communism, for the United States as well as for *Sur*, were evils to be eliminated.

Between 1942 and 1945, María Rosa Oliver, a founding member of the *Sur* magazine group, collaborated with the Office for the Coordination of Inter-American Affairs, organized by Nelson Rockefeller with the goal of promoting economic and cultural programs in Latin America. Both worked against the forces in Argentina that opposed the "American

front" for peace coming from the United States.[20] Although Rockefeller had to resign his post as assistant secretary of state for Latin American affairs, he did not renounce his objectives.[21] In September 1945, he wrote to María Rosa Oliver: "If only things had moved more rapidly in Argentina, we could face the problems of the peace with a completely solid front in the Americas. . . . My interest in our mutual problems is in no way diminished as a result of my leaving the Government, and I look forward to the continuation of the associations which have meant so much to me during the past five years. There is still so much to be done—your wisdom and judgment, your integrity and insight are greatly needed."[22]

For *Sur*, as well as for the United States, Peronist Argentina was nothing more than a waiting period, a period to skip over and, if possible, to eliminate.

Abstract Artists Between Communists and Liberals

In 1945, while artists of the Independent Salon were publicly demonstrating in defense of civil liberties, other artists were forming less strident groups that left national politics out of their work. Active members of the groups of geometric abstraction were opposed to all forms of realism. They wrote manifestos, they spoke out among friends, and they debated the role of precursors, seeking to validate their movement through discussions on absolute truth and knowledge of the single legitimate meaning of creation, art, and history.[23] To form part of the avant-garde was to join with the advancing world, as emphasized by Tomás Maldonado:

As concrete artists, we trace our origins to the most progressive tendencies of European and American art. Members of cultural chauvinism call this "living on European reflections," even though on a lower level they perpetuate the adorable "biscuit" of the Frenchman, Bouguereau. And, because we derive from these tendencies, we are against all forms that imply a regression.

Thus, we are against the mental and technical cowardice of the neo-realists, photographers bound to their paralytic and morbid representations, against those who feed off of the recipes of the turncoat, Lothe, against the dreamers of wilted carnations and interior worlds, who try to reproduce in our times of reconstruction and of struggle, a romanticism for interiors, and, finally, we are against the up-and-comers, false dialecticals, who speak of "abstraction" as an artistic event of 20 years ago, ignoring the remarkable development of non-representational art in the pre-war period.[24]

Modern art formed a single international front, a landscape into which the artists felt they had in some way succeeded in forming part when, in 1948, the Argentine Madí group was invited to participate in the Salón des Réalités Nouvelles in Paris. This space, which was almost regressive after the war in the Parisian art world, was full of connotations for the Argentines. It meant that geometric abstraction had crossed national borders and arrived in the city that, for Argentines, still represented the center of modern art. However, they were not all convinced that geometric abstraction offered the most suitable way to enter into the postwar Parisian art scene. The success of André Fougueron's realism (fervently defended by the communist poet Louis Aragón) at the Salon d'Automne in 1948 demonstrated that the Argentine abstract movement did not necessarily point the way for the postwar order. The hope these artists entertained of participating in the modern art debate, upon seeing their works hanging on French walls was, as history would soon show, no more than an illusion. It was not long before North American art demonstrated that the United States was the only country capable of producing a rebirth of the modern art movement.[25]

What is certain is that to some extent the ideal of *Sur* coincided with the ideal of the concrete artists. In contrast to the opposition to fascism expressed by artists like Forner, Centurión, and Policastro, through the iconographic content of the image, the concrete artists represented the model of "uncontaminated" culture to which the magazine of Victoria Ocampo aspired.[26] Although the explicit defense of dialectical materialism by artists such as Hlito and Maldonado could have been an obstacle, not to mention Lozza's membership in the Communist Party, this did not become a problem because they excluded any identifiable representation of it in their images.[27]

What was central to concrete art was the opposition to all forms of illusion. The objective was not "to abstract," but rather "to invent," to present new realities, which did not in any way imply remaining on the margins of the world's problems: "That a poem or a painting should not serve to justify a rejection of action, but rather, on the contrary, to contribute to locating man in the world. As concrete artists, we are not above any conflict. We are involved in all conflicts. And we are on the front lines."[28] All this speculation on the new art form was defined by a concern for establishing what was the aesthetic expression appropriate to the present. The artists felt that their art was a historic response, that the forms and structures they were proposing were appropriate to their times,

that through them they could resolve all the contradictions revealed by previous art forms, and that this would lead to the definitive creation of a better world. They approached their work as part of a revolutionary commitment that could be materialized in the transformation of awareness through a revolutionary transformation of forms. And, for these artists, a revolution in art necessarily implied revolution in the world:

Our works have a revolutionary mission; their goal is to help transform daily reality through the effective intervention of every reader or spectator of the aesthetic experience. That is, we reject, for all practical purposes, the "evasion" that the old representational technique established as one of the conditions for the work of art.

Consequently, the artist of our movement will not remain indifferent before the everyday world nor before the problems of the common man. The concrete artists are united with all the peoples of the world and with their great ally—the Soviet Union—in its efforts to maintain the peace and to stop the imperialist intent to revive fascism.

These artists do not see, therefore, either a way out or an opportunity for the invention they are proposing within the forms that the imperialists and the reactionary bourgeoisie are trying to impose on humanity.[29]

It should be noted that the artists of Buenos Aires declared their solidarity with the Soviet Union, while ignoring the imposition of socialist realism that had been established at the Writer's Congress of Moscow in 1934 and had been accepted by the communist parties of all countries as a rule for all the arts. Apparently, considering the new world situation and the beginning of the Cold War, it was more important to express opposition to North American imperialist capitalism and its plans for starting an atomic war (which Zhdanov had referred to in 1947 at the first meeting of Cominform) than to spend time engaged in aesthetic debates. Nonetheless, even at a time when they were not making their aesthetic dissent public, the artists' commitment to the situation could not, in any way, reside in the defense of so-called social art. Although they had in common more extreme intentions of contributing to the revolution of the period through their art, the ways they went about achieving this goal were radically different: "It is difficult to represent the will of the people by comfortably marching in the rear. In art, to effectively be with the people, it is necessary to march at the front, with a fixed gaze and complete awareness of how society develops and of the conditions necessary for its transformation. We find it difficult to consider as friends those who

are immersed in a rigid aesthetic, deaf to spiritual projects for social and technical progress, and who lack a sufficiently audacious imagination to accept, in the near future, the popular expansion of a new art form. Deep down they distrust the people and consider them incapable of all mental enterprises."[30]

Like *Sur*, the abstract artists defended modern art and an international model of culture. The magazine did not act, however, as an identifiable platform in defense of the concrete art groups. Aside from the brief participation of Maldonado in a survey conducted by the publication on abstract art in 1952, the artists of Arte Concreto Invención as well as of Madí and, later, Perceptismo, organized their own magazines as spaces for the dissemination of their ideas. Indeed, their intention was more radical and exclusive, in aesthetic terms, than *Sur* could have sustained.[31] Nonetheless, they both unquestionably coincided in the defense of an aesthetic that was in direct opposition to the populist rhetoric of the government, its cultural festivals, floats designed for the May 1 celebrations, and, especially, all the ritualization engineered around the image of Eva Perón.[32] All of this, for these sectors—for obvious reasons—could not be considered legitimate art.

The Platforms for the Displaced

The actions taken by the art critic Jorge Romero Brest during the Peronist years in order to establish modern art in Argentina are crucial for understanding the vast number of decisions made in the art scene after 1956 with respect to establishing institutions oriented toward the promotion of the avant-garde. Romero Brest was, in this context, a central figure. After 1956, Romero Brest, who was now situated at the center of the art scene as director of the Museo Nacional de Bellas Artes (MNBA, National Museum of Fine Arts in Buenos Aires), would discover that this institution was the ideal space for carrying forward the project he carefully delineated during the years under Peronism.

Romero Brest's background wholly justified his occupying a position of central importance after 1956. He had served on the board of directors of the Colegio Libre de Estudios Superiores (Free School for Advanced Studies) since 1940, an institution that opposed the Perón regime and functioned at that time as a space for the formation of intellectual groups that, after the fall of Perón, acted in various official settings (ranging from the university to the political sphere). At this institution in 1941, Romero

Brest and Julio E. Payró founded the Department for Artistic Research and Orientation, whose objectives included not only offering courses of general interest, but also studying artistic activity with "modern methods" ("historic, aesthetic, and sociological") and considering "the Argentine situation as a starting point" for proposing an "artistic orientation in the country."[33]

In 1946 Romero Brest became a victim of the so-called interior exile which affected a broad sector of the intellectual elite.[34] As a professor at the university in the city of La Plata, he was involved with one of the sectors that had acted most visibly in opposing the rise of Perón. Calling for institutional normalization, in August 1945, the university had suspended classes, declared strikes, and protested on behalf of the laid-off professors who, arriving in September, occupied the university. The university in La Plata, having resisted normalization, ended up being closed and was then targeted by protestors from the beef industry workers union of Berisso who, on October 17, marched through the university chanting, "Shoes yes, books no!" The rage of the workers toward the university escalated throughout the day and culminated with the sacking of the rector's home.[35]

The tensions did not decrease in 1946. The intervention decree signed by Farrell and Oscar Ivanissevich's appointment as administrator shortly before Perón took office in June 1946 were the prelude to a year of faculty layoffs, resignations by sympathetic professors, and suspensions and expulsions of students in an attempt to free the university of political interference, just as Perón wanted.[36] Following the student strikes toward the end of 1946, particularly vociferous in La Plata, the layoffs continued into early 1947, and Romero Brest was among those affected.[37] With Peronism in power, he found himself forced to make radical decisions regarding his political affiliations, finally joining the Socialist Party and, in so doing, confirming his lukewarm conversion to the left which had begun in the 1930s.[38]

From the pages of the socialist newspaper *La Vanguardia*, Romero Brest committed himself to direct involvement as a grassroots militant:

I hope to be useful to the Party, insofar as I have strength and to the fullest extent of my ability, by helping the leaders to carry out this great task of cultural education in our country, which I believe is of the utmost urgency. At the risk of wounding the modesty of Arnaldo Orfila Reynal, secretary of the Cultural Commission of the Party, I want him to know I have faith in his plan of action and that

I am fully inclined to work at his side, editing *El Iniciador*, organizing libraries, broadcasting radio programs, etc., until the time comes when we can establish and develop the Worker's University, which is absolutely necessary.

Furthermore, in case the Party wishes to make use of me as an advisor regarding artistic activities, which are my specialty, I enthusiastically offer my services.[39]

His action program also included aesthetic definitions. In June 1946, Romero Brest delivered his lecture, "On the so-called 'Social Art'" in numerous socialist centers.[40] In this lecture he returned to a theme that had generated agreement among the sectors that defended the autonomy of art, among which the group *Sur* could be included. In his lecture, after reviewing Plekhanov and Kamenev, Romero Brest concluded, "The fundamental error is to consider art as an instrument of knowledge and struggle."[41]

The definition of art that he wanted to establish in Argentina, a country that he felt was still very distant from modernity, required the definition of clear positions regarding what the true artist should aspire to: "One could accept that the artist serves society and that art contributes to the development of human consciousness and social improvement (Plekhanov) as long as one understands these ideas in their spiritual, rather than material, sense. I don't mean to say that we should not pursue social improvements and a consciousness of greater justice with all the force of our convictions and actions, but art is not the most effective instrument for this struggle, at least not at this time. Art is only a spiritual product through which we receive notice of past conquests."[42]

Romero Brest worked to illuminate consciousness, and consequently he agreed with the decision of the Socialist Party to undertake a cultural and political program that opposed the state of confusion in which society appeared to be living. Américo Ghioldi described the terms of this conflict in a statement published in *La Vanguardia*, "How can we confront this miserable reality other than by working to produce a change of states of consciousness and sentiment, the source and point of departure for all concrete action?"[43] In this struggle, which he described as "the ant against the elephant," there was a deferred task to be undertaken: "Courses, conferences, meetings, programs, demonstrations, pamphlets, leaflets, publications, posters, etc., etc., in short, the ranks of activists for cultural and social change must be maintained by all those who believe that politics threatens all of us and that all of us are, in some measure, obliged to be active in politics. To defend and maintain a better level of

cultural and political action, we call for the generous contributions of our friends!"[44]

The road was long and arduous but one could not give up. Romero Brest's actions during the Peronist years conformed to Ghioldi's stated instructions in every way: as founder and professor of the Altamira Escuela Libre de Artes Plásticas (Altamira Free School for the Visual Arts), together with Lucio Fontana and Emilio Pettoruti in 1946,[45] as co-founder of *Argos* publishers, together with Luis Miguel Baudizzone and José Luis Romero (also in 1946), as lecturer and instructor in Buenos Aires and elsewhere in Latin America,[46] and as founder and director of the magazine *Ver y Estimar* in 1948. His actions had to be sufficiently diverse and constant so as to avoid falling into the "obscurantism" that, in his own words, had taken hold of the official art scene.

The Official Policy Toward Art

In the visual arts field, the first space in which the Peronist government took definitive action was at the National Salon. In 1946 important modifications to the regulations were introduced: The grand prizes for painting and for sculpture were renamed for the "President of the Argentine Nation" and, in addition, ministerial prizes were created in order to provide the offices of each official ministry with works of art that corresponded to their respective functions. Thus, paintings and sculptures would be judged on the basis of how they addressed prescribed themes.

Although the suggested topics could be interpreted to some degree as regulations, they were not altogether exclusive. The exhibition at the National Salon, which was still considered the artistic event of the year, featured diverse themes and styles. In 1946 artists such as Berni, Forner, and Fontana, who had previously formed part of the Independent Salon, were included in the National Salon. Mixed in with the realist works, there were also works by abstract artists such as Pettoruti, Salvador Presta, and Curatella Manes. Only one, however, alluded to recent events—the painting *Los descamisados* by Adolfo Montero.

Despite the government's use of the images for its propaganda campaign, the visual arts were practically barren of artists who idolized the regime through their works or, conversely, of exhibitions with a political slant that might result in the systematic disqualification or elimination of works and artists, as happened in Spain and Germany.[47] Although he produced many paintings intended to deify the image of Eva Perón,

Numa Ayrinhac, an artist of French origin (and a portrait painter for the upper class), was himself overshadowed by the subject of his paintings to the point that his work came to play a central role in the official government rhetoric but was not highly regarded in the art world. It would be very difficult for this type of art to be taken seriously, given that the art scene overall was aligned with sectors opposed to the government.

Among the issues that most irritated the opposition were the good relations maintained by the Argentine government with Spain. In October 1947, with images still fresh of Eva Perón having dinner with Franco during her tour of Europe, the Spanish government sent the Exposición de Arte Español Contemporáneo (Exhibition of Contemporary Spanish Art) to the MNBA.[48] Although the exhibition made a point of including the word "contemporary" in its title, it omitted the most outstanding and current of Spanish artists: Juan Gris, Maruja Mallo, Joan Miró, Picasso, Manolo Hugué.[49] Nonetheless, some innovators with connections to the Academia Breve de Crítica de Arte were included—Angel Ferrant, for example—but the exhibit reeked of nationalism and everything else that the opposition vehemently condemned. Refused by Washington and London for not including Picasso and Miró,[50] the exhibition was strongly criticized by *Sur* in an article by Julio E. Payró. Although they avoided the most predictable of dangers—that of "propaganda"—the six hundred works included in the exhibit could not justify the title: What was presented was "extemporary" art.[51] It did not reach beyond the "international academy," which was something that was deplored by the sectors that longed to rekindle relations with the international modern art world: "Decapitated, the enormous body of Spanish art lay spread out on the Museum floor, lacking its enormous imaginative and creative head, its many muscles, viscera, nerves, and vital organs extirpated. . . . In such conditions, the exhibition of Spanish 'contemporary' artistic production was disappointing, tiresome. It reminded us of the official European galleries of forty years ago."[52]

If these were the only international contacts still accessible for Argentine art, the best thing that could happen would be to lose them. Added to the disappointment produced by this exhibition and the theme-oriented awards offered by the National Salon were the conflicts surrounding abstract art at the time, whose central figure was the Minister of Education, Dr. Oscar Ivanissevich.

Owing to his anti-reformism, anti-liberalism, irrationalism, and unconditional admiration of the military, Ivanissevich was greatly valued by

Perón, for whom it was necessary to oppose the forces of the Democratic Union.[53] The minister's artistic tastes and preferences, which probably were not very important to Perón, led him to deliver one of his most fanatical speeches, railing against the modernist aesthetic. What irritated the minister most in art was abstraction and, acting upon his instincts as a surgeon, his first inclination was to extirpate it. This impulse led to his outburst during the jury deliberations of the National Salon in 1948, demanding that the painting by Pettoruti, *Sol en el ángulo*, be rejected, for which he "took full responsibility." His demand was refused by the jury, under the leadership of Raúl Soldi and Cesáreo Bernaldo de Quirós, and the controversial painting was accepted.[54]

Still the minister did not lose the opportunity to publicize his opinion of what he considered "morbid" art the following year at the opening of the National Salon. His speech on that occasion provided ample reason to form multiple parallels between the artistic model favoring Peronism and that imposed by Nazism. The daily newspaper *La Nación*, ardently anti-Peronist, did not waste a word of it, publishing it in its entirety and without commentary, letting the words "speak" for themselves.[55] There were many points of contact between the views of the minister and those expressed, for example, at the opening for the exhibition on degenerate art held in several German cities between 1937 and 1938.[56] In this speech Ivanissevich assumed "responsibility" for the "thankless task of classifying normal and abnormal anxieties." Among the latter he included abstract art: "Nowadays people who are failures, who have anxieties over the future, without making an effort, without studying, without talent and without morals, nonetheless have a refuge: abstract art, morbid art, perverse art, infamy in art. These are progressive stages in the degradation of art. They show and document visual, intellectual, and moral aberrations of a group, fortunately small, of failed people. Definitively and incorrigibly failed people who refuse to keep their pitiful misery to themselves, just as if a leper at his most repugnant were to go out in public and make a show of his festering ulcerous tumors."[57]

In this description the minister employed a set of "medical" metaphors that imbued his speech with particular discursive characteristics. Abstract art, in his view, made it possible to construct a virtual manual of pathologies. These classifications, and his concern for popular taste, ran parallel to the text of *Degenerate Art*, the German catalogue for the exhibition. Furthermore, elements of nationalism postulated the existence of an "Argentine" art and clearly established what could and could not be

considered "true" art: "Morbid art, abstract art, does not fit in, there is no place for it here with us, in this youthful, blossoming country. It does not fit in with Peronist Doctrine because this is a doctrine of love, of perfection, of altruism, with heavenly ambitions for the people. It does not fit in with Peronist doctrine because it is a doctrine born of the innate virtues of the people and is intended to maintain, stimulate, and exalt those virtues."[58]

Nonetheless, even though the minister's speech contained echoes of the text for the exhibition Degenerate Art, his views were more general and lacked, among other things, the furious and explicit anti-Semitism that was so prominent in the German catalogue. On the other hand, the burnings, exhibitions, prohibitions, and massive sales that characterized Nazi policies toward art were absent during the Peronist period. Peronist policy depended more on the interests of specific agencies rather than on a predetermined program. Thus, while Ivanissevich was attacking abstract art, other officials, such as Ignacio Pirovano, the director of the Museo de Arte Decorativo (Museum of Decorative Art), were defending it and even collecting it.[59]

Above all else, Ivanissevich wanted to forewarn spectators so they would not feel embarrassed when they did not understand what, according to his postulates, was inadmissible art. The minister had good reason to worry inasmuch as there were two exhibitions at that very moment that could have given rise to dangerous confusion.[60]

The French Invasion

In 1949 European modern art burst upon the Buenos Aires art scene led by France. On June 23 the exhibition of French paintings De Manet a nuestros días (From Manet to the Present), opened at the MNBA and, the next month, the Institute of Modern Art opened its galleries with the show Abstract Art, organized by the Belgian critic then residing in Paris Léon Degand. Both exhibitions brought together works that were abstract enough to upset the minister as well as the critics, though for different reasons.

In the pages of Sur, Julio E. Payró could not contain the irritation he felt as a result of the museum's exhibition, organized by the state (the "great State") of France.[61] What infuriated Payró was that France should have underestimated its audience by sending second-rate works belonging to art dealers, among which were included only 15 museum pieces out

La peinture de 1905 à 1925

1. Exhibition: De Manet a Nuestros Días (From Manet to the Present), 1949, Buenos Aires. (Explanatory notes included in the catalogue, p. 108.)

of a total of 165. Without the "magnificent" contribution of Argentine collectors (Santamarina, Wolf, Crespo, Williams, Helft, Wildenstein, and Koenigsberg) who had lent works by Braque, Cézanne, Forain, Guillaumin, Léger, Monet, Picasso, Rafaelli, Rouault, Toulouse-Lautrec, Van Gogh, and Vuillard, the exhibition would have been a complete failure.

Annoyed by the didactic tone of the catalogue, as well as the staging of the exhibition—both of which were accompanied by sophisticated synoptic charts (figure 1)—Payró offered his own suggestions and displayed his own extensive knowledge of French art. After praising the masters of Impressionism and classifying the decades of the 1920s, 1930s, and 1940s as periods of "aesthetic defeat," he concluded by praising the art of the

twentieth century as a return to the "splendid point of departure": the combined forces of the fauves and the cubists which, for him, included the works of Atlan, Calmettes, Desnoyer, Gischia, Le Moal, Manessier, André Marchand, Patrix, Pignon, Schneider, Singier, Tal Coat, Van Velde (Dutch), Vernard, and Beaudin. After a detailed explanation of his reasons for identifying those artists as outstanding, Payró congratulated them for not falling into one of the most dangerous traps of art in that moment: "It is greatly satisfying to see, among other things, that the sermons of the proselytizers of 'committed art' (for it will never be anything other than painting at the service of propaganda, inferior painting) have resoundingly failed in France."[62] Nonetheless he sent them a warning: Their works might be "valiant, enthusiastic, vibrant with color, and tightly formed," but they lacked "true authority and profound eloquence." In his estimation, French art was about to lose the scepter it had held for so many years and that it still firmly held for the Buenos Aires elite.

In contrast, the exhibition at the Institute of Modern Art would elicit praises from Payró. He considered the exhibit outstanding, especially for having brought to Argentina, for the first time, works by Delaunay, Herbin, Picabia, Vantongerloo, Domela, and Kandinsky. Payró also mentioned in his review those artists whose work he considered to be of dubious quality: Bruce, Magnelli, Lapicque, Kupka, Marie Raymond, and González.

It should be noted that in the exhibitions that had arrived from France, Payró interpreted a level of confusion with respect to the appropriate direction for art in the postwar period. The exhibition sent by France demonstrated that critics such as Jean Cassou were doubtful and ineffective when it came to perceiving what was innovative on the current French artistic scene. While Cassou was unable to free himself of prewar models, Léon Degand knew that they did not represent the way for France to retain its supremacy: Instead of vague rationalist humanism mixed with positive populist sentiments and, of course, quality technique, as preached by Cassou, Degand concentrated all his attention on abstract art.[63] And Payró clearly understood the difference between lack of definition and purpose.

However, despite the magnificent contribution of the Degand exhibition, there was a certain element of "confusion" in it that Payró could not let pass by: Its title, Abstract Art, and certain "declarations contained in the catalog" led to an untenable error: The majority of the works on

display did not pertain "to the category of abstract art but rather to *non-figurative* or *non-objective* art."[64] Here Payró was bringing up the protracted and unresolved debate that had been raging between critics and abstract artists in Buenos Aires and that had played out in the forums of various newspapers and magazines.[65]

Payró's "clarification" demonstrates that Degand's exhibition had not arrived in a land wholly void of abstraction, which had pretty much been the case in Brazil, but rather it had found a context in which various groups were at odds and had taken clear and differentiated positions with respect to abstract art.[66] In this sense, 1948 had been a year of controversies that the exhibitions of 1949 only served to revive. The same title for the exhibition held in the Van Riel Gallery in 1948—"New Realities" Salon: Abstract–Concrete–Non-figurative Art—brought the real battle over taxonomies and nominalisms into the arena, which would soon be echoed by the critics.

Controversies on Abstract Art

In the eighth catalogue published by the Institute of Modern Art in 1951, the critic and writer Guillermo de Torre wrote the introduction to Torres-García's exhibition as a direct response to Payró's commentaries and clarifications of Degand's exhibition.[67] One of Payró's outstanding personal traits was his tirelessly didactic spirit. Ever since the 1920s he had made the defense of modern art a personal crusade and he was now offered the precious opportunity to engage in a public debate on abstract art with an interlocutor of "elegant spirit" with whom he also shared the same goal of gaining acceptance for modern art.[68]

Fundamentally they both agreed on one thing: The misbehavior of Michel Seuphor in "deceitfully omitting" Torres-García from the pages of his book *L'art abstrait* was highly suspect and warranted attention. Seuphor himself let slip the proof of his offense by mentioning in his autobiography that it was with Torres-García that he had organized the first international exhibition of abstract art in Paris in 1930. The causes for his indiscretions were well known:

To fully interpret that disdain—said Guillermo de Torre—would mean entering into an international border zone, laced with dangerous traps or, at the very least, with psychological convolutions. I will only point out that this incriminating ignorance or oversight, like others that can be observed daily, pertain to a peculiar

Parisian attitude: that of only considering valid and current that which is parochially nearby, without making the slightest effort to cross borders. It is a centripetal system, in contrast to the generous outward exposure that everyone else contributes; it is shortsighted curiosity, limited peripheral vision, navel gazing: the paradoxical product of a cross between provincialism and cosmopolitanism.[69]

As a result of this "navel gazing," Torres-García was a recognized artist so long as he remained in Paris, but he was ignored once he had returned to Montevideo.[70] However, apart from their agreement on the question of Torres-García, they seemed to disagree over a question of terminology, which Payró could not pass over and to which Guillermo de Torre alluded in his essay when he specifically disputed the term "non-objective art," proposed by Payró. In Torre's opinion, the term lacked precedents and, thus, was unjustified: "As a local case in point" Torre explained, "I would recall the cases of the new Argentine groups of painters who have emerged recently, addicted to this aesthetic. They call themselves abstract artists, concrete artists, 'Madís,' 'Perceptistas,' but none of them have asked to be called 'non-objective.'"[71]

Payró debated Guillermo de Torre's historical references point by point. However, this is not the place to enter into an academic discussion of the first coinages, translations, and genealogies of the terms employed in these pages.[72] Nonetheless, it is interesting to note the degree to which Payró valued the voices of North American critics, in contrast to his view of French misapprehensions, and to note his insistence on pointing out that it was precisely in the United States where a museum of "non-objective" art had been created (the Solomon R. Guggenheim collection) which validated his position. Despite his efforts to resolve this controversy, Payró did not believe that his opinions had much bearing beyond the national borders: "I seriously doubt that either you or I, or both of us, from the city of Buenos Aires, could possibly have an influence on the universal acceptance of an appropriate term to qualify this art as, shall we say, abstract? Concrete? Non-figurative? Non-representational? Anti-naturalist?"[73]

The question had become so crucial for critics and certain sectors of the art scene that, the following year, *Sur* decided to publish the results of a survey that included the international perspective. It is interesting to note that, although the disagreement between Payró and Degand had given rise to this controversy among the art critics of Buenos Aires, the French did not participate in the debate. In addition to members of the local media

(Córdova Iturburu, Tomás Maldonado, Gyula Kosice, Manuel Mujica Láinez), other subjects of the survey pertained to the School of Altamira (Spain) and of Mathias Goeritz (Angel Ferrant, Ricardo Gullón, Hans Platschek). In spite of the love he still felt for France,[74] when it came to debating modern art, Payró's contacts with the modern art movement in Spain were much stronger than those he maintained with the French critics.[75] But beyond all these verbal conflicts, everyone agreed that the future of art lay in abstraction.

Between Peronism and Abstract Art: Coming to Terms

While the ink of the intellectual elite was filling page after page in an effort to resolve the question of terminology, the government appeared to be much more practical and operational as it organized two official exhibitions in which the groups Madí, Perceptismo, and Arte Concreto Invención were to take part.

Following the intense confrontations between the early Peronist government and the modern art world, a tacit agreement had now been established and, by 1952, the abstract artists had come to occupy a prominent place at the official exhibitions. One example of this was the mega-exhibition Argentine Painting and Sculpture in This Century, held from October 1952 to March 1953 at the National Museum of Fine Arts. This exhibition, which was an overview of fifty years of Argentine art, left nothing out. The 519 works by 271 artists—painters and sculptors of the most diverse tendencies—filled the museum's galleries and overflowed into the adjoining gardens. The exhibition was sponsored by the General Offices for Culture of the Ministry of Education and, as described in the catalogue, it was "the cultural event of the 2nd Quinquennial Plan."

The plan clearly expressed a desire for renewal and greater international openness, and the exhibition was in line with these ideas. Pluralism was the guiding principle of the exhibition, composed of an ordered progression of styles with several galleries and pedestals dedicated to abstract paintings and sculptures.[76] The Madí and Perceptismo movements, "springing directly from Buenos Aires"—as proclaimed in the introduction to the catalogue by the museum's director, Juan Zocchi—could not be omitted from this exhibition, which was intended to define the new "Argentine man," capable of creating in not just one, but rather, many styles. The exhibition was representative of a repositioning of the govern-

ment, which, nonetheless, did not neglect the rhetorical use of the image: Alongside the Justicialist coat of arms on the museum's facade, portraits of Perón and Eva flanked the entrance to the exhibition. Although this tactic must surely have irked the members of *Sur*, Payró made no mention of it. In addition, while his review recognized the pluralism of the exhibition, he was not nearly as optimistic as Zocchi. "The Museum does not present the ideal panorama for Argentine art—a collection of master works that we could proudly display to the rest of the world some day—but rather the essential reality of the national effort with some of its successes and many of its undisguised failures."[77] Payró's skepticism was so strong that he even denied the avant-garde qualities of the works presented by the concrete artists, attributing them directly to "the ways opened by the Neo-Plastic artists prior to 1920."[78]

A few months later, for political purposes, abstract art would form part of the official delegation to the 1953 Biennial in São Paulo, Brazil. Indeed, the works of abstract artists dominated the selection.[79] For a country that was trying to open up its economy, attract foreign capital, and orient itself in a way that would demonstrate new forces of progress at work, paintings of gauchos and flatlands—the usual topics of regionalist nationalism—would hardly have served as a standard. Abstract art was a timely political instrument that the government employed to introduce itself onto the international scene.

Ver y Estimar on the Ramparts of Modern Art

It might be said that by 1953 abstract art maintained a safe distance from official aggression, but this distance had not been won without a great deal of effort. The long and difficult confrontation had been fought on various fronts, and one of central importance was that organized in 1948 by Romero Brest from the pages of *Ver y Estimar*. In April of that year there was no doubt that, for the moment, official channels were closed to the critic. On the other hand, the forums offered to him by the Socialist Party did not appear to be the most effective for the task that lay before him once the Peronist period had ended. The audiences for his conferences at the socialist meeting centers were not necessarily the most appropriate for carrying forward effective action in the area of visual arts. It was a forum involved in politics and from such a vantage point it was impossible to depend on the support of influential sectors in the cultural milieu—such as *Sur*, which was perhaps the most important. Therefore,

to launch the art of the future, it was necessary to work from some other platform, isolated from politics and sustained exclusively by a concern for art in its purest and most uncontaminated form: something close to a laboratory.

The declaration of principles that accompanied the first issue of the magazine, although it did not allude directly to what was occurring culturally and politically in the country, did not fail to clearly indicate its position. It described a panorama from which the only escape for the "intellectual minority" was to take refuge in the safe territory of pure ideas, isolated from immediate eventualities.[80] Those sectors would have to be "increasingly removed from the situation . . . because the horror it produced, owing to its barbarity and senselessness, would only lead them to look toward sources of universalist thought."[81] In the face of an unspeakable present, the only possibility was to take refuge in the past or leap toward the future, and for Romero Brest the first option was out of the question.

The plan, as specified by Romero Brest, was clearly summarized in the very title of his magazine. *Ver y Estimar* (Observe and Judge) aspired to establish values through theory, history, and aesthetics, without neglecting sensitivity. The objective was to reach an understanding of the creative; conceptually it sought to achieve equilibrium between the individual act ("inspired genius") and the "collective forces" that gave rise to it.[82]

The magazine was intended as a space for the construction of values, something considered urgent for a national condition that it described as impoverished: lacking important pre-Hispanic cultures, lacking colonial records (architectural, pictorial, or sculptural) that merited any consideration, invaded by avid "travelers," and under the influence of the most mediocre of Spanish painting, there was not much reason for hope. Faced with these bleak prospects, any action at all was better than no action. But to be able to achieve these lofty aspirations—to establish a modern and universal art form in these bereft lands—it was necessary to proceed step by step: "It was necessary to know how to paint like the naturalists," the magazine affirmed, "in order to innovate like the moderns." One had to avoid imposing modern art like a "fictitious and inert structure of foreign ideals." In 1948 the paradigm, the ideal toward which the magazine was striving, was an internationalism without frontiers whose model was still Europe and, more exactly, Paris: "European art, in our century, has become universal art; and if Paris has achieved the greatest mastery ever

recognized for any city in the history of humanity, it is because for fifty years it has been the melting pot of universalist aesthetic theories."[83]

Outside of this milieu, replete with adversities, which in itself was a formidable opponent, *Ver y Estimar* did not admit rivals. It did not present itself as an organism emerging on the scene in order to differentiate itself. Its purpose was to break new ground and, in order to accomplish this goal, its strategy was to eliminate the existence of all competing discourses. Then, faced with a void, it would have no enemies, but it would also have no collaborators. To achieve this, Romero Brest managed his publication with the "collaboration of his disciples" who, presumably, shared his point of view.[84] Romero Brest knew that his true collaborators, his peers, were in other countries.[85] Thus the international world of art criticism could connect with a project whose multifaceted focal point was located within the national borders, in the city of Buenos Aires.

The list of collaborators is significant. It is possible to view them as members of an international "resistance" community. Many of them shared a life in exile because of the Franco dictatorship in Spain: internal exile, because of delays in official policy (as in the case of Sebastián Gasch),[86] and external exile (which brought Rafael Alberti to Buenos Aires). For all of them, and for José Luis Romero and Guillermo de Torre, there was no difference between Franco and Perón.[87] Romero Brest's collaborators were also unified in the rank and file of those who supported modern art, such as Max Bill, Mathias Goeritz, and Léon Degand, among others.

Beyond the ideological and aesthetic agreements among the members of this editorial team, the spokesperson bringing all these views together in one magazine was undoubtedly Romero Brest. By bringing together this diverse group for his magazine, primarily based on his personal connections and constant correspondence with them, he was able to integrate their cultural capital and contributions into the margins of the official scene.

From the pages of *Ver y Estimar*, Romero Brest was able to put together, albeit somewhat fictionally, that which the national situation had made so difficult for him. His intention was to use the written word in order to bring to the country those images which could not be seen in Buenos Aires owing to the country's international isolation. This information was contained in the critical bibliography and "miscellaneous" sections, where international exhibitions and publications were listed. The idea was not only to provide information on events outside the country, but also to show that Buenos Aires formed part of the larger international

art circuit, at least with respect to its collections of European art. Thus, another section, the "Inventory" section, offered a survey of paintings by such artists as Renoir, Goya, and Gauguin, which could be found in Argentine collections.

Besides this effort to reclaim local cultural heritage, there was something that the current situation definitely did not offer: a way to address Argentina's marginalization from international competitions. Argentine absence from such events made Romero Brest's position doubly important. He was invited to form part of the jury at the 1951 São Paulo Biennial[88] and the 1953 International Sculpture Competition titled The Unknown Political Prisoner, organized by the London Institute of Contemporary Art to "commemorate all those unknown men and women in our time who have given their lives or liberty for the cause of human freedom."[89] The fact that Romero Brest, the representative of a country suspected of having fascist sympathies and of having collaborated with the Axis forces during the war, had been invited to be a member of the jury at this celebration of freedom, at the same time as he was radically separated from the Argentina of Perón, seemed to saddle him with the mission of reestablishing national prestige. Through these activities, he had become everything that his country was not: modern, international, open to the world, a champion of freedom.

The values upon which *Ver y Estimar* based its legitimacy were, above all, those which defined for Romero Brest the domain of true art: a domain that would not bow down in servitude either to politics or to the realities of life. Nothing outside of language, outside of the specificity of the means for artistic expression, could serve to justify the meaning or function of art. In the defense and foundation of these positions, Romero Brest was not alone. In addition to the constant and militant participation of his disciples in support of his actions, Julio Payró was also active in a parallel, and even anticipatory, sense. However, despite his tireless advocacy, his goals were still too ambitious to be achieved. As seen above, Payró's description of the national artistic panorama in 1953 was tinged by the same tearful, regretful tone that ran through the introduction to Romero Brest's magazine.[90]

The formative enthusiasm, entrenched in European tradition, that drove the director of *Ver y Estimar*, clearly left its mark on his thematic concerns. Already in the second issue of the magazine, the essayistic model was clear, beginning predictably with the work of Picasso.[91] This served magnificently for the purpose of explaining one of his central values, the

idea of invention: "He is the man who did not want to play the same way as his predecessors, or even as the majority of his contemporaries; who has glimpsed the new ways of living, shuddering and contradictory, and attempts to give them artistic form; who is creating the alphabet of our times, dynamic and Faustian, based in rhythm and character, in the passionate anxiety, perhaps disproportionately so, to be universal."[92]

For Romero Brest, this question is no less central than the question of how the relation between art and politics should be approached. Again, Picasso provides the best arguments: *Guernica* is the paradigmatic work to which Romero Brest could refer as both model and proof. Faced with the possible means of resolving such a dramatic problem, Picasso, "far from expressing his feelings through the usual means of representation by endowing the objects with an emotional charge," instead used "his bare forms so that they would *allude* to the facts by allegoric means." To this end, Picasso condensed "the emotional essences into the formal essences, without anymore support material than was necessary." In his opinion, this was "the normative capacity of Picassoesque invention." The problem of political affiliation was not a problem for Romero Brest—as it was for many of Picasso's biographers—primarily because he did not give in to precepts, but rather converted his political position into form. According to Romero Brest: "Clearly, the war and political affiliations strongly influenced Picasso's art. How could it have been otherwise? But he is not a man to act on reflex, but rather for the sake of creation, so that this influence was mostly manifested in certain aspects of his baroque styles, now more instinctive than ever."[93]

The example of Picasso and cubism took on a normative character for Romero Brest. Whereas in 1950, in *Ver y Estimar*, he had delegated to others the responsibility of explaining this movement, in 1953 he took the task upon himself in his contribution to the first issue of the magazine *Imago Mundi*.[94] In his view, to analyze "the value of formal invention," which cubism implies, was to make a foundational moment in Western art comprehensible and possible to teach. Thus the emergence of a "new language" could be identified whose logic could be clearly established as *an evolutionary chain of forms* that passed through Manet, Degas, Cézanne, Van Gogh, Toulouse-Lautrec, the fauves, and the expressionists, defining a timeline of progressive transformations that culminated in the style of Braque and Picasso: "Cubism was not a brilliant stroke of madness, but rather a solution to a problem that had persisted for almost fifty years."[95] At the same time, his view proposed a way of conceptualizing history:

"Instead of cross-sections, I propose longitudinal cuts. What should interest the historian, in the case of the visual arts as well as any other cultural activity, is the process of formation, culmination, and declination of the *formal systems*."[96]

This whole legacy—the coherent evolution of pure forms that Romero Brest wanted to appropriate and quickly transfer to these deserted lands—did not disqualify, for the moment, the gains of realist movements such as the muralists. For this reason, the magazine also featured tributes to José Clemente Orozco (issue 13) and Cándido Portinari (issue 4). Naturally, in praising Portinari a point was made of his wise "search" wherein, without renouncing what was perceived as "contingent," he captured the "necessary form": Portinari does not "reflect," he "constructs."[97]

The idea behind *Ver y Estimar* was clearly to form part of the avant-garde in modern art; thus it celebrated the foundation of the Institute of Modern Art and understood that its voice was sufficiently authorized for it to take charge of the inaugural program for the institution.[98] It was this same motive—that of peering into the future and indicating the new directions in art—that spurred the magazine on to delineate the history of a movement as new as the local expressions of concrete art.[99]

In 1951 Romero Brest seemed to have made a decision about the future of art. After his third trip to Europe, in 1948–49, he understood "the importance of the movement begun by Kandinsky and Mondrian, now called concrete," but after his fourth visit to Europe and his first to New York (1950–51), he felt much more secure about his program. Upon publishing a compilation of more than ten years of reviews, he seemed to feel obliged to redefine his program. If in 1948 he wrote, in the first issue of his magazine, that it was necessary for Argentine artists to "turn their eyes to the earth"—or, more specifically, to their cities—as a way of opposing European influence, three years later he described a radical change of direction: "This new form of expression is the one that is emerging, probably more in the United States than in Europe, along the path called abstract art. I don't question the terms—call it concrete art, or non-objective, or non-figurative. What is important is to understand it. That is why I have been making an effort, in my courses and lectures, and soon in a little book that is to be published by the Fondo de Cultura Económica de México, titled, *Hacia el arte abstracto* [Towards Abstract Art],[100] so that my friends and followers may correctly understand the postulates it is based on. . . . It is an artistic movement that will undoubtedly progress over many dozens of years, and whose validity will only increase."[101]

Romero Brest sensed that he was on the threshold of a change, of an imminent metamorphosis that could establish the "style" of the century, and all the present responsibility for representing the future, in his opinion, fell squarely to abstract art. In 1952, *La pintura europea (1900–1950)* (European Painting, 1900–1950), by Romero Brest, was published by the Fondo de Cultura Económica, with distribution all across Latin America.[102] In this book, after reviewing all of twentieth-century European art, without failing to question the projects of each and every one of the celebrated avant-garde upheavals, Romero Brest redefined his view in still more definite terms: it was a rational, mathematic art that reworked the expressive forms of the past and unified the production of painting, sculpture, and architecture in a common language so that they all converged in a style that corresponded to the present and projected into the future.

The themes and designs that occupied the pages of *Ver y Estimar* reflected the limits of his activities: to work from the shadows for a definition of a model for art sufficiently solid and clearly articulated that, with the advent of new periods—those of the deferred "liberation"—it would be so primed that it would only be necessary to set it in motion.

The coup d'état that overthrew Perón in September 1955 left the critic better positioned than he could have ever dreamed. In October of that year, Romero Brest closed the pages of *Ver y Estimar* forever in order to become active in the official institutions, allied with the new state, as director of the National Museum of Fine Arts. From that moment onward, he would demonstrate better than anyone else that art forms are not purely forms, but also political instruments.

2

PROCLAMATIONS AND PROGRAMS

DURING THE REVOLUCIÓN LIBERTADORA

My work was a form of protest, and I had a lot to protest about. All of us artists who did not follow the crowd, who did not become affiliated with the unions "by decree," who did not resign from our departments—I avoided the latter because I did not belong to any—who did not have shows in the official galleries, we simply lived as exiles in our own land. It was very difficult to adopt this way of living, renouncing all that was ours by right. For those of us who were no longer beginners, it was a sacrifice to live as if entombed for so many years; we lost so much by not having contact with the public or any contact from abroad.—Raquel Forner

During my stay in el Buen Pastor, I discovered, among other things, that the physical prison is less terrible, and less dangerous morally for innocent people, than the other prison: the one I'd come to know in the houses, in the streets of Buenos Aires, in the very air I breathed. That other invisible prison is born of the fear of prison, and the dictators know that very well.—Victoria Ocampo

Until only yesterday, they were triumphant and believed that we did not exist. They were sure that in the streets, on the walls, in the air, and in texts, only the rule of that voice was possible, the voice that was known and recorded in infamy. We remained suspiciously hiding in forbidden meetings, comforted by our friendships, between the lines of some written article. They had confused their own recklessness with the reality of the country. . . .

But the truth is restored. They would be able, now, to undo the spell of the public plaza, to quiet the cry that led them astray and to withdraw to an impulsive past. Without their thugs and torturers, without the constraint of their infernal propaganda, they would be able to regain their dignity. What they knew by the name of social justice was nothing more than a trap to forget justice and alienate freedom.
—Victor Massuh

The Honor Award that Raquel Forner received at the National Salon in 1956 from the hands of General Pedro Eugenio Aramburu, president of the nation and leader of the military government that called itself the Revolución Libertadora (Liberating Revolution), was a kind of vindication. Critics agreed that, had she been a participant at the National Salon in 1945, she would have won this award for her painting *Liberación*. Whereas at that time her painting was a plea on behalf of freedom lost, the prize she was now awarded was understood as a symbol of freedom regained.

On September 23, 1955, a coup d'état ended the presidency of Juan Domingo Perón. The new government, under the leadership of General Eduardo Lonardi, assumed power with the slogan, "ni vencedores ni vencidos" (neither winners nor losers). This conciliatory attitude could not be maintained under the pressure exerted by the most anti-Peronist sectors of the armed forces, led by the vice-president, Admiral Isaac F. Rojas. On November 13 Lonardi had to resign and was replaced by General Pedro Eugenio Aramburu. In the postwar period, conditions in Latin America were constantly being modified. The tensions of the Cold War, the opening up of Western markets as a result of new monetary regulations imposed by the International Monetary Fund (in 1947 the monetary agreements of Bretton Woods established the dollar standard and capital once again flowed freely around the world), and, furthermore, the formulation of a policy designed by the Comisión Económica para América Latina (CEPAL, The Economic Commission for Latin America), were all elements working together to improve international participation. In particular, reforms were established by CEPAL which made it possible for developed countries to provide support to underdeveloped countries in order to make progress through appropriate investments in key sectors, as well as structural reforms (such as agrarian reform).

The new conditions were intended to help eliminate factors of backwardness and thus benefit Latin America and, in particular, the new Argentine government. Thereafter modernization and the opening up

of the economy were values shared by various sectors. For the next two decades, one of the central problems was how to design strategies to attract foreign capital. Modernization, however, implied modifying the improved status of workers during the Peronist period. Designing policies for the exclusion of Peronists was therefore a prerequisite for the kind of transformation that the victorious sectors wanted to bring about and, at the same time, they were the point of departure for the continuing conflicts that characterized the beginning of the period of the Revolución Libertadora. The prohibition of the Peronist party in the elections and, consequently, of the workers, together with continuing conflicts between different military sectors, defined a fictitious, illegitimate, and inherently unstable political scene.[1]

The National Salon was one of the first spaces to demonstrate just where the visual arts stood in the new political situation. Although the salon was opened by the de facto president and the vice-president, Admiral Rojas, everyone—from the director of the museum, Jorge Romero Brest, to the French and Italian ambassadors—attended the ceremony as if it were a celebration of the return to democracy. The words spoken by the new minister of education, Carlos Adrogué, were meant to leave no doubt about the matter: "Tyrannies may put their members in chains, but never their ideas, and all the violence they are capable of inflicting on the body never reaches the confines of the soul, from which they have never succeeded in plucking a single flower for their sad glory; every attack against freedom is a crime against intelligence. Ladies and gentlemen, the rejoining of a people with their historic way of life promises, like a river returning to the mainstream, the force of destiny. The Revolución Libertadora has brought us before a new Renaissance: therein lies the responsibility of men dedicated to culture."[2]

The critical reception highlighted, with repeated emphasis, that this year the salon was *more* than the traditional coming together of artists and their public. It was a moment that seemed like a clear break with the past and the salon functioned as a space for demonstrating, like a display window, the site occupied by the new victors. The newspaper *La Nación* cautiously recorded the signs of change: the incorporation of artists of "genuine significance in the country, whose absence was striking in the national exhibitions during the dictatorship" and who could now be seen again in the galleries, and the repeal of clauses that enabled artists to bypass the jury, that eliminated much of the previous "shilly-shallying," granted the salon of this year "a new, youthful, and harmonious outlook."[3] The

restoration of spaces, together with a *new* and *youthful* outlook (albeit, as we shall see, not so *harmonious*) were repeated features guiding many of the decisions made thereafter regarding culture.

In describing the current situation, the new cultural leaders constantly emphasized those aspects that tended to highlight a comparison with the immediate past. Romero Brest's "Preliminary Words" for the Argentine presentation at the 1956 Venice Biennial could be read as an excellent summary of the vision that liberal sectors had of Peronism and of the period beginning with the onset of the Revolución Libertadora for the art scene:

The country has just been put to a difficult test: more than ten years of a dictatorship that, in addition to slowing down social progress and decimating the economy, also attempted to annihilate the national spirit in every possible way by distorting history, extolling false values, and inciting the basest instincts. All of which led to a suicidal reclusiveness. But the most vital forces were not exhausted, as demonstrated by the magnificent Revolución Libertadora of September, which enabled the country to catch up with the other civilized countries of the planet and, on the art scene, this exhibition reveals the efforts of the young painters and sculptors to speak the free language of modernity.[4]

The representational discourse on Peronism emanating from the visual arts field was based on descriptions focusing on a set of notions that, repeatedly, served to disqualify the preceding period: dictatorship, tyranny, attacks against freedom, international isolation, demagogy, populism, the lack of aesthetic values.[5] In addition to these features, what characterized the various discourses on the visual arts in the post-Peronist period was the degree of agreement prevailing over what the next program should be. The agenda was primarily focused on reestablishing conditions considered necessary for artistic production: absolute freedom for creators, openness to the international scene, modernization of languages. In this sense, and in contrast to other intellectual groups such as those formed in association with the magazine *Contorno*, which quickly revised the previous anti-Peronism of their members, the discourses emanating from the visual arts field were characterized by a persistent and sustained monolithicism.[6] The general perception was that much needed to be done and that, furthermore, coordinating forces was essential. This explains why the new leaders called upon the combined support of both public and private sectors as they had never done before. What this outpouring of discourses, programs, and assessments shows, in addition to the repeti-

tiveness of their terminology, is that in the area of the visual arts, just as in politics, economics, and culture in general, the sectors that had come to occupy center stage now felt it necessary to take action. An important aspect of this process was the new role of the State. The review published by the newspaper *La Razón* on the National Salon in 1956, clearly defined this role: "With the conferring of the award for the XLV Salón Nacional, the State has returned, after long years of turbulence and confusion during which time the assessment of artwork was devalued in favor of political demagoguery, as the driving force, rather than the judge, of the fine arts."[7]

It was in this role as a "driving force" that the new State would address the task of promoting and providing incentives in a totally different direction from that taken by the Peronist State. *Novelty*, *youth*, and *internationalism* would be the key words upon which institutional projects would be organized with increasing frequency. In little time, with the intense process of initiatives intended to create the context considered essential for the promotion of the cultural renaissance of the nation, there emerged a climate in the visual arts space of a certain *requirement*: with the advent of the new government, conditions had been created that were perceived as propitious for the creative enterprise. Now what was needed were avant-garde artists whose works would be so original and of such unquestionable quality as to accomplish the mission of installing Argentine art on the international art scene.

The Embassies of Art

Between April and June 1956 two official exhibitions were organized that simultaneously expressed the government's aspirations to show the rest of the world the artists of a nation reborn from the ashes. This was practically the first time that a broad representation of artists from the national art scene was given international exposure. Like a two-faced Janus, one exhibition gazed toward Europe and the other toward the United States.

The first exhibition opened in April at the National Gallery in Washington and then continued its tour of museums in New York and other cities in the United States.[8] The exhibition was not only a representation of art. The political tone of the exhibition, which could be read between the lines of the commentaries published in Argentine newspapers, was clearly stated by David E. Finley, director of the National Gallery, in the

text of the catalogue, aspects of which were repeated and highlighted in the newspaper *La Prensa* in an editorial dated April 17:

In addition to the intrinsic value of the works, Mr. Finley points to an aspect related to international politics. "The collection," says Mr. Finley, "has arrived at a very opportune moment given the rising interest in Argentine history and culture. Today, more than ever before, there is a feeling of greater solidarity between our countries. These works will contribute to a better understanding, on the part of the North American people, of the history, life, and aspirations of the Argentine people."

By Mr. Finley's statement one might suppose that artists can also be genuine and effective ambassadors. Wherever they go with their paintings they carry echoes and visions of their native country, which they present in special and unmistakable ways.[9]

The period of international isolation under Peronism had finally ended, a new era of relations between Argentina and the United States had begun; these images were seen as emissaries of a transformed country and as instruments of a new period in international politics.

The Evening Star, a Washington newspaper, emphasized the importance of the exhibition at a moment when, following Peronism, new conditions for cultural exchange were opening up: "Presiding over the new Argentina was Dr. Eduardo Augusto García, the Argentine ambassador to the Organization of American States. The Perón government never ratified the letter of the OAS, thus Ambassador García is the first representative sent by his country. Dr. García, who spent three years in prison for his opposition to Perón, said, 'now the circle of solidarity is complete.'"[10]

The power of culture and art to represent nations was already well known in the United States. The use of images to convey messages that referred not only to beauty but also, and moreover, to the power of their emissaries had been used extensively by European cultures, especially France, and since early in the Cold War, it had been a significant mechanism of North American foreign policy.[11] As "arms," the paintings of new U.S. avant-garde artists spoke of creativity, decisiveness, and the virility of a victorious people. They also spoke of opportunity for all citizens: the success of Jackson Pollock, a common man with nothing more than his raw talent, was proof that in the United States desire was power. These values, which the new world power disseminated around the world with its paintings and politics, could also serve as an example for the disordered Latin American republics. Argentina, after its "suicidal isolation" during

the period of Peronism, found itself on the threshold of a new era and was eager to emulate the experiences of other countries.

Those who had felt marginalized during the Peronist years now had good reason to think that they had chosen the right direction to move in and that, just as it was necessary to develop more open policies, politically and economically, the cultural program of the new nation also had to focus on the dissemination of Argentine art and its contact with the most avant-garde art in the world. But what was Argentine art? What aspects defined its "identity" that could transform it into a unique product, capable of competing on the international market of artistic images? It was clear that paintings with *gauchesco* themes and rural landscapes were no longer competitive in the world that was now opening up. The choice of works was characterized, from the beginning, by an attempt to bring together a broad range of images that left nothing out: neither realism (not including, of course, "social realism"), nor abstraction in its diverse forms (both geometric and "lyrical" abstraction), nor those paintings that, owing to their earthen colors and certain images related to magical-religious forces, alluded to a continuation of the pre-Hispanic tradition. In 1956 geometric abstraction was no longer interpreted as avant-garde. Exhibition organizers compromised by offering a varied selection, free from traces of traditional nationalism, but also lacking in images that reflected a strong, original, and distinctive Argentine art form. The actors themselves would soon have to step forward onto this stage that was being set for them.

All of these discourses collided, in the form of a controversy, over the selection of the delegation of Argentine art to the Twenty-eighth Venice International Biennial Art Exhibition of 1956. The editorial in *La Nación* on July 16, 1956, highlighted the importance of these meetings, which attracted the "attention of the world" to the topic of comparing the present situation in the country to that of the years they preferred to forget: "The deposed regime distinguished itself by its absolute disdain for these issues, just as it linked itself to the authentic spiritual aspects of our nation. Thus we were left, unjustifiably, following behind the rest of the world, while countries whose art does not rise to our level were occupied with disseminating their creations with dedicated enthusiasm. . . . Things have certainly changed now and if there is one thing that can be said for our provisional government, it is that they have demonstrated a sincere determination to return our intellectual values to their position of pre-eminence in the context of the Republic."[12]

However, not everyone shared this enthusiasm. The problem arose from the selection of artists made by Jorge Romero Brest and Julio E. Payró. As expressed in his introduction to the catalogue, Romero Brest thought that if the idea was to exhibit the culture of a renewed country at the Biennial, this could not be done by selecting images of the past. What they had to demonstrate was hope for the future and confidence in their youth, the embodiment of that hope. Everything had to be new, young, and exuberant. This stance, which Romero Brest would maintain from that moment onward with unwavering dedication, would soon earn him much rancor and animosity.

For this selection of works, *La Nación* explained, Romero Brest and Payró had favored "thirty paintings and eight sculptures pertaining to artists—*from recent graduating classes, deliberately selected*—whose styles were figurative, concrete, abstract, or independent."[13] This "deliberate" decision caused an immediate protest from those artists who thought that, after years of "dictatorship" during which they had been unable to participate in international events, they were again unable to do so because of the irresponsible actions of the jury. In a letter to the minister of education, Atilio Dell'Oro Maini, published by *La Nación*, a group of artists declared that, given the importance of the Biennial, it was necessary to exhibit the best and most civic-minded national artwork:[14] "We understand that this is an opportunity for our country to exhibit abroad the work of artists whose civic and aesthetic activities confronted the most tragic moments in the life of our nation. Therefore, by expressing our surprise at the exclusion of artists whose value is indisputable, artists whose democratic behavior has been proven, we respectfully request information regarding the criteria applied by the jury in the decision-making process, regarding the partiality of the members, and regarding other factors that are indispensable for a selection whose outcome determines the future participants."[15]

For an artist like Raquel Forner, who felt ostracized from distinguished art spaces during the Peronist years, it must have been particularly upsetting to be excluded yet again and not for reasons of quality but for reasons as superficial as those of "youth." And the young artists, for their part, did not remain quiet in response to the declaration of the excluded artists but responded by sending another letter, also addressed to the minister, in which they expressed that "We cannot accept that any group should assume the right to monopolize artistic quality and civic-minded conduct."[16] Ignored by Peronism, those artists were again isolated for

generational reasons that, as explained by Romero Brest in the catalogue, had been decisive in the selection he and Payró had made inasmuch as the task fell to the youth to "construct the spirit that the country was to have in future decades."[17]

What this selection said to the local art scene was that, from that moment on, the focus would be on young artists, which did not necessarily mean that the art they produced was good, avant-garde, or represented any particular image; for the time being, Argentine art was unable to offer these qualities. Thus, the alternative was to select all new art that could potentially provide the key to success. This change in legitimizing criteria also led to the displacement of the idea of avant-garde, and was a prelude to a radical transformation (not only in art but also of man and society) toward the idea of avant-garde as fashion, as a substitutive process whose dynamic simply resided in the idea of "novelty." This concept of avant-garde as "fashion" would be a central element in the dynamic of displacement that characterized the art scene of the 1960s,[18] a displacement that became possible because some artistic sectors defined their projects in terms of negotiating with average tastes and with the options offered by the new leaders and institutions.

The controversy over the new criteria of selection, which had a public dimension, made it clear that the end of Peronism, despite the restorative tone that characterized the speeches, did not necessarily imply a restoration of those artists who had been displaced. Although the idea of providing restitution was important in awarding the Grand Prize at the National Salon, it was not the primary criterion in the reorganization of the artistic field. It may have been circumstantially decisive for a traditional institution like the salón, which was linked to the past and no longer played the central role it had previously, but for such a crucial space as the Venice Biennial, which those same excluded artists considered to be "the most prestigious exhibition in the world,"[19] those restorative priorities could not be relied on. Nor did the division fall between quality art and bad art, it was already established that the good artists were those excluded by the regime. What had changed were the criteria that organized the hierarchies. From that moment on, youth was granted a central position at the moment of selecting not only the international delegations but also the awarding of local prizes that were exclusively created for "young" artists.[20] The debate that arose over the selection of artwork to be sent to the Venice Biennial clearly reflects the indignation of artists linked to liberal sectors. The sensation was that a new card game had begun and,

unexpectedly, some of the players had not even been dealt a hand to play with. The question was to what extent youth had become a precondition for participation, just as national themes had been a precondition during the years of Peronism. Many artists must have asked themselves this very question.

A Revitalized Museum

The designation of Romero Brest as director of the Museo Nacional de Bellas Artes (MNBA, National Museum of Fine Arts) in October 1955 was just one of a rapid succession of decisions intended to give key positions to those persons who had been displaced from directorial spaces during the Peronist period. As I demonstrated in chapter 1, "displaced" did not necessarily mean "inactive." During the preceding years, Romero Brest had developed a formative strategy that was extremely coherent. The central elements of this strategy involved, on the one hand, introducing onto the local scene criteria for aesthetic evaluation, and, on the other hand, presenting the principles and history of modern art that, until then, had its base of operations in Paris. The opportunity was now presented to substitute action for words and to demonstrate that the model he had explained in the pages of his magazine could be exhibited on the walls of the most important museum in the country. The apparatus Romero Brest assembled to this end was intended to meet all the requirements he had set out in the magazine *Ver y Estimar*: to improve the museum's collection, to attract important international exhibitions, and to transform the museum into an educational space capable of shaping the aesthetic tastes of future generations. However, even when the direction of the principal artistic institution seemed to have gained a privileged place for developing the policies necessary to achieve these goals, Romero Brest found himself at the helm of a museum that had been abandoned, was inactive, and lacked the money necessary to keep its doors open. The new State had expressed its support of culture but this did not mean that it could finance it: support only implied broader freedom to create, but not the financial conditions that had prevailed under Peronism.

Romero Brest's intervention in the selecting of the artwork to be sent to the Venice Biennial, emphasizing the importance of the present and future, was unthinkable in terms of the museum's collection. It not only lacked important and representative pieces of ancient art, but could scarcely boast of any examples of modern art and absolutely no contem-

porary art. It would be difficult, therefore, to mount a historical display of the evolution of modern art as he had explained it in the pages of his magazine. Nonetheless, as we shall see, the critic knew very well how to use the few elements at his disposal to exemplify the extent to which modernity could be explained through a language of organizing forms and colors on the surface of the canvas.

Romero Brest was finally in possession of the position he wanted, but he could not do much with it. One year after his appointment he still had not managed to eliminate the marks "left by the machine guns and the troops" during the Revolución Libertadora (when the museum had been occupied by the 1st Motorized Infantry Regiment). Resorting to drastic measures, he decided to reopen the museum by hanging paintings over the bullet holes.[21] During the eight years that he directed the museum he would periodically describe his difficulties to the print media. The lack of resources became strikingly visible and public when, faced with the opportunity to acquire a Picasso (which, as we have seen, was a crucial artist in his version of the history of modern art), Romero Brest organized a fund-raiser which failed, however, to bring in the necessary 150,000 pesos to buy the painting. The solution for future purchases was provided by passage of the New Cinematic Law, which promised the museum three or four million pesos for acquisitions.[22] But the problem, as we shall see, was not exclusively the lack of money.

After months of repairs in the galleries and the restoration of many works of art, the museum reopened in June 1957 with the exhibition Arte moderno en Brasil (Modern Art in Brazil) featuring the Santamarina collection, and a selection of paintings from the museum "presented chronologically" and organized "by schools of influence."[23] Romero Brest thus managed a threefold success: an international exhibition attended by the ambassadors of many countries (Uruguay, Brazil, Chile, Paraguay, Bolivia, Mexico, Cuba, El Salvador, Costa Rica, Spain, Canada, Belgium, China, Japan, India, etc.),[24] the presentation of an important collection of Argentine art, and the presentation of his version of the evolution of the history of art through a selection of images. For Romero Brest, at that moment, the internationalist project involved breaking out of isolation and, to that end, his policy was to bring international exhibitions to the museum in order to inspire local artistic activity.[25] His modernizing project developed in a political environment that was favorable to his principles. After the elections of 1958, which brought Arturo Frondizi to power as president, a development policy emerged that was characterized

by an intense expansion of the economy, but was also plagued by a climate of constant military, political, and social conflict.[26]

The response to Romero Brest's activities as director of the museum demonstrates that, in the artistic field, conflict was not a question of confrontation between political sectors. In an anti-Peronist block such as the one that dominated the scene, divisions were basically produced by the confrontation of modernizing versus traditional sectors.

In March 1958, a little after Romero Brest publicized his project for renewal, Carlos A. Foglia, the critic for *La Prensa*, published the book *Arte y mistificación* (Art and Mystification).[27] Foglia was not exactly a critic who was capable of supporting a project for the renewal of art. As champion for the existence of a "national" tradition rooted in local themes— he had written books such as *El riachuelo inspirador de artistas* (The Riachuelo River: Inspiration of Artists) in 1951, and another on Cesáreo Bernaldo de Quirós in 1961—he considered Romero Brest to be one of the "revolutionary leaders" who misguided the youth. Romero Brest's projects did no more than irritate him. Foglia championed a conservative and nationalist aesthetic, representatives of which could be found in the ranks of both the Peronists and the anti-Peronists. His aesthetic views had nothing to do with his adhesion or opposition to the deposed regime, but rather to his opposition to any proposed confrontation with the art of the past that was in the national tradition (the gauchos, the pampa and littoral regions, and above all, art that was "well-executed"). For Foglia, it was almost an obligation to put a stop to "contemporary art," which was, in his view, an incorrigible evil: "The intemperance of the propagandists for Contemporary Art, united in their unbridled enthusiasm to promote new forms of artistic expression, and having practically taken over the highest public offices in the field and almost all the modern means of communication, obliges us to take up a cause that we view as serving the common good because they have begun to systematically deny, right before us all, the most sincere and spontaneous creations of our culture."[28]

What Foglia perceived was that Romero Brest had managed to form an organization that included the Associations of Friends of the MNBA, MAM, and the Galería Bonino ("bastion of the newest forms of expression" and from where directives were issued that either elevated or destroyed reputations),[29] where these associations made purchases on behalf of the museums.[30] In his view the result was that all these spaces, the galleries as well as the competitions, had experienced a pernicious invasion of servile

imitations and copies under the supervision of Romero Brest. In one sentence, Foglia summarized the way Romero Brest exercised his power: "In other times artists were chosen, not recruited."[31] In his arguments against all the renewal projects spearheaded by the critic, Foglia resorted to a series of comparisons between abstract painting, schizophrenia, and abnormality, which surely would have delighted Ivanissevich.

In March 1960 Romero Brest felt that despite hopes generated by the revolution of 1955 he was still unable to give definite form to any of his objectives (neither the development of the collection nor the restructuring of the museum). Consequently, he offered his resignation citing the obstacles and impossibilities facing his directorship. His resignation was not accepted. This action—perhaps more of a symbolic gesture than a true decision—gave him the opportunity to reiterate the scope of his program: the remodeling of the building, refurbishing of the conference room, renewal of the library, publication of a monthly bulletin, public conferences, guided tours, concerts, and so on. However, Romero Brest only managed to achieve a few of these goals. The obstacles and opposition he had to confront during his term as director—which ended in 1963—clearly reveals that the optimistic and promising speeches of the Revolución Libertadora did not imply, in any way, that there was a consensus about what institutional program should be implemented in the artistic field. On the other hand, it was soon evident that the institutions capable of carrying forward the necessary transformations in the artistic field would not be those that were dependent on the State, such as the MNBA, but rather new and private foundations and institutions. Pursuing his policy of combining forces, Romero Brest would soon join with these organizations.

A New Museum for the New Art

In addition to the measures taken to restore artistic institutions, which entailed recognizing and promoting public figures within these institutions as part of the spirit of renewal, the first initiatives of the Revolución Libertadora were intended to create spaces that could accommodate the new art form that everyone hoped would flourish. A museum of modern art was a symbol for a large city, and the model for these institutions in Latin America was primarily the Museum of Modern Art in New York.[32] This city and its recent rise to artistic glory not only constituted a point of comparison for local cultural figures, but also, as we shall see,

was viewed in these terms by certain critics, such as Pierre Restany, who saw in Buenos Aires a Latin American city that could repeat the process of cultural expansion that had made New York the center of the international artistic scene.

The sense of urgency that resulted from the knowledge that ten years of national artistic development had been lost helps us understand why, even without being promised a permanent space in the immediate future, Rafael Squirru accepted the first directorship of a museum that initially operated in the passageways and cabins of a ship.[33] At the same time that Raquel Forner was receiving a national award, and artwork was being sent to Washington and Venice to represent the national art scene, the ship, the *Yapeyú*, the mobile home of the Museo de Arte Moderno (MAM, Museum of Modern Art in Buenos Aires), was leaving the harbor of Buenos Aires with the objective of bringing Argentine art to all the ports of the world.[34] This exhibition, which was Squirru's first opportunity to initiate the activities of the museum, was the symbolic and highly anticipated culmination of the internationalist project that would influence many of the decisions made in the artistic area in subsequent years. The desire to transcend national borders was already apparent in the pompous yet vague text that Squirru wrote for the catalogue. Filled with allusions and metaphors that the critic used to infuse his writing with a messianic quality, Squirru's introduction concealed between the lines a prophetic tone that soon became something like the scream of a crusader whose "holy city" was represented by the international art world.

The selection of works for this first exhibition did not appear to favor any particular group or party. Although some important names from the abstract art scene were missing (such as Kosice, Maldonado, and Lozza), this seemed to be the result of organizational circumstances rather than premeditated exclusions. For Squirru, what was important was to establish the museum's existence. To this end his principal strategy was to fill the available spaces of the city with all the works of art he could muster:[35] "For me it was a question of tearing down a wall, of breaking through the circle of pontiffs who pontificated in direct proportion to their own ignorance, of shining light through the darkness, and I thought that any action that might help reach this goal was worthy of the museum's support."[36]

The decree that established the MAM included, almost as a declaration of principles, the goal of opening a space for those "new tendencies" that, "on the margins of museums and other cultural institutions," had seen

their development impeded.[37] During Squirru's directorship of the museum, despite the improvisational nature of his decisions and the direction they took, he managed to present exhibitions that introduced new ideas, such as the launching of an informalist group that took place at the Museo Sívori at the end of 1959 under the auspices of the MAM. Thus the MAM was linked to the entrance of the "new" tendency into Buenos Aires. In 1960 the MAM also sponsored the first exhibition of Arte generativo which took place at the Peuser Gallery as part of the revival of geometric art.[38]

The foundational decree also took into account two important questions that linked, on the one hand, the centralist desires of Buenos Aires and, on the other hand, the need to create institutional mechanisms that would facilitate the integration of the arts. Like other large capitals of the world, Buenos Aires needed to have a space capable of attracting a large public and of functioning, like other important centers of modern art, as a structure that permitted the interaction of different forms of artistic expression.[39]

These considerations which, for the moment, lingered more on the horizons of desire rather than of possibility, successfully anticipated those very programs that would be implemented in the 1960s in order to generate an avant-garde, to make Buenos Aires an international artistic center, and to create a new public capable of appreciating modern art. These desires and intentions, which responded to a set of artistic as well as political needs, increasingly grew as the project of modernization was articulated and gained strength. All of these projects, based on the idea of generating an avant-garde or, at least, of providing ample institutional support for one, raised the problematic question of how closely active collaboration may take place between an avant-garde movement and the institutions of a given society. The central question is what were the points of negotiation between the two entities. As we shall soon see, many artists still conceived of the avant-garde as implying active opposition to the existing order. In contrast to the early period of concrete art, which considered the artistic avant-garde as being associated with the political avant-garde, for those artists working toward a change, this could only take place, for the moment, in the context of language and form. The political program of the avant-garde, for the time being, was not being discussed. This parenthesis created an undefined space in which it was possible to maintain a productive alliance between the avant-garde and the institutions. Certain sectors, such as the group Espartaco that spoke in the name of an

artistic and political avant-garde—expressed through realist or muralist methods—were not recognized as avant-garde in the artistic milieu.[40]

For the institutions that were being reorganized, internationalism at that time meant attracting foreign exhibitions to the country, as well as taking all available Argentine art to other countries, with the prime objective of breaking out of the isolation that had affected Argentine culture throughout the Peronist years. Together with this movement, another way of understanding the internationalist imperative was emerging. Primarily, this involved the artists' efforts to participate, *at the same time*, in the transformation of language that was taking place in the major artistic centers, whose functional core, as far as Argentines were concerned, was still Paris.

Boa, *Phases*, and the International Front of the Avant-Garde

> *I have entered the house of Tristán Tzara as if it were the temple of Chefren, and found the idol that had created the epic of elementary man, slightly animal, slightly flower, slightly metal, slightly man, and found him, I would say, playing alone at chess with an almost mystic obsessiveness, he who had wanted to replace the archaic notion of inspiration with his own manipulation of delirium.*
>
> *In that immense space on the Boulevard Saint-Germain, only furnished with his books, which numbered in the thousands, his sculptures from Africa and Oceana, which numbered in the hundreds, and his ghost, which was all of humanity for the devoted pilgrim, who casts a spell over the temples, without knowing what to tell us, we stared at one another.*
>
> *He walked with me through the large rooms, like a modest guide of the museum of himself, of the museum of the man he had been or, perhaps, of the man he would have liked to be, who knows.*
>
> *I did not see the objects he described to me, nor did I hear the things he said. Rather, I saw him thirty-five years ago, howling: "Thought is produced in the mouth," or pounding ferociously on the head of a drum, in the middle of a Dada performance, while Serner placed a bouquet of flowers at the feet of a seamstress's mannequin, and a voice, emanating from beneath an enormous sugarloaf hat, recited poems by Hans Arp. I saw him writing: "How can one give order to the chaos that constitutes that infinite and formless variation: man?"*
>
> *But the ashes that devastated the features of that almost holy little*

*spirit perhaps came from other, less pristine sources: from politics,
which, following Marxist criteria for interpreting history, had led
him to retract his grandiose statements. I didn't want to see what I
was seeing or hear what I was hearing. I wanted to be with the same
little giant who had found, in almost all related principles, essential
flaws that turned them into the prison of humanity, rather than the
manifestation of human power and terrestrial happiness.*

*Similarly, that Breton of the Café de la Place Blanche was not
the one I had frantically loved, the one of Les Pas Perdus: "Aban-
don everything. Abandon Dada. Abandon your wife. Abandon your
lover. Abandon your hopes and fears. Sow your children in a corner of
the woods. Abandon the light and enter the shadows. Abandon what
was the life of comfort for that of necessity, which will afford you hope
for the future. Depart by the roads."*

I had definitely arrived late for everything. — Julio Llinás

After exploring all the avenues in Buenos Aires that might prepare him
for the road that lay before him, Julio Llinás arrived in Paris in early 1952.
To learn about the city's streets and cafés, to be familiar with the battles of
the artistic and literary avant-garde which had been fought there, to bear
in mind the names of the writers and artists he would have to meet, the
places he would have to visit, and to even know about the events that had
shaken the city he had been dreaming of in the days leading up to his voy-
age: all this formed part of the initiation rite to be completed before set-
ting out on the journey. In Buenos Aires there were specific places where
all this knowledge could be attained. If one was a regular customer of the
Galatea bookshop,[41] the Jockey Club, or, later on, of the Café Chambery,
where artists gathered, it was possible to gain access to one of the many
versions of that city that fed fantasies about those illustrious groups of
bohemians and avant-gardes.

In 1952 Llinás, youthful poet and writer, found himself in a place where
he could "touch" the legend: Breton, surrealism, and all the central fig-
ures of that heroic epic that he had re-created while reading, over and
over, the story of that desperate desire to upset the order of history to
which he had gained access for the first time, in French, when he held the
History of Surrealism, by Maurice Nadeau, in his hands:

That book contained the secret history of my thoughts, it contained the beat of a
ferocious, tragic and vital spirit.

The names of Tristán Tzara, André Breton, Benjamín Péret, Paul Éluard, Louis Aragon, unknown to me until that moment, left their mark on my brain like red-hot branding irons. The anecdotes, the sentences, the poems, the fragments of manifestos, everything seemed to come from that messianic world that I summoned up, lost among my own labyrinths and desires and the labyrinths and desires of others. . . . in the book of Nadeau one breathed another kind of oxygen. A beautiful dream, without a doubt.

That afternoon, that very afternoon, I decided to bet my life on that dream.[42]

Even when Paris had already lost its former ability to launch avant-garde forms into the world, it still fascinated the youthful artists of Buenos Aires and induced them to travel. Nonetheless, what Llinás encountered once he arrived was little more than a shadow of what he had imagined. In a letter he never sent, addressed to Aldo Pellegrini, director of *Qué*, the first Spanish-language surrealist magazine, published in Buenos Aires from 1928 to 1930, Llinás offered a cutting description of Breton and surrealism:

Dear Aldo, I truly feel that now we would have a lot to talk about, you and I, that we could talk *for the first time*. I could fill millions of pages and accomplish nothing. So, to use Dalí's favorite word, I will limit myself to being "objective." Much has happened since my last letter. Of course, I met the two-headed monster, Breton-Peret, who are as inseparable as the white thighs of *La Belle Jardinière*. Breton is truly a lion, he has hands that look like they have been kneading immense fortunes. Only someone who is very perverse could discover in his imposing presence the first symptoms of his being worm-eaten. Peret, less *ferocious*, is exactly the kind of person who you'd expect to ask, at any given moment, "Why did you kill Trotsky?" I met them one Saturday in the legendary café, La Place Blanche. Lam introduced us to one another. . . . I gave him *La Valija de Fuego, Costumbres errantes, Panta Rhei*,[43] and your letter, and I tried to explain to him that in Buenos Aires there are some people who are trying to *do something*.[44]

The situation of surrealism that Llinás was describing was, in his words, "disastrous." He felt as if he was witnessing a fragile and weakened surrealism, and the best proof of this was the exhibition that Breton himself had organized in Paris with the participation of, among others, Max Ernst, Joan Miró, Marcel Duchamp, Wifredo Lam, and Toyen:

To see that exhibition, knowing that it was organized by Breton, by André Breton, the man who had written *Nadja* and *The Manifestos*, created a nightmarish atmosphere. And to hear the "enfants," restrained, conventional, frightened, discussing

whether or not one could say that Rimbaud was French, can you understand me? I'm describing shit in its purest form.

This, my dear Aldo, is the scene. I believe ferociously in America, in America that breathes with its two lungs. I had to come here in order to see that Europe was consumptive, that Paris was a myth, and that I was a strong man. Of course it's true that there we have nothing more than just that: lungs. But, in the end, it's all about having lungs. Please don't misunderstand me. I'm not disappointed. What I hoped to find here, I've found. . . .

Must we sit down around our private god and dreamily stir up the thick surrealist broth of twenty years ago when we live like pigs, when we are the systematic negation of all of that? Must we write poems beginning with "My wife . . ."? Must we feel that we are heirs to "those experiences" just because we sit at the same table as our god? And must we hurl ourselves wholeheartedly into living, to win or lose, but *to reach the end*, in any case?

Shit, violinistic shit. I'm breathing an air of oppression, of terror and misery. . . . In America you find naiveté. Here, naiveté is a delicacy one eats cold. In America you find imbecility in its pure form. Here you find imbecility packaged and decorated with a bow, which is its most dangerous form.

And the Liberty of Paris, ah, the liberty, yes, but the *liberty to die anywhere*. Who is it that understands Liberty in that way?

You speak to me of the surrealists over there as "the remains of a shipwreck." All right, but they are the fallout, the ruins of one and the same shipwreck: the one here. ANOTHER SHIP MUST BE LAUNCHED. Today more than ever I believe in surrealism. Breton must be shown that surrealism is not him. Surrealism is life. You ask me if the change has transformed me. It has not transformed me. It has made me! . . . When I return, we will truly do something.[45]

Restrained, conventional, frightened. That is the state in which Llinás found the movement that had ignited his imagination. Having arrived in Paris, Llinás felt that the city of his dreams had gone up in smoke and that what had emerged, powerfully, was the need to *launch another ship*. The power of surrealism had weakened after the war. The reasons were aesthetic as well as political. When Tristán Tzara proclaimed that the logical culmination of surrealism was communism,[46] Breton replied that surrealism, more than ever, could not be assimilated into any doctrine. Roger Vailland, of the group Revolutionary Surrealists, responded with the text "Surrealism Against Revolution" (1947). The apoliticalism that Breton called for also elicited a response from Sartre: "If Breton thinks that he can pursue his inner experiences on the margin of revolutionary activity

and parallel to it, he is condemned in advance, for that would amount to saying that a freedom of spirit is conceivable in chains, at least for certain people, and, consequently, to making revolution less urgent."[47] Sartre understood that violence and passivity were gratuitous acts, without utility. A metaphysical and abstract expression of rebellion that left the world "strictly intact": "The total abolition it is dreaming of does not harm anybody precisely because it is total. It is an absolute located outside of history, a poetic fiction."[48]

In fact, by 1952 the radicalism of surrealism was practically nonexistent. After the exhibition at the Maeght Gallery of Paris in 1947, even its ability to unify different groups had dissipated. Llinás's portrayal of surrealism would seem to be more apropos of an epic account of the movement—its determination to destroy all bourgeois, conservative, and academic tendencies in art—rather than what remained of it in 1952. However, Llinás's criticism was not politically motivated. He was not calling on surrealism to place itself at the service of revolution, but rather, and more specifically, he was expressing his disappointment using the same general terms that the surrealist movement had used for its generalized criticism of reality. In other words, Llinás was using surrealist phraseology to define a Latin American sense of distance from the condition in which he found the European movement: whereas Paris was no more than a myth, he was a "strong man," with "lungs" and, as he told Pellegrini, it was all about having lungs. Nonetheless, his initial disappointment was not so complete as to inhibit the rebirth of his enthusiasm when presented with the possibility of joining a movement striving to renew the unifying force of surrealism. Llinás found such a project when Wifredo Lam introduced him to Édouard Jaguer, who immediately invited him to join.

In 1951 the last issues were published of *Cobra* and *Rixes*, the European magazines that had praised the new forms of free and experimental expression during the postwar period and had tried to organize an international circuit.[49] Following those, there were no other spaces dedicated to such goals. In 1954 Jaguer published the first issue of *Phases* with the intention of restoring lost contacts between groups, now scattered among numerous countries, that shared similar goals.

This "modern art international" saw itself as a space for the union of forces, confrontation, and experimentalism in different regions of the world. In contrast to internationalism as it was understood in Argentina—the presentation of Argentine art abroad, organized by official institutions—this union sought to eliminate borders and organize intellectual

and artistic programs "at a distance." As associations that shared certain principles of artistic production, these groups—Movimiento Nucleare in Milan (1951), the magazine *Il Gesto* (1955), *Salamander* in Malmö, Sweden (1955)[50]—formed a *constellation* with various points, whose foundational activity involved the organization of an exhibition and the creation of a magazine. This was a type of organization that could also be seen, at first, as oppositional to institutional initiatives. Rather than curatorial projects organized by museums or the State, which sent national delegations abroad, the exhibitions framed within this broad but unified international program of experimental art were organized by artists who, in different parts of the world, identified themselves with, and adhered to, a single program with similar principles. The magazines mentioned above offered a mixture of information from all different places that included images, poetry, programmatic texts, and reviews. The basic idea was to bring together views that had points in common, came from different cultural backgrounds, and materialized in magazines and exhibitions organized in cities of Europe and America (Paris, Milan, Lima, Montevideo, Santa Fe, Guadalajara, Buenos Aires, etc.). This form of horizontal organization—which, more than seeking to expand a national style into other regions, sought to establish one through a participatory network or organization—acquired greater visibility when it was contrasted with other forms of expansionist internationalism that characterized many of the networks created for the circulation of Latin American artistic images during the 1960s. *Phases*, as Jaguer explained during his visit to Buenos Aires, hoped to function on the basis of a structure of agreements: "It was not strictly speaking a question of forming a group that functioned according to the model of the surrealist group, but rather a 'structure of reception,' a sort of permanent 'council' composed of creators who shared the same working spirit, but worked in formal areas that not only could be, but *had to be*, different. So, this structure had to be flexible, insofar as possible, and open to diverse possibilities of production whenever offered, such as publications, exhibitions, or other formats. Such flexibility was the only formula that could make it possible to address, under the best conditions for dialogue and emulation, the efforts being carried out in such a diverse order by different individuals and groups in a dozen different countries."[51]

During the 1950s, France was no longer so sure that it had the means to set the evolutionary order of styles. The new North American school of painting had managed to undermine France's power through a set of

strategies organized not only by institutions such as the Museum of Modern Art in New York, but also by the arguments of critics such as Harold Rosenberg and Clement Greenberg. These critics explained how modernism had been saved thanks to artists of the North American avant-garde who had guaranteed its continuity. Faced with the complex ideological apparatus assembled by the North Americans, the French were to some degree unaware of what was happening in the struggle for control over images on the world art scene. Although in 1952 it may not have been possible to visualize this process in its definitive form, the difficulties of organizing a unified project were indeed evident.[52] Jaguer's initiative could be understood as a type of response to this inertia. Nonetheless, his proposal lacked a fundamental element if it was to have any real impact or receive recognition, that is to say, it lacked definition.

Jaguer wanted to resurrect the international colors of surrealism but with a different aesthetic from that of Breton in his moment. Rather than Toyen or Simone Hantai, to whom the father of surrealism was still clinging, Jaguer extolled De Kooning and Pollock. The aesthetic program that joined the artists of *Phases* was based on a minimal but specific agreement: to unite the explorations of surrealism and non-figurative art. The lack of radicalism in the program (in aesthetic as well as political terms) may explain their ability to secure so many spaces for their exhibitions, as well as the relatively high visibility of the group. Although the writers and intellectuals affiliated with *Phases* were numerous, this extensive group did not have a great public impact. For this reason it was not—and has not become—an important turning point in the history of the European and Latin American avant-garde movements, in contrast to its opponent, *art autre*. Taken by the hand of Michel Tapié, who was more enterprising than Jaguer and in possession of a more convincing rhetorical apparatus, art autre would have much greater impact.

Llinás was involved in Jaguer's project from the beginning as the Argentine correspondent in the first issue of *Phases*.[53] He had in mind, however, something beyond an occasional collaboration. He wanted to organize a group in Buenos Aires that would form part of the international network and whose foundation he had been involved in.

After his return to Buenos Aires in 1954, Llinás wanted to publish a magazine with ties to *Phases*. This finally came about in 1958 with the publication of the first issue of *Boa*. The magazine, which ended after only three issues, could also be seen as an attempt to resurrect the project

begun by Aldo Pellegrini, whose goal was to organize a surrealist front in Argentina,[54] a task in which Llinás had also been involved.[55]

Argentine surrealism, however, had already received a great deal of attention and this coincided with Jaguer's objectives for his publication of *Phases*. In 1952 Pellegrini had brought about the merger of the concrete artists with four independent semi-abstract, or "lyrical" abstract, artists.[56] In this way the group of Argentine modern artists that transcended international borders was formed.[57] The relationship between abstraction and surrealism proposed by *Boa* responded as much to the references made by *Phases* as it did to the relation between the two tendencies that Pellegrini had already proposed. In 1953, in the article "Arte surrealista y arte concreto" (Surrealist Art and Concrete Art), published in the magazine *Nueva visión*, directed by Tomás Maldonado, Pellegrini wondered, "In which theoretical expressions of the surrealists can we establish a foothold for considering all non-figurative plastic expressions as having the right to pertain to this movement?"[58] Taking as a starting point Breton's book *Surrealism and Painting* (1928), Pellegrini asserted that the abstract artists used a purely internal model in their works, recalling what Breton proposed as a crisis of the imitation principle: "The objectification of what is spiritual, according to Kandinsky's classic expression (also used by Breton) is the key that establishes the union between artists of the modernist tendency—if they are really artists—be they surrealist or concrete artists."[59]

Llinás returned to Buenos Aires in 1954 intending to publish a magazine comparable to such European publications as *Phases*, a magazine that, as Jaguer said, "could provide a platform, like its European sisters, for a coherent collective activity, which could eventually translate to more or less ambitious exhibitions, with painting as the preferred vehicle of our effort to serve the public. And *Boa*, it might be supposed (though I never asked him), was the title that Llinás gave the magazine as a humorous and poetic reference to *Cobra* and *Salamander*."[60]

Llinás's explanation of the magazine's title coincides with Jaguer's, except for one additional footnote, which was that he chose *Boa* (the name of a powerful Amazonian snake) as a *Latin American translation* of *Cobra*, its European predecessor. Just as Llinás had written to Pellegrini in 1952 about the necessity to "launch another ship," the magazine he was now organizing contained, even in its title, the need to differentiate itself. The combination of references apparent in the name was appealing to Euro-

peans (with their predilection for Orientalism) as well as South Americans (who were anxious for internationalization but also intent upon maintaining elements of localization).

Like *Phases*, *Boa* also defined itself as "International notebooks for the documentation of avant-garde poetry and art." What differentiated this magazine from previous attempts to publish surrealist magazines in Buenos Aires was the central role and predominant space allotted to visual artists in the first issue of *Boa*.[61]

This magazine restored the union between surrealism and abstraction (albeit along the lines of informal abstraction rather than concrete art, which was dominant during the 1940s), but it now included an additional element: it presented itself as one more link in an international network. Painters and sculptures formed part of a united front that was convenient for both groups. On the one hand, the French could now wave the internationalist colors, which had been debilitated by the North American postwar cultural offensive. On the other hand, the Argentines now appeared as the exponents of a discourse that could be heard in its multiple voices, in many cities, simultaneously. *Boa* proved, in a certain sense, that the great hope of integrating with the artistic centers of the world was becoming a reality. The possibility of comparing works from different places in the pages of the magazine provided Jaguer the opportunity to establish parallels between, for example, the jungles of Max Ernst and the pampas of the Argentine artist Caride. In fact, the works that were reproduced in the first issue of *Boa* were not very different from those that could be seen at that moment in Paris. They portrayed a gestural abstraction that experimented with materials, with a certain residual geometry, clearly departing from the radicalism they had experimented with in Buenos Aires during the 1940s.

The first issue of *Boa* came out on May 5, 1958, and although Jaguer saw the magazine as a "sister" to *Phases*, Llinás tried to clarify from the beginning that there were some differences. In a letter to Jaguer dated April 17 of that same year, Llinás explained to him how he conceived of *Boa*:

I don't want to imitate *Phases* (I recognize that the magazine is widely admired, but I don't like imitations). *Boa* will be a South American magazine joined in spirit and by its relations, its director and, I admit, by a certain concept of honesty, to *Phases*. It borrows from *Phases* the epigraph, "International notebooks . . . ," receives information from *Phases*, and would like to become her subtropical sister.

It possesses a very deep feeling of fraternity (not that of the French slogan!), does not believe in physical borders, is impassioned, and excited. It will take its first steps in a singular, difficult environment, in a post-colonial country with a strong nationalist feeling, and all that repellent nonsense. BUT it can also be informative, it can also situate its message among those savages of Europe.[62]

Llinás's explanations of his position were intended to establish differences without neglecting to conform to Jaguer's model. For the presentation of the magazine in Buenos Aires, Llinás started from preexisting initiatives: the first issue of *Boa* was also the exhibition catalogue for a group of artists who were already established and had exhibited a year earlier in the Pizarro Gallery.

On June 12, 1958, Llinás published the second issue of *Boa*, which was also the catalogue for the exhibition *Phases*, which opened in the Van Riel Gallery and was billed as the "1st International Comparison of Experimental Art" ever held in South America. With the magazine in his hands, Jaguer—who effortlessly observed how others gave form to his internationalist aspirations—wrote an enthusiastic, congratulatory letter to Llinás:

It's masterful. I cannot express myself any better and convey my satisfaction and personal respect for your work, than to say the following: you did it as if you were an old hand at avant-garde publishing and you appear to be so "in your element" with this concept, as is evident in the magazine, that there is absolutely no trace of provincialism. It could have been produced here, except for the use of the Spanish language, and I would be proud to recognize your work as if it were my own. There is something else I would like to tell you, something that can't wait any longer: You have compensated me hundreds of times over for the little effort I have made to help you; very few times have I ever had the impression, until that 16th of June when I received the second issue of *Boa*, that I was really working for something and that there were people in the world on whom I could really depend, and above all, that among the best of them was Llinás, who had succeeded in the unprecedented feat of producing, one after another, two superb issues of the magazine. . . . So, I say to you, Julio, on behalf of us all, once again, BRAVO and "HATS OFF TO YOU!!!!"[63]

It is not hard to imagine Llinás's delight upon reading this outpouring of praise which, undoubtedly, must have acted as a palliative for all the difficulties and unpleasantries he confronted while producing the magazine: "Your words, exaggerated as they were, have been the best of com-

pensations. . . . Nothing was improvised, neither in its pages nor in its conception. Of course, there were as many surprises as there were frights. The defections of people I counted among my best friends in Buenos Aires was a powerful blow for me. Not only because of their distancing themselves from the pages of *Boa*, but because, above all, I suddenly became aware of the degree to which people who are practically your brothers one day can become sordid and unrecognizable the next day. One of them even came out and said to me that I wanted to produce *Boa* in order to 'promote' Martha."[64]

In addition to the sensibilities of other artists and intellectuals who had accused him of arranging the exhibition in order to promote his wife, Martha Peluffo, were the monetary difficulties of financing *Boa* and organizing *Phases*, all of which Llinás had managed to do on his own—not only assembling but also translating the texts to be included in the magazine. Nonetheless, not everything was a misadventure. Llinás also mentioned the successes and satisfactions of the experience:

On June 12 everything's ready. The battle is won. After the day of the opening, the expressions multiply. The halls of the Van Riel are always full. *Boa* sells like hotcakes. There is talk of *Phases*, of Jaguer. There are always people looking through the Van Riel show windows where numerous copies of *Phases* and *Boa* are on display, alongside catalogs from Lam, Scanavino, Baj, Götz, etc. There's also an issue of *Cobra*, another of *Il Gesto*, posters of Movimiento de Arte Nuclear, etc. The critics come through, they look, they greet me and wrinkle their noses, the "art" critics. A week later they write their typical nonsense . . . "it is very interesting," "it is necessary to encourage this type of exhibition," etc., etc. They interviewed me on the radio, on television; they filmed the opening of *Phases*.[65]

We can also imagine the satisfaction that Jaguer felt knowing that the international network of magazines and contributors that he orchestrated was gathered all in one place in Latin America. The new international surrealism that he had set in motion had become a reality and this letter proved it. However, Llinás's efforts were not exhausted by this one epic transference. Llinás, and the artists of Buenos Aires, hoped to generate their own movement whose distinguishing features no one could identify yet, but whose symptoms everyone wanted to diagnose. What dominated in Buenos Aires, more than a style, was an eclectic bunch of remnants among which geometric abstraction and gesturalism mixed, without successfully articulating any convincing rhetoric. Furthermore, the impact of the internationalist project of *Phases* did not yield in Buenos Aires the

positive results that other representatives of French culture would produce one year later. The exhibition of the tachiste painter Georges Mathieu, and the visit by André Malraux, minister of cultural affairs in Charles de Gaulle's government, were both more official and more theatrical events, and they were both opposed by *Phases* and *Boa*.

Conflicting Internationalisms

Llinás's rejection of the statements made by André Malraux in Buenos Aires appeared as the heading to the third issue of *Boa* in July 1960. During his brief stay in Buenos Aires, Malraux did not hesitate to declare to the press, on numerous occasions, the political motives of his visit, in addition to giving the Grand Cross of the Legion of Honor to numerous prominent figures (a gesture which was reciprocated when he received the Grand Cross of May for Merit from dignitaries of Buenos Aires). In response to the question of why he had come to Latin America during his press conference at the French embassy, he replied,

First, to propose a plan for development in a world where there are 1.7 billion people who don't get enough to eat, it won't be possible to avoid war if we don't resolve this problem. . . . France proposes a technical and scientific organization, especially for Latin America because in its current circumstances of development it is one of the most important places in the world.

Second, we believe that the civilization that begins with us (call it atomic or not) is a civilization without precedents. Because, until now, large nations inherited their own culture. Now, for the first time, we are heirs to all the cultures of the world. But the majority of us believe that the culture we should now form, for example, will be neither the culture of Russia nor of the United States. There is nothing political in what I'm saying. We may be profoundly linked to the United States, and my country is not unaware of its debt to that country. That's one issue. The creation of a world culture is another issue. Consequently, whether we refer to ourselves as Latins, or by some other name . . . we know that there is a group we belong to, that we will call the old and new Latin world, whose profound points in common call for a new civilization of our own.[66]

In this attempt to replace the slogan "America for Americans" with the slogan "America for the French," Malraux was also explaining the meaning of the proposal of a "third force" (a term that resonated, in Argentine ears, of the third position proposed by Perón): "It has to do with the following: we are the West, and in the West we understand that we

are those who maintain and continue cultivating the high western values of yesteryear. And these values are neither in Russia nor in the United States. There are certain values that were always ours and that we may refer to as the 'transcendence of art and the spirit.' We must maintain these great, transcendent values. It is not a question of reconciling Russia and the United States with this third force, but rather of making our own world with our own hands. . . . In two words: I call upon the Latin world to do its duty."[67]

Faced with the imminent danger of the dissolution of the colonial order, which would soon result in the loss of several of its colonies, the new French government was reactivating pan-Latinism: if the United States extolled the forces of capitalism, and the Soviet Union extolled those of communism, the French upheld the "forces of the spirit."[68] Faced with the new policies of dividing up the world, so visible in the traveling campaigns of diplomats and presidents who were surprising in their dedication to explain their respective programs, Latin American countries listened and tried to consider, with only relative success, the offers being made to them by the different world powers that shared the same basic assumption: that the continent was available.[69]

Concerned with the "forces of the spirit," Malraux also dedicated much of his stay in the country to understanding Argentine culture. In addition to having lunch with Victoria Ocampo at her home in San Isidro, he accepted the invitation of Rafael Squirru to visit one of the many locations of that peculiar museum without a home, which he had put together with the cooperation of a series of available galleries spread across Buenos Aires. The newspaper descriptions spared no details in demonstrating that Malraux knew how one should observe art. After sitting down on the floor, or walking in a circle around each work, depending on how each piece was best appreciated, and after commenting on the works and establishing hierarchies among the various artists, Malraux declared that "youthful Argentine painting exists."[70] In response to this statement, repeated over and over in the Argentine press as if to certify that a goal had been reached, Llinás launched his own arguments. Llinás concentrated primarily on the advice Malraux had volunteered, specifically, that "this painting that represents the South American avant-garde must venture out into the world, it must be shown and it must challenge the great critics."[71] This advice bothered Llinás, not only because of the skepticism with which it was viewed on the local scene ("always hoping to be 'discovered' by one of those distant princes who are responsible for all

that rises to glory in this world"),[72] but also because of the intentions he perceived lurking behind the trip itself and the words of this cultural diplomat: "Does Mr. Malraux really know 'Argentine painting?' Or could it really be that, in his haphazard perception of certain canvases, what produced his surprise was simply the apparent or real level of his effort? But we are surely mistaken. It was necessary for an 'illustrious Frenchman' to discover us, just as an 'illustrious Spaniard' discovered our estuary and several 'illustrious' North American corporations daily 'discover' our oil."[73]

The points Llinás focused on in this article were significant. His arguments were intended to refute comments made by Squirru who referred to Llinás as the "captain" of a group "whose gaze is set on the refined Europe." In response to this, Llinás defended the internationalist model with which he was aligned: "To try to define the admirable and dangerous experimental activity of the painters of 'Phases' through a generic and hasty allusion to the bourgeois myth of 'European refinement,' is ingenuous and symptomatic. Our gaze is set on the world, on a world without borders whose destiny is our own."[74]

A second point in his argument that deserves attention, which also formed part of the aesthetic of Phases, was the attack on "rhetorical geometry" as well as "informal libertinism" or, as he reiterated, on "all substitutions for creative adventure by mere confection, be they products of the compass or the mortar and pestle."[75] Faced with the new optimism regarding the values of Argentine painting, which energized the rhetoric of the critics and stimulated the awakening of interest in art appreciation among certain "evolved" sectors of the upper middle class, Llinás declared:

The time has come to admit, with respect to the great achievements that punctuate the history of art since the beginning of this century, that "Argentine painting" could not have contributed less. The analysis of why this is so can be left to sociologists and psychologists to figure out. But the fact itself is undeniable. So undeniable as is, for example, the outstanding role played in these same achievements (especially in recent years) by North American painting.

Isn't this hope of universally rehabilitating the supposed values of our painting a symptom of our capitulation to the *large corporations*? Or is it that with our approach to art, so purely aesthetic and well-crafted, that we may try to gain an outstanding position on the subaltern level, with *hard work as our battle standard*? . . . Wouldn't it perhaps be more important for us to commit ourselves to elevating

our level, to seeking a greater and more transcendent understanding of what, in 1960, the activity of a painter or a poet really means?

More important than an analysis intended to determine whether or not there exists a supposed "Rio de la Plata painting" by comparing color ranges and their relation to the quality of light in this part of the continent, we should, in our view, try to set into motion a profound feeling for the present moment, and a creative mechanism for honestly expressing it, free of the pitiful conquests that condition and implant a "chimera of success." *Active* participation in the artistic mainstream must be encouraged not by the brilliant assimilation of what was done *yesterday*, but rather by an impassioned commitment to the extraordinary adventure of psychic creativity, and by means of a language without borders that will convulse and transform the lethal values of this planet we call Earth.[76]

Contradicting the optimism inspired by Malraux's statements, in addition to encouraging numerous institutional initiatives, Llinás's response was that the task had yet to begin. His reasoning had the tone of a summons to creative authenticity, a quest for a groundbreaking and profound form of expression. But rather than this analysis, whose terms did not succeed in setting out a specific plan, what is most interesting in his commentary is his rejection of the obsession with success that he recognized in many of the public figures of the moment, particularly Squirru. In his criticism, Llinás emphasized the messianic component that led many of the cultural actors to deny the reality of the situation.

Llinás's reaction was not only against Malraux's words, but also against the informalist explosion that had been unleashed a year before in Buenos Aires. Whereas in the first issue of *Boa*, Jaguer had referred to the great "informal storm" that could been seen in European art and the "repeated libertinism of colored blotches," which were nothing more than "pure mechanical discharges" or "the pious externalization of a new intellectual comfort," José Pierre's article, included in the third issue of *Boa*, provided the names of those people who were responsible for this new plague assaulting artistic language. The best examples of this confusion were to be found in Hantai and Mathieu, whose paintings Pierre did not hesitate to classify as "authoritarian," and he complained that "what has died or, at least, what has reached the point of total saturation of its expressive possibilities, is the idea of 'informal,' to use the catchy vocabulary of Michel Tapié."[77]

Presented by the Bonino Gallery with an abundance of paraphernalia and a catalogue that included a virtual battery of praise (from Clement

Greenberg, who said that he is "the European painter I most admire," to Malraux, who declared, "at last, a Western calligrapher!"), Mathieu showed Buenos Aires what his concept of art was: to paint a lot and to do it quickly. In a "pedagogical" demonstration for the students of the art school Bellas Artes Manuel Belgrano, he produced his enormous canvases in one sitting.[78]

The Exploration of Materials

Artists who entered the artistic milieu after the fall of Perón could sense, in public speeches as well as in the concert of coordinated institutional initiatives, the imposition of a requirement. If Peronism had implied isolation, which for liberal sectors translated into backwardness, what was necessary now was to update: to bring to the local scene all that which, since the end of the war, could not be viewed in Argentina. Paradoxically, the end of isolation, which the discourse called for as if by decree, and the requirement of a new and high-quality art form that could be measured in terms of the restructuring of the cultural scene, placed artists in a difficult situation. The current openness and receptivity of the institutions toward what was considered "new" suddenly implied ignoring what had formerly been the true test of avant-garde artists: not being understood by the artistic milieu and being rejected by its institutions. Conditions were now very different from those in which abstract groups had worked under Peronism, without international information and without broad official recognition. These were adversities that, at the same time, had provided a sense of security in the knowledge that they were headed in the direction of a true avant-garde. The new conditions, which required that artists find new forms that were also accepted and recognized as avant-garde by the institutions, confronted them with a paradox that, over the course of the 1960s, would become increasingly complicated to the point of being unsustainable.

What were the strategies that could be employed to develop a new language? What was, in Raymond Williams's terminology, the "selective tradition machine" that guided their choices?[79] What images did they see, how did they see them, how did they modify them?

Given the new availability of options implied by this openness toward the international world and the liberty to establish and publicly confront its programs, artists began, almost compulsively, to import and translate the poetics of the postwar period. They also explored the possibili-

ties available to them and offered by the new materials now at their disposal thanks to informalist programs, experimenting with these options through the potentially revelatory technique of collage. The productive relation established between materials and practices paved the way for the stylistic experimentation that occurred in the 1960s.

For a culture of the image, generated by copies and few originals, as was the case in Buenos Aires, to import and translate were to continue a familiar practice.[80] The problem was how to be original without ignoring the repertory introduced by the international avant-garde, to which they were gaining entrance via a selection of images that operated in the same way as a library. In this machine of quotations and translations, certain figures played defining roles. Kenneth Kemble was extremely educated, boasting a double profession as both a critic for the *Buenos Aires Herald* and a young painter, and one of the few artists who spoke, read, and wrote in English, his native language. Kemble played a central role not only because of the international information he processed, but also because, to review artistic activity in Buenos Aires, he was obliged to know, compare, and evaluate what was being done in other places at that time. He had to take sides and, above all, discover the symptoms of change and—what everyone was waiting and hoping for—originality.

In contrast to what artists experienced in the past, they were now expected to produce exact copies, quotations, and translations of the very latest—the most current works of the avant-garde. If Argentine artists had made the wrong choices up to then, which critics had repeatedly evaluated as anachronistic and out of step, then it was now essential not to repeat the same mistakes.

The exploration of nontraditional materials presented the possibility of introducing more immediate elements of the present reality into local art spaces, playing an important role in the translation and the subversion of originals that were observed in magazines. Successive shifts gave way to gradual transgressions of the poetics that served as points of departure. At the same time, and directly related to this climate of compulsive exploration being promoted by various discourses (of modernization, progress, updating), a space was generated for debate and intense exchange between artists who were starting to function as a group, creating a dynamic space for the bartering of ideas where the discoveries of one artist were incorporated into the materials and solutions of another. Kemble described, with great clarity, the results of this new dynamic wherein the artists departed from the work of international artists and were inspired "one from

another . . . Thus producing, perhaps for the first time, a phenomenon of cultural and creative self-sufficiency."[81]

After 1957, when the Asociación Estímulo de Bellas Artes (Association for the Stimulation of the Fine Arts) presented the exhibition Qué cosa es el coso (loosely translated, What a thing is the thing!),[82] the use of "disagreeable" materials became an increasingly viable option. Resources not previously considered legitimate, such as tar, flour, feathers, and coins, were now mixed to produce a series of paintings and collages that recalled the dadaist repertory. Between 1958 and 1959, with exhibitions of the informalist group and other artists such as Kemble, Alberto Greco, Luis Wells, and Antonio Berni, materials such as rags, mops, nails, sheet metal, and burlap inundated the surfaces of works of art, as the artists sought to find the key to whatever could be considered "new."[83] Paradoxically, this new period, to which everyone wanted to contribute a repertory of more adequate forms to represent it, was at first expressed on worn-out canvases and rusty sheet metal. The materials and plastic forms of expression were borrowed more from European informalism than from North American abstract expressionism. Within this tendency the most recurrent influences were those of Burri and the Spanish informalists (especially Tápies), whose crowning moment in Venice had placed them at the center of the international art scene.[84] Burri was replicated by Kemble, Tápies was replicated by López Anaya; as copies of copies (as soon as the works appeared as reproductions in the magazines), the images of European informalism were transplanted to exhibitions in Buenos Aires. These productive conditions, according to Luis Felipe Noé, produced a series of confusions that had to be corrected as soon as they were compared with the originals; the layers of material and the depth of the reliefs could only be guessed at in the reproductions.[85]

The exhibitions of the informalist groups were attacked, first because they were not considered as having produced the highly anticipated "new thing" that everyone had hoped for. They had followed the wrong path, a regressive path, which was nothing more than an out-of-step reference to dadaist irreverence, which had never enjoyed much recognition in Buenos Aires anyway.[86] Second, and perhaps most significantly, the practice was seen as counterproductive insofar as it attacked the concept of form and composition. The dominant view was that if this was accepted, anything would be accepted, which implied abandoning conquered territory to replace it with a lawless direction in which everything—that is, anything—would have value. This was not viewed as the kind of quality

art that would fulfill the plan for the modernization and international recognition of Argentine art that everyone wanted. It was not serious enough to achieve these goals.

The exhibitions became spaces of discovery, even for the artists themselves, due to the pace at which the shows were held, and the number of artists included. There they could see how others were using similar materials in order to apply the new techniques in their own work: the cardboard tubes used by Luis Wells could also be seen in Kemble's work (*Homenaje a Luis Wells*, 1962) and in *Mordazas* (Gags) by Santantonín;[87] both Kemble and Greco used common kitchen towels in their work. Gradually a *productive machine* was organized in which the discovery of materials and formal solutions were exchanged, reproduced, and superimposed with such intensity that it was soon difficult to know what originated with the European avant-garde and what came from this experimental laboratory that had emerged in Buenos Aires.[88] An eloquent example of this is the relation that could have existed between the pieces of sheet metal Kemble used in his *Paisajes suburbanos* (Suburban Landscapes, 1958; plate 2) and those used by Berni in his *Juanito Laguna* series. A relation in which, as we shall see, the points in common were less striking than the differences.

Kemble's idea was to use materials he had found in the slums of Córdoba to create a new expressive art form and to "show on Florida street an Argentine reality that should concern us all."[89] This was not the same as Berni's idea, which was the intensification of a long-explored theme (the environment and conditions of poverty), using materials that functioned simultaneously as compositional elements and as evidence. Furthermore, the theme, as it was explored by Berni, did not reside exclusively in his images. In 1957 Bernardo Verbitsky published *Villa miseria también es América* (The Slum Is Also America), a book in which he described life in a slum, the forms of organization, solidarity, conditions for subsistence, and the irreparable social consequences. The word and the image operated simultaneously in this exploration of the new conditions for a transformed Argentina. After the process of postwar industrialization, a new wave of immigration was produced (in Latin America, but not Europe) and an intense migratory process shifted the population from rural areas of Argentina to the belts of poverty that sprang up around the cities. Nevertheless, Kemble's investigation did not explore the same repertory of elements as Berni's; his principal concern was with materials more than with the theme itself.

The distance between Kemble and Berni is the distance between the fragment and the complete narration. This is the most visible distinction between the transgression of Kemble with respect to Berni, and it also afforded Berni the possibility of choosing from what was offered to him by the new artistic panorama (both from Kemble and from the way new materials were used in European art),[90] radicalizing his themes in the story of Juanito Laguna which he presented in the Witcomb Gallery in 1961.[91] These techniques reappeared in the glued, folded, and stretched fabrics that Kemble took from Burri and that Jorge de la Vega took from both in order to use them, in turn, in his fantastic narration *Esquizobestias*. But these consequences were superficial and could only be visualized at a distance. At this time what spread like a veritable informalist fever and what quickly dominated the Buenos Aires artistic scene was the degraded and sugarcoated version of the European models. As Alberto Greco emphasized, the first stages of informalism did not take place as the restorative movement he would have liked to initiate: "When I arrived from Brazil, my dream was to establish an informalist movement that was terrible, strong, aggressive, against good manners and formalities. What took place was the worst of informalism: decorative, easy, that which cannot be seen a second time."[92] Greco and the artists belonging to the first avant-garde group of the 1960s turned against this domesticated informalism that invaded the galleries and the market.

3

THE "NEW" ART SCENE

As a result of the process that began a little more than 30 years ago, the Argentine plastic arts are on the threshold of acquiring an "international dimension," a characteristic that is not necessarily the result of an improvement in the quality of its latest works, but rather of favorable, extra-artistic conditions that hold true for the moment in this country. — Hugo Parpagnoli

As we have seen, from 1956 to 1960 Buenos Aires entered a period of dynamic change on the artistic scene, marked by moments of tension and rupture that could be measured in terms of the images generated as well as the institutional initiatives that reorganized the local art scene. Both the images and the initiatives were transformed by gradual rifts that only became clearly evident at the beginning of the 1960s. In this moment the term *internationalism* changed meaning. Whereas for concrete artists and the sectors that banded together around the magazine *Boa*, it had meant forming part of the so-called modern art international and uniting with forces beyond national borders, in the early 1960s internationalism was perceived as a project aligned with the official scene, as defined by the private sector and state institutions.

Whereas the organization of exhibitions abroad had been among the first initiatives of the Revolución Libertadora, with the objective of breaking out of the isolation that had prevented Argentine art from being seen on international circuits, now a difference was established that was more than a tentative step forward. The concern that immediately motivated

the majority of institutional initiatives was one that consisted in gaining recognition for Argentine art abroad so that it could act as representative of the "new" nation coming to life.

How did this shift in orientation take place? What produced this displacement of emphasis from the utopian aspirations of an experimental avant-garde, capable of visualizing the forms of a new sensibility in the making, to a more pragmatic one, linked to the more immediate interests of a State seeking forms of recognition in those areas deemed necessary for its projects of economic development? At what precise moment was a term like internationalism redefined to be understood as a form of nationalism intended to be effective on the international scene? What were the institutional and artistic programs that led to the implementation of these projects?

Together with this shift in orientation, new institutions also emerged. Although the activities of artists in preceding years had not succeeded in producing a rupture to the degree desired, nor the inaugural moment they had hoped to provoke, institutional initiatives had also failed to be more efficient. Inasmuch as the institutions reorganized by the Revolución Libertadora were still not completely established, they were unable to give immediate form to the project they had formulated and were only able to do so in a convincing way at the beginning of the following decade. In 1960 the institutional framework that had gradually developed over the previous four years proclaimed its existence with a spectacular show of fireworks: the Museo Nacional de Bellas Artes (MNBA) and the Museo de Arte Moderno (MAM) celebrated the year with exhibitions that were intended to summarize the nation's artistic development and compare it with other currently outstanding figures on the international art scene. Several foundations and private corporations joined in with the spirit of this revival that the official institutions had generated, implementing unprecedented forms of organization in Argentina. The Torcuato Di Tella Foundation and Kaiser Industries developed strategies that, although different, shared many of the same goals, especially those related to the internationalist project.

In this complex scenario with its unusual mix of elements, where institutional initiatives and forms that represented themselves as avant-garde had been established, not only is the degree to which these dynamic forces worked in cooperation surprising, but the distance they kept from the immediate political and social situation is especially remarkable. It was a situation whose statistics were not nearly as promising as the

rhetoric generated by all these activities would have had us believe. In 1959 the expectations generated at first by the Frondizi government were practically wiped out. Leftist sectors that had supported anti-imperialist positions regarding oil policies, and that had seen in Frondizi the possibility of combining national and popular interests, felt "betrayed" by the swing to the right that characterized the economic program implemented as part of the Stabilization Plan at the end of 1958.[1] At the same time, the government's commercial appeasement of the socialist block emphasized the opposition of both civil and military anti-communist sectors. At a time when the United States was starting to demand support for, and solidarity with, its opposition to the Cuban Revolution, Frondizi's meeting with Che Guevara in August 1961, his agreement with President Janio Quadros and, above all, his vote of abstention at the Conference of Foreign Ministers in Punta del Este, at which Cuba was expelled from the Inter-American system, were all elements that did not satisfy North American requirements.[2] Nor did they satisfy the requirements of military, anti-Peronist, and anti-communist sectors in Argentina. All of these elements, together with the victories of various Peronist candidates in provincial elections, combined to destabilize the Frondizi government. On March 28, 1962, the armed forces deposed Frondizi who, in an attempt to preserve constitutional continuity, organized his own replacement by the president of the senate, José Maria Guido.[3]

In July 1961 the magazine *Sur* published a remarkable issue with contributions from thirty political, military, economic, and cultural specialists. This special edition was intended to provide a "history and evaluation of thirty years in the life of a people—from 1930 to 1960—in terms of its principal aspects."[4] The articles were very illustrative of how each author understood the current situation in Argentina. Two cases are exemplary in this respect. The first essay in the publication, by Tulio Halperín Donghi, is permeated by a suspicious tone toward the Frondizi government's promises for development and the actual directions pursued. In contrast, the article by Hugo Parpagnoli on the visual arts expresses great fervor and enthusiasm.

In his identification of the active forces in the country, Halperín Donghi reconstructs the dynamic at work between Frondizi's promises for future development, the opposition forces of Peronism, communism, and the armed forces. In Halperín Donghi's view, it was a dynamic of conflicts that represented a constant threat to the political equilibrium of the nation. This author's distrust of the development plan predominates

his view of the situation which, as declared by Frondizi in the second stage of his government, was based on three tremendous concessions: "Our future prosperity will have the same humiliating and bitter taste as our current situation of hardship: meekness, resigned acceptance of a position in the Western world not of our own choosing, a world that Dr. Frondizi continues to see (and now seeks to become part of, whereas before he examined it with a hostile eye) as governed simultaneously by the Vatican and the United States. In that prosperity, under the guise of meekness, they hope to find a way out of the political problem faced by their group, which is also the problem faced by this country."[5]

In contrast to this critical view of the current situation, the article on visual arts by Hugo Parpagnoli, included in the same volume, selected information from the current artistic panorama and interpreted it enthusiastically and optimistically as a function of the internationalist project:

1960 has been a decisive year, indicating that the "international dimension" of Argentine plastic arts has arrived at a threshold.

The 1960 season began with echoes of André Malraux's visit still resounding along Florida street. We heard this keen and intelligent critic say: "Brazil has architecture; Argentina has painting . . ."

In the same year another outstanding figure arrived in Buenos Aires, José Gómez Sicre, plastic arts director of the Unión Panamericana . . . Gómez Sicre gave several press conferences, visited several studios, made prudent and general statements, vouched for the quality of what he saw and went away with very good memories. . . . a little later there was a veritable festival of painting at which the foreign star was Lionello Venturi who arrived in the country in September to participate, along with Jorge Romero Brest, as jury member for the Di Tella Award. As they said in those days, this was the first award that could truly be considered an award for artistic production.[6]

For Parpagnoli, the fact that Malraux, Gómez Sicre, and Venturi had appreciated Argentine painting, in addition to the fact that, from that moment on, the Di Tella Institute would organize the annual presentation in Europe of an Argentine artist "accompanied by excellent publicity that will not permit, in each case, that the artist's presence go unnoticed by Europeans,"[7] were all elements that inspired him to propose a set of strategies to guarantee the success of Argentine art abroad. In his view, if the corporations joined their forces, if they proceeded intelligently and made good use of their contacts, if all this artistic activity were disseminated in the best visual arts magazines of the world which, "for the mo-

ment," were not Argentine magazines, then "the international dimension of Argentine art will be assured."[8]

To these extra-artistic conditions, the critic added others that were related to the state of the visual arts in general: a total command of abstract art which, because of its standardized repertoire of forms and colors, would be capable of eliminating national differences, together with the use of new materials that would also influence the unification of artistic language (such as reinforced concrete, plastics, industrial pigments, "international materials, without local color"), thus creating favorable conditions for the urgent, and apparently inevitable, internationalization of Argentine art. According to this view, desire implied ability. All of this enterprising resolve, which seemed to transpose theories of economic development to the artistic field, nonetheless required a decisive element that the Argentines could not exclude from their calculations: "The birth in these lands of a brilliant artist, because this, alone, would give rise to brilliant art."[9]

Many of the postulates of development policy were applied to the policies for artistic promotion. In both areas it was understood that evolution obeyed certain laws and there were ways of establishing those laws. The line of reasoning that could be read between the lines of Parpagnoli's text postulated that, just as it was necessary and possible to reverse the deterioration of the terms of commercial exchange between commercial centers and the peripheries, this could also be done in the area of culture. The "dramatization" of economic and social change that characterized development policy, as indicated by Carlos Altamirano, could also be found in the cultural programs related to the dynamic of artistic institutions.[10] Both explanatory models shared the idea that backwardness affects not only the economy but also culture and art. Having diagnosed the situation and having indicated the strategies for effecting a transformation, it was necessary to act quickly. In this context, Guido Di Tella, evaluating the leap taken by Argentine art during the 1960s, delivered a particularly eloquent interpretation of the situation fifteen years after the closing of the Visual Arts Center. "We took up impressionism when it was finished in Europe; we did cubism a couple of decades later, but we did geometric art only a little later and some say we did it a little before Europe; informalism, two or three years later and the pop movement two or three hours later."[11]

On the other hand, from the perspective of the development policy model, to achieve a structural change it was not only necessary to attract

international capital, but also to act quickly.[12] This acceleration of historical time can also be observed in the coordinated institutional programs for the visual arts at the beginning of the 1960s. The idea that institutional intervention could produce changes in the quality of Argentine art, as well as contribute to its insertion into the international art scene, was one of the linchpins of the policies for artistic promotion organized by private institutions established at the end of the 1950s.

Viewed in the context of these policies, which operated in several spheres of society, the trip Guido Di Tella took in March 1960 to complete his father's art collection takes on additional significance. In Argentina, as evidence of the instability and crisis that characterized the national political climate, the government was implementing the Plan Conintes (*Conmoción Interna del Estado*, or, loosely translated, the Internal State Disorder Plan), which was intended to counter and suppress terrorist attacks through military action. Meanwhile, Di Tella hurriedly left the country to carry out the purchases that would enable him to present his collection as the most contemporary in all of Argentina and, probably, in all of Latin America.

Journal of a Collector

In 1960 Guido Di Tella did not consider it a high priority to make up for the predictable gaps and discrepancies of his father's collection, one that had been put together in Latin America and that, in addition, covered an excessively broad period of European art. However, when he presented it to the Argentine public, he did deem it absolutely necessary that his collection include a selection of works that were outstanding for their contemporaneity. This necessity and sense of urgency help explain why, in March 1960, the young entrepreneur visited some ten art galleries in London, Paris, and New York, keeping a schedule that resembled more that of a business trip than one of pleasure, as would have been more appropriate for the contemplation and acquisition of works of art.[13] The urgency to complete the collection was not a simple matter of personal whim. It was a unique situation, and the opportunity to present to society a collection that lived up to the expectations brewing among the cultural and political circles of the nation could not be wasted.

In 1958 Di Tella had returned to Argentina after finishing his graduate studies at the Massachusetts Institute of Technology. He began to work in the management of the family business as well as in the organization

of the Torcuato Di Tella Foundation, which opened on July 22, 1958, exactly ten years after the death of Guido's father and was founded in his memory.[14] In that year Guido Di Tella's activities had reached a feverish intensity that not only reflected the values that had guided his father, Torcuato, but also a new set of goals that were quickly taking shape between 1958 and 1961 until they acquired the form of a clearly defined project in 1962.

The foundation had a modernizing mission based on the certainty that it was possible to transfer development policy objectives from the economic to the cultural sphere. The principal concept was that culture, together with the economy, could play a transformational role. What was implicit in his institutional project was the basic postulate that if the necessary material conditions were set up, the quality of the cultural productions could be raised.[15] From the perspective of sectors committed to the development myth, the transformations in art were not anticipatory of a transformation in the current situation, but rather were oriented toward symbolically representing a situation that was already in the process of transformation. At the same time, however, culture played an important role in the process of national development. Inasmuch as avant-garde art was a symptom of an advanced society and economy, these images could function, to some degree, as a letter of presentation that could also yield benefits in the economic sphere.

In this sense, it is interesting to consider the degree to which statism, which characterized development policies, also permeated cultural policies.[16] Just as the State intervened in the planning of the economy, it also organized artistic institutions, which at first and under certain conditions, was not a problem. Provided the State did not intervene with preestablished poetics and practices, as in the case of postrevolutionary Mexico, its activities did not represent a danger.

Accordingly, Di Tella slowly and deliberately developed his cultural project, considering it of the utmost importance to complete and update the collection. To this end, Guido continued to consult with the Italian critic, Lionello Venturi, whom his father had chosen as a consultant when he first began acquiring works.[17]

Venturi and Torcuato had met during the war years. At the time, Di Tella was financially supporting antifascist groups of North and South America and, like Venturi, he was a member of the Socialist Party and opposed communism.[18] Venturi, for his part, was an internationally recognized art critic whose books were widely circulated in Buenos Aires.[19]

In 1943 the Torcuato Di Tella collection included some medieval and Renaissance works, but only attained a degree of continuity beginning with the Impressionists. Venturi evaluated the collection in a short text, affirming that it organized a historical sequence beginning with the painting by Manet, *Portrait of Monsieur Hoschedé and His Daughter* (1875), in which, according to the Italian critic, one could perceive "the entire future of impressionism, with its unfinished quality, its rapid succession of images, its consequent intensity, and the light effects derived from the use of chiaroscuro."[20] The historical sequence was the classic succession of those artists who had contributed different elements to the canon of the modernist paradigm: Pissarro, Sisley, Cézanne, Renoir, Degas, Gauguin, Matisse, Kandinsky, Rouault, Klee, Picasso, Modigliani, Sironi, Chagall, Morandi, Miró, Henry Moore, and so on.[21]

Collecting these images implied the appropriation of European cultural capital and its transportation to these new lands where Torcuato Di Tella had chosen to establish his financial empire. His concern was that his collection should be considered important and, to this end, Venturi advised him as to how he should organize his purchases: "I'm convinced that, given your present situation, you should acquire any famous work, but you should only concentrate a large investment in one single painting. Furthermore, as a matter of making a wise financial investment, I think this is the best thing you could do. If, for example, we made a three-year plan to spend about fifty thousand dollars per year in order to obtain one painting of each painter, Van Gogh, Rembrandt, and Greco, I have no doubt that your collection would not be very remarkable. I think you've been very fortunate to have bought the Renoir and the Cézanne, the Perugino and the Tiziano, for well below their value. But for the 'major works' you can't be so fortunate."[22]

"Good and cheap" were not criteria to apply to art. If the industrialist wanted his collection to represent the empire he was organizing, he had to be willing to spend money. However, with the death of Torcuato Di Tella in 1948, this streamlining plan to improve the efficiency of his spending was placed on hold.

The family decided in 1951 to continue with the project of the collection and with the advice of Venturi.[23] In May of that same year, Di Tella's widow and her children visited Venturi in New York. Through the ensuing mail correspondence she related her difficulties in allotting large amounts of money to acquire important works of art.[24] She also described her children's enthusiasm for art ("I'm very happy to see that the children are

so passionately cultivating the artistic inclination of Torcuato!")[25] especially in the case of Guido: "Just imagine how my son, Guido—who has the same enthusiastic character as Torcuato—dreams of nothing but the catalogue of our collection!"[26]

Nonetheless, the acquisitions were not made at a regular pace during those years. With the exception of a Marino Marini in 1954, the majority of the purchases were made in 1960 when Guido organized his tour of important galleries. In 1959, from March to December, the correspondence between Venturi and Guido Di Tella was very intense and permeated by the enthusiasm that the young heir expressed for each acquisition. On March 17 he wrote to Venturi about his decision to complete the collection with paintings by contemporary artists: "I'm writing to you about the plan to acquire important paintings by contemporary painters. I emphasize the word important because I think it would be better to buy fewer paintings of real value, than to buy more works of only secondary status."[27] Di Tella was referring to a list of "five names that would survive the contemporary movement" which Venturi had drawn up, including Picasso, Braque, Chagall, Rouault, and Matisse. His intention was to incorporate works by these artists into his collection as well as works by other artists not included on the list, such as Léger, Mondrian, Miró, Klee, and even some younger artists who had not yet been established, such as Vasarely, Manessier, van Dongen, and Dubuffet. "As you can see, I need to reorganize my ideas a little and so I ask you to orient me with your advice, which has always been of great value to us."[28] Together with this childishly enthusiastic confession, Di Tella reiterated his decision to publish a catalogue as a tribute to his father. In his response, Venturi added other names to the list of young artists—"the most important in the world"—such as the French artists Bazaine, Wols, De Staël, Fautrier; the Italians Afro, Corpora, Santomaso, Vedova; and the North Americans Pollock, Kline, and some residents of the United States, such as De Kooning and Gorky.[29] The letters, containing Di Tella's requests for advice and Venturi's responses, were constant and separated by only a few days, highlighting Di Tella's hurry to finish the collection. Why was he in such a hurry?

In addition to the added significance implied by its marking the beginning of a particularly promising decade, 1960 was also a historically remarkable year for Argentina. The celebrations of the 150th anniversary of the May Revolution were carried out in several forms, one of which took place in the privileged space of the visual arts. For the young Di

Tella, in charge of a corporation that was trying to be a central force in the transformation and industrial development of a budding nation, it was important to present the collection at that precise moment. The year 1960 was one of celebrations that were particularly special in the area of the arts, with large exhibitions organized by the MNBA and the MAM. To this concert of images, intended to demonstrate what had already been accomplished in, and to project the future for, the national art scene, Di Tella wanted to add his own contribution by making his collection public and becoming active with programs oriented toward promoting the definitive modernization of Argentine art.

In March 1960, when Di Tella went on his whirlwind buying spree, he had only completed the part of Venturi's list that contained the Italian artists—Emilio Vedova, Antonio Corpora, Afro, and Santomaso. Following the Italian critic's advice on the European leg of his trip (through London, Paris, and Switzerland), over the period of one year he acquired paintings by twenty-one contemporary artists.[30] The highest prices he paid were for paintings by Picasso (*Reclining Woman*, 1931, purchased from Louise Leiris Gallery in Paris for $80,000) and by Modigliani (*Portrait of a Young Woman*, 1917, purchased from the Louise Leiris Gallery of Paris for $60,000).[31]

From the original list, the painting Di Tella could not acquire as quickly as he would have liked was the one by Pollock. On repeated occasions he tried to buy it, without success, from Sidney Janis. The struggle over this painting deserves special attention. For Di Tella it was imperative to obtain this painting *before* the first public presentation of the collection, but he was not willing to pay the prices the North Americans were asking, nor were they willing to lower their demands.[32] On the other hand, the question did not seem to be a simple matter of money. The correspondence reveals that the New York galleries were not willing to sell an "important" Pollock to a Latin American, not even one who could pay for t.[33]

In February of that year, Bonino, who had powerful connections with the European galleries and had exhibited Italian, French, and Spanish avant-garde artists, tried to venture into the North American market. Bonino wanted to organize in Argentina a collective exhibition of new art from the United States and, to this end, he had entered into a partnership with Di Tella to purchase the Pollock. In a letter to Bonino, Di Tella described his interests, in order of priority, according to what he had seen on his recent visit to the New York galleries: (1) Tobey and De

Kooning; (2) Sam Francis, Appel, Baziotes; and (3) Guston, Albers.[34] "I think this could be a great opportunity to organize a large collective exhibition of North American art in Argentina, as well as for you to conduct some prestigious and profitable business transactions, and for me to acquire paintings at, I won't say reasonable but, at least, less unreasonable prices. As you can see, I can't manage to do this with my businessman's instinct."[35]

What this correspondence reveals is that, at the beginning of 1961, neither the North American galleries nor the institutions were interested in showing their artists in Latin America. No matter how important it was for the United States to demonstrate its world supremacy in the arts, the efforts made to this end at this time were not, in any way, comparable to those made immediately after the war to conquer the Europeans. To exhibit the new North American art in Brazil or Argentina was more important for Bonino and for Di Tella than for the North Americans. The work by Pollock that Di Tella finally managed to add to his collection at the beginning of 1961 was not acquired in a North American gallery, but rather in the Beyeler Gallery of Basel.[36]

At the same time as Di Tella was buying the work of new European and North American artists, he was also buying works by young Argentine artists from the Bonino Gallery.[37] Through these acquisitions he had managed to put together a collection of works that, albeit not very extensive, did have a clear sense of direction. It was a predominantly European collection in which there very few outstanding representatives from North America (Gorky and Kline), Uruguay (Figari and Torres-García), and Argentina (Badii, Fernández Muro, Ocampo, Testa, Iommi, Sakai, and Pucciarelli). Of seventy-four works, twenty dated from between the twelfth and eighteenth centuries, and the rest dated from the nineteenth and twentieth centuries. The chronological order in which the list of works was published, according to the birth dates of each artist, offered an additional significant element: the youngest artists, who appeared at the end of the list, were all Argentines.

Coming Out in Society

Di Tella's strategy of exploding onto the Buenos Aires cultural scene was not only implemented through the presentation of his art collection. At the same time, he organized an awards competition for painting as well as an exhibition of the work of an avant-garde artist who, following the

advice of Venturi, was logically and predictably an Italian.[38] In addition to these events, Di Tella introduced and explained to society his newly organized institutional program, which from that moment forward, was to involve both the foundation and the Torcuato Di Tella Institute. The institute was in charge of channeling the funds administered by the foundation, all of which derived from the capital established by the original endowment.[39] At the same time, a number of research centers were also created, all dependent on the institute and dedicated to different fields. The first of these foundations were the Center for Economic Research and the Center for the Visual Arts.[40] The latter was intended to support national cultural projects such as the organization of a public gallery to exhibit the collection, to organize annual competitions for Argentine artists, and to exhibit the work of international avant-garde artists in Buenos Aires.[41] In conjunction with this project, plans were set to cooperate financially with the UNESCO program to conserve the ruins at Nubia, as well as to add an Egyptian art section to the public collection.

Inasmuch as the ITDT at this time did not have its own space yet, the Center for Visual Arts (CAV) began its activities at the MNBA, for which Romero Brest offered the use of the second floor. Di Tella was determined to carry out a task that, in his eyes, was his bound duty (not only was it important for his business, but also, and above all, for the country), thus he considered it necessary to coordinate the initiatives of various institutions, both public and private. Accordingly, he worked with Romero Brest in the Museo Nacional, and with Alfredo Bonino, participating financially in their projects, as we have seen above. For Bonino, Di Tella was a buyer, an associate, and a driving force behind his projects. At this time, not long after opening his new gallery in Rio de Janeiro, he sent Di Tella a letter informing him of his recent success: "I am writing to you because I am currently receiving critical praise and you, too, should share in it as you were one of the first to encourage me in this undertaking and to support my carrying it forward to this successful outcome."[42] Thus, the institutional network that Carlos Foglia had foreseen in 1958, and had tried to thwart by denouncing it in his book, had become a reality that was expanding and growing stronger day by day.[43]

The need to optimize all these efforts and to produce a real impact led Di Tella to plan the public presentation of the foundation as a triple extravaganza organized on the second floor of the MNBA: the exhibition of the collection, an awards competition for young Argentine painters,

and the exhibition of an international avant-garde artist (the informalist Italian Alberto Burri). In a letter written to Venturi on June 22, he refers to the organization of the awards competition and the transformational function it would play on the Buenos Aires art scene:

Please find enclosed photographs and pamphlets of six outstanding artists of the middle-aged generation. Three of these should not be invited, especially not Fernández Muro, Sarah Grilo, and Miguel Ocampo. They are considered very good painters in Argentina but work in the Argentine tradition of perfectionism and superficiality. Ocampo was in Rome for four years and did not assimilate any of the postwar tendencies. . . . Also, in Fernández Muro's case it is doubtful whether he is capable of assimilating any of them. So, we could invite three other painters, all of whom are about thirty years old and, in their cases, you would be inviting the younger generation, which is much more interested in current European tendencies and in whom the informalist tendency is more clearly visible.

Mr. Romero Brest has stated that in Argentina there is a certain tradition in painting, writing, and thinking that entails refinement, elegance, and discretion, but that we have very rarely been able to paint, write, or think, with conviction, audacity, etc. It is as if we were afraid to risk getting ourselves very deeply involved in what we are doing. Personally, I think that Romero Brest is quite right and that this can be confirmed in the case of Fernández Muro, where you will be able to observe technique of very high quality which, however, is not very profound. This is also the reason why the concrete movement has been so popular in Argentina and men like Max Bill, Vantongerloo, Mondrian, etc., are so well-known and admired.

If you approve of these procedures and criteria, then Romero Brest will select fifteen Argentine painters to be excluded, applying his own personal prejudices. I see no alternative to proceeding in this way, but I will wait for your advice before making a final decision.[44]

In this letter there are various interesting features. First, there are the models that Guido Di Tella considered important to follow in order to promote Argentine art. Whereas on the one hand he wanted to emulate the institutional example set by the North Americans,[45] on the other hand, with respect to artistic styles and despite his eagerness to acquire a Pollock, what he really wanted to introduce locally were the most current European movements and, in particular, informalism. This hunt for whatever was new in Europe did not necessarily mean that, for Di Tella, the Italian avant-garde was more important than the North American

avant-garde. Rather, at the time and because of the contacts he had made, it was probably easier for him to acquire works in Italy. There was simply greater availability of art for Di Tella in Europe.

It is also interesting to note Di Tella's observations on the conservatism of Argentine aesthetic tastes and the way in which he tried, basically with a businessman's mentality, to implement mechanisms to eradicate those tendencies that did nothing more than hinder change. On the other hand, Ocampo and Fernández Muro, who he felt adhered to the tradition of "perfectionism" and "superficiality" that was so characteristic of Argentine art, were among the six young Argentine artists he had included in his collection. This detail reveals a central point upon which he based his decisions and initiatives: a constant wavering between summarization and defiance. These artists, who were representatives of the middle-aged generation in Argentina, were apparently unable to assimilate the postwar tendencies, which Di Tella considered fundamental for bringing Argentine art up to date. For Di Tella, they lacked conviction and audacity. To make up for these shortcomings, it was necessary to find younger artists.

Finally, in referring to Romero Brest and his arbitrary views, it is clear that Di Tella felt that relying on Romero Brest was risky. But Romero Brest seemed to be the only person willing to participate in the project of radical transformation that Di Tella was so intent upon. Although the critic and the patron of the arts did not exactly share the same tastes in art, they did share a deep concern for lifting Argentine art out of its isolation and introducing it to the world.

The award for Argentine artists served both a formative and prestigious function. As explained in the catalogue, the award consisted in a gallery exhibition in Europe or the United States—that year the exhibition would take place in the Pogliani Gallery in Rome—and the sponsorship of a one-year trip and residency in the city of the winning artist's choosing.[46] Confirmed as the best among local artists or, more precisely, as possessing the greatest potential, this artist would complete his or her studies abroad. However, rather than attending an academy or studio, the artist would have to live in the artistic milieu of the chosen country, mixing with the local artists and trying to show his or her work there. The grant was intended, therefore, to give the winner the opportunity to evolve as an artist abroad and, above all, to learn the secrets of an international career.

Before plunging into the adventure of announcing the details of the award to the press, Di Tella had to find out if there was a gallery that

wanted to show Argentine artists. The promise of a single-artist show was not a simple undertaking for an institution that was just beginning its activities. This explains Di Tella's preliminary inquiries with the Pogliani Gallery to see if it might be interested in exhibiting any of the artists that would be participating in the competition. To this end he asked Venturi to show some photographs to the gallery with which he was coordinating an exhibit of Burri's work in Buenos Aires. In this arrangement, in which the Pogliani offered its prestige and Di Tella offered his money to finance the venture, the gallery still wanted some kind of guarantee of the commercial returns. All of these considerations were addressed by Venturi in his letter to Di Tella on July 14: "Pogliani, who has notified me of Burri's willingness, wants to know if there is any hope of selling a painting, which is to say, whether you will choose to keep one of the paintings sent to Buenos Aires. If you make me an offer, a positive sign, this would help Burri make up his mind. With respect to the show of Argentine painters, I've examined the photographs and transparencies you sent me. Of course I can't give you a definite answer, but I found the works by Kasuya Sakai particularly interesting. I showed the reproductions to Pogliani who said that for those works, or others of the same quality, he is willing to arrange a show in Rome."[47]

This exchange of letters reveals the underlying interests motivating this complex institutional network. The search for new markets and prestigious spaces led the initiatives from one place to another according to the dictates of the rules for interchange. On the other hand, it is curious that, for all Guido Di Tella's interest in bringing the most current art to Buenos Aires, he did not realize that informalism had already arrived on the local scene, a year earlier, and that Burri—particularly Burri—was not an unknown artist in this milieu. Why did Di Tella attach so much importance to a style that Buenos Aires artists, for their part, already considered to be the cause of the stagnation and the epidemic of textures and fillers that stood in the way of the emergence of a genuine avant-garde, which they were all so intent upon generating? Most likely, the possibility of circulating *originals*, rather than those pernicious copies that were constantly being published in magazines, was a feat that was in itself considered important. The exhibit of Burri's work in Buenos Aires was sufficiently representative to bear out the significance of his contributions.[48] For Di Tella, the new styles (in this case, informalism) appeared to have a power that was comparable to a new technology, capable of revolutionizing a system of production. For this reason, he was concerned by

Romero Brest's resistance to this tendency which, it seemed, contradicted the Argentine critic's aspirations for geometric abstraction.[49] The fabrics and materials that the Europeans were employing in their work were external references to the flat surfaces of the canvas and they upset Romero Brest's ideal of the autonomy of language. Di Tella, fearful of the Argentine critic's attitude, explained his view of the situation to Venturi: "I am sending to you by airmail a catalogue of the exhibit being shown at the Museo Nacional so you will have information on these painters and so you can see what Mr. Romero Brest has written about them. I think Romero Brest has substantially changed his point of view with regard to the informalist movement subsequent to his recent trip to Europe. He is now very aware of the limitations of the geometric movement and I have hopes that he will take a similar stand to your own when evaluating the Argentine painters."[50]

Romero Brest's acceptance of informalism was a relief for Di Tella and, for the critic, represented the beginning of a process of change that led him to defend artists and works he would never have imagined recognizing as such during the 1950s when he was directing the magazine *Ver y Estimar*, or when he published his book *La pintura europea de este siglo*. As we will see, Di Tella's observations regarding Romero Brest foreshadowed a process of transformation in the critic's aesthetic system that would take place in the mid-1960s.

In this first competition, the winner was Mario Pucciarelli, an artist who had already received considerable recognition, who had lived abroad, and who, despite his youth, had established an identifiable image in accordance with the language of informalism (particularly Italian informalism). Furthermore, he was an artist who spoke English and Italian, which could not have positioned him better for taking advantage of the opportunity offered to him and from which he appeared eager to reap the benefits. In this context, the artist's sense of mission upon receiving this award is noteworthy. His correspondence with Guido Di Tella in 1961 and 1962 reflects the degree to which Pucciarelli tried to convey to his benefactor the commitment he had assumed, which consisted, fundamentally, in opening the way for other Argentine artists. After informing Di Tella of his plans to show his work in Rome (at the Pogliani Gallery), New York, Paris, Israel, India, and Mexico, he declared, "I have to program everything and I have to develop this plan which will have repercussions for the careers of my Argentine colleagues. Fontana, Penalba, Kosice, and I

are forging a great breakthrough in the international panorama, and no one should have to repeat the bad luck of Torres García."[51] On the other hand, these letters also reveal the devastation Pucciarelli, who sensed that he represented a country that was on the brink of renewal and embarking on the path to progress, must have felt when he received news of the coup d'état that deposed Frondizi: "You can't imagine the depression I've felt over what has been happening in Argentina, which is truly inexplicable. It's caused me great pain to hear us referred to as 'the white Congo.' Most of the people I've seen only think about escaping the chaos and dedicating themselves completely to their own personal development in an attempt to keep alive the spirit of the 'new man.'"[52] Clearly, a military coup d'état was not good publicity for a country that was trying to show how it had changed, nor was it good for Pucciarelli, who was acting as the country's representative and emissary.

The new chapter that the CAV wanted to write on the development of Argentine art was becoming increasingly replete with new activities, boosting the ambitions of the original project. The 1961 awards competition implemented various modifications: it included the participation of two Uruguayan and two Chilean artists, and the single-artist show was no longer restricted to one European artist but also included an Argentine artist.[53] In this way, the initiative assumed a regional dimension and, at the same time, created a broader space for the recognition of Argentine art. Despite the doubts Guido Di Tella had expressed in his letters to Venturi, the work of the locally celebrated artist, Antonio Fernández Muro, was displayed alongside the work of the internationally recognized Spanish artist Antonio Tápies.[54] These exhibits, together with the latest presentation of the collection which now focused on twentieth-century works of art, all formed part of an exhibit at the Museo Nacional de Bellas Artes titled 4 evidencias de un mundo joven en el arte actual (4 Instances of a Young World in Current Art). The dominant criteria applied in these events were still European: a Spanish informalist artist was exhibited, and the only juror, in addition to Romero Brest, was again an Italian, Giulio Carlo Argan. The prevailing tendency continued to be informalism, in whose transformative powers Guido Di Tella still had faith. In a letter to Argan, he explained: "Professor Venturi's visit has undoubtedly signaled the beginning of a new period for Argentine art. Modern painting has become a problem for a vast sector today: principally, for those who simply didn't care, given that they were ignorant of the existence and importance

of the entire postwar movement. This movement will be noted, undoubtedly, in the greater liberty and security of our painters, distancing us from the danger of formalism, still present in the modernist tendency."[55]

While Di Tella still considered informalism to be a progressive and healthy style, the artists felt it had grown old and overused. Their search had already led them in new directions. The exhibits held in 1961 in various Buenos Aires galleries reflected these efforts of experimentation and discovery.[56]

In addition to the program that was implicit in the organization of activities by the CAV in 1961, the catalogue contains references to the friendly relations existing between the institutions and the avant-garde movement that deserve our attention. The text of the catalogue affirmed that the rejection of new tendencies by institutions and their unwillingness to exhibit the most current works of art had completely disappeared. Until then, the history of avant-garde art had been written with an emphasis on its constant rejection, which was considered proof of the transgressive and innovative character inherent to the idea of avant-garde art. Now the most current art was not only exhibited without difficulty, the institutions also promoted and praised it. Romero Brest explained this, emphasizing the new position occupied by the artist in society: "Snobbery? Perhaps, in some cases. But also recognition: such that the artist is no longer a 'marginal' being, living on the fringes of society, but rather a 'member,' sensitive and trained to notice and objectify in his work the constantly changing vision of man facing the world."[57]

But the question remains: To what degree can an avant-garde that is celebrated by the institutions still be considered a genuine avant-garde? This question, which no one clearly formulated, nonetheless formed part of the latent contradictions.

The First International Exhibition

In 1960 Rafael Squirru managed to complete several of his projects. The opening of the MAM was a mega-exhibition that occupied four floors of the building that also contained the Teatro General San Martín. The exhibition successfully brought together in one space the foremost figures in the international modern art world with those of the Argentine art scene. This event turned out to be a combination of elements that made Squirru feel that his aspirations of converting Buenos Aires into an important international center of art were becoming a reality.[58]

We know what this museum represented for Squirru. We know how much effort he had to exert all over the city to bring about the opening of the museum and to what extent he imagined it as a parallel entity to the MOMA in New York. What Squirru wanted was to repeat the success that the MOMA had enjoyed once the lights of Paris had been extinguished and the artists of the New York school had taken charge of relighting the torches of modern art. In his fantasies Squirru dreamed of doing something similar with his museum. However, for the moment, the reality was that all he had were the walls of a building that had been conceived as a theater, walls that were on temporary loan and that, to cover them, he had to resort to works of art that were also on loan. In the introduction to the catalogue, written in his characteristic messianic tone, Squirru interpreted these difficulties as auspicious signs: "Saint Ignatius of Loyola said that when the tasks he undertook would run into serious difficulties, it was a sign that he was doing something important because whenever one tries to honor the glory of God, the devil always interferes. This international exhibition, which is only a prelude to our future activities, has certainly had to overcome many difficulties in order to become a reality. An alliance of all the cultural forces active in this country has been necessary to bring this cause to fruition."[59]

Despite all the adversity, and obstinate in his conviction that constructing fictions was the way to create realities, Squirru managed to organize a spectacular opening, working only with what he had at hand. A year earlier he had sent invitations to the fourteen participating countries. Now he could proclaim to the press "the importance of fourteen countries sending works of art to this exhibition, thus demonstrating their good will toward Argentina, and without this country having to spend a single cent because the costs have been covered by the invited countries."[60]

Of all the international delegations, the one that gave definitive stature to the exhibition was that organized by the International Council of the MOMA in New York. The occasion was important: it meant the opening of a museum of modern art in an important city like Buenos Aires. Just as the MOMA had maintained a presence at the First São Paulo Biennial, it did not neglect to be involved with the emergence of an institution that was perceived as an ally of its own efforts. Nonetheless, delegations of North American art to Latin America did not become a regular policy until 1963. Thus the opening of the museum in Buenos Aires was an important event and, although the selection made by Frank O'Hara for the

delegation was not very broad, it did bring together important figures of the North American art scene: Franz Kline (*Requiem*, 1958, oil on canvas, 257.8 × 190.5 cm, col. Albright Art Gallery), Willem de Kooning (*Woman III*, 1951–52, oil on canvas, 172.7 × 190.5 cm, col. Miss Frances Pernas), Jackson Pollock (*Number 5*, 1950, oil on canvas, 136.5 × 99 cm, MOMA), and Mark Tobey (*Edge of August*, 1953, casein on wood, 121.9 × 71.1 cm, MOMA).[61] The *Buenos Aires Herald* praised the delegation and explained the ways in which it was important:

The four American painters presented in Buenos Aires for the opening of the Museum of Modern Art in Argentina next Saturday are very representative of the avant-garde movement that emerged during the Second World War.

The painters are Franz Kline, Willem de Kooning, Mark Tobey, and, finally, Jackson Pollock. Although all four are classified as pertaining to the "New School of North American Painting," each one possesses his own personal style. The movement these artists represent began in 1940 and received no real recognition until 1950.

Alfred Barr, critic and director of the Museum of Modern Art in New York, said of these artists, "They refuse to accept the conventional values of the society that surrounds them. They are not politically committed although their works are encouraged, praised, and condemned as symbolic expressions of what liberty signifies as a political attitude."[62]

"Success," "freedom," and "apoliticalism" were the main ideas that, according to this interpretation, North American artists maintained in their work and that could serve as an example to the artists and institutions of a young nation committed to the internationalization of its art.

However, Squirru overcame all these propositions by organizing this exhibition as a more powerful ideological operation than that represented by the North American delegation. With the display of images he organized on the walls, commingling the works of Argentine artists with those of the most outstanding figures of the international avant-garde, Squirru put together a veritable testing and proving ground. He wanted neither the public nor the critics to be able to avoid making comparisons. He wanted them to see, side by side, the work of the world's top avant-garde artists and the work of the new Argentine artists, and to feel obliged to draw their own conclusions. And the critics did not hold back. From the pages of *La Prensa*, Hugo A. Parpagnoli first explained (as he had already done in his article in the book published by *Sur*) the benefi-

cial effect that the new network of institutions could potentially produce for artistic creation: "Circumstances extrinsic to creation that promote and stimulate artistic creation, whether they be trips, residencies, studies abroad in countries that innovate movements and styles; the multitude of publications that keep the alternatives of artistic movements up to date in the large cities; worldwide organizations of critics, 'marchands,' galleries, art biennials and triennials; the interest shown by governments, public and private institutions for these activities; the grants, awards, et cetera; all of the above favor, in some way, everyone."[63]

All this organization had suddenly decreased the distance between Argentine and European artists. Another element that had bearing on this international comparison was the evolution of abstraction: "For the moment we refuse to declare whether it is an advantage or a prejudice. We have to admit that the suppression of local images has 'internationalized' the plastic arts."[64] Nonetheless, although the voyages, the circulation of information, and abstract languages had facilitated the blurring of national borders, in the exhibition of the MAM it could still be seen that there were "maestros" and "disciples": De Kooning and Macció, Tápies and López Anaya, Soulages and Sakai, Pollock and Del Prete, Tobey and Ocampo, Kline and Kemble, and so on. Of course, recognizing this did not necessarily mean admitting the superiority of the former over the latter: "Sometimes the work of the maestro is the better of the two, other times it is the work of the disciple that is superior."[65] Parpagnoli's final conclusions were illuminating and stimulating because he was able to point to specific artists as referents for those artists who did not seem to have referents (Clorindo Testa, Alberto Greco, Luis Felipe Noé, Alfredo Hlito). On the other hand, and with respect to the obvious relations that could be drawn between local and international artists, the history of modern art had demonstrated that to copy did not necessarily mean to lack identity: "A painting by Delacroix copied by Van Gogh will always be a Van Gogh."[66]

Parpagnoli's efforts to provide stimulating information for his readers highlights the need felt by certain sectors to identify the symptoms of what could be considered new and innovative. The exhibition, presented as "international," had not written its curatorial script in terms of a desire for interchange or a dialogue among peers. The ideological purpose of the exhibit had more to do with a form of *internationalism* that was understood as a *national mission*; an internationalism whose essence had to do

with redesigning the local art scene in order to achieve the emergence of a new national art. This was precisely the idea conveyed in the lofty language used by Squirru in his introduction to the catalogue:

This is not just another exhibition of paintings and sculptures; it is the realization of a national aspiration that, like everything that is genuinely national, has been born into the world accompanied by birth pangs. To speak of the Museum of Modern Art in Buenos Aires is not to speak of just another institution, it is a new palace meant for the new muse, it is the new home of the new man. . . . Generosity, courage, and tenderness are characteristics of the new man that are flourishing in the new art. The dangerous aspect of nationalism as been overcome in exhibitions like this one. The healthy aspects have been confirmed and indicate that all that is profound has its roots somewhere. The Argentine Republic, sufficiently mature to host this spiritual celebration in 1960, will overcome all obstacles in order to fulfill its noble destiny, as written in the stars.[67]

Nonetheless, despite Squirru's predictions and the efforts of Parpagnoli to hold up signs of hope, originality was not yet an outstanding feature in Argentine art. The history of art had demonstrated that only works capable of revealing themselves as new in the eyes of the world could conquer the international art scene. Squirru's exhibition provided a swift and dramatic view of the state of the situation, and the most immediate conclusions to be drawn indicated that there was much yet to be done: Argentine art may have brought itself up to date with the rest of the world, but it was still incapable of leaving its mark on the evolution of modern art.

The 150th Anniversary Celebrations

Whereas the first international exhibition had induced comparisons with, and evaluations of, the most recent artistic productions, the mega-exhibition of Argentine art organized by the MNBA to close the year was the great summing up of the entire national artistic evolution.[68] In contrast to Squirru, who had to struggle to find the space, the works of art, and the budget for his exhibition, without receiving much support, the exhibition for the 150th anniversary of independence from Spain was organized with a full year's anticipation and received the support of a special commission created by the national congress for this purpose (National Executive Commission for the 150th Anniversary of the May Revolution). Covering the period from 1810 to 1960, the show presented

an inventory of images in Argentine art organized in temporal blocks, each accompanied by an analysis that was the responsibility of a different critic or specialist.[69] In accordance with the festive nature of the national celebrations in general, the organization of the exhibition was presented as a celebration of Argentine artistic achievements up to the present. To this end, a system of "traveling exhibitions" was organized that, transported by trucks, traveled through all the provinces of the country over a period of several months.[70]

All the texts in the catalogue maintained a tone of confirmation and validation. Although Samuel Paz ended the catalogue with an essay that ventured a prediction on the future,[71] the general character of the texts was tightly restricted to certainties and documentation. The conclusion of the essay by Córdova Iturburu was, in this sense, very eloquent: for its "range and immediacy," for its "aesthetic and technical dignity," Argentine painting "is comparable to the highly evolved painting of countries with much more extensive artistic traditions than our own." In the last paragraph, he characterized the "exclusive" physiognomy that defined "the most outstanding aspects of what is best in our national identity": "These particularities—notable in our measured conception of form and our harmonious sense of color—are the consequences of a balanced, controlled, and tempered spirit whose evolution has been favored by the nature and benevolent climate that destiny has granted, at least in its dominant aspects, to our country."[72] Córdova Iturburu explained, as Hipólito Taine had done before him, that it was in reaction to this "harmonious sense of color" and against the "balanced, controlled, and tempered spirit" that the artists and even the institutions—such as the ITDT—now directed their energies in their efforts to discover what was new and innovative in their art. The attack on "good taste," "the finished surfaces," and the norms of "balance," was the objective upon which many of the early avant-garde artists of the 1960s concentrated their energies.[73]

A Plan for Success

Nothing should lead us to think that in 1961 the Argentine art scene was defenseless before the eyes of the world. On the contrary, the institutions were being reorganized according to a clearly designed project that, in its very formulation, functioned as a complicated line of reasoning whose purpose was one of persuasion. The process of redesigning the artistic sphere involved a sophisticated rhetorical apparatus whose initiatives

yielded discourses that, one way or another, inevitably repeated the same thing: Argentine art stood at the threshold of a world that was ready to receive it. Internationalism was a notion that, as such, did not have a precise meaning. The term was defined in a relational sense and supposed the hypothetical existence of an even exchange and interaction among those who ventured to use the term. What were fascinating were the arguments constructed by those who used the term as a cry of legitimacy in order to utilize its connotations for their own benefit. There were those who enumerated general characteristics to determine if a work of art was international or not. For example, Parpagnoli, referring to abstraction as the language of international art, had tried to do precisely that. However, for Argentine artistic institutions, to internationalize was a process that had to be brought about as part of a planned action whose realization required the previous persuasion of the actors involved.

In August 1961 Kenneth Kemble wrote the outline for a "Project for the organization of a traveling exhibit in the United States of the work of young Argentine painters and sculptors." The text is a paradigmatic piece for analyzing the degree to which the conviction had taken root that the critical moment for Argentine art had arrived. The institutions and artists, far from accepting that their peripheral condition was inevitable, were eager to permanently reverse the terms of exchange that, until then, had distanced them from the great centers of the art world. Kemble, as we have seen, was an educated artist who was extremely informed about what was happening in both the Argentine and international art worlds. He was very preoccupied with generating an avant-garde capable of positioning Argentine art at the great international centers. He prepared a project in which he explained, with surprising frankness, how an exhibition could be designed as an instrument that would lead to the success of Argentine art. He proposed an exhibition of young Argentine artists' work, accompanied by a steward capable of explaining all aspects of Argentine culture in recent years (music, literature, theater, dance, and film) that would tour a vast circuit of North American cities until arriving at its final destination, the new Mecca of international art, New York City. What interests me here is to outline the arguments Kemble used to explain why it was necessary to carry out this plan *now*. The arguments were founded on the premises that the work of these young artists was at a stage at which it was flourishing, it was "especially rich and varied," and the international situation was propitious: "If we wait any longer it is very possible that, given the international political circumstances, the

critical quarter of an hour will pass and we will lose this opportunity just as we have lost so many in the past. For example, it is now the moment to promote Pettoruti and Fontana. But we must do this intelligently and not by blindly improvising according to the more or less informed judgment of their agent or agents, the way we usually do on these occasions."[74]

However, even more interesting than Kemble's evaluation of the international situation were his arguments to explain why this exhibition was necessary:

1. We want to be better known and valued in the United States and we believe that this exhibition could be the beginning of a more active policy of cultural exchange than has existed until now. . . .

2. To demonstrate that in the Argentine Republic there is a strong cultural and artistic movement with evident Western and democratic roots and that it is in the midst of upheaval with plans for the future (here we should include a list of the names of exclusively young artists). In other words, that we are not a country that is as underdeveloped as is commonly believed, but rather a civilized people pertaining to an evolved Western culture, similar to them.

3. To also demonstrate that we speak a *universal* and *contemporary* language and that the quality and high technical level of our work—which can be compared to that of any of the important countries of the world—is indicative of a higher level of efficiency and responsibility in other spheres and activities than has been granted us until now.

4. To demonstrate that, just like the United States, Argentina, which is a melting pot of races and different peoples, also has the ability to assimilate these peoples and to extract from them the best they have to offer; and that, furthermore, it can be the refuge of all individuals of real value. Included on the list of painters there are 6 Italian names, 6 Spanish names, 1 Syrian-Lebanese name, 1 English name, 1 Japanese name, and 1 Irish name.[75] (And there should also be one Jewish name.) In this way we should earn the sympathy of the racial minorities, which are very powerful in the United States.

5. To demonstrate that in our country there is an effective collaboration between the initiatives of the private sector (Di Tella, Kaiser, Bossart, and Pipino y Márquez) and a government that is intelligent, alert, and up-to-date in its institutions (the Museum of Modern Art and the Department of Cultural Relations). The latter objective is of fundamental importance because North American investors are of precisely the opposite opinion.

6. To demonstrate that there exists, albeit quietly and surreptitiously (only the experts would be aware of it), a slight North American cultural and artistic influence in our country (Muro-Rothko, Macció–De Kooning, Kemble-Kline); and that, therefore—because of this supposed affinity—one could suppose that there is increasing closeness between our two countries. This could also be a way of playing upon North American vanity.

7. To promote, through informative conferences on works of art, the institution or corporation sponsoring the exhibition (Di Tella, Kaiser, etc.).

8. To demonstrate that a great corporation in Argentina can now enjoy the luxury of creating a prestigious and influential institution, or simply sponsor a cultural event, thus inspiring unlimited confidence in the economic stability and future of the country.

9. To create a North American tourist industry in Argentina. The market for Argentine art is inexpensive in Buenos Aires. Compare with the Mexican example.

10. To create a market for Argentine art in the United States, one of the largest buyer markets in the world.

11. To demonstrate in our country that Argentine art has universal appeal through the publication in local newspapers and magazines of positive criticism and commentaries that have appeared in the United States with respect to the exhibition. Thus, to create an awareness of the value of our art as well as a local market for it. In other words, to speculate on our local snobbery and fashion consciousness. These critical reviews would be sent by cable to Buenos Aires immediately after their appearance in the United States. Their publication here would have to be guaranteed by some of the most important local newspapers. In this respect, it would be convenient to send the exhibit to at least two of the less important cities, such as Denver or Minneapolis, where the level of sophistication is not so high, just in case the reception is not a total success—which I doubt will be the case—so that we can be sure of positive reviews from these minor art centers for publication in the Argentine newspapers.

12. To take advantage of the current international political situation and the policy of cultural rapprochement of the Kennedy administration (which will not last forever) to obtain aid and subsidies from the North American State Department and Embassy in our country with respect to the transportation of the works of art, expenses of the exhibition, posters, contacts, etc.[76]

This document, which is quite similar to the description of the different phases and objectives involved in a plan for an invasion, or a marketing strategy, demonstrates that by the end of 1961 many people were aware that genuine recognition of Argentine art had to be obtained in the United States and that, furthermore, there were many detailed views on how to achieve this goal. For Kemble, as well as the Argentine institutions, art could be an efficient instrument for the dissemination of propaganda. This proposal was deposited with the Torcuato Di Tella Institute. In subsequent years the institute, which shared many of Kemble's convictions (though it never expressed them with such frankness), pursued its institutional program, using many of these same strategies.

4

THE AVANT-GARDE AS PROBLEM

Thus revolutions are produced, when conceit takes possession of the youth and they become convinced that they are revealing the world. And this is necessary because to create something that did not exist before is extremely difficult, one has to have a lot of guts, a lot of balls to say something is art or that something is worth the trouble when it has few if any precedents. — Kenneth Kemble

A work of art is not, then, exclusively a model of the relations of man during a certain period and the world in which he lives; it is also a project or an anticipatory projection of a world that has yet to exist, a world in the process of being born. Thus the true artist has a prophetic function: he is quintessentially someone who helps his contemporaries invent the future. — Roger Garaudy

The artistic year has been active and prolific in Buenos Aires but I think we were hoping for more. I think there is something like a Great Cloak of fear covering us all . . . all my latest creative efforts have been directed at perforating that cloak. Of course, I was not the one who discovered this situation nor am I the only one with such grand ambitions. There is a group of individuals, isolated (for the moment, perhaps), who are working toward the same end. It is a great adventure, with many mistakes, and a sense that there is a latent desire to upset the insecurity of Buenos Aires. I know I should really say Argentina, but I think that in this way, paradoxically, I am less localist, because

otherwise I don't think I would be representing Buenos Aires, but rather universalizing it. This is rather vague, perhaps it is a dream, perhaps a prophecy, or maybe the atmosphere is real and I can feel it. —Rubén Santantonín

He returned to his home and from the door he contemplated the jumble of wood huts, hovels, and tin shacks. Disappointed, he spoke to his mother and his sisters who were already awake, "And this is Buenos Aires?" —Bernardo Verbitsky

Between the "dream" and the "prophecy." These were some of the words Rubén Santantonín chose to use in his letter to his friend, the artist Marta Boto, then residing in Paris, to describe the unprecedented, though somewhat vague, artistic atmosphere in Buenos Aires as he perceived it at the end of 1961. Undoubtedly, it had been a year distinguished by new ideas, characterized by the intense and incessant battle of forms. The season's exhibitions had brought with them, one after another, a repertoire of artistic images, techniques, and concepts that were new and different not only for the artists and critics, but also for the public to some degree. All these innovations generated great consternation over where they were headed and what the limits were on what could be said and done.

To what degree can the art of the 1960s be considered in terms of the avant-garde? Is this not a term that is legitimate for use in reference to prewar art, but inadequate for art that was no more than recycled productions of the heroic period of the historic avant-garde? What were the frames of reference that were used for conceiving of the artistic process? These and other questions were posed either in veiled or overt form during this period; they filtered into the discourses of the critics and the artists, and ran through the debates on art. Among the terms used by the institutions, in the programs organized by various cultural agents, what was expressed most vaguely, under the very nonspecific term *arte nuevo* (new art), represented for the artists a challenge they were eager to accept: to generate a new avant-garde. The decade of the 1920s had given rise to a type of avant-garde that was loosely defined and excessively derivative. The Argentine painter Emilio Pettoruti was the clearest example of this, but he was not exactly an iconoclastic example, either in terms of language or in institutional terms. The willingness to anticipate a world or to confront the institutions (both important attitudes for giving rise to avant-garde forms) were not clearly present in the 1920s when anti-

institutionalism, in the artistic training area, was more a gesture than a real possibility. In fact, it was materially impossible.[1]

In the 1960s there were new paradoxes. The artistic sphere was being reinstitutionalized as a function of promoting new art and the artists were unreservedly joining this process; thus, it seems impossible to define the avant-garde in Peter Bürger's terms: as a confrontation and break with the institutions. At the beginning of this period, it was critical to establish up-to-date forms whose referents were simultaneously the international languages and the local traditions which were understood in negative terms and perceived as an aspect that should be done away with. What was "over" included characteristic Argentine "good taste," which was described by Juan Pablo Renzi (among others), some years later, as the "marmalade culture."[2] They were features that indicated the preferences of the local bourgeoisie. It was against these tendencies, established in Buenos Aires art, that the artists defined the central element of their rebellion. They were striving to generate an avant-garde in terms of experimentation and renewal in language, as an attack on established tastes and, above all, the search for originality (but always with references to figures on the international art scene). For Kenneth Kemble, an avant-garde art movement was one that "contributed something new on a genuinely creative level," and he recognized those features in the work that the artists of his generation were doing.[3] These artists had put an end to the "exquisite refinement of our elite" that had inhibited creativity activity, opening the way for "exploration that was free of all established canon."[4] This avant-garde measured itself against the international scene, but conceived of itself in a national context. For many of these artists, they had to make a difficult decision in this respect. Upon his return to Buenos Aires, after living in Europe, Luis Felipe Noé stated, "I returned to Argentina to help develop a national form of expression through a living image, the result of an inventive process that grew out of internal necessity. It is time for us to create our own avant-garde."[5]

However, as we have seen, these concerns also formed part of the overall plan of the institutions. Hoping to avoid the contradictions that might arise from appearing to unite, in a single front, the avant-garde and the institutions, they transformed the term *vanguardista* (avant-garde) into *arte nuevo, arte de avanzado* (progressive art), and even *arte de exportación* (art for export). These transformations were intended to suggest an art without references, molding the character of this unique product to the

objective of producing a quality culture that might recalibrate the unequal relations existing between Buenos Aires and other metropolitan centers. This attitude was apparent in the economic and sports metaphors that were favorites of Squirru, who wrote that with a "team of people capable" of promoting our artists and with artists capable of comporting themselves as "athletes," always willing to compete to improve their product, the country will be able to "export culture."[6]

In 1969 Romero Brest published a version of Argentine art history in which, rather than conceptual or stylistic classifications, he used evaluative terms associated with the idea of "progress." The notion of "backwardness," which he used to characterize most of Argentine art prior to the 1960s, disappeared from his discourse beginning in 1963 when he became director of the Di Tella Institute Center for Visual Arts (CAV) and Argentine art emerged for the first time as an "up-to-date" product.[7] The use of such limited classifications, in conceptual terms, which paralleled artistic change with sports competition, with goals to achieve, transforms his version into a simple succession of organized events with a single objective: "to advance."

In its quest for renewal, 1960s art resorted to various and diverse sources. In a seminal essay, Thomas Crow proposed a rereading of the original formulation of modernist theory in which he reestablishes the productive tension between modernism and the avant-garde. Historical verification enables us to understand the degree to which the avant-garde renews or reinvents itself, identifying itself with outsider movements, with "nonartistic" forms, with ephemeral forms, which later form part of the modernist canon (albeit in a subordinate position). The avant-garde strategies—appealing to low culture, to extra-artistic materials, to provocative tactics, and to the formation of closed groups for the purpose of social survival—all constitute, in some way, the dynamic element, the "evolutionary moment" in the modernist continuum,[8] This participative logic was absent in Clement Greenberg's interpretation. He avoided the problem of low culture and organized a teleological model of modernism, characterized by its autonomy, introversion, self-referentiality, and its tendency to consider artistic activity as self-criticism,[9] According to Crow's line of reasoning, modernism repeatedly carried out subversive equations between high and low culture, whereas this relation disappears in Greenberg's view.[10] In contrast to the development of modern art in the 1950s, what was difficult in the 1960s was the possibility of reestablishing the interactive model between high and low culture, which until then

had regulated the evolutionary direction of modernism. Popular culture now seemed dominant and the artistic language no longer considered the problem of its own autonomy to be of central importance.

For this first generation of avant-garde artists, including those whose experimentation went to various extremes during the late 1950s and mid-1960s (referred to in chapter 2), the main problem consisted in exploring all the resources available for establishing a new artistic language. The social position of the artists was defined principally in terms of their commitment to the artistic activity itself, which they understood as serving to transform society. The dominant aspects of their activity consisted in an increasing rejection of pictorial forms, as well as experimentation with all the materials and themes that surrounded them in their immediate environment. This environment included the slums and shantytowns, and successive references to and appropriations of the popular urban cultural center in Buenos Aires known as the Parque del Retiro (the area surrounding the central train terminal, named Retiro). For these artists, this was the first time that an avant-garde art movement had been realized in Argentina. Although the artists initially tried to adapt their productions to the new institutional scheme, this strategic alliance was established on the basis of a conflict that, by the end of the 1960s, was impossible to contain. The conflict soon exploded in an anti-institutionalism that was so radical that it called into question the very legitimacy of the artistic practice itself.

Another issue involved the reception of these artists' work by the local intelligentsia. In the first half of the decade, the precarious relations between artistic and intellectual groups resulted in a curious lack of comprehension regarding works of art, not only on the part of the critics writing for the liberal print media, but also on the part of numerous magazines published by the new critical intelligentsia. These sectors not only denied the legitimacy of the projects presented by the artists as "avant-garde" because of their political biases, but also because of their aesthetic conservatism. The first generation of artists did not consider the relationship between an aesthetic avant-garde and a political avant-garde to be a problem. This was primarily because they conceived of the artistic avant-garde itself as a transformational force with respect to the social order.

The short, clipped, and spontaneous sentences that characterize the impulsive writing of Santantonín are illustrative of the anxiety he experienced when conceiving of himself as agent of such an overwhelming task. Santantonín wrote quickly, trying to get his ideas onto paper in the most

immediate way possible, trying not to lose any of the vibrations he felt palpitating around him. In his descriptions he ordered events as if each one was proof of something unprecedented and looming on the horizon: unimagined and extraordinary events that would shake the Argentine art world from its long, deep lethargy.

In 1960, the large exhibitions that were organized as part of the re-institutionalized art scene, which itself was a response to new art, re-inforced the sense of urgency that the first experimental efforts had unleashed between 1957 and 1959. The Argentine and international artistic culture displayed on the walls at 150 Years of Argentine Art, the First International Exhibition of Modern Art, and the spectacular presentation organized by the ITDT constituted something comparable to a convocation. The public and private organizations that were reinstitution-alizing the artistic milieu as part of a project of renewal required images and visual discourses that could be used as letters of presentation on the international art scene—other instruments in an expansive plan intended to be effective on both the internal and the international level. In 1960, what could be read between the lines of these exhibitions was that the art scene had only come so far. Now it was up to the young artists, with their enthusiasm and creativity, to give Argentine art the transcendence it was still lacking. To gain center stage, the general conviction was that it was necessary, as well as sufficient, to produce "quality" art. Quality implied, above all else, innovation and originality—art without previous referents. Clearly, according to what had been seen at the international art exhibition, this was something that Argentine art could not yet offer.

It was necessary to define new forms and contents. What were the symbols that this society, undergoing a process of intense transformations, identified with? What images registered these changes? For a country that wanted to leap the barriers of backwardness in a single bound, the image that best represented this mutation, and that might lead to a stellar future, was the image of its own capital city. Buenos Aires, with a yearning gaze turned northward, had never given up trying to create itself in the image of the other two great and mythical centers whose brilliance it hoped to mirror: Paris and New York. Those were the cities most adored by Buenos Aires artists and with whom, during the 1960s, they had woven an extremely perverse relationship, not just because of its complexity, but also because of the contractual knots through which it had been developed. The traditional bipolar relationship that Buenos Aires had maintained with Paris since the 1920s, whereby the artists would travel to the French

capital to study and discover the forms of modernity, was suddenly upset by a process of triangulation in which the artists restructured their system of obtaining new forms, poetics, and spaces of legitimization. During the 1960s the artists would travel to Paris and New York (in that exact order) to observe and learn in the former, while seeking legitimization and recognition in the latter. In this way, what the artists ended up bringing to the new world art center were images that combined elements taken from European movements (Cobra, nouveau réalisme, Italian and Spanish informalism), assuming new structures and meanings in their surfaces and objects.

The Material Limits

After the emergence of informalism, the expectations excited by this tendency were deflated by the profusion of earth-tone works that inundated the galleries of Buenos Aires. Gestural affectation and aesthetic limitations, influenced by the conservative tastes of art collectors, the public, and many Buenos Aires artists, subdued the violent and dramatic charge conveyed by the gestural materiality of the Spanish and Italian informalists. What could be seen of the informal aesthetic in many exhibitions, aspiring to form part of the avant-garde, were affected copies of Burri, Tàpies, Guinovart, and Millares. These were degraded versions that asphyxiated important aspects of Spanish and Italian informalist painting which contained gestural force and material violence; after the exhibition of contemporary Spanish painting—Espacio y color en la pintura española actual (Space and Color in Current Spanish Painting), organized at the Buenos Aires National Museum of Fine Arts in August 1960—there were no more doubts about it.

In the lukewarm iconoclastic panorama of Buenos Aires, Alberto Greco always managed to be an exception. At the second informalist exhibition held at the Museo Sívori, Greco's work (a partially charred tree trunk and two framed floor rags) caused consternation. Shortly thereafter, in his work *Pinturas negras* (Black Paintings) shown at the Pizarro Gallery, Greco accentuated the obscurities of informalism to the point that the contrasts disappeared and the outlines of the forms were invisible. On the huge billboards that plastered the city in 1960, displaying self-congratulatory slogans (saying, "Greco, you're great!" and "Greco: the greatest informalist painter of America"), Greco satirized local informalism and its lack of radicalism.

Greco was inventive, impulsive, irreverent. His strategy for entering the artistic world was based on such a systematic provocation of the icono-clastic limits that neither the institutions nor other artists could tolerate it. Excluded from all the awards contests of 1960 and 1961, Greco spent several months traveling through the country aboard trucks carrying the traveling exhibitions of Argentine painting, organized as part of the cul-tural events of the 150th anniversary of Argentine independence. Thus ostracized, he resentfully described the Buenos Aires artistic milieu:

I have time to kill here, and I also have silence. Time to meditate on my painting and the painting of others. I'm thinking of taking aggressive action regarding certain living corpses when I get back, there's no reason for things to be post-poned on account of someone else's idiocy. Because they don't think at all. They begin to inflate someone, and they keep blowing until that person explodes. For example, one case in particular: Mr. Carreño, winner of the Ver y Estimar award, winner of the De Ridder, nominated by Venturi for the Di Tella award and the Critic's award. All in 1960. Perfect. Now let's think. Is (Mr.) Carreño an impor-tant painter?

"No!" As you say, he always paints the same painting. He paints well. But it is so boring to paint well! . . .

Unanimous triumph and praise. What I never had, nor will I ever have, even if I ever do. I'm dying of fear. I am an AVANT-GARDE painter. (Oh! Yes, excuse me, I forgot.) I was unanimously rejected by the Di Tella (Ha, ha, ha!) (Oh, oh!).[11]

Playing with the boundaries of the system, Greco showed everyone, artists and institutions alike, the limits of their practices. His unfulfilled desire for recognition, followed by his immediate renunciation of the spaces he conquered, defined a game that was not exempt of sadism. Though it might have been attributable to aspects of his personality, it also exposed many of the contradictory features that characterized the space in which the avant-garde was being played out: defined by the ne-cessity to break the limits of bourgeois tastes and at the same time unable to confront the institutions that, though they sought to foment innova-tion, tended to legitimate the least disruptive alternatives. The tensions between the avant-garde and the institutions, which Greco's attitudes exposed, amounted to nothing more than a demonstration of the diffi-culties that arise when the need to confront the system collides with the desire to achieve success and recognition. In reference to Greco's situa-tion in the artistic milieu of Buenos Aires in the early 1960s, Luis Felipe

Noé emphasized this paradoxical and conflictive relationship between the avant-garde and the institutions:

In a milieu like ours, Greco was an irritating element. For him, there were no limits . . . Absolutely trapped at the time by the "artistic culture," desperately in need of being recognized and valued, he would get himself invited where he was not welcome, and then he wouldn't go. He always scorned what he held in his hands, after having desperately pulled all kinds of strings to get it. . . . Greco was the topic of a thousand conversations in the artistic milieu, whether to curse him or defend him. He had become a legendary character. And when society transforms a real person into a legend, it's because it needs something from him; he signifies something. What Greco signified was freedom from prejudice. That is why his very victims—the most prejudiced members of high society—were those who flirted with him most. They saw him as a kind of liberating angel come to free them from the very prejudices that bound them.[12]

Greco's first period of painting lasted until October 1961, when he presented the exhibition Las monjas (The Nuns) in the Pizarro Gallery.[13] Subsequently, he focused his work primarily on reality. For this highly promoted exhibition, anticipated by the entire Buenos Aires artistic milieu, Greco did not create the pieces until a few days before the opening, in the bathtub of his room at the Hotel Lepanto, where he lived. There were a few paintings that featured figurative elements, among which the most notable was a shirt with tar and red paint titled La monja asesinada (The Murdered Nun).[14] Ignacio Pirovano (who, as we have seen, was a collector and champion of abstract art during the Peronist period and whose attitude was very positive during the period of artistic revival) saw in this piece a portentous sign and he wrote to Greco: "Your 'Monja Asesinada' had a tremendous impact on me. Your other paintings did too. A new series of 'horrors' to be counted among the crude testimonies of these times. Times of transition the likes of which we may never know again, from an old world to a completely different new world that we hope will be wonderful and that we are living in anguish as though giving birth and through your painting, you capture that birth so well in your cry: ferocious . . . atrocious!"[15]

The premonitory terms of this letter could also be found in innumerable texts written in response to other objects in which signs had been found or looked for indicating the same thing: evidence that something transcendent, radically different was about to happen. Greco had created

one of the possible forms to fulfill this desire. However, although he had managed to have an impact, the goals that were crucial that year for the group Nueva Figuración were to achieve success, recognition, and immediate critical acclaim.[16] They offered a solution that was accepted and celebrated as the best way out of the dead-end alley in which the informalist movement found itself.

If Greco had darkened the surface to the point that nothing could be seen in it anymore, the artists who held their first public exhibition under the title Otra figuración (Another Representation), proposed breaking with the self-referentiality of blotches and textures, and revitalizing them with the figure. At the end of 1960 Noé announced his willingness to break through the limits at which painting had arrived, but without abandoning the celebratory commitment to painting itself: "To paint is nothing less than to transform one world into another and a person—the painter—is the minister of such an operation . . . I want to insert chaos into order, to discover a new order, to leap to a new world. That is why I'm moving away from blotches, from which I extract forms without intending to destroy their suggestive power."[17]

In the catalogue for the first exhibition the artists declared that "we do not consider ourselves a movement, a group, or a school." Nonetheless, in 1961 they succeeded in generating a seductive climate of mystery around their reduced circle of artists, having decided to work together in a single studio.[18] After their first success, the four members of the group set out, each in their own way, on the mythical voyage to Paris, but once there, they only heard talk of a new artistic center, located in New York City.[19]

The Art of "Things"

What was important for avant-garde artists of the first generation was to find *new* forms and languages. Among the succession of proposals for innovative forms was Rubén Santantonín's work *Cosas* (Things), presented in September 1961. This was a collection of forms whose aesthetic definition was more ambiguous and difficult than that proposed by the artists of Nueva Figuración or than that shown two months later by artists participating in the exhibition Arte Destructivo (Destructive Art).

Santantonín arrived on the art scene from a marginal position: late in life, without formal education, from a quiet neighborhood, he only painted occasionally while running a small family business. In 1960, when he exhibited his work at the Van Riel Gallery, he was "discovered" by two

of the most important figures in art at the time: Kenneth Kemble and Luis Felipe Noé. A year later Santantonín began work on what he called the "art of things," from that time on forming part of the group of artists that Kemble called "Argentina's Band of the Damned."[20]

Between November 8 and December 31, 1961, Santantonín wrote fourteen hurried pages in his diary describing his desperate struggle to transcend the limits of his situation. Moved by this impulse, Santantonín organized an apparently contradictory combination of elements, employing precarious materials (rags, paper, wire, plaster) as part of a radical project which was, in his words, to give form to the "existential devotion" constituting "art today." Thus it was expressed in the text of the catalogue for his exhibition at the Lirolay Gallery in 1961:

I do not attempt to combine painting and sculpture. I try to remain at a distance from these two disciplines insofar as they can be method, system, and medium. I believe I make *things*. I sense that I am beginning to discover a way to create that has positioned me at an existential crossroads with a more intense vibration than if I reduce my being, with its increasing anxiety, to the canon of *painting*. . . . For my gawking spectators today, who I do not call observers, I want them to have a means of communication with those *hanging things* that reaffirm in me the idea of what I believe art is today: a participatory existential devotion, a devotion without peace or leisure. I confess, then, that I am devoted to the silent image and I create it knowing that I have no way out.[21]

Santantonín applied the term "things" to the reliefs he created from cardboard as well as to the forms he suspended from the ceiling with wires or string. The hanging things constitute the most radical part of his work. Whereas formal aspects in his reliefs still play a central role in the composition of the work—owing to the disposition of the rhythms and the semi-spherical forms, as well as to the fact that the support material on which they are placed is the wall itself—in the hanging forms, the indetermination is even greater. In some of these "things," the gestalt responds to the concept of a bulky shape, a partial bundle of fabrics and leftover materials from which small fringes protrude or hang, or they are inhabited by elements of a decidedly preformal nature. Constructed of fabric, wire, cardboard, and plaster, his works depart from indetermination and explore avenues that enable him to create the forms of his most extreme aspirations.

In creating his new repertoire, Santantonín explored different materials in an attempt to establish an order that is filtered with aspects of Sartrean

existentialism. At that time, Sartre was being discussed by intellectuals and artists in Buenos Aires bars such as the Moderno and the Coto.[22] The question is, how did the artists work these ideas into their art, how did they combine their explorations with the new forms, how did the philosophy they unsystematically read and discussed over café tables enter into the forms and materials with which they were experimenting? It is surprising to find in Santantonín's writings the lack of a systematic approach, but rather he paraphrased excerpts from Sartre (especially from the novel *La nausea*)[23] that he wanted to re-create both in writing and in images.[24] In a milieu in which structuralism, existentialism, and, especially, Sartre had still not had much impact, these were important references for the Buenos Aires intelligentsia.[25] In the early 1960s, Santantonín not only began to create his "things," but he also donned the typical "existentialist garb" (high-collared black turtleneck sweater) in which he was photographed and presented as the "artist" in magazine articles. At the same time, he began to write a brief diary, always in the first person, with a structure that is reminiscent of *La nausea*, a book that narrates in the first person, and in Cartesian style, intellectual illumination: the discovery of contingency.[26]

Santantonín writes: "Culture grows slim on history. It thrives on the present. I want to immerse myself madly in that existential whole that for me is the present. I want to feel that I existed as part of my time. NOT ANOTHER . . . I want to bleed existence."[27] The lines of his diary do not speak of events or actions, rather they refer to descriptions of interior events of consciousness. In these texts one also notes traces of Sartre and Merleau-Ponty's *Phenomenology of Perception*.[28] Merleau-Ponty proposes redefining everything in terms of perception and phenomenological description, returning to things themselves as a way "to return to that world which precedes knowledge, of which knowledge always *speaks*."[29] In his own words, Santantonín's things want to be a "predominantly sensorial" search capable of offering to perception "a greater diversity of sensations" that cause people to "no longer observe things," but rather "to feel themselves immersed in them": "THING ART does not seek to enlighten, improve, deceive. It seeks in all different ways to touch that no man's land that every person has—that very place where things atrophy, that place of tedium. . . . Thing-art seeks to complicate that part of a person today that is on the loose, the ego, to complicate it with poetic existence."[30]

Those suspended objects (figs. 2a–g), like tubers, roots, great masses

whose swollen contents seemed to be on the verge of exploding; those tactile and larval forms among which Santantonín immersed himself, among which people could wander, objects that were rough, opaque, perforated by craters, dripping with color, taught, squeezed, bound and gagged, all of this constituted that sensorial absolute, that "vital turgescence" that Santantonín sought for defining a new art. Tactile forms of an intense material: all of his work is a liminal inscription traversing the border of indeterminancy, seeking the most precarious forms for the most absolute desires. Forms that appealed to tactility, rather than objects meant to be observed like those proposed by pop art. Non-objects. Non-persons. Non-painting. Non-sculpture. Non-work of art. Art-thing: what Santantonín was after was "the development of a new form of expression"[31] that "would be above all an acknowledgment that the consciousness of our generation can do more than what is commonly believed and that creative freedom is now beginning in Argentina."[32]

The direction taken by Santantonín—like that taken, to a certain degree, by Emilio Renart, Kenneth Kemble, Alberto Greco, and Luis Wells—is intended as an exercise in disassociation through the use of dehierarchized and perishable materials for achieving maximum intensity. He displayed an element of precariousness not only in the materials that he chose for his creations, but also in the unstable forms he chose for expressing them.

"I live because we are, not because I am": in all of his writing, the individual persistently tends toward the universal.[33] Kemble and Pablo Suárez believe that it is for this reason that Santantonín, even though he was against museums and the idea of the enduring work, still exhibited in those institutions. "He exhibited," Suárez said to Kemble in their conversation, "because to some degree what he believed was that he had to help [the process] that was taking place at that moment in painting."[34] As if that situation that he foresaw in the future of his culture, that collective energy that he understood as a force that could transform the present as a function of the future, also required the transforming energy emanating from his "things."

All of Santantonín's work was intended to be exactly that: pure energy, a hardly perceptible but highly potent charge intended to be effective in a precise moment and to materialize more in the work of others than in his own. The precariousness of his materials, the incompleteness of his forms, the transitoriness that affects all his creations, would seem to sup-

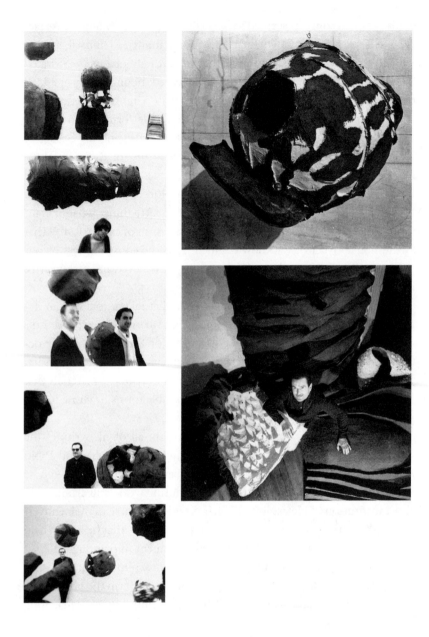

2. Rubén Santantonín, *Cosas* (Things), 1964, Lirolay Gallery exhibition.
Jorge Romero Brest Archives, Instituto de Teoría e Historia del Arte "Julio E. Payró,"
Facultad de Filosofía y Letras, Universidad de Buenos Aires.

port this view. This lack of durability, permanence, and conservation was an important part of his program. His "things" were intended to act in reality as pure transformational material.

Santantonín summarized his program as follows:

—No more salons

—The street, vibrant and exclusive environment for the artistic *act*

—Agony of gallery and salon art

—Against artistic conservation

—Against the idea of prestige in Art

—In favor of the vital instant

—In favor of surprise over the unusual

—In favor of instantaneous vibration, fleeting but charged with vitality

We understand that those who count the most are the others, those who *perceive*, and for them, the instant of surprise is more valuable than inexorable death. . . . While Gallery and Salon Art dies, we are creating this kind of unsellable art.[35]

The remaining inventory of Santantonín's work does not exceed five lines. This is not only because its dissolution was included in his program, but also because he supervised the destruction of his own work by setting fire to it in 1966. Kemble explains this decision as a reaction to the lack of understanding: "Frustrated by the possibilities to continue creating in an indifferent milieu, he destroyed almost all his work before dying."[36] Santantonín felt that the collective subject in whose name he wanted to speak did not understand his project. He found himself isolated, alone.

In 1964, reviewing what was probably the first complete exhibition of Santantonín's hanging "things," at the Lirolay Gallery, the critics dismissed it on the basis of the following criteria: "Without anyone saying anything, just as we are accustomed to doing, we attend some exhibitions that, beyond the absurd, reach to the heights of cruel and inexplicable mockery. Whoever enters, for example, the Lirolay Gallery, will find hanging from the ceiling by strings, at head and waist height—they should have calculated all the possible heights—several bundles of rope, never new of course, generally in the shape of common packages to be sent to the laundry. With the utmost aplomb, the artist—can he be referred to as such?—offers the explanation, as if it were some extraordinary discovery, of what he calls 'things.'"[37]

Although the critics could have connected this use of materials to the

revitalization of dadaism, which was being produced on the New York scene at the time, what is certain is that Santantonín's "things" had no precise referent in the national tradition or in the international avant-garde. His intention was to generate a local avant-garde that could also compete on the international level: for this reason the work did not acknowledge paternity and it resisted being grouped with pop.[38]

If Santantonín's "things" remind us for a moment of some of Claes Oldenburg's first forms, this relationship soon dissolves when compared to the referential and ironic directions taken by the North American artist's work in the context of trends in mass culture.[39] The irony, kitsch, and mockery are totally absent from the existential orientation inherent to Santantonín's unshapely masses. Rather than North American pop, the forms Santantonín created from rags, plaster, and wire were more closely linked to Spanish informalism, especially the work of Manolo Millares, whose originals Santantonín was able to view in the exhibition of contemporary Spanish art at the MNBA.[40]

In his "things" all meaning based in mimesis or in composite principles has been eliminated. The "things" are characterized by the intensive use of a material that is opposed to what would be permitted within the canon of painting or sculpture: "No more 'lines' or 'planes' or volumes. I want 'the thing' to include *directions, intentions, 'contacts,' connections, bulk, wrinkles.* I have withdrawn the old expired canons from my soul."[41]

Santantonín eliminates from his work both a value criteria based in content as well as a formalist criteria that supports the self-sufficiency of artistic languages. The relationships of the objects to reality are no longer important. Likewise the internal relationships established among the materials are not defining because the material is no longer what it represents, it is not representative of its structure, but rather it is a *presence*. It is also the record of a search: "No material in and of itself means anything to me. I prefer the idea that as I search, I become the material."[42] It is an exploration that the artist describes as a destructive force: "Art today destroys whoever creates it or lives it. If it is observed directly, without averting the gaze, art today KILLS." It is the instant of danger: "I see my things better when they're *hanging* . . . they live a moment of precariousness, like a pigeon hanging in the moment of evading the cat's chase."[43] Santantonín's main intention is to perturb:

Thing art . . . tirelessly insists that man cease to contemplate things, that he feel immersed in them, with wonder, anxiety, pain, passion. THING ART does not

seek to enlighten, improve, deceive. It seeks in all different ways to touch that no man's land that every person has—the very place where things atrophy, that place of tedium. . . . Thing art does not dream of improving anything vital, because that has never been where the success of art lies. But I insist: there is a virgin space in man that is imaginatively paralyzed, poetically lethargic. It is, I repeat, that place full of tedium, that no man's land: no man's because it is the place of the ego; for this reason I believe in the existential ego-complication as a way of invading that space which, apparently pertaining to no single man, is paradoxically all of ours.[44]

Santantonín's work, as he was creating it, was not left out of the system. In contrast to the exhibition Arte Destructivo, which, as we shall see, was seen as an experiment whose destiny was to exhaust itself, Santantonín's "things" were quickly absorbed into the institutional circuit and were included in numerous official prize competitions and exhibitions.[45]

Nonetheless, his images did not represent what the public and the institutions were looking for as a defining form of "sixties art." This image was provided by the artists of the second wave in the 1960s, whose work was more easily codified and, thus, more operative. The artists who created the *happenings* offered an element of scandal and celebration that turned out to be more appropriate than the indeterminacy and the precarious identity of the aesthetic code that Santantonín's "things" were immersed in.[46]

An Aesthetic of Violence

> *It's up to the artist to show that destruction hides a powerful seed of beauty; so that when one tells a woman that her beauty is destructive, it is one of the highest compliments and it is understood that we are not confronted by passive beauty but rather a beauty that possesses the qualities of fire and explosion.* —Aldo Pellegrini

After several months of group work, having gathered materials, recorded a soundtrack, devised the procedures for breaking down poetry, discourse, and music, a group of artists presented the results of this period of experimentation at the Lirolay Gallery in the exhibition Arte Destructivo (figs. 3a–i).[47] This exhibition, which effectively brought the year to a close in 1961, represented the materialization, the point of maximum achievement, of a program that Kemble had worked on in his 1958 collages of

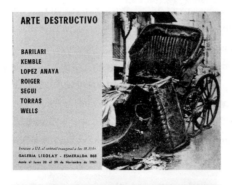

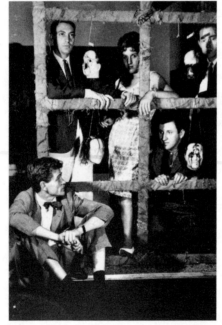

3. Exhibition: Arte Destructivo (Kenneth Kemble, Luis Wells, Silvia Torras, Jorge López Anaya, Jorge Roiger, Antonio Seguí, Enrique Barilari), 1961, Lirolay Gallery, Buenos Aires. Kenneth Kemble Archives.

sheet metal and scrap materials and that he had to tried to reinforce with criticism in the *Buenos Aires Herald*.

Although this experience was later considered by the participants them- selves as a terminal point and one of dissolution, Kemble presented it as part of a process of exploration whose target was, as always, the future:

This exhibition has the character of an experiment, a tentative rehearsal, an idea that occurred to me a little more than a year ago. Like all relatively new experi- ments, its presentation might be imperfect and confusing and, above all, exces- sively heterogeneous. But it will have the precise value of its imperfection by leaving various avenues open for future experiments. By no means did we want to codify this attempt, nor to coin a new "ism" based on pretentiously absolute premises, but rather to simply explore an aspect of our being, old as man himself, but never fully explored until now in the field of art.

In the first moments of its conception, it seemed to me to be totally ludicrous, but I have learned over the years that it is the most ludicrous ideas that lead to new worlds.[48]

This oracular, premonitory tone was not new. Nor was the use of found materials, which had been seen in abundance since 1957. Although the found object already formed part of the expected repertoire (and even more, found material), what was now added, not as an extra, but rather as a central element, was the systematic work with the idea of violence and destruction. The uniting concept of the group resided, precisely, in exploring the results of a violent action directed toward objects.

The idea of destruction was being explored in various enclaves of the international avant-garde. As Kemble himself declared, "It occurred to me when I saw a photograph in the *Times* magazine of a Junk Art exhi- bition."[49] These productions (which the British critic Lawrence Alloway had already been defending since the 1950s as a reaction to the idealism of abstract expressionism), in which both elements—waste and destruc- tion—were present, constituted (in Buenos Aires as elsewhere) one of the ways through which assemblages evolved toward environments and happenings. The use of found and destroyed objects was also being seen at that time in Arman's accumulations, in Tinguely's auto-destructive machines, in César's compressions, in Gustav Metzger's public actions and his manifestos on "auto-destructive art" first published in 1959,[50] and in the objects that Rafael Montañez Ortiz was making in the early 1960s.[51] The idea was being processed at the same time in different places

and from different perspectives, and among these places Buenos Aires was included.

An important and differential ingredient of this experiment was that it was the result of a long process of group work in which the artists not only met to collect materials, but also to discuss the idea of destruction and work on it through audio and visual supports. Using the audio results of this long experimental process, they recorded a soundtrack which was played during the exhibition. Much of the visual material was collected in the area of the port and the area where the city's waste was incinerated ("la quema"), two parts of the city whose connotations were added to those already associated with the selected objects: a bathtub, the foghorn of a ship, the metal liners of three coffins, automobile fragments, and so on. In addition, there were objects that each artist had found on his own: umbrellas and broken chairs, a split-open armchair, dolls, burnt candle stubs, and their own informalist works, ravaged and included with all the rest of the junk. All these materials, devastated by time and disuse, were brought together to mount the exhibition and were destroyed all over again in order to be organized into a body of works ready for their final presentation. Death, sex, violence: these were the themes superimposed on the selected objects through the respective actions used to modify them. The sexual allusions were obvious, for example, in the slit down the middle of the armchair from which fibers and burlap were swelled upward. Death was presented metonymically in the coffins that had been found riddled with bullet holes. But beyond these easily decoded signifiers, what is interesting to note is that the exhibition functioned in a complicated multisensory register, made up of objects (dividing the space, hanging from the ceilings and walls, and blocking the passageways), shadowy lighting, and sounds based on alterations and dissonance.[52] Thus it was the first experiment to successfully express an integrated effect where the totality of the space was transformed through the insistence on one single problem: how to explore, through multiple supports, the creative possibilities of destruction and violence.

This experiment also enabled Kemble to achieve a kind of materialization of that collective energy that, like Santantonín, he perceived as a latent force among Buenos Aires artists. It produced a shared deliberative space in which, although references to international movements did not disappear, the immediate energizer was the work of others and the discussions and opinions generated by working as a group: "What interested

me was creating, the processes of creation, trying to promote a spirit of exploration and adventure that would enable us to create our own world and not always be dependent on the latest fashion from Paris or New York."[53]

In many ways this exhibition was a *manifesto in images*. First, because the presence of their own ravaged informalist paintings, hanging from the walls of the gallery, implied an attack on the style they themselves had introduced and whose negative consequences were seen multiplying in the galleries of Buenos Aires: "I foresaw the end of informalism, which had been converted into a cheap formula for making paintings," López Anaya declared.[54] What was being challenged was the type of informalism that had been assimilated by the institutions and the market: the watered-down informalism that so irritated Greco. Second, an attack had been launched on what was considered surrealism in Buenos Aires, a formula that was closer to metaphysical painting, or a painting within a painting, rather than the liberating proposal they had seen in surrealism when it affirmed, for example, the beauty of destruction. In this respect, they saw themselves as the agents of true surrealism. In the words of Kemble, "We were the first genuine Dadaists and surrealists."[55]

The third point in this program, written through objects, resided in the introduction of absolutely heteronomous elements. Until that moment, materials that were foreign to the system of "painting" or "sculpture" had been incorporated into the compositional order, that is, what was foreign was introduced through compositional aspects that established the harmony of the parts. In this way, what was heteronomous was reordered in the "art" system, a self-regulated system capable of establishing a sense of order through its own laws. These characteristics were still clearly found in Kemble's scrap metal collages. Now, however, the possible space for negotiation between self-reference in language and heteronomy, seemed to have dissolved in the face of this collection of disagreeable junk that had invaded the gallery. What this exhibition made clear was that the evolutionary system of language that, until then, had managed to sustain itself by assimilating the emergence of informalism, could no longer recover. This undeniable fact, which the critics still managed to ignore, delegitimizing the experiment as an out-of-step venture and assimilating it, once again, into surrealism and dadaism,[56] nonetheless represented a change that could not be reversed: the appearance of what was most immediate, and even most vulgar, in local art spaces. This change, still mediated in this exhibition by the concept of destruction, thereby giving meaning to the

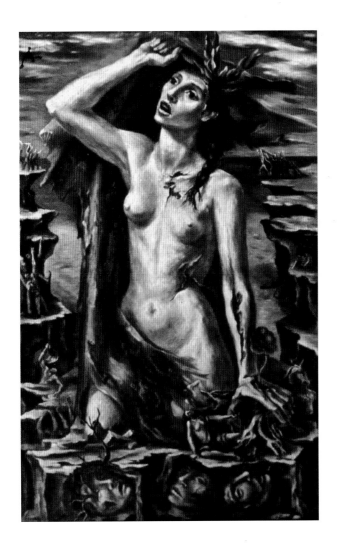

Plate 1. Raquel Forner, *Liberación* (Liberation) (from the *El drama*
series), 1945, oil on canvas, 1.54 × 0.97 m. Private collection.

Plate 2. Kenneth Kemble, *Paisaje suburbano II* (Suburban Landscape II) 1958, sheet metal, wood, plaster, and oil on hardboard, 100 × 120 cm. Private collection.

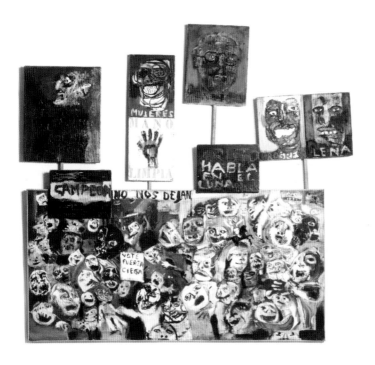

Plate 3. Luis Felipe Noé, *Introducción a la esperanza* (Introduction to Hope),
1963, mixed techniques on canvas, 97 × 195 cm. Museo Nacional de
Bellas Artes, Buenos Aires.

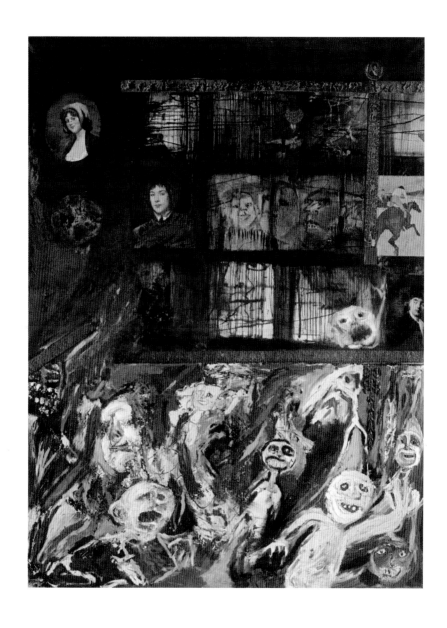

Plate 4. Luis Felipe Noé, *El incendio del Jockey Club* (The Burning of the Jockey Club), 1963, mixed techniques on canvas, 199.5 × 150 cm. Private collection.

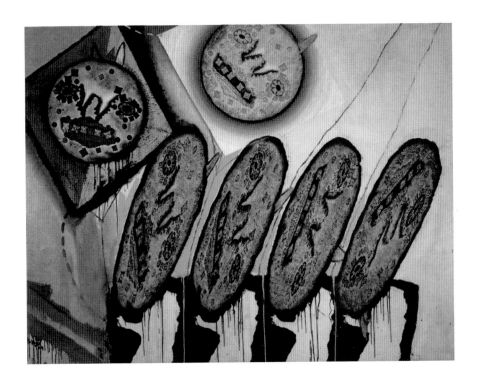

Plate 5. Jorge de la Vega, *Conflicto anamórfico N° 4* (El aire) [Anamorphic Conflict No. 4 (Air)], 1964, mixed techniques on canvas, 194 × 255 cm. Private collection.

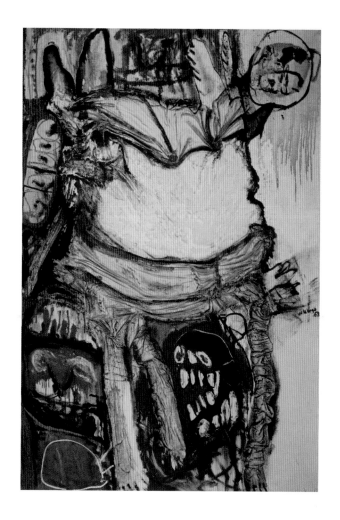

Plate 6. Jorge de la Vega, *Danza en la montaña* (Dance on the Mountain), 1963, mixed techniques on canvas, 195.5 × 129.5 cm. Private collection.

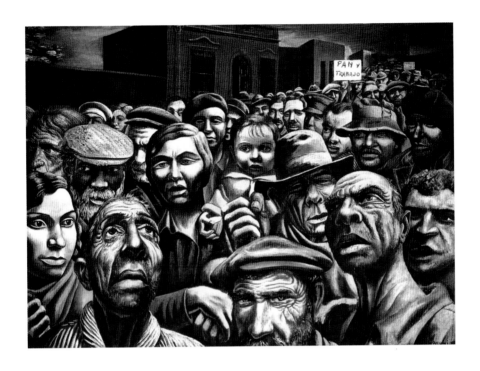

Plate 7. Antonio Berni, *Manifestación* (Demonstration), 1934, tempera on burlap, 180 × 249.55 cm. Malba-Colección Costantini, Eduardo F. Costantini Collection, Buenos Aires.

Plates 8a–k. Marta Minujín and Rubén Santantonín, *La Menesunda*, 1965, environment at the Instituto Torcuato Di Tella, Buenos Aires. Marta Minujín Archives.

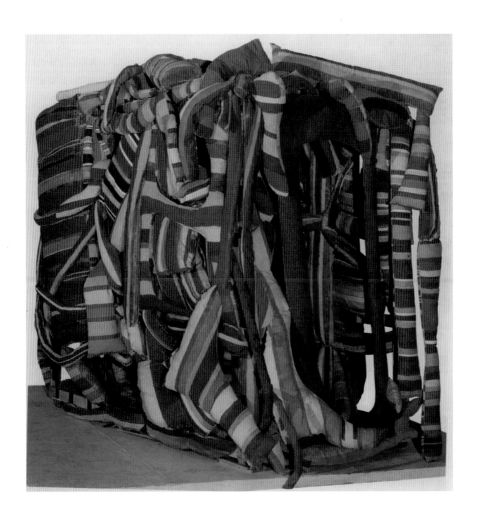

Plate 9. Marta Minujín, *¡Revuélquese y viva!* (Roll Around and Live!), 1964, canvas, sponge rubber, wood, springs, 3 × 2 × 2 m. Private collection.

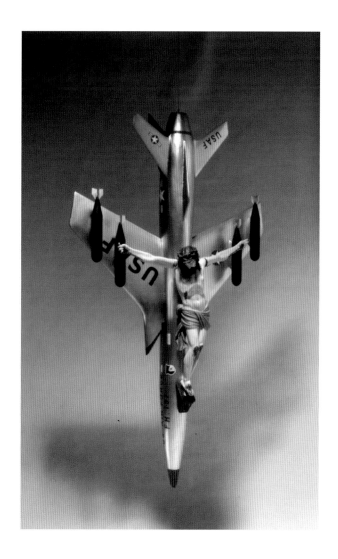

Plate 10. León Ferrari, *La civilización Occidental y Cristiana*
(Western and Christian Civilization), 1965, polyester, wood, and
cardboard, 200 × 120 × 60 cm. Alicia and León Ferrari Collection.

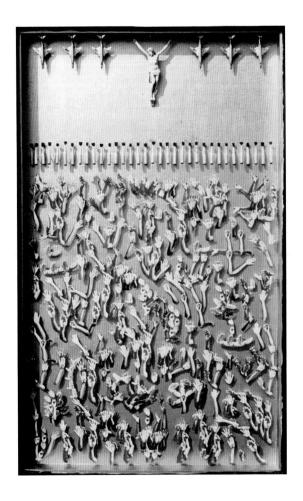

Plate 11. León Ferrari, *La civilización occidental y cristiana bombardea las escuelas de Long Dien, Causé, Linn Phung, Mc Cay, Han Yanh, Aan Minh, An Hoa y Duc Hoa* (The Western and Christian Civilization Bombards the Schools of Long Dien, Cause, Linn Phung, Mc Cay, Han Yanh, Aan Minh, An Hoa and Duc Hoa), 1965, 100 × 70 cm. Work missing. Alicia and León Ferrari Collection.

junk art pieces (existential violence as a problem of man and humanity) indicated, nonetheless, a slippery area whose consequences were apparent in subsequent years, and which resulted in artistic discourses that were increasingly reflections on reality (daily, concrete, aggravated violence).

Although the system of *selective tradition* that was operative in critical evaluation at the time still referred to the European avant-garde and to the past, comparisons were made that, for the purposes of this analysis, are extremely suggestive. In addition to the references to dada and surrealism, others compared the exhibition to the recently disappeared Parque del Retiro (Retiro Park), previously called Parque Japonés (Japanese Park), in Buenos Aires. This location, mentioned in numerous tangos and folklore, was part of the city's history. The quotation that the artists acknowledge they had in mind ("We met in the Japanese Park. It drove us crazy, we loved it," according to López Anaya),[57] is indicative of another important point in the transformation of the artistic system that was operative at that time. Just as artists of European nouveau réalisme collected materials in flea markets and streets and channeled them into their art, the artists of Buenos Aires collected their junk in the garbage dumps in order to refer, in turn, to another area of the city that had just disappeared: a popular amusement park that was active during the first half of the century and that had been replaced by the most luxurious international hotel in the city, the Sheraton.[58] This "urban archaeology," in addition to introducing heteronomous materials, now incorporated into the art scene a feature of the city that had previously been shunned by circles of high culture, just at the precise moment that it was all disappearing, torn down by the forces of "progress." The artistic avant-garde was being revived through the introduction of elements drawn from popular culture. The syntax of objects, surprise, craziness, monstrosity were all typical features of the amusement park. Now the difference was that these elements would not be reintegrated into the artistic system but rather they would upset its very foundations and make these foundations disappear.[59]

This break with the modernist paradigm would make it possible for one of the experimental lines of the 1960s to displace the reflections on language and insert reflections on reality, propelling the system to a limit that would make it impossible to propose an evolutionary direction in the same terms that had prevailed until that time. The next step, the next break, which would also take place in the 1960s, is one that supposes a total confrontation with the system, now understood not as the language norm, but rather as the circuit of legitimizing institutions of the artistic

system. At this time, the question emphatically posed to the art world, becoming the sole basis for its existence, was, what was the function of art?

Nonetheless, the programmed content of this experience was not carried out by the artists who had conceived of it. In this sense, rather than a point of departure, the exhibition represented for them the end of a process. Although the institutional transformation up to that time had created an environment that stimulated innovation, the artists felt that they were the only actors in this process and they did not feel they were getting the social recognition they were after.[60] The reorganization of the art scene in Buenos Aires, with the new and promising institutions, was still unable to guarantee recognition for the artists. The process was predictable since the most important galleries were already exhibiting some of the informalist artists (such as the group Nueva Figuración, at the Bonino Gallery) and they were making inroads into the international circuit, which seemed to demonstrate that the institutions were opening up new avenues for the first time. However, these artists also felt that what these institutions were looking for was something less radical, less innovative, less upsetting. They were still in charge of the transformation process: "It was all very dizzying, all the time inventing new things. (This) began in 1959 and was constantly increasing until 1963, at which point it stabilized a bit. Perhaps when the Di Tella opened it slowed a bit also, because a new direction had appeared. Before that, it was all up to us. At that moment, both the Di Tella and a leading figure, so to speak, appeared. So to speak because the simple fact of the decisions he made—about who was going to participate—already implied a direction."[61]

The internationalization of the Di Tella award, the centrality commanded by Jorge Romero Brest, the sending abroad of exhibitions of new Argentine art, and the presence of international critics evaluating the quality of Argentine art and international art at the same time, all pointed to the fact that the institutions were also leading the way. The degree to which each side was disposed to make concessions (institutions, by accepting more than they had ever accepted before, and artists, by receiving more recognition than avant-garde artists generally received) leads to the conclusion that, for a period of time, the artistic avant-garde and the institutions were excessively linked one to another.

Argentines in Paris

In 1962 the Moderno bar had practically moved to Paris. For Argentine artists Paris still formed part of a myth. Now that they were actually there, the fact that they only heard talk of New York operated in an instructive way: if this young nation had been able to generate such an important art as to overshadow the prestigious Paris School, other American countries could follow the example and achieve the same success. What was emerging from this new distribution of international power in the cultural sphere, as we will see below, was broadly capitalized upon by the neo-Pan-American and internationalist discourses.

At the beginning of 1962, the artists of the Nueva Figuración settled into Paris and began working relatively close together: Luis Felipe Noé was living with de la Vega in Issy les Moulineaux, a suburb of Paris, while Deira and Macció were sharing a studio in Fontenay aux Roses.

Paris was the place to go, primarily to see works of art, to witness the latest artistic expressions, and to make contact with artists, gallery owners, and influential personalities.[62] It was where one traveled, in principle, to learn the secrets of the international career, with the ultimate goal of starting one's own. However, Noé and de la Vega, far from feeling overwhelmed by admiration, remained relatively isolated in the city and they devoted much of their time to discussing how they could generate new forms of art. The voyage was extremely productive for them, though not in the traditional sense. There they came to understand that the works they had hung in the Peuser Gallery, shortly before traveling, did not represent the rupture they had in mind when they had planned the exhibition. Their long discussions focused precisely on what the best way was to produce this rupture.

Partly as a form of exploration and partly seeking a possible answer, on a night of Parisian insomnia, Noé painted the work *Mambo* in which, for the first time, he compartmentalized the surface with a variety of different supports.[63] For Noé, this was much more than a novel formal solution. The idea provided him with a way to introduce his conception of national history: a history marked by dramatic ruptures, whose tensions he could now express visually. Beginning with his *Serie federal* (Federal Series), exhibited in 1961 in the Bonino Gallery, national history was a central theme for Noé. With this new idea, he was able to address the tensions and antagonisms of national history from a composite structural perspec-

tive. Noé created an opposition between the front and back of the painting, chromaticism versus monochromatism, the blotch versus the written word: a full set of contrasts fused together as a woman's figure pasted to the stretched canvas, a figure whose form culminated in a sketched head that, among blotches and splatters, could be made out in the upper part of the canvas.

The conclusion that Noé had drawn after his first trip to Europe was that he had to create a painting that successfully established a close bond with its very medium, like that which he and de la Vega had admired in Brussels when they observed the profound relation existing between that city and Flemish painting.[64] With this idea in mind, he returned to Argentina to publicly express his view that it was necessary to establish an avant-garde art movement in Buenos Aires.

Nonetheless, not all the artists found the same thing when they arrived in Paris. Whereas Noé and de la Vega had chosen to cloister themselves in their own discussions, observing everything from a critical perspective, others still experienced in Paris the excitement of discovery.

In March 1962 Marta Minujín sat in a Paris bar (having arrived in the city six months earlier) writing a long letter to Hugo Parpagnoli[65] in which she described the impressions of "a 21-year old person, arriving for the first time in Paris, submerged for days and days in this immense ocean of painters, critics, and public."[66] After reviewing for him the most important galleries (Stadler, René Drouin, Jeanne Bucher, Claude Bernard, Armand, Paul Fachetti, Galerie de France, Iris Clair, among others) and which painters most surprised her (including Bran van Velde, Gironella, Bettencourt, Tinguely, Rauschenberg, Marca-Relli, and Arman), Minujín explained that Niky de Saint Phalle and the artists of the Restany group were the only ones that she felt had presented something "new" in Paris:

There is a gallery "J" belonging to the critic, Pierre Restany, which is one of the galleries that excited me the most. It exhibits one of the most defined tendencies I have seen here—which doesn't exist in Bs. As.—they call themselves the "New Realism"—for example, Niky de Saint Phalle constructs brutal white objects. One has an immense steering wheel from a tractor, emerging from the canvas, as well as a fox trap, also glued on, and some boxes and I don't know what else. It is all covered in white plaster and dripping with paint. Another is a kind of white plastered box with colored lightbulbs; with romantic lights and flowers like those found in gardens during the 1800s. But I assure you it is very well-done and offers a visual image that is easy to observe and is very picturesque. I like it very much.

Another, for example, is of draped clothing, very simply: a chair with strewn clothes all over it. Another is a canvas with bottles, glasses, toothbrushes, shoes. A fish skeleton pasted up above—I didn't like that one—others, some very baroque collages, but very integrated with clothing, women's brassieres, corsets, stockings, men's shoes. But all very well assembled and composed as if it were a painting. Another shows, for example, ladders of all different sizes or objects in general, pieces of wood with scraps of metal, shades painted like squares, flags painted all in black . . . torn posters, all of which signifies—according to Restany's explanation—the advent of a new brutal and realistic period, in which what has already been done, cannot be done any better. Quite exasperating but I assure you that many, many young people are following this tendency and it deserves attention. They are real. I have become friends with some of them and there is some real conviction. Well, in fact, I am doing the same thing with my cardboard boxes, without any future. A material that may not exist tomorrow—which is to give no value to the future, perhaps a bit defeatist. . . . Really, this is all there is that is new and different in Paris. I am telling you what there is and not what I was able to see, because I believe there is nothing more for me to see that is current. Of course, this contradicts the preconceptions of the Argentines in Paris, for whom it takes 13 years to get to know the painters and critics and to become known. I, in 4 months or less, have gotten to know more people than all of them put together. I'm friends with many painters—Domoto, Manrique, Zoo Wou-ki, Kemeny, Kalinowski[67]—so, I have had some opportunities that I didn't waste and I have overcome my shyness—which, deep down, we all have.[68]

This letter expresses an impression of Paris that is quite different from that of Noé and de la Vega, and even of Llinás, for whom their culture was linked more to the past than to the future. For Minujín, young, full of expectations, enthusiastic to meet critics and artists, and no less enthusiastic to gain recognition, the city still had much to offer. She was inclined (perhaps more inclined than anyone else) to discover whatever was new, everywhere. For her, despite all the predictions of its imminent demise, Paris was still a city of revelations.

In early 1962 there were so many young artists in Paris that Germaine Derbecq was able to organize the exhibition 30 Argentins de la nouvelle génération (Thirty Argentines of the New Generation) parallel to the exhibition of works by the Argentine sculptor Pablo Curatella Manes during his Parisian period (from 1921 to 1946).[69] This exhibition demonstrated the power to draw crowds that Paris still held over the Buenos Aires artistic milieu at the beginning of the 1960s. Thirty artists were brought

together but, as affirmed by Damián Bayón in a commentary published in Buenos Aires, the exhibition could have included many more: "Many other Argentine artists in Paris, serious and interesting ones, were not included in the exhibition, for different reasons. I can recall many whose work was not exhibited at the Creuze gallery."[70] Minujín commented to Parpagnoli on the success of the exhibition and on its various projects:

In fact, I don't know what your impressions were of the exhibition of Argentine artists, but I can tell you [that I am astonished] because people who really interest me liked it very much. I can tell you that the magazine, *Aujourd'hui*, wanted to feature an article about me, individually, apart from the group exhibition, and they are going to do it. I am not going to exhibit because it is impossible for me to stay here. I don't have a studio or money to pay for a studio, I've worked as best I could in a chambre de bonne where I live and was on the verge of poisoning myself by sleeping beside the car paints I use in my work. But since I've received some interesting propositions I am leaving some paintings here to exhibit them in a gallery of young artists and in an important exhibition of Latin American painting that will open here on the first of August. I'll be returning to see if I can get a grant from the French embassy because, really, 8 months is not enough for me. I need at least two years to affirm myself in what I believe and what interests me. But I'm happy. I've had a good experience and I've also had some unique good fortune now that I'm known, I've been recognized very favorably and there has been much more interest expressed for me here than in Bs. As.[71]

For Minujín, like for Greco, it was important to have been noticed. Their actions were formulated according to a model that understood the avant-garde to entail having an impact, and through their work they both were able to generate provocative situations in Buenos Aires, as well as in Paris and New York. The collection of anecdotes from the 1960s that reflects the scandals of the avant-garde primarily involved these two artists.

In the exhibition at the Creuze Gallery, Derbecq and Noé financed the work of arte vivo (live art) that Greco presented under the title Thirty Rats of the New Generation, which was, just as the title indicated, thirty live rats that Greco brought, as he always did, ten minutes before the opening, and which the gallery owner demanded he remove by the next day because of their odor. The thirty rats, which Greco had baptized with the names of the thirty Argentine artists participating in the exhibition, created labyrinths in the bread loaves they had been given to eat: "I have

realized my dream of working as part of a team!" Greco wrote in a letter to Lila Mora y Araujo.[72] In this effort, Greco was not an innovator. In March 1961, in Spoerri's first individual exhibit of his table-paintings at the Schwartz Gallery in Milan, he presented a pack of rats as artistic collaborators. Nor was co-participative art a novelty: in 1958–59 Yves Klein produced his anthropomorphic paintings and in 1961 Piero Manzoni presented his *Living Sculptures* and *The Magic Base*.[73] Nothing that Greco proposed was particularly original or new, but his work was nonetheless highly significant; they were actions through which the artist appropriated different resources and gave them a unique spin.

On March 13, 1962, during the exhibition Antagonisms 2, organized by Francois Mathey in the Musée des Arts Décoratifs, with the participation of Klein, César, and Arman, Greco wore a sandwich board that said, "Alberto Greco, work of art not in the catalogue." During the opening, carrying his sign, Greco borrowed Klein's ballpoint pen in order to sign two works of arte vivo: a duchess and a beggar. After that, Greco began to produce his *Vivos Ditos* in the streets of Paris, where, with a piece of chalk and a friend (preferably a photographer), he indicated "works of art" and signed them.[74] In this way, with Klein's pen in hand, Greco was performing the kind of action that was linked to the experiments taking place at that moment on the Parisian art scene. Greco had taken part in an exhibition to which he had not been invited and with a borrowed pen he had begun the most representative period in his career, the *vivo-ditos*, a series of works that have been interpreted as the precursors of Latin American conceptualism.[75] From his position on the margins, and making use of borrowed materials, Greco began in Europe a project that did not fit into the history of the European avant-garde, but rather was seen in the context of the history of the Latin American avant-garde, as a portentous and precursory act.

Minujín also wanted to create scandal and to make herself unforgettable. After the first paintings she exhibited in Buenos Aires, which Argentine critics categorized as informalist, she created in Paris large cardboard constructions covered in automotive paint, formulated as flat and curvaceous surfaces that projected from the wall into space. The works that she and Greco showed at the exhibition organized by Derbecq earned favorable reviews from a Belgian magazine:

Marta Minujín is difficult to classify, situated somewhere between sculpture and painting. This young twenty-year old is undoubtedly the revelation of this youth-

ful group of artists. She creates cardboard reliefs covered in automotive paint, violently translating emotions inspired by life as she judges it to be at the age of twenty. She paints her world in dark colors, almost black, matte finish. Alone, a strange thing is posed upon a tripod, dripping in the color red: it is called "the dead dog." Such art eludes description: one feels the impact, or one moves away. Finally, an unforeseen attraction at this exhibition: a glass cage filled with white mice that scurry in and out of a loaf of bread, all under the title, "Live Art."[76]

In Paris, both Greco and Minujín presented their art in environments related to their work, thus the effects they achieved were expressed in the form of collaboration, co-participation, or rejection. Before returning to Buenos Aires, Minujín exhibited in her own home the cardboard constructions and some mattresses that she had exhibited in various Paris galleries. On the last day of the exhibition she burned them all (fig. 4). In a letter to Parpagnoli, she tells him: "I am going to have an exhibit on May 30th in my own studio with two other painters. It is a solution to the bureaucracy of the dealers and galleries . . . I'm doing this because I want to scream about what I need even if only a few people are listening and then I will destroy everything. I've had enough; on to other things. I'll exhibit in the studio because I have no other option and when one is not in Argentina, nor here, it is difficult. There they forget you and here they don't know you, so I'm going to take these measures."[77]

The spectacular, photographed pyre of Minujín was her first happening. It was an action in which she was able to fuse (or, more precisely, to burn) all her previous work. Thereafter she would refer to this action as an act of destruction-construction. It was a solution that avoided transporting her work to Buenos Aires and that, at the same time, enabled her to bring together many of the artists who were in Paris at that moment:

Midway through 1963, I found myself at the end of the grant that had made it possible for me to travel to France. I decided to destroy all my work of the previous three years, but I wanted to do it in a creative way, a way that sprang from my particular point of view at that time regarding death and art. . . .

I was working with mattresses, which I would get from the hospitals, discarded and dirty, and I put them on stretchers, I added some pillows and splattered them with white, black and red paint.

I felt and declared that art was much more important for human beings than that eternity to which only the most cultured have access: art kept in Museums and galleries. For me it was a way to intensify life, to have an impact on the observer, shaking them up, arousing them from their inertia. So, what was I going

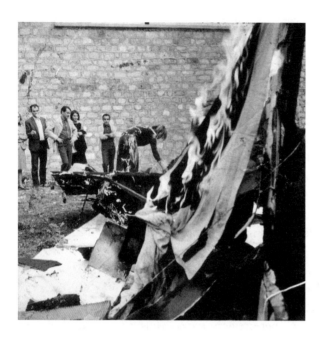

4. Marta Minujín, destruction of her work at the Impasse Ronsin, 1963, Paris. Marta Minujín Archives.

to keep my work for? . . . So that it would die in the cultural cemeteries, the eternity that didn't interest me, I wanted to live, to create life.

I was living in a studio in Rue Delambre, an enormous studio without water or heat, which I had rented unconcerned about its discomforts. I was drawn to the immense space that I could fill with the large constructions I was making at the time.

At one point I decided to use the space as a gallery and I invited two artists to exhibit with me—Lourdes Castro, of Portuguese origin, and Miguel Otero, a Venezuelan. . . . We prepared a catalogue in which I announced that at the end of the exhibition I would destroy all my works. And that is how I began to carefully plan my first happening. I started working on it a month earlier. First I had to find a place to do it. Niki de Saint Phalle, Tinguely and Larry Rivers let me use an empty lot between their studios. . . .

Those were very busy days, all kinds of people came, critics, collectors, artists, dealers, nobody could buy anything of mine, only look at it, because my work was headed to the slaughterhouse.

I took advantage of that moment to invite artists to take part in the destruction of my work. They were to come to the empty lot—Impasse Ronsin—at 6 P.M. on

Thursday, June 6, bringing with them tools they used for expressing themselves in their own work, and they were to create upon my work (as symbolic destruction), they were to impose their images over mine, cover up, erase, modify my work. Create while destroying; incinerate my identity.[78]

In this description, Minujín narrates all the operations she conceived for this unique action: to bring together figures from the Parisian artistic milieu, to show them her work, and have them participate in the creation of their own work using works that she had created while living in Paris (with materials gathered in that very city) and, undoubtedly, make herself known on the Parisian art scene. The artists that took part in the coordinated incineration became, in some way, performers of their own scores. The event was loaded with suggestive consequences. The "use of others," which such artists as Yves Klein were incorporating into their work, such as using female bodies as paintbrushes in his *Antropometrías*, acquired additional significance in the case of Minujín. A young South American artist had succeeded in getting her Parisian colleagues to collaborate on her new work, utilizing her previous work. Thus, she managed to convert them into paintbrushes. Minujín had appropriated resources she had picked up in Paris and had put them at the service of her own work. The act was a connotative action; she had, in a sense, "swallowed" all that she had seen and accomplished in that city where she had gone for learning and now, her works only had meaning insofar as they formed part of the learning process and the assimilation of new ideas whose material remains she had decided to eliminate. After this symbolic and ritual act of the collective pyre was completed, Minujín was fully prepared to return to Buenos Aires and take advantage of all that she had learned in Paris. The burning of her work signaled the end of a period and marked the beginning of what was to become a constant in her work: the only thing that mattered was the present. The action also indicated that she was not considering an immediate return to Paris and that, had she returned, she would not exhibit those works that, in the evolution of her work, represented the past.

With the photographs, critical commentaries, and typewritten account of her actions in her suitcase, Minujín returned to Buenos Aires satisfied that she had found a magical solution to the problem of how to recycle her Paris work in an easily transported format, which she could quickly reveal in Buenos Aires as news. She had seen and learned in Paris all she needed to know, for the moment. Upon her return, all her energies were

focused on occupying the central position in the Buenos Aires art scene, seeking to leave such a profound impression that no one would forget her in the future.

Avant-Garde and Narration

As we have seen, when Noé returned to Buenos Aires in September 1962, rather than ideas, what he brought with him was the decision to contribute to the elaboration of an avant-garde. In the port of Buenos Aires, he was met by Macció, Deira, and de la Vega, with whom he shared a studio for some time. The studio functioned as a laboratory-space where they all worked together.[79] Although they did not all subscribe to the same program, they created a space for the exchange of ideas where they consolidated a group project that found a formula for success. The recognition was immediate and was a consequence of the exhibition at the Bonino Gallery,[80] the invitation they received from Romero Brest to exhibit their work at the MNBA in 1963, and, above all, the participation of the group in the ITDT award competition of that year, at which Noé won the national award and Macció won the international award.[81]

The review published by Hugo Parpagnoli in *Sur* emphasized that it was in the work of these award-winning artists, especially in the work of Noé, that the new ideas had truly risen to meet the challenge:

Noé's paintings are something else. It is more comfortable to see them as a kind of monument to painting. In order to comment on the new creations that they propose, it is necessary to resort to such terms as scenery, amusement parks, visual documents, or natural history books.

They are not comfortable. They make few concessions to the visual customs that even the most audacious painting has given rise to in spectators today. They narrate, express, argue, symbolize and represent. They cannot please on first sight nor can they please thereafter in the same way as paintings are pleasing. The painting, on the side, is like the written text of a theatrical drama. Noé's paintings are stage-works. It is evident that they are the work of one person, but they invite one to imagine a mural composed of the faces and hands of an entire nation, they recall the anonymous work that reveals a period and a world and open the breach through which painting could be freed from the confinement to which it has been subjected for centuries by undersized easels. They constitute a unique case of "popular art" in which the word, art, has nothing to do with practical objects like pots, baskets, or fabrics, but rather with the extraordinary gifts of a painter and

in which the popular word has nothing to do with tedious political literature but rather with the customs, misery, joys, and hopes of the people.[82]

If Noé had returned to Argentina with the mission of establishing forms for a homespun avant-garde, as he expressed in the prologue to the Di Tella awards exhibition, then the favorable and optimistic recognition he received for his work from the pages of *Sur* represented a confirmation of his achievement. This was the verdict of the critics and, in addition to belonging to the most prestigious magazine of the liberal intelligentsia, it also expressed all the ingredients that the modernist tradition had established as symptoms of the avant-garde: Noé's work was audacious, made no concessions, and transgressed established tastes. He was also an artist whose rebelliousness updated all the iconoclastic acts that had been explained to the point of exhaustion by modern art historiography: "The day that women stand before these paintings, exclaiming, 'how pretty'— Parpagnoli said—Noé himself, if they don't domesticate his triumphs, and some other artist of another savage race arising from these lands, will be stirring things up with new and unbearable works. Then it will be necessary to recall (how tiresome!) the famous opera whistles and catcalls that the grave experts expressed standing before Manet's unacceptable *Olympia*."[83]

At the same time, however, there was a series of elements that Noé forcefully vindicated in his work, which escaped the modernist discourse sustained until the 1950s. His paintings were not flat surfaces covered by colors, as Maurice Denis had established in his *Aesthetic Theories*.[84] They were paintings that forcefully responded to his intention of capturing the contradictions of recent history in a space that functioned as a high-tension field.

Noé wanted to compose his work by incorporating the force and the violence of the nation's history, and to accomplish this he worked the surface of the painting as if it were a machine capable of condensing all the tensions operative in the most critical moments of this history. He attempted to approach Peronist populism—one of the most dynamic national experiences in Latin America—in terms of its key aesthetic elements: "The aesthetic phenomenon that has most impressed me in my lifetime, even when I was young, was the awesome onslaught of Peronism. I never stopped seeing, and later participating in, its enormous demonstrations."[85] His interest in Peronism was not due to his adherence to its program. On the contrary, Noé belonged to a family that was so

deeply anti-Peronist that his father had even been the final editor of the *Libro negro de la segunda tiranía* (Black Book of the Second Tyranny).[86] Nonetheless, the aesthetics of the Peronist demonstrations fascinated Noé, the banging of the bass drums—which he considered to be music that was more authentically Argentine than tango or folkloric music—and the huge crowds.[87] All of this he had lived and experienced in person, watching the Peronist demonstrations, and he found himself faced with a torrent of experiences, all condensed in his memories of those marches.[88] The images that appeared in his paintings in 1963 sprang from those experiences.

Introduction to Hope (Introducción a la esperanza, plate 3), the painting for which Noé won the Di Tella national award for 1963, is composed of a repertoire and visual form that derives from a demonstration: the crowd, the placards, the slogans, the soccer contingent, the leader. The painting was practically a representation of a demonstration. At the same time it was an aesthetic program that condensed, in a single image, the formal solutions and arguments with which Noé sought to formulate a response to a series of requirements arising from the need for a local avant-garde that would take into account the national situation as well as the international scene. His painting was a program with starting points, the formulation of problems and solutions, a manifesto written with paintbrushes and colors; they were painted words that, through color and form, organized the various points of his program.

The compartmentalization of the support, an option he had experimented with when he painted *Mambo*, was a malleable way to approach the topic of daily conflicts, which he wanted to capture in his images.[89] In the early 1960s, Argentina's destiny was in question. The country was trying to rebuild itself according to a project plagued by promises, encouraged by the discourse of international development superimposed upon a situation that unfailingly contradicted the possibility for optimism. As investments rose and industry developed, so did conflicts between the opposing blue and red sectors of the army, as well as staunch opposition from labor to the consequences of forced modernization, all of which demonstrates that the optimistic discourse expressed by the government and liberal sectors did not have widespread support.

In *Introduction to Hope* Noé painted a demonstration portraying a crowd—reminiscent of Asger Jorn or Alechinsky—and the placards bearing slogans: "He's with the people, who are with him," "Women," "Clean

hands," "Honest," "Progress," "Firewood," "Champion," "Vote for Blind Force," "Don't abandon us." Although the painting could enter into a dialogue with the local tradition of representing demonstrations (for example, Antonio Berni's painting *Demonstration*, 1934; see plate 3), what this painting really alluded to was the immediate present. This was clearly reflected in the representation of Perón on one of the painted placards. What is certain is that, with this painting (awarded as a representative achievement of young Argentine art and as a sign of cultural development), Noé succeeded in introducing an aesthetic which, during the Peronist period, would have been excluded from high culture as populist propaganda.

With this kind of painting, Noé hoped to establish a close relationship with his surroundings, similar to that which he and de la Vega had observed in the Netherlands during their trip to Europe; surroundings which were, at the same time, radically opposed to those that existed in those countries. The way he believed he could best accomplish this was to work with the contradictions. Dividing the surface was an efficient way to demonstrate the opposition between the two worlds that had entered into conflict with the rise of Peronism. *The Burning of the Jockey Club* (El incendio del Jockey Club, 1963; plate 4), referred directly to an episode that formed part of one of the most violent moments in Peronism's recent history. The painting portrayed the moment in which a crowd of people set fire to a place where, traditionally, intellectual sectors gathered to discuss culture—principally European culture.[90] Noé represented these two worlds (the masses and the intelligentsia) by dividing the surface into two clearly differentiated sections: below, the masses, in blazing colors and engulfed in flames; above, elements that referred to high culture, the paintings that, together with the library, had been incinerated by Peronist factions.[91] The paintings and the faces, appearing in different sections, were intended to reflect the cultural conflict upon which Peronism had been structured and that powerfully affected the current reality.

While Noé wanted to capture the cultural antagonisms that left their mark on recent Argentine history, Jorge de la Vega subverted the material in such a way that reality was incorporated in his works, but he also gave form to his own fantasies. In 1963 he started gluing medallions, folded fabric, and broken mirrors onto pieces of plastic, creating his *Bestiaries* (which he called "schizobeasts" or "anamorphic conflicts"; plate 5). In the text he wrote for the catalogue of the 1963 Di Tella awards, de la Vega maintained, "I want my painting to be natural, without limitations or for-

mulas, improvised in the same way as life, growing in all places and doing whatever it wants, even if I don't want it to."[92] De la Vega combined fragments of the world that surrounded him, not to narrate history the way Noé wanted to do, but rather to insert them into the composition of his imaginary figures, presented in series. The pasted together fabrics were folded alongside fragments of plastic, glass, and metals (in which there was a notable trace of Niki de Saint Phalle or Enrico Baj); forms which, in turn, de la Vega created through a process of frottage with which he repeated the original structure once, twice, three times, submitting it to violent anamorphoses.

Dance on the Mountain (1963; plate 6) is, in a certain way, a collage of references and quotations. The upper left corner of the painting is composed of several pieces of colored glass enclosed in a circle of paint that refers to the spatial concepts that Fontana used in the mid-1950s. The white canvases, folded and glued together, were seen in Kenneth Kemble's large monochromes—such as *Why Do You Fear Me So Much if I'm Human?*, 1961—and, before that, in the paintings of Burri and Manzoni. It would be possible, from a formalist perspective, to trace a genealogical tree for these paintings. The combination is not arbitrary, but rather it is selection of elements taken from the poetics that propose freedom of creation and experimental investigation of materials, but from a perspective deprived of existential dramatics, such as might be found in the paintings of Burri. The materials used by de la Vega and, especially, the color, also disturb the drama and obscurity of the experience surrounding the ephemeral but intense Buenos Aires informalist episode. The innovation was that the information had been combined in such a way that, even when the origins of some resources and forms could be detected, the results took off in new directions.

The collage, understood as a vehicle for quotations and multiple references, and not as a claim to absolute innovation, gave rise to programs that took into account that, in referring to reality (whether this meant a collective, broad history or individual history, with psychological or social connotations), this was a legitimate response to the need for a national avant-garde. In this sense, more than narrative techniques, what varied were the contents of the history being related. Whereas Noé focused on the broad account of history, Antonio Berni investigated the world of the displaced, of those who represented the other face of progress and development and who viewed the big city from its margins. At the beginning of the 1960s, he introduced into his paintings the story of the life of

5. Antonio Berni, *Ramona obrera* (Ramona the Worker), 1962, xilo-collage, 143.5 × 56.5 cm; *Ramona costurera* (Ramona the Seamstress), 1963, xilo-collage, 142 × 55 cm; *El strip tease de Ramona I* (Ramona's Strip-Tease I), 1963, xilo-collage, 137.5 × 56 cm; *El strip tease de Ramona II* (Ramona's Strip-Tease II), 1963, xilo-collage, 137.5 × 56 cm. Private collection.

Juanito Laguna, a boy from the "shantytowns," and Ramona Montiel, a prostitute (figs. 5a–d, fig. 6).[93]

In the 1930s the artist had painted the worker as a protagonist of history, but now his representations entered the world of the displaced and the defeated. Previously, when he painted the workers marching through the streets of Rosario, Berni unified the surface using a single vehicle, whereas now he narrated the different moments in the life of his characters through the accumulation of waste materials. He did not resort to the use of realistic materials as if it were a question of presenting a formal display, avant-garde audacity, or as an iconoclastic or irreverent gesture. On the contrary, insofar as these elements formed part of the world that the artist wanted to penetrate and reveal, he presented them as a form of testimony. Berni built upon fragments, not to reconstruct a unified whole in hopes of bringing about change and unification in the common struggle, but rather to show the contradictions that shattered the discourse of promise. In the creation of his works, he narrated episodes

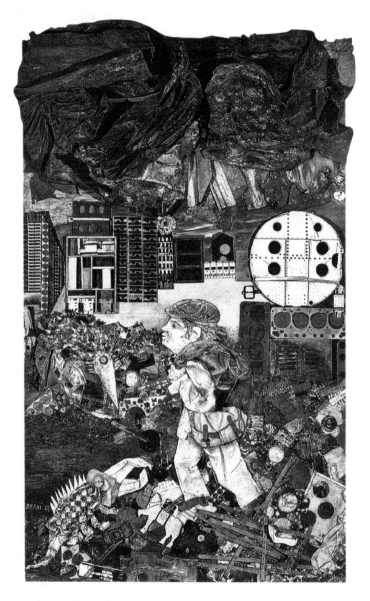

6. Antonio Berni, *Juanito va a la ciudad* (Juanita Goes to the City), 1963,
collage on wood, 330 × 200 cm. Private collection.

of two discarded lives, composed of materials taken from the world that surrounded them. Without possibilities, without future, without promise, his discourse was, precipitously, the discourse of defeat.

The Total Art Object

> We are concerned with the spectator, not in the process of avoidance. We would like to turn him around, like one turns a glove inside out. For him to have different sensations from all the aesthetic experiences he has had in his life before. An art that is inside, moving outward, not the inverse, for this reason all that is proposed to the spectator is meant to have a character of something interior.
>
> We aim for an eighth art, one that goes beyond cinema, one that does not avoid the spectator, one that confronts him with his total desire for being. An art of vital commitment . . . We are interested in all sensations of being, what might be experienced during a soccer match, at the dentist, when waiting for a chicken to be cooked at the rotisserie, when visiting the doctor . . . in the courtroom or at the police station.
>
> Everything seems old to us in the present moment. We want man to feel the old age of his previous attitude when confronted by the artistic object, to feel complicated, committed, his own image combined with what he feels, sees, and tries to do.
>
> To provoke in the participant a new sensation, so new that he himself will have to create a name for it. —Rubén Santantonín

In 1964 the Di Tella Institute barged into the public sphere in a wave of controversy. What was exhibited and awarded that year at the national competition caused confusion among the critics, the public, and the media. In general terms, the selection of works consisted of a synthesis of all that had taken place on the Buenos Aires art scene since the end of the 1950s: Phases (Borda y Peluffo), the Nueva Figuración (Deira and de la Vega), geometric abstraction (Silva, Magariños D.), and surrealism (Aizenberg). But the controversy was centered around the work of two artists that evaded these categories: Marta Minujín and Emilio Renart. Although in 1962 the first issue of the magazine *Primera Plana* had already explained in detail what the "happenings" in the Village were, such words became fully charged with power in 1964.[94] In the case of the Di Tella award, it was not only surprising that Minujín's group of mattresses

(with such a provocative title as *Roll Around and Live*), or the gigantic vagina that Renart displayed on the floor and walls of the ITDT should be called "art"; what was most irritating was that they should be the award-winners. The message that the Di Tella Institute communicated to the public was, unequivocally, that this is the best there is in young Argentine art. And the best, at that moment, was that which invaded the spectator's privacy, values, morality, and even compromised his or her body. The special award that was conferred on Le Parc in the international category of the Di Tella awards that same year established a form of expression that further encroached upon the spectator's space. Le Parc presented work that questioned the closed and definitive character of the art object, he rebelled against the underestimation of the creator and called for the inquisitiveness and participation of the spectator. He wrote in the catalogue to this effect:

We want to develop in the spectator a strong capacity to perceive and to act.

Spectators who are conscious of their power to act, who are tired of abuses and mystifications, could bring about the true "revolution in art" all by themselves.

The spectators could put into practice these slogans:

It is forbidden not to participate.

It is forbidden not to touch.

It is forbidden not to break.[95]

The decisions that were made at this awards competition (which we will return to shortly) were, probably, the same decisions that convinced Romero Brest to finally authorize moving ahead with the project that had been on the drawing boards of the ITDT since 1963. That year Rubén Santantonín addressed a letter to the ITDT with an extensive description of a work which he presented as a complicated and comprehensive experience.[96] The direction in which Santantonín was moving, working materials to an extreme degree of indeterminacy, coincided with his interest in submerging the spectator in a conglomeration of materials and textures capable of inciting new perceptions. In the project that he proposed to the Di Tella Institute, Arte-cosa rodante (loosely translated, Mobile Thing-Art), Santantonín imagined an immense mobile mechanism, twenty feet long, into which the public could enter to participate in a "magical and different world, much of which they themselves would create."[97] A space with lights, textures, dancing, objects animated by people, popular or symphonic music, humor, lotteries, and literature (ranging from the comics of Oski and Landrú to the literary works of Sábato and Borges).

A varied space in which materials, colors, and sensations would coexist, capable of removing office workers, laborers, politicians, and even the artists themselves from their daily lives, inviting them to enter into a fantasy world.[98] Santantonín wanted to raise the aesthetic experience to much greater heights than that of simple observation. His aspirations had points in common with those of Minujín with whom, finally, he worked in order to carry out the experience. In 1963, Minujín was burning her work in Paris and expressing her desire to take art out of the museums and galleries in order to jolt the public and attack the general inertia.[99]

What was being seen in Buenos Aires at that time, and what the artists planned to do in the future, had nothing to do with static objects intended to be hung on walls. "Intensification," "participation," "dissolution," "consumption," "movement," "event": these were terms being used to explain (in Spanish) the disconcerting English words ("happening," "op art," and "pop art") that had invaded the cultural sections of newspapers and described the entertaining and scandalous objects of the new, emerging art form.

In *La Menesunda* (plate 8a–k), Santantonín wanted to take the implicit and latent program of his previous work to an extreme. Beginning in February 1965, he wrote a series of proposals in which he planned different aspects of a multisensory installation. The stages, or stations, basically consisted in the designs of different spaces intended to generate the most varied visual, auditory, tactile, and olfactory sensations. Santantonín imagined this space as a perceptual capsule capable of exciting dormant elements within the spectators, upsetting, compromising, and involving them in an aesthetic experience that would invade different aspects of their sensibilities. In a work such as this, the positive aspect of a term like "compromise" affected nothing less than the creation itself, but it did so to an extreme. For Santantonín, this proposal was the radicalization and culmination of all his efforts. It was a complete experience, a total art object. The proposals reveal that the conception was much more complex than what was finally produced.

In this installation, the spectators had to find their way around various obstacles: to pass through a corridor of neon lights ("we tried to create the sensation of a condensed Calle Lavalle");[100] see for the first time their own image on a television screen; walk over unstable surfaces, squat down, experience winds, cold, heat, blinding lights, odors of fried foods, smoke, a dentist; enter an enclosed space that produced an asphyxiating sensation; enter a refrigerator; pass through a room where they saw a

couple in bed; enter a tunnel where flies were "imprisoned" by a mosquito net against the walls; pass into an enormous telephone where they would have to find a number that would enable them to find their way out; go inside an immense female head filled with articles of cheap perfume and cosmetics; and, finally, find the exit where there was a projector that had recorded the entire process of the spectators passing through the installation.

Not all that Santantonín and Minujín had planned was actually realized, and many circumstances worked against the effect that the work was intended to produce. As Romero Brest emphasized at the conference he gave at the Di Tella Institute regarding this work, "the show was not well-conceived. Nor do I believe that all the experiences have been equally successful. . . . I don't believe they all have the same intensity and, furthermore, I don't believe that the vast majority of the visitors gave themselves over to the experience with the profound commitment that is necessary."[101]

The term *experience*, used repeatedly in Romero Brest's conference on *La Menesunda*, went on to form part of the discursive constellation that defined the problem of the avant-garde. The notion opened an infinite field of possibilities for the artist inasmuch as the experience has no limits whatsoever. It was, by definition, the space into which art was expanding: "I believe that the artists of our time are trying to broaden the field of experience, an experience that never ends, an experience therefore that has no limits, an experience . . . that responds to no prejudices but rather occurs naturally."[102]

Romero Brest did not know how to codify these new forms of expression nor did he know where they might lead. Nonetheless, he decided to adopt an open and positive attitude. In response to those who attacked the installation for its vulgarity and because, in fact, all it offered could also be found at an amusement park, he affirmed "it is probable that the amusement park is the great expressive form of this modern world to which we all belong."[103] Romero Brest had decided not to stand in the way of "development and progress." He confidently maintained that by suppressing political mandates and emphasizing the destruction of all antinomies through "laughter" and "informality," we might establish a "happier" world.[104]

Although this work represented the culmination of all the implicit objectives in Santantonín's program, having written numerous drafts explaining each situation, its significance and how it should be realized, and

although it was Santantonín who had worked with a group of artists, discussing and creating numerous solutions to the manifold problems they faced over the entire two months that it took to assemble the installation, despite all of the above, the mass media attributed *La Menesunda* to Minujín.[105] Youthful, impetuous, imaginative, mass media–oriented Minujín, "the goddess of the Menesunda" and "the girl on the mattress," as she was baptized by the newspapers and magazines, was transformed into a fetish, a celebrated personality, the perfect synthesis for constructing the image of the artist who could establish and legitimize Argentine art throughout the world.

As Santantonín wrote about and created his works, he imagined a powerful turbine capable of bringing the future closer to the present and he witnessed the degree to which this immense collective energy quickly collapsed around the centrality that this young woman magically and incomprehensibly acquired as she was transformed into the model artist that a whole sector of society had been looking for. They did not want a suffering individual, anguishing over the meaning of existence or creation. Nor did they want someone who was concerned for the political or social problems of the world. Rather than the high-collared black turtleneck worn by Santantonín, the media preferred to photograph the necklaces, blond hair, and colorful clothing worn by Minujín at her public appearances. For Santantonín, who had conceived of his work as a radically transformative experience, the disintegration of all his aspirations for *La Menesunda* into the superficial and anecdotal images that appeared again and again in the media represented a complete and utter failure. It was a failure he felt with an intensity that was as profound and powerful as the energy he had invested in the creation of the work itself. His response was to build an immense bonfire into which he threw and incinerated nearly the entire body of his work.

5

THE DECENTERING OF THE

MODERNIST PARADIGM

After being a historian for thirty years, and a critic for half that time, always focusing on theory with an eye toward European art, circumstances were such that with respect to my own country I adopted a politician's attitude, willing to go as far as men will venture, and pointing out the way for others. —Jorge Romero Brest

An ideology of replacement today covers up the weaknesses of the aesthetic that preceded it, at the same time as it signals the appearance on the immediate historic horizon of new realities. Recent art history can help us discover some key indicators. —Oscar Masotta

The first time Romero Brest saw one of the "appetizing" Claes Oldenburg hamburgers, he experienced a variety of sensations, a combination of "astonishment," "disgust," and "stupor."[1] The impact was similar to what he had felt in 1960, standing before a painting by Robert Rauschenberg, one in which the artist combined a stuffed bird with broad brushstrokes. Romero Brest could explain a piece like this by virtue of his experience with dadaist assemblage, but confronted with the soft forms of Oldenburg, representing such vulgar objects as hamburgers, he confessed that he was disoriented and ill-equipped for attempting an analysis.

The anecdote is important as it demonstrates Romero Brest's awareness of the change that was taking place on the international art scene. The evolutionary order of forms, in which each shift in modern art could be seen as a partial solution inexorably surpassed by the next, had been

totally betrayed by the direction taken by the new art of the 1960s. It was not a simple situation for Romero Brest, who had invested so much energy trying to help the Argentine art world find a way to overcome a national art scene whose backwardness had become almost palpable, and who, conversely, had identified abstract art as the art of the future. In this sense, Romero Brest found himself trapped between the program he had previously designed, the program that reality now offered him, and the institutional policy decisions he was required to make on behalf of the MNBA and the ITDT, which he directed. These institutional policy decisions were driven primarily by objectives that, for the first time, seemed to be within reach: achieving success, recognition, and the triumphant ascension of Argentine art in the rest of the world. The international art scene was a game that had opened up for new players to join in, and Latin American artists were not only sitting comfortably at the table reserved for "invited guests" but were formulating their own strategies.

In the transition from the 1950s to the 1960s, the international art scene had changed its agenda and this change was not simply one of degree. The relationship between high and low culture could no longer be regulated by the modernist canon of economy that had determined its evolutionary direction until the end of the 1950s. What had been lost was control. The notion of artistic autonomy, understood as self-reference in language, as anti-narrativity, and as self-criticism, was in crisis, and the avant-garde—or what represented itself as such at the time—appeared to have lost the ability to reestablish itself as the critical authority.

In contrast to other moments in history when Romero Brest felt the need, and had the time, to explain transformations in contemporary art, now he lacked both. In Buenos Aires, although informalism and exhibitions such as Arte Destructivo had introduced elements that destabilized the model which had defined the art of the future, until 1963–64 there were no dominant forms of expression to compare with those that had shaken the New York scene. For this reason, despite his confusion, Romero Brest did not feel it was crucial to try to explain the contents of these changes. In addition, his schedule as functionary and cultural administrator was not compatible with the writing of such extensive books as those he had written in previous years.

The need to take a position and lend direction to the new forms of expression was incumbent on Romero Brest, particularly when he had to judge and referee new work on the local art scene. The Di Tella award of 1964 was the first event to require that he take a public position on art

related to pop, new realism, post-painterly abstraction, and kinetic art. It was at that time that he probably recognized that several of the works on exhibit implied a rupture for which there were no terms of negotiation available between new forms and previous traditions. In other words, artists such as Arman, Rauschenberg, and Minujín needed to be analyzed within different and previously unexplored conceptual parameters.

By the mid-1960s the international art scene had been transformed and Romero Brest could no longer avoid taking a position. In 1965, the Buenos Aires public was aware that to approach "art" it was no longer enough to merely observe a painting hanging on a wall. It was now necessary to wander through neon tubes, to stare at a couple lying together in bed, and to have makeup applied to one's face in an exhibition hall. All this would happen to ITDT visitors who waited for hours in order to confirm the truth of what the newspapers and magazines reported was happening there. The Di Tella Institute fascinated the public by virtue of the confusion and controversy it provoked. It fascinated office workers, young people, artists, intellectuals, and the public that strolled along fashionable Florida Street. It provoked excitement because, as people said, the center of the avant-garde movement was there, establishing limits were being broken, and whoever went there could see and feel things that were prohibited everywhere else.

Such works as *La Menesunda* had transformed art into scandal and spectacle. The newspapers and magazines of Buenos Aires quickly understood that art was now news and they soon created space for the almost daily chronicling of whatever was happening on the "crazy block" of the Di Tella Institute. For a country beleaguered by constant political crises, battered by periodic conflicts between the armed forces and various sectors of the population, a place like the Di Tella was an anomaly as well as a breath of fresh air.

For this ambitious decade there were certain key words that had to be invoked whenever it was necessary to recharge the batteries of enthusiasm and vanity. Words such as *success, recognition, fame,* and *youth* were almost synonymous and they permeated speeches and tiresomely recurred throughout the magazines, such as *Primera Plana*, that contained sections regularly dedicated to art.

At this time a generation of artists came forward and renewed the concept of "youth" that could no longer be represented by those who had emerged in the late 1950s and early 1960s. These "new" young artists cast off the remnants of existentialism and all concerns for political

history and social reality. They turned toward the more vulgar aspects of their immediate environment. Days followed in which one could go to the ITDT and the galleries of Buenos Aires (particularly in Lirolay) and see the acrylic daisies with lights by Susana Salgado (1966 and 1967); the leather and acrylic shoe designs by Delia Puzzovio (1966); the yellow acrylic automobile by Juan Stoppani (1966); the figures of farmers by Alfredo Rodríguez Arias (1966); and the installations with flowers and astronauts by Delia Cancela and Pablo Mesejean (1965).

Amid this climate of excitement and creativity, whose merit was acknowledged by the numerous critics who visited the country to serve on awards juries (such as Lionello Venturi, Giulio Carlo Argan, Jacques Lassaigne, Pierre Restany, and Lawrence Alloway), Romero Brest perceived that his role was, above all, to help open up the ways for change. His function was to enable artists to work toward an art form that would finally do away with the characteristic backwardness of Argentine art that he had called attention to in the first issue of the magazine *Ver y Estimar*.[2]

However, though he spent the greater part of his time imagining the future, the new creative spirit did not merge quite the way Romero Brest had envisioned it. His model was not very different from the one Alfred Barr used to explain the evolution of modern art, nor was it that distant from those intricate genealogical labyrinths the French used to teach the evolutionary twists and turns of the Paris school. Although the development of modern art in this region of the world was never described with such sophisticated schemes as those used by the French (see fig. 1), books such as *Pintura moderna*, published by Julio Payró in 1942, or *La pintura europea contemporánea 1900–1950*, edited by Romero Brest in 1952, showed that the modernist movement was indeed studied, learned, and taught. But the art of the 1960s clearly departed from the ways anticipated by the modernist project. The problem for Romero Brest was not so much deciding on what attitude to assume toward the ongoing transformation, but how to explain it and make it comprehensible.

The precise moment in which Romero Brest had to revise his thinking is significant. Faced with a battle of opposing aesthetics between which he had to make a choice, and confronted by the commotion provoked by *La Menesunda*, which had such tremendous public impact, explanations were urgently needed. Because of the various situations that this participative installation brought together, it was impossible to concentrate on the aesthetic form as stationary content. *La Menesunda* was more precisely a collection of unresolved trivialities combining elements of urban iconog-

raphy with games and liberating situations. All this defined a certain state of confusion for Romero Brest. He realized that if he wanted to preserve the space for reflection and centrality that he had sought to establish for himself in relationship to art, he would have to devise mechanisms for identifying the change.

From 1965 to 1967 Romero Brest came up with various ways to address the latest in contemporary art: from a suspension of judgment and the adoption of a descriptive position, unconditionally affirmative, to more theoretical responses that he worked out from the analytic referents that he had at his disposal. In this way he resorted to both the modernist tradition and certain existential concepts. This sudden need to design models that would identify change not only highlights his commitment to a public he did not want to neglect, but also reveals the degree to which his assumptions about art were in conflict. It is important to emphasize this sudden need because it brought about a collision of several elements: his own convictions, the requirements arising from his commitment to his audience, and the contract that, in fact, he maintained with the institutions whose policies he not only implemented but also helped design. Also important is the combination of concepts, traditions, and references that Romero Brest used to prepare his response to the transformations that were operating in the art of his time. In this combination we see how eager the critic was to explain and legitimize the change.

Although Clement Greenberg was not a figure to whom Romero Brest referred in his meditations, a comparison of the two authors is nonetheless relevant. Greenberg confronted an uncertainty similar to that described by the Argentine critic, and he also felt that a game was being played on the aesthetic field from which something important was being lost. The exploration of a repudiative aesthetic, as conducted by Greenberg, was in stark contrast to the decisions made by Romero Brest, and at the same time it reminds us of the existence of a common debate that went beyond the national art scene. However, it is the national insertion into the modernist rupture, the fact that it happened at a moment when for the first time artists and institutions felt they were part of the great international scene, that affords insight into the strategic choices that Romero Brest designed and the course of his decisions. From this perspective, it is necessary to consider the aesthetic dilemmas that besieged Romero Brest in the context of his personal journey from critic to director of an institution dedicated to the promotion of experimental art and the project of internationalizing Argentine art.

During the 1950s, Romero Brest adhered to a model for art that was comparable to the one designed by Greenberg. They both defended formalism and high art as opposed to kitsch and the effects of middle-class expansion in industrial civilization. However, whereas Greenberg responded to the development of an anti-formalist pragmatism within North American liberalism by making himself the representative of a form of modernism that was distinct from emerging models, Romero Brest's attitude consisted in finding ways to embrace the new aesthetic. While Greenberg was publishing such articles as "Modernist Painting" and "Louis and Noland," which reflected a neo-Kantian twist in his aesthetic and in which he constructed an anti-centralist model,[3] Romero Brest was directing the most important institutions of his country and saw his role, for the moment, as that of nurturing anything that projected an aura of being "new." The resistance Romero Brest had expressed in 1959 toward informalism—when he defended the abstraction of Vasarely (whose work he could still place in his evolutionary model)—clearly gave way to the emergence of local pop art in 1964.

In 1968, Greenberg still thought that the art of recent years was immersed in a "state of uncertainty" and he upheld the following principle: "Artistic value is one, not many. The only artistic value anybody has yet been able to point to satisfactorily in words is simply the goodness of good art."[4] For Greenberg there was superior art and terrible art, the art of pastiche. In the evolutionary order of styles, abstract expressionism marked the culminating point that had been dominant in the cultural environment of the 1940s and 1950s. But this hegemony had collapsed in the 1960s when art had become show business more than renewal. Confronting what he saw as a "Babylon of styles," Greenberg commented in a confessional tone: "Maybe I don't know enough of what happened in those days. I will allow for that and still maintain my point."[5] This obstinacy increasingly distanced him from the central position he occupied in previous decades. Conversely, Romero Brest, rather than pursuing the repudiative aesthetic he espoused in the 1950s, began in the mid-1960s to embrace the anti-formalism that had consolidated positions in Buenos Aires into a common front, unconditionally bent on the conquest of success. Although he would confess his confusion in the face of what the avant-garde had to offer, he would not allow himself to be drawn away from the pinnacle of power he had conquered. This decision enabled him to gain such a position of centrality that it was soon difficult to discern

which factor was most important: the artists, the Di Tella, or Romero Brest himself.

Suspending Judgment and Embracing Novelty

La Menesunda, with its vulgar repertoire of kitsch, had not only taken over space dedicated to art, but also proposed the idea that art was no longer merely an object for contemplation but rather an event to be lived. In 1965, faced with mounting public anxieties in Buenos Aires caused by this installation, Romero Brest gave a lengthy lecture in which he emphasized that in order to deal with the confusion that even he was experiencing as a result of these new forms of expression, he had decided to suspend judgment. And that is precisely what he was suggesting others do who participated in this new artistic experience. The new situation revealed that art was no longer made to last, and that the abstract and idealist foundation had given way to the notion of the "experience." The idea of "representation" was replaced by "presentation"; man had ceased to live in eternity and had plunged into the temporary.[6] By adopting this posture of openness and flexibility, the critic was expressing his awareness that a threshold toward change was being crossed, but it was a change he could not yet conceptualize clearly; thus, he felt it was necessary to avoid prejudice and preconceptions.

In 1966 Romero Brest published his *Ensayo sobre la contemplación artística* (Essay on Artistic Contemplation),[7] in which he advised both spectator and critic to assume a phenomenological posture, one of contemplation and description: "The method I advocate in order to escape this impasse and to understand the works of the ages, from the perspective of 'time,' is simple, though not easy to apply. It requires a radical change in the attitude of the observer as well as the critic, in order to manifest the 'evidence' of 'existing' with words that constitute judgment, instead of being a comparison of 'forms' with 'realities' and 'unrealities.'"[8]

Nonetheless, for Romero Brest it was important to know that change is positive, that it is not a regressive transformation, but rather that it confirms the principle of progress in art. He found the key for explaining that contemporary art had taken a step forward rather than backward in a statement by Sartre, one that the philosopher proposes near the end of *L'imagination*: "An image is an act, not some thing."[9] Based on this statement Romero Brest concluded in his essay that, with works of art, reali-

ties are neither created nor observed, but access is gained to what is real somewhere between the potential to be, and the act of being, reality.[10]

In 1966 Romero Brest also published an article in the magazine *Américas* in which he explained the new situation in Argentine art as the emergence of "consciousness to imagine."[11] He was concerned with differentiating the current situation from the one he had described in the first issue of *Ver y Estimar* in 1948. Romero Brest held that Argentine art at that time was victim to a "formalism" without consciousness, without creative potential, diluted by acts of imitation; now the situation was different. This awareness of a new situation had been awakened in him by the enthusiasm that Pierre Restany had expressed for the new Argentine art in 1964.[12] The younger artists, liberated from the "formalism" that had been paralyzing Argentine art until then, made it possible for art to free itself of its "consciousness of the image" and to rise to the "consciousness to imagine" (which Romero Brest described as "unblocking the unconscious"). So, rather than merely creating images, the goal of art was to provoke the consciousness to imagine. Rather than being the product of creation or thought, what was important was the act itself of creating or thinking. Romero Brest interpreted the happenings as a nonalienating option that eased man's existence.

Clearly, this view did not coincide with the formalist model he had advocated in the 1950s. In 1974, in the new edition of his book, *La pintura europea 1900—1950*, first published in 1952, Romero Brest noted his change of position and the new criteria that now guided his approach to art. From his new perspective, the views he had expressed in 1952—ideas related to ideal categories—were unfulfilled prophecies: "Two correlated errors led me to formulate the aforementioned unrealized predictions: having believed that our art was in hot pursuit of a particular style, and that it would be realized by the Concrete artists. Errors that sprang from my hope—that is, my ideology—holding that in our century 'disintegration is more apparent than real.' So much for optimism! In these twenty-five years we have seen that we were not in pursuit of a style, that humanity is disintegrating because of ideological pluralism, and the Concrete artists, who I recognized as immature in that text of the past, never overcame this immaturity. So I predicted a metamorphosis, but not at all the way it actually happened."[13]

In other words, his predictions of the 1950s had been answered categorically by a reality that did not fit his previous models. Those models

were only valid as a function of the experience with painted images and categories that fit the type of experience that they themselves proposed, but they were inoperative with respect to new aesthetic experiences. For Romero Brest the imagination was now essential for any form of consciousness, even a thinking one. Having said this, he could cast off with absolute confidence the evolutionary characteristic he had attached to his conception of an aesthetic system. This posture was not, however, the only one—nor the final one—that he would adopt with respect to that art which, despite all his plans, had been so transformed.

Other Genealogies for Modern Art

In November 1967, Romero Brest wrote the essay "Relación y reflexión sobre el pop art" (Relations and Reflections on Pop Art), in which he attempted another interpretation to explain the change, now adhering closely to evolutionary assumptions on artistic language. In this text there is an apparent attempt to show that, in the end, the detour taken by modern art was only superficial and that, beyond the contradictions, one had to know how to find the continuity.[14] The text betrays a moment of doubt against which the critic rebels in order to rewrite the genealogy of modern art and to clarify—to clarify for himself—that no principle had been betrayed and that avant-garde artists, properly examined, had not departed from what they believed they had to do. Fundamentally, and using the term that Romero Brest loved to use, they had "to advance."

This essay, which Romero Brest did not publish, is a crucial piece which provides us with direct access to the interplay of tensions and contradictions that riddled the critic's decisions at a time when there was not much tolerance for expressing doubt. His complicated reasoning does nothing more than reproduce all the traps that had ensnared the artistic development of a country that was watching and waiting on the periphery for the right opportunity to move to the center of the art scene. His various lines of reasoning reproduced the contradictions of a culture that did not want to give up its store of knowledge, accumulated after so much long, hard work. Rather than erase it all with one sweeping brush stroke, the idea was to use this knowledge as a launching pad.

Attempting to analyze his "astonishment" over the new North American art, Romero Brest did not just refer to art history. Instead, he began by formulating the basic ontological question that he had so often posed

when confronting a central problem for the comprehension of aesthetic phenomena. Specifically, what was the "being" of this new type of pop art image?[15]

As mentioned above, Romero Brest felt he could understand Rauschenberg through dadaism, but when confronted by an enlarged print of a Lichtenstein comic, or when observing an Oldenburg hamburger, he could not simply resort to a retelling of the history of modern art.[16] He decided to appeal to philosophy and to depart from the idea that there had to be explanations for pop art. For Romero Brest, it was only necessary to ask the right questions. To this end, he began with what has been the springboard for philosophy since Plato and Aristotle: "asombro" (astonishment). This was, in fact, the word he used to define his first impression of pop art.

As part of his argument in this essay, Romero Brest narrates an experience he had in 1964 and that now, recalling it, enables him to understand that pop art responds to a different system. While visiting the halls of the U.S. consulate during the Venice Biennial in the company of Gildo Caputo, director of the Galerie de France in Paris, he witnessed his companion's confusion:

In my discussion with Caputo, I lived the conflict of two conceptions of life in the artistic field, both well-defined and unyielding. It wasn't so hard for me who, like a good Latin American, tried to accept them both . . . The fact is that I suddenly realized how the old continent, represented by France in the person of Caputo, and the new continent in its advanced phase, owing to the "pop art" of the United States, were in real opposition . . .

[Caputo] was resisting—and it wasn't hard for me to understand why—because of the smooth and depersonalized surfaces of the works on exhibit, longing for the touch of the human hand that for millennia had given character to painted or sculpted figures, whether they were primitive, classical, or romantic.[17]

Considering the French works that were selected for the exhibit, we can understand why Caputo was so disconcerted. The paintings of Bissière and René Brô responded to an aesthetic that was very different from that of Rauschenberg and Kenneth Noland, whose works formed part of the U.S. contingent at the Biennial.[18]

In Romero Brest's opinion, the works they were observing introduced two novelties: a surface upon which the gesture and touch of the creator was absent, and the unusual resurrection of the painted or sculpted image with "explicit content" and "simple meaning." It is interesting to note

that while Rauschenberg and Noland were not the same—for Green-
berg, for example, they were diametrically opposed—Romero Brest saw
them as the expression of one and the same system, in contrast to Euro-
pean painting. "How to explain my stupor in 1963 and that of Caputo in
1964?" he wondered. "Was it because we had nothing to interpret, or be-
cause we interpreted everything at first glance?"[19] Rather than demand-
ing interpretation, this new experience simply required observation and
it had the unusual effect of making them feel compelled to move "among
the signs, obedient to an extremely familiar code, exercising our imagi-
nations in a vicious circle: from painted or sculpted image to object, and
vice versa."[20]

To these thoughts, which summarized his own feelings as well as the
feelings of others, toward a different art form—an art form that stirred
up feelings of "astonishment"—Romero Brest added another basic philo-
sophical principle: doubt for all the explanatory systems used to study
contemporary art which reached him through the modernist tradition.
He tried to establish a new genealogy and, to this end, he recalled his im-
pressions on a trip to Greece several years before, in 1957, when his aston-
ishment before Greek sculptures was similar to what he felt in the early
1960s when confronted by Rauschenberg's assemblages and Oldenburg's
sculptures.[21] The Greek images impressed him for two reasons. First, he
found in them the expression of present time, without past or future.[22]
Second, he foresaw in them the imminent revaluation of the academic
forms which was to take place with the new preferences expressed by pop
art.

Recalling the impressions he had formed of classical Greek art in 1957,
while pondering the change he perceived in pop art in 1967, enabled him
to better understand Lawrence Alloway's reaction in 1966 during his visit
to Argentina as jury member for the ITDT awards. On that occasion,
Romero Brest was showing the British critic the MNBA galleries, where
the paintings were still hanging as he himself had originally arranged
them. "When I showed him *Nymphe surprise*, by Manet," Romero Brest
explains, "bored and as if to challenge me, he said: 'I prefer this other
painting.' It was a very academic painting that I had hung near the Manet,
when I was director of the Museum, so that visitors would measure the
enormity of this painting by comparison."[23]

Romero Brest's comparison and Alloway's challenge were both signifi-
cant. Whereas the Argentine critic had re-created the Parisian exhibit of
1865 with his arrangement of the works by Manet and Bouguereau (see

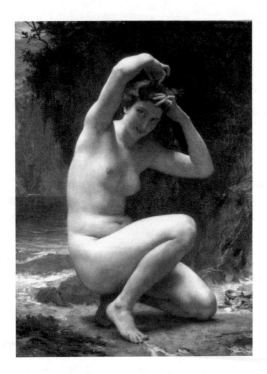

7. William Bouguereau, *La "Toilette" de Venus*, 1873,
oil on canvas, 130 × 97 cm. Museo Nacional de
Bellas Artes, Buenos Aires.

figs. 7 and 8), which had defined a possible point of departure for mod-
ern art, Alloway's averted glance implied a disqualification of all subse-
quent established tradition regarding the visual history of modernity. In
his comparison, Romero Brest wanted to show the degree to which the
nymph's body summarized the battle over modern art. Of all the conclu-
sions that could have been drawn from the placement of *Olympia*—the
painting Romero Brest had in mind when he hung *Nymphe surprise* be-
side Bouguereau's painting—he was most interested in those related to
language.[24] Rather than the chiaroscuro convention employed by Bou-
guereau to depict his Venus, X-ray analysis conducted by the MNBA re-
vealed that Manet had retouched the body of his nymph until it became
an almost homogeneous light area. The nymph was *more than the subject*,
Romero Brest argued, explaining that the paint was not necessarily what
it represented. It was Romero Brest's pragmatic opinion that the bright

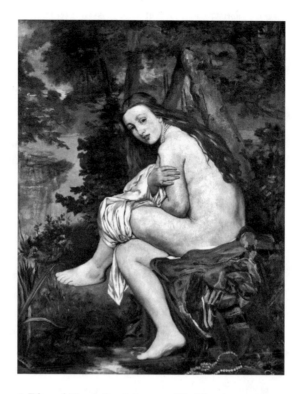

8. Edouard Manet, *La ninfa sorprendida* (*Nymphe surprise*, Surprised Nymph), 1861, oil on canvas, 144.5 × 112.5 cm. Museo Nacional de Bellas Artes, Buenos Aires.

surface of the nymph's body was the beginning of painting as an autonomous and self-reflective practice. At the same time, the critic also demonstrated by this comparison that the model from which each of these artists had departed was a significant factor. Instead of the cold marble surfaces of Hellenistic Greek sculpture employed by Bouguereau, Manet preferred the warm, sensual flesh he had so often caressed with his own hands.[25] By using his own wife as a model, Manet also opened the way toward liberating painting from theme and mythology.

Alloway's answer—turning his head away—epitomized his reaction against formalist, teleological, and evolutionary tradition in the history of modern art. His rejection also enables us to understand why Alloway attacked the exhibition Post Painterly Abstraction, which Clement Greenberg organized and staged at the Los Angeles County Museum

as a demonstration that it was possible to maintain the continuity of the picture plane and modern art.[26] With this exhibition Greenberg was trying to reestablish the force of a tradition that pop art and its successor, "bad art"—capable of turning the Milky Way into a "work of art"—had disrupted.[27]

Alloway's position was diametrically opposed to that of Greenberg. In 1958, when he published his article "The Arts and the Mass Media," Alloway was trying to broaden the dominant view on the limits of art and, to this end, needed to take issue with Greenberg.[28] He especially wanted to dispute Greenberg's criticism of mass-media culture, as set forth in his celebrated article "Avant-Garde and Kitsch," considering it "ersatz culture" and directed at those who did not recognize the "value of genuine culture."[29] Romero Brest's astonishment had points in common with the displeasure of Greenberg, but for different reasons. These reasons did not spring from his frustration over the disappearance of a system that he himself had helped establish through his criticism. Instead, they were related to his feelings as he watched the new directions taken by art, after having learned and taught the modernist lesson from his position on the margins. In contrast to the rejection and obstinacy of Greenberg, Romero Brest was willing to learn the new lesson being offered to him.

Trying to explain his impressions of Greek sculpture, Romero Brest reached the conclusion that its coldness arises from its exemplary character and thereby constitutes a style consisting of norms for achieving an ideal man.[30] Proceeding from this premise, Romero Brest connected this art to that of Mondrian "whose ideas are so strict when it comes to the relationship between reality and art, that one might think they had been expressed taking into account the creations of that heroic past."[31] Thus he established a connection between Greek art and the art of concrete abstract artists. Both artistic expressions, said the critic, seek an imminent legality of form, a trait also found in pop art.

To construct the theoretical model he needed to evaluate pop art, in addition to classical Greek art, Romero Brest resorted to existential elements, by means of which he understood that man has employed two methods for artistic creation: "one that tends to present the essential part of certain realities, considering them necessary, and one that tends to existentialize other realities, accentuating contingency."[32] He associated the second method with pop art, and from this perspective he considered forms on the basis of their "thingness," that is, "outside of historical context."[33]

After the Greeks and the neoclassicals, Romero Brest claimed, the line of "thingness" was restored by the abstract concrete artists, the creators of "things," as opposed to abstract, figurative, or nonfigurative expressionism that depended on feelings. But the limitation of the concrete artists was that they did not refer to any content, and it was now necessary to return to content in order to reestablish the connection between the individual and the community. This is what, according to Romero Brest, the pop artists did, surpassing the neoclassicals (who still referred to mythology) and presenting things as painted or sculpted images that, like the Greeks, existed in a perpetual present.

The "being" erected in the images of pop art were depersonalized, vacant of ideas and emotions. The comparisons between Greek art from the classical period and North American pop art could be sustained, according to Romero Brest, by precise examples: "At the risk of offending more than one reader," Romero Brest said, "I declare that the painted image of a Campbell's Soup can (Warhol), or Oldenburg's famous 'Bedroom Ensemble,' are as permanent, serene, and exemplary artistic expressions as Policleto's 'Doriforo' or the Parthenon itself."[34]

In this way, Romero Brest established new connections and continuities in Western artistic culture that sprang from classical Greek art, proceeded to neoclassicalism, then skipped the entire modern art tradition in order to be incubated and developed by the Paris school (from Courbet to cubism), and finally emptied out directly into Mondrian and pop art.

In fact, Romero Brest was not the first to establish this connection between pop art and Greek art. In 1966, Nicolas Calas, referring to the hegemonic artistic shift from Paris to New York, made a similar comparison when he wrote: "After the fermented light of the Impressionists, the aromatic pines and apples of Cezanne, the intoxicating colors of the Fauves, and the alcohol dreams of the Surrealists, defeated Paris was reduced to the imageless insomnia of Existentialism. The center of art moved to New York. With the self-assurance of Periclean Athens, New York mixed its Doric and Ionic elements."[35]

The difference between Calas and Romero Brest was that Calas, on the one hand, vindicated pop art specifically to avoid dealing with essential questions because of his addiction to the image as image, and to fight this battle with a repertoire that was previously disdained, such as commercial advertisements for consumer goods—that is, "life" or anti-art. Romero Brest, on the other hand, combined his explanations with elements of

existential philosophy (which, according to Calas, had also contributed to the fall of Paris) and did not dedicate a single paragraph of his essay to popular icons or the images of pop art, which Calas had focused on.

However, with this new and strange explanatory system, Romero Brest had achieved his goal. Having established the direct genealogy between North American pop and the glorious culture of the classical Greek period, he felt that his problem was resolved. Recent North American art, the latest avant-garde, according to this point of view, sprang from a tradition that was different from the one established in France, but was nonetheless legitimate for Western culture. The Athens of Pericles was in no way inferior to Paris. The whole problem resided in finding a different way to arrive at the same point.

Even Romero Brest must have found this explanation to be forced and absurd; in fact, one paragraph before he had confessed in a defeated tone that "the argument is not altogether convincing."[36] This was probably the reason why he decided not to publish his essay. Several years later, in the reprinted edition of his book *La pintura europea (1900–1950)*, published as *Pintura del siglo XX (1900–1974)*, the critic included some ideas from this text, returning to the comparison of Greek and pop art, but he abandoned the idea of drawing parallels between Warhol and Policleto.[37] In the interval between writing the essay and deciding to publish certain fragments of it, what had changed was his need to find lines of continuity.

However, for the moment, this new associative chain enabled him to reestablish the evolutionary logic that seemed to him to have been suspended by pop art. Contemporary Argentine artists were producing happenings, installations, and objects; They were no longer exploring territory that lacked past and future. Production could once again be understood within a tradition to which the artists belonged, to perpetuate it and supersede it on the "voyage to new regions" that art always implied. Romero Brest observed: "I think that once the stupor has passed no one in all honesty could fail to notice how the traditional characteristics of painting and sculpture remain in the works of pop art. The evolution of Lichtenstein towards landscapes complete with elements of Greek architecture, and that of Rosenquist towards large decorative murals, not to mention the 'Matissean' compositions of Wesselmann, all testify to the scope of the revolution they embodied. Even the soft objects of Oldenburg, charged with the sensitive plastic suggestion of form, are related to traditional sculpture."[38]

In stark contrast to Greenberg, who placed pop art alongside pastiche, Romero Brest had found a place for pop in his discourse on artistic progress: "How can one think, then, that pop artists had taken a step backward by resurrecting the painted or sculpted image of explicit content? Moreover, how can one not think that, by doing so with such impersonality, they did not also facilitate a step forward?"[39] Having been incorporated into the history of artistic progress, in a unique way, pop art was also prepared to receive its own death certificate. "Generally speaking," declared Romero Brest a few pages later, "I dare say that pop art is finished."[40]

In this new view of the evolutionary chain of forms, Argentine art became one more link, revealing its new independence and originality: "[In our country] pop art at first resembled more the pop art of the Europeans than that of the United States, but the consequences here were different, not only because the creators soon stopped being 'pop' but also because they turned toward 'media art' and 'visual experiences.'"[41] According to Romero Brest, then, Argentine artists had come to understand the language of progress, they had become a part of it, and, finally, they had continued the march toward the future by developing new forms of artistic expression.

By the mid-1960s, like a juggler performing his craft, Romero Brest conveniently switched from one explanatory principle to another: the modernist tradition, the new North American art, the new Argentine art, and the need to sustain through criticism the sense of movement and renewal that characterized it, with the ultimate goal of securing its place on the international art scene. It is interesting to mention that all his different explanations, the different models that he developed in order to note the change, concluded with an affirmative view toward the future. Romero Brest was convinced that this was a great moment for Argentine art. He conceived his own role as that of a charioteer whose duty was to guide and facilitate the unlimited expansion of the process taking place around him, even though he was no longer able to anticipate the forms toward which Argentine art would evolve.

In an interview in 1968, he was asked, "What is the meaning of the struggle you are committed to?" Romero Brest responded, "At times, I am the first to be horrified by the consequences of my liberating attitude. But I will never turn back."[42]

An All-Consuming Aesthetic

Oscar Masotta's writings on art constitute an intense and compact phase of his intellectual production. It was intense because Masotta quickly immersed himself in the most contemporary art. He wanted to see it, to grasp it, to develop a theoretical approach to it. It was compact because all of his work on the subject was produced between 1965 and 1969.[43] During those years he taught courses, organized conferences, traveled, arranged and analyzed happenings, and published various books. Despite being contained within a precise period of time, it was also an intense phase because his theoretical contribution was one of the most innovative and, in this sense, practically the only one that focused on Argentine artistic production during those years. Much occurred in Argentine art during the 1960s, but there were very few aesthetic analyses to accompany these events. In this context, Masotta himself considered the Argentine media to be virtually inarticulate with respect to analytical consideration of the work of art.[44] In *Conciencia y estructura* (Conscience and Structure), he comments that Romero Brest, Pellegrini, Derbecq, Parpagnoli, and Paz are the only critics in Buenos Aires with knowledge to discuss the most contemporary productions, but that they rarely write in publications other than catalogues.[45] During those four years, Masotta did not try to consider all the artistic phenomenon taking place in Buenos Aires. He did not behave as a critic. He dedicated himself to a restricted "new" zone.

The chronology of his incursion into the field may be situated and documented: it began in a highly visible location, the Torcuato Di Tella Institute, where Masotta led two conferences on pop art in September 1965 which were published as a book two years later with a prologue dated August 15, 1967. Between the conferences and their publication he took two trips to New York, which provided him direct access to those artists and works of art that he had written about before he had actually seen them.[46] Masotta summed up the experience in a single phrase: "The 'fantasies' I had about the works before making any direct contact with them proved to be quite similar to what I was able to perceive when facing the works themselves." In contrast to Romero Brest, for whom the reproductions were not sufficient preparation for the shock he experienced when he first saw Oldenburg's hamburger in 1963, when Masotta saw Segal's work at the MOMA in 1967—a plaster cast of a bus driver in a real seat behind a

steering wheel—he was already accustomed to the images from what he had seen in books and magazines. Masotta had read, written, and spoken extensively about the novelty of pop art, which he considered the most important change imaginable in twentieth-century art after surrealism—the definitive leap and radical metamorphosis of the work of art.[47] Whereas Romero Brest analyzed pop art from an existentialist perspective, following the evolutionary model of modernism, Masotta approached it with the theoretical instruments pertaining to the translation theory machine recently arrived in Buenos Aires—essentially, structuralism—of which he was, at that moment, a principal proponent.[48] Between September 1965 and August 1967, Masotta not only traveled a great deal, he had also become an organizer and creator of happenings. Unlike Romero Brest, Masotta was not troubled by the artistic tradition of modernism; this tradition did not form part of the wealth of experience and knowledge that he transmitted during those years. He did not have to settle any debts with the past and, for this reason, he could afford to confront the most recent art of the twentieth century and select that which enabled him to analyze and affirm in superlative terms the changes wrought by pop art. The problem of the autonomy of language, the crux of the discussion on abstraction and realism, was not a problem for Masotta and, as he himself declared, it was not a problem for art either. For this reason he valued the rupture and the anticipation that dadaism represented (the movement reviled by Romero Brest in his *Historia de la pintura europea*, published in 1953) and which, only now with the pop explosion, could be fully understood and developed. In this sense, for Masotta, dadaism was an anticipated and inadequate movement in its own time; the pop artists were the first to assimilate the lessons of Duchamp.[49]

In the 1967 prologue, Masotta confirms two central hypotheses proposed in his 1965 conferences. First, the distinction between pop and surrealism based on the homologization of the difference between redundancy and metaphor. While metaphor works *through* constituted meaning, from which other meanings are produced, redundancy is an operation whose objective *is* the constituted meaning: an operation at the service of the transmission of meaning. Pop art is situated where meaning is constituted. Second, Masotta refers to the great historic correlations established between surrealism and psychoanalysis, on the one hand, and pop and semantics, on the other.[50]

In his first approach to pop art, Masotta proceeds according to an au-

thoritative criteria, recognizing the sites established by those who have already written about pop (Alloway, Salomon, Hahn), and through his quest for some structural unity in pop. For Masotta, this is where the problem of the relationship between real and imagined objects is located; the presence of a code is brought to light. The multiplications of the pop image express the structures of social content transmission, they give prevalence to "structure" over "form."[51] Masotta is familiar with and discusses some of Romero Brest's hypotheses, for example, his assertion that Warhol makes images. Warhol repeats images and in this reiteration resides the interpretive key. The individual image is eroded by the multiplication, it is reduced to a sign. In pop art, the subject is not the thing but rather the language.

Segal's work—plaster casts that maintain a strong internal, rather than external, relationship to the individual—provide him with the opportunity to explore an interpretive theory of pop art as an "inverted mask." The exterior of the cast masks the object and this mask is the equivalent of language, of the system of social communication captured in a block of plaster. Segal's casts conserve, embedded within them, a collective code of gestures, of corporal movements socially marked by the profession, family, and class of whoever served as the model for the cast.[52]

One last element in Masotta's book deserves mention: his anticipated answer to the politicization of art, to a later debate regarding the relationship between art and politics, as indicated by Beatriz Sarlo.[53] In this context, he affirms:

It is difficult to see a reactionary art in pop art, as affirmed by its detractors on the left. First, because in a certain sense no art could be reactionary, and because to think of a relationship of immediate inherency between politics and art only leads to a dangerous cultural terrorism. And, second, when things are seen from a perspective with the mediating potential of knowledge and the sciences to reduce the power of technocracies or to upset this power, this potential seems today to consist in a certain conversion of knowledge into method, in the construction of knowledge that is capable of proving its value and its truth not only on the level of the totalities that it can realize, but also on the very level of concrete operations, on the immediately perceptible and on the products of social action that are effectively realized.[54]

The publication of these conferences suffered criticism for what was included and what was excluded. This is explicit in the prologue when Masotta emphasizes that the arguments of the book do not consider the

correlation between visual arts and communication media.[55] Masotta considered these aspects after his conferences. The results would appear in subsequent books in which the impact of his readings of Susan Sontag are apparent,[56] particularly in the essay he wrote on the simultaneous exhibitions of Noé, Le Parc, and Minujín in New York.[57] In these texts Masotta adopts a descriptive approach to the works under consideration in order to differentiate between them and identify their particular and unique qualities.

Masotta's letter to Romero Brest from 35th Street in New York, dated January 2, 1966, reveals the impact produced on him by the cultural environment. When Masotta arrived in New York, Romero Brest had just departed. The climate was unseasonably warm and Masotta considered this fact in his own particular way: "Is something happening? In fact, this 'summer in the winter' (as the cab driver said) seems to *mean* something. But don't get upset now: in fact, it means nothing."[58] Masotta had traveled to New York with financial support from the Di Tella Institute and this letter served, in a certain way, as a report on his activities: "Since I am in a certain sense a 'Di Tella man,' given that the institute sponsored my trip, I thought it useful to let you know that, at the very least, I am not wasting my time." At that moment, Romero Brest was trying to get the North American galleries to help fund the International Di Tella Prize competition. Masotta had learned of this from Marta Minujín. For this reason, he had offered to collaborate by studying and interviewing the artists that might be invited: "In this way, during the prize competition there, I could support your work and explain to people about the invited artists, one by one, their tendencies, objectives, positions, the groups they belong to, their biographies, characteristics of their work. I could play the role of a Di Tella 'curator.'"[59]

The letter reflects the distance between what Masotta imagined and what he was discovering. It was a distance marked by the constant comparison of how he processed the information he read in books and how he now confronted the actual works. He needed to have at his disposal new intellectual instruments, including perceptual tools. Romero Brest seems to have served as a good interlocutor for what Masotta was discovering:

It's a pity that you and I never dared to speak more. Had it been otherwise, I could now summarize for you what seems to me to be "going on" here, as they say, in New York. I mean: in "painting." But since I'm afraid of "designations," I'll avoid that word. However, I will tell you that it seems to me that I'm beginning

to understand. What I'm sure of is this: if one wants to pay attention to works of art, today, to consider them, one cannot avoid taking into account three levels of difficulty: a) works of art inextricably linked to criticism, particularly today; b) criticism, by which I mean to say, the verbal language written about works of art; and c) the works of art. It is generally the case that when one speaks about the works (especially when one creates "panoramas"), the three levels overlap. In fact, it is very difficult to escape this danger given that the words are linked to the objects we are discussing and those are already worked through the words. In any case it seems to me that we can not forget this "zero degree" of critical reflection. At least I try not to forget it.[60]

As the works were linked to the discussions, Masotta also intended to study the critics. This consideration quickly became his purpose: "This year in my seminar at the University I will try to work, from the beginning, on this idea, and I will begin by classifying the different criteria of detectable classifications in certain critics, those who speak to us and have spoken to us about what is happening in the 'visual arts' panorama (I'm not sure what term to use) since 1950."[61] Masotta set to work on this task. For this reason, he spent every day in the library of the Museum of Modern Art. Consistent with the initial proposal in his letter, in addition to closing himself up in the library, Masotta also visited art exhibitions: Yves Klein at the Jewish Museum in New York; a sculpture exhibit at the Whitney (which led to his decision to study the meaning of such designations as "primary structures," "cool," and "systemics"). In addition, he met with Scott Burton, lunched with Kaprow, and was surprised that Michael Kirby was making objects: "According to our anxious mentality, from the happenings (particularly those by Kirby, who had already discovered the instrument, or the reality, of the 'information media') to the making of objects, there is a regression. Can there be? Marta and Jacob[y] would say yes." Masotta attended a happening "in the old style," held by Kaprow at 13th Street and Sixth Avenue, and he described it in his letter: "The happening was scheduled as one of this week's 'Angry Arts' events. We left from St. [Mark's Church] and, walking, Kaprow took the group of people who were participating to the location. There, beneath the open sky and hardened by the hard buildings of New York, he distributed whistles and told us to blow them and, lighting matches, he told us to separate and to walk away, and that was all. It seemed idiotic: but, as they say, there was poetry. We were in the middle of an immense parking lot and off to one side there was the enormous building of the Electric

Power Station. In that 'short happening' (that's what it said, in writing) Kaprow exemplified himself. I liked it."[62]

In December of that same year Masotta wrote to Romero Brest again, but this time from Buenos Aires, bringing him up to date on the project he had proposed for a Guggenheim grant and for which Romero Brest was to be one of his references.[63] Among his objectives, Masotta emphasized the importance of developing, a posteriori, a pedagogical project for the training of personnel regarding the relationship between visual and audiovisual arts and communicational problems.

I have been committing myself, little by little, to the visual (or audiovisual) problem. Martha [Minujín] has had a lot to do with this: she's the one who inspired me with that "anxious object" that she has above her, and that definitive penchant for "anxious history," which is to say, for the evolution of a process where every stage devours the one immediately preceding it. People here are beginning to associate me with the happenings: but, in truth, I have already devoured them. Perhaps in Martha, and in you, as well as in myself, there is a lot of pedantry, in the "grand style," and a muted fear of death. But, for my part, I have to say, at least, that I have come to know the fascinating inverse of those pedantries and that death: a taste for "things." Sometimes I suspect that the happenings have not died. But, anyway, how can one reconcile that suspicion with the inverse suspicion, the one that speaks to me of "anxious history"? An inferno.[64]

This second letter followed his experience as organizer and designer of happenings and signaled the tension of replacement that was driving his aesthetic line of thought—a tension in which one experience devoured another. It also defined a relationship between Masotta and Romero Brest that was not characterized by confrontation. Beyond the differences that can be seen between his way of thinking and Romero Brest's—which Masotta subtly highlights—Romero Brest was also disposed to support him, through both the Di Tella Institute and his personal recommendations. In this sense, Masotta performed the role of a creator capable of theoretically sustaining a process of aesthetic transformation that Romero Brest wanted to stimulate and prevent from stalling.

A short time after writing this letter, on January 15, 1967, Masotta concluded the prologue for his next book, *Happenings*—a collection of diverse texts driven by a single methodology: structuralism, structural anthropology, semiology, communications. All the contributions refer to what he calls happenings, some anti-happenings and Roberto Jacoby's

"art of the media." Masotta synthesizes the differences: while the happening is an art of the immediate, of the appreciable, of perception, mass media art is an art of mediations, it is more immaterial.[65] The sociological subject of the happening demands the language of sociology. Signaling again a difference between him and Romero Brest, Masotta indicates the difficulty of speaking about Lichtenstein or Kaprow with the language of Heidegger.

In the compilation of this book, Masotta brought together texts by Alicia Páez, Eliseo Verón, Roberto Jacoby, Eduardo Costa, Raúl Escari, Octavio Paz, and Madela Ezcurra. In a seminal essay—"Los medios de información de masas y la categoría de 'discontinuo' en la estética contemporánea" (The Mass Information Media and the Category of "Discontinuity" in the Contemporary Aesthetic)—Masotta traces a genealogy of the local happening (Arte Destructivo, Alberto Greco, Marta Minujín, Squirru, Puzzovio, Giménez, Marilú Marini), he signals the definitive and radical leap produced in relation to the transformation of the artistic object, and he investigates the possibility of finding a general principal that might help understand this new genre of artistic expression called the happening. The text proposes, again, the reading of great historical correlations, the relevance of the signifier in relation to the signified, and the notion of "discontinuity" or of "compartmentalized structure," which signals the conditions that permit this particular form of constituting messages that characterizes the happening. Referring to Barthes, Masotta indicates the expressive potential of the discontinuous, the bricolage of materials, of living, organic substances. This notion of "compartmentalized structure" permits the analysis of the happenings by Michael Kirby and the works of Rauschenberg.

Upon his return from New York, where in just a few months he had witnessed approximately ten happenings (by Allan Kaprow, Dick Higgins, Al Hansen, Carole Schneemann, and Vostell), Masotta planned to hold a series of happenings in Buenos Aires which he had to postpone due to the tumultuous political situation resulting from the coup d'état that brought Onganía to power. Finally, he was able to proceed with his plan in November 1966 at the Di Tella Institute. He described it as a festival of happenings driven by the pedagogical purpose of introducing a new aesthetic genre and, in the process, he was transformed from critic into creator of happenings. He hired twenty croupiers, "the kind that auction off cheap jewelry," to whom he paid more than they usually charged for

their work in order to display them to the public at the same time as Masotta emptied twelve fire extinguishers. This happening took place in an uncomfortable setting in the context of political radicalization which was rapidly affecting the intellectual field.[66] When his leftist friends asked him about the meaning of it, Masotta replied, "My happening . . . was nothing other than 'an act of social sadism made explicit.'"[67]

Masotta's reflections on art culminated in *Conciencia y estructura* (Conscience and Structure), the book he published in 1969 with two prologues, one from April 1967 and the other from September 1968. In "Después del pop: Nosotros desmaterializamos" (After Pop: We Dematerialize), Masotta noted four properties of the avant-garde—updating with respect to art history, opening up of new aesthetic possibilities, negation relative to preceding art, and questioning of the great genres—which suggested that the happening was a form of avant-garde expression. Nonetheless, within the happening a feature could be glimpsed that revealed its own negation: a new genre of artistic activity had emerged in Buenos Aires in 1966, the "Art of the Mass Communication Media," whose creator, Masotta affirmed, was Jacoby.[68] A dematerialized art inasmuch as "The 'material' ('immaterial,' 'invisible') with which this type of informational work is constructed is none other than the processes, the results, the facts and phenomena of mass media information (for example, the media of radio, television, newspapers, periodicals, magazines, posters, billboards, comics, etc.)."[69]

To this end Masotta organized a new series in the Di Tella Institute with a happening that he called *El helicóptero* (The Helicopter)[70] and a purely communicational work titled *El mensaje fantasma* (The Phantom Message).[71] Masotta also offered an explanatory conference, "Nosotros desmaterializamos" (We Dematerialize), a title he took from a short article by El Lissitsky, particularly that phrase which refers to the process of dematerialization that marked the period (from letters to telephone to radio), in which material diminishes and multiplies: "Lazy masses of material are replaced by liberated energy," the Russian constructivist concluded. This idea functioned as a trigger, as a seminal nucleus for his own ideas.

Media art was for Masotta the new avant-garde form of expression. It was an art that constituted objects, that spoke not to the eyes but to the understanding. Carried out with immaterial materials, media art is produced for unspecific audiences and it uses the same media as advertising.

Masotta argued, "The problems of contemporary art reside less in the search for new content than in research of the 'media' for the transmission of that content."[72]

Romero Brest and Masotta arrived, by different avenues, at conclusions that converged upon a single certainty: pop art, the happenings, "media art," and "visual experiences," mutually overcoming and devouring one another, had converted Buenos Aires into an avant-garde center.

STRATEGIES OF INTERNATIONALIZATION

When we first put forward the concept of the Alliance for Progress, one of the proposals . . . called for a much greater flow, back and forth between North and South, of the intellectual, artistic and cultural life . . . the signs of the vitality of a society. I think that too often we . . . look more to Europe and not enough to the South. . . . Latin America also looks to Europe for its inspiration in these areas and not to North America.

So I am glad now, instead of our all looking East, which we must on many occasions, that we now look North and we look South. And we hope from this current back and forth, there will be greater stimulation. — John F. Kennedy

The young artist in America knows that new international centers of art are being born on this continent and they are already prerequisite points of reception, from New York to Buenos Aires, from Rio de Janeiro to Lima, from Mexico City to São Paulo, from Caracas to Washington. — José Gómez Sicre

We wanted to convert Buenos Aires into another recognized art center. Since the Second World War Paris had lost its undisputed position at the center and we believed it was possible to incorporate Buenos Aires into the group of great cities, each with its own recognized movements. — Guido Di Tella

Buenos Aires is on the threshold of a great organic mutation comparable to that which made New York an international center of contemporary creativity. On the Río de la Plata we are witnessing the first signs of this awakening. The day is not far off when Buenos Aires will be invaded by a cloud of collectors, galleries, critics and analysts and, above all, by creators "of 100% Argentine art." — Pierre Restany, "Buenos Aires y el nuevo humanismo"

I remember that, until the decade of the 1960s, every time I opened a European or North American magazine, something surprised me, but during the 1960s nothing surprised me. We had done everything. . . . Well, we were in the period of the Di Tella Institute, we were there, at the heart of the international avant-garde. — Kenneth Kemble

Although these quotations contrast sharply, they all express the need to discuss and rethink the structures of international power in art. The point emphasized in each refers to one of the many projects defined by the institutional initiatives of the 1960s. The idea of occupying vacant space, as suggested by Guido Di Tella, contrasts in meaning and force with the abolition of existing power relations that Gómez Sicre called for during the 1960s from his offices at the Organization of American States (OAS) in Washington, as well as the idea of generating a flow of cultural exchange between North and South American cultures, as called for by President Kennedy. It is important to recognize these differences because various projects emerged from them that, while occasionally complementary, did not share the same goals. There was a latent conflict between these projects that became unsustainable as it developed. Although the implicit disagreement never took the form of outright public confrontation, it could be perceived and its impact was felt in the public discourses that served for the promotion of institutional initiatives and, above all, in the images used for these initiatives.

During the 1960s, exhibitions of Latin American art circulated with unprecedented frequency and dynamism. The program for the exhibition of Latin American art (organized at the headquarters of the OAS beginning in 1947),[1] the selections of art that were sent to North American and European museums, and the initiatives organized in every Latin American country all generated an intense circulation of images that crisscrossed diverse spaces in an energetic search for recognition. In both Latin America and the United States institutions were created and reorganized in order

to respond to these new currents in cultural exchange. The ideological goals underlying institutional policies were not always aligned, as we can see through a careful analysis of the process of reorganization of the institutions and inter-American circuits during this period. The often direct confrontations that took place, together with the myriad frustrations that drained the enthusiasm of artists and extinguished the fervor of the proclamations emitted by new institutional programs, soon revealed the degree to which such terms as "internationalism" and "exchange" could evince contrasting and often antagonistic agendas.

The goal of this chapter is to examine the organization of institutional circuits and the degree to which competitions were converted into spaces of dispute and conquest in which, more than fleeting recognition, what was at stake was confirmation of having risen one more step on the ladder to success. A secondary aim of this chapter is to review the situation of Latin America vis-à-vis the interests of the United States after World War II in order to reevaluate the project of restructuring that took place during the 1960s—a process intended to add credence to the conviction that Latin America was a priority and that its culture, as well as its social and economic problems, had awakened a genuine interest among the most outstanding personalities in the North American professional world.

The American Family

After 1945, North American policy toward Latin America could be characterized by its certainty that there was a shared geography, history, and destiny, and that Latin American republics were effectively part of a natural front in the West that had to defend democracy against communism. However, belonging to this front did not yield the same benefits for everyone: whereas Western Europe received 65 percent of United States foreign aid, Latin America received only 3 percent.[2]

As indicated by Elizabeth A. Cobbs, for the nations that had formed the OAS in 1948—to foment inter-American relations in the postwar era—the unanswered question was why there was no Marshall Plan for Latin America. Neither the formation of the United Nations Economic Commission for Latin America (CEPAL) in February 1948, nor the ratification of the Letter from the OAS in May of that same year, had successfully modified the ways in which the United States viewed relations with Latin American republics. These views were clearly expressed in a letter written in 1954 from Dwight D. Eisenhower to his brother Milton, then

presidential advisor on Latin American issues: "In the case of the Americas, I do believe that loans are more appropriate than grants. . . . We want to establish a healthy relationship that will be characterized by mutual cooperation and which will permanently endure."[3] This policy would be modified in the mid-1950s when pressure was intensified to establish an economic assistance program similar to the Marshall Plan in the context of the process of democratization and economic growth taking place in various Latin American countries. On the basis of a letter written in 1958 from Brazilian president Juscelino Kubitschek to Eisenhower, proposing a "Pan-American Operation" to revitalize the inter-American system through political and economic cooperation, a series of recommendations known as the Bogotá Act was presented at the meeting of the OAS in September 1960. Here the United States supported the need to promote programs of social and economic development financed by internal sources as well as a Special Inter-American Foundation for Social Development to which the United States would immediately contribute $500 million to be managed by the Inter-American Development Bank.

The Alliance for Progress was officially launched by President Kennedy in an address delivered on March 13, 1961, to the Latin America Diplomatic Corps in the White House. In ten points he outlined an assistance program oriented toward economic, social, and cultural development as well as toward promoting Latin American studies in the United States.[4] In August 1961 the Inter-American Economic and Social Council of the OAS called a meeting in Punta del Este for the signing of a document in which the United States offered $20 billion over the next ten years for financing a plan of action for economic, political, and social reforms directed by three organizations—the OAS, the Inter-American Development ment Bank, and CEPAL. That same year these organizations signed the Tripartite Agreement sharing responsibility for directing and carrying out the Alliance program.

The factor that triggered the creation of the Alliance was the Soviet Union's association with the Cuban Revolution and the "First Declaration of Havana," which was a response to the OAS condemnation of Cuban policies, read by Fidel Castro on September 2, 1960, declaring "Cuba a free territory of America." This "declaration" also established the right of self-determination for all people, repudiated North American invasions and foreign involvement, and defended Cuba's solidarity with the Soviet Union in case of imperialist attacks. In early April 1961 the

Kennedy administration went ahead with the Bay of Pigs invasion, which had been planned by the previous government, was carried out by the Central Intelligence Agency (CIA) working with Cuban exiles, and ended in a spectacular defeat. Faced with the spread of communism throughout Latin America (a threat whose danger was better appreciated when it was seen that these territories could be converted into bases for missiles aimed at the White House), other solutions had to be considered. Finally, economic aid was adopted as the most suitable strategy.

In the redesign of the civilizing mission that the United States undertook as part of the last stage of Westernization in the postwar period, the ideology of development was hegemonic. As indicated by Arturo Escobar, this gave rise to a particularly privileged space for exploring the interconnection of practices and symbols of reason, economics, representation, society, and modernity.[5] From a critical perspective, *development* as *ideology* might be described as a device to link forms of knowledge of the third world with forms of power and intervention. At the same time, it functions to muffle other realities that are seen as extraneous to its purposes. Mark T. Berger has analyzed the degree to which area studies programs created since the postwar era emphasized language and culture as a key space for understanding various parts of the world that have been of concern to the United States.[6] The United States' understanding of Latin America served to strengthen inter-American power relations and to contribute to North American management of Latin America.[7] The idea of modernization based on the transference of North American values and institutions was viewed as a solution to problems of underdevelopment. This theory dominated professional discourses, which were conceived as offering theoretical alternatives to Marxism.[8] The conviction of the North American government, as well as intellectual circles concerned with these areas of study, was that the poverty of underdeveloped nations facilitated the spread of international communism. The theory of modernization, with roots in the Industrial Revolution and the French civilizing mission, and whose objectives were organized according to a lineal view of history, was understood as a period of tutelage that would end when colonial society emerged civilized and independent. During those years, specialists in international relations generated policies that were formulated on the basis of these premises.

In 1963, the American Assembly published the results of a meeting held at Columbia University the previous year titled Cultural Affairs and

Foreign Relations.[9] This volume, which forms part of a larger series of similar publications that were published in the United States during the 1950s and 1960s with the objective of formulating international policies, contains a magnificent summary of the strategies and objectives on the basis of which North American cultural policies were organized during the Cold War. The book focuses on a line of argument mainly intended to raise North American consciousness regarding the necessity and importance of culture for the improvement of the U.S. position vis-à-vis international scrutiny. Images of art, as Nelson Rockefeller anticipated, played an important role in the good neighbor policies.

For the Columbia University intellectuals, two examples demonstrated the efficacy of using art and culture as propaganda: the success of the French in their "civilizing mission" and the use of intellectuals by the Soviet Union to spread communism throughout the world.[10] Regarding Soviet policies, George N. Shuster—who was among those gathered to discuss international cultural relations at Columbia—stated, "One of the most widely employed methods was to form elite groups, generally composed of discontent and unemployed intellectuals in neglected areas, through whom could be spread propaganda specially designed for this purpose."[11]

In February 1961 the Kennedy administration created the post of assistant secretary of State for Educational and Cultural Affairs, responsible for developing programs to stimulate the flow and exchange of young talent on the continent. In September of that same year the new Fulbright-Hays legislation was passed, authorizing the use of government funds for attracting prominent cultural and sports figures to the United States and for exchanging books, translations, and international exhibitions.[12]

At the Columbia University conference, Philip H. Coombs emphasized that international politics and cultural and educational issues were now as important as political, military, and economic issues.[13] Coombs summarized some of the measures that had been taken in order to accelerate and focus the flow of exchange:

—Give more emphasis in exchange programs to inviting foreign visitors who have been strong critics of the United States, and liberalize visa regulations to make this possible.

—Put more accent on youth in exchange programs, on labor, women, and intellectual leaders, and on all the influential progressive elements of less developed countries.

—Increase our educational and cultural interchange with communist nations as rapidly as feasible even while political tensions prevail, taking care to safeguard our own vital interests but avoiding unproductive rigidity and quibbling in small matters.[14]

Such objectives and programs (whose explanatory logic was not so different from that used by Kenneth Kemble for the exhibition he wanted to send to the United States) are abundant in books, articles, and reports published in the early 1960s. These goals gave rise to a series of institutional initiatives for which artistic images played an important role and whose most surprising feature was the repetitive nature of their expressive formulas. The artistic images (just as in the case of postwar relations with Europe) were important in the configuration of the ideological apparatus intended to show the world the new North American supremacy. However, in the case of Latin America, the crux of the strategy, beyond sending North American art exhibitions abroad, consisted in the organization and reception of Latin American art exhibitions in the United States. This task was undertaken by a succession of institutions that replaced one another as their objectives became increasingly precise.

In 1963, after an enjoyable conference in the Paradise Islands of the Bahamas, a group of intellectuals established the Inter-American Committee (IAC). This First Inter-American Symposium was financed by Huntington Hartford, president of the magazine *Show Business Illustrated* and a controversial figure in the New York artistic milieu. At that time he was constructing the Gallery of Modern Art in Manhattan in order to oppose the MOMA's influence over the concept of modern art ("My museum represents the taste of the country more," affirmed Hartford, whose aesthetic tastes were eclectic and conservative).[15]

North and South American painters, writers, composers, architects, and educators had gathered to discuss, face to face, the problems of Latin American intellectuals and, above all, the causes of their anger toward the United States.[16] The discussions were organized to focus on very precise questions that addressed the position of the intellectual in society, that raised questions about the interference of politics in art, the potential political power of intellectuals in South America, and the position of intellectuals with respect to the United States, with respect to Fidel Castro, and with respect to the Alliance for Progress.[17]

In response to accusations of military interventions, of supporting dictatorships, and of anti-communist paranoia by the Latin American repre-

sentatives, the North Americans maintained that change was under way. The creation of the IAC (which would be composed of Latin Americans and North Americans) was approved at the end of the conference and celebrated enthusiastically by President Kennedy when he received the committee at the White House upon its return from the Bahamas: "We don't want to see the artistic and intellectual life used as a weapon in a cold war struggle," the president affirmed, "but we do feel that it is an essential part of the whole democratic spirit. . . . The artist necessarily must be a free *man*."[18]

The program of the IAC was organized on the basis of objectives similar to those dominating discourses that proposed stimulating "exchange" as a form of propaganda: "Developing ways to obtain broader distribution in Latin America of U.S. books and pamphlets to counteract the flood of these same materials from China, Russia and other Communist countries."[19] Such goals, like many others that accompanied these new programs, were expressed in different ways but generally carried the same message: in the face of the communist threat, it was necessary to join forces and these forces derived from investors, cultural agents, and government organizations among which, as would soon be revealed, was the CIA.

The IAC was presided over by Robert Wool, chief editor of Hartford's magazine and a genuine activist for inter-American relations. The new institution was intended to serve as an information center, offering assistance and organization related to cultural issues on the continent to all institutions that might need aid. The IAC presented itself as unique in this area; however, a few months earlier, the MOMA had launched its own international program for Latin America. This overlapping of functions gave rise to conflicts that affected harmony with the Rockefellers. In 1963, when Wool requested a subsidy from the Rockefeller Brothers Fund, David Rockefeller noted the conflict of interests existing between the international program of the MOMA (on whose board of directors he was a sitting member) and the IAC (to whose board Rodman Rockefeller belonged).[20] The aid was conditioned by an agreement between the MOMA and the IAC in which the role of each institution in the "dialogue" was clarified. In the Memorandum of Understanding drawn up and agreed upon by these institutions, it was established that the IAC would focus on cultural areas, but it would recognize the professional experience and ability of the MOMA in the areas of graphic arts, painting, and sculpture.[21]

As a way of affirming the cultural aspect of its exchange program, on February 20, 1964, the IAC changed its ambiguous name to the Inter-American Foundation for the Arts (IAFA), the name it would use until its dissolution two years later.[22] The proliferation of initiatives designed for the promotion of knowledge, communication, aid, and improved relations in general, assumed specific forms of visibility in the visual arts spaces. "Knowledge," "dialogue," and "exchange" were words that permeated all the programs seeking to counter the policies of confrontation between the United States and Latin America.

However, exchange policies were not being stimulated exclusively in the United States. Latin American institutions also actively participated in generating strategies to ensure that their own interests were served. This was particularly evident in the case of Brazil, where Nelson Rockefeller's interest in promoting the emergence of innovative artistic institutions stimulated the initiatives that led to the foundation of the Museum of Modern Art in São Paulo in 1948.[23] Nonetheless, as indicated in chapter 1, in spite of Rockefeller's interest in this event, the museum opened with an exhibition organized in France and brought to São Paulo by the canned-goods magnate Ciccillo Matarazzo Sobrinho.[24] Although Matarazzo received Rockefeller very amiably when he visited São Paulo in 1946 (he even made him a gift of a painting for which the millionaire had expressed his admiration), there is no doubt that the Brazilian businessman used all the aid received from the first world to formulate his own program: to endow São Paulo with a cultural institution that would showcase its new economic power. This would be achieved definitively in 1951 with the opening of the first São Paulo Biennial which, in 1953, would even succeed in bringing Picasso's *Guernica* to Brazil. Despite much of what has been stated regarding the use of art in Latin America as an arm for fighting the Cold War, as well as observations to this effect by Shifra Goldman and Eva Cockcroft,[25] it should not be concluded that only North American institutions were motivated by political programs. As we shall see, the virtual flood of Latin American art exhibitions that flowed into the United States in the 1960s was also promoted by the new and very active Latin American institutions.

International Awards for National Recognition

The main problem for institutions and administrators in carrying out the internationalist project in Argentina was how to develop strategies that would lead to success. Although the coup d'état that toppled Frondizi's government represented a major setback for the projects generated by the modernist discourse, the parenthesis provided by the election of Arturo Illia in October 1963 gave new hope to the idea of democratic continuity in spite of the fragility of the institutions. Beyond the periodic crises that affected the stability of the political and economic system, many still held the conviction that a great opportunity was at hand for Argentine art. The year 1961 was key as successive exhibitions increased the certainty that Argentine artists finally had something new to offer. To communicate this message of certainty to the rest of the world it was necessary to place their work beside the best in international art.

In 1962, at the same time as the Di Tella Institute was undertaking its first ambitious initiatives by organizing the First International Prize for Sculpture, Kaiser Industries of Argentina began to organize its own internationalist program. These circumstances vividly illustrate the degree of linkage and competition established between the two institutions. The models for cultural activism that were constructed were very much in accordance with the origins of the institutions themselves: Di Tella splendidly represented the aspirations of the national bourgeoisie fortified by "developmentism," while Kaiser, with headquarters in Oakland, California, was more closely tied to inter-American concerns.

The distances and points of contact between the two programs were established, primarily, through the implementation of the events they organized. The organization of prize competitions, jury selections, the images they both recognized—all may be seen as programs that were never clearly articulated, but whose goals were clearly discernible when the decisions made in each case are critically reviewed.

In 1962, when the First American Art Biennial was announced, Kaiser Industries had already been involved for some time in the annual organization of events recognizing Argentine art by holding exhibitions in regional galleries. The initiative was intended to be decentralizing with respect to the powerful city of Buenos Aires and to respond to a foundational spirit that sought to create a new cultural space. It expressed a passion for adventure that was meant to perpetuate the legend of Henry J.

Kaiser, who left the Eastern United States to make his fortune in the West.[26]

Hoping to transport their financial success to the symbolic sphere of cultural representation, Kaiser Industries of Argentina (IKA) concentrated on designing a complex apparatus to operate within a context of activities they denominated "public relations." During the early years IKA underwent intense growth which nourished various community programs—workers' housing, health clinics, and educational institutions.[27] In 1962 organization of the American Art Biennial was added to their involvement with regional galleries.[28] These policies were designed very much in accordance with those designed by the OAS, under the guidance of José Gómez Sicre,[29] director of the visual arts division, who not only was active as a jury member for the first and second biennials, but also served as consultant for its organization and on questions relative to the position it should adopt vis-à-vis the conflict between communism and the "free" world that was raging over the continent.[30]

On his visit to Argentina, after attending the inauguration of the Alliance for Progress and the signing of the Letter of Punta del Este in Uruguay in August 1961, Gómez Sicre expressed his opinion to Argentine newspapers regarding the Soviet Union's first submission to the biennial: "Truly horrible. A provincial gallery from any underdeveloped American country would have exhibited a higher level of artistic conception."[31] He expressed his concern over the "international political intrigues" that were attempting to convert the São Paulo Biennial into a forum for the dissemination of the "marvels of the artistic culture of the Soviet Bloc" in Latin America.[32] The images of this submission were drawn from a social realism that had no relation to any of the programs of artistic renovation under way at that time (among the institutions, artists, or sectors of the critical intelligentsia), as confirmed by its presence in São Paulo.

In 1962 both the national and international situations contradicted the optimism that Kaiser Industries hoped to encourage with its initiatives. Shortly after President Frondizi refused to vote to suspend Cuba from the OAS at the meeting of consultation in Punta del Este (in February 1962) and the triumph of Peronist candidates in gubernatorial and legislative elections, a coup d'état overthrew him on March 29. Meanwhile, the presence of the minister of the armed forces for Cuba, Raúl Castro, in the Soviet Union in early July foreshadowed the imminent missile crisis of October 1962. Not only did this situation not affect the organization

of the Biennial but, quite to the contrary, it seemed to consolidate the ideological bases of its program. The underlying idea for the organizers seemed to be that the biennial should contribute to the unification of the American continent in the face of the communist menace.[33] This call to brotherhood also colored Gómez Sicre's repeated militant proclamations in the editorials he wrote for the *Bulletin of Visual Arts* of the Pan-American Union. Institutions, magazines, and competitions all combined to produce a stream of insistent discourses aimed at establishing a consensus on the necessity for art to join the struggle against communism.

To crown the initiative's success, the American Art Biennial carried out active press campaigns, consulted with specialists, invited representative figures from both the national and international art worlds, and organized traveling exhibitions of selected works from the biennial. From the start, the plan involved three successive stages, reaching out first to neighboring countries, then to all of South America, and finally to the entire continent, including the United States. In contrast to the São Paulo Biennial, which was geared toward remaining cutting edge and measuring up internationally, the American Biennial aimed more for the diffusion of local artistic values. Rafael Squirru emphasized that it was a politically useful program: "It is important as a manifestation of culture, and culture is the most important means of political penetration. . . . It is necessary that our men travel; that they visit other countries, bring back prizes, and later speak of what they have done."[34] However it was also necessary for prestigious figures from the international circuit to appreciate what the country was doing in situ. In this context, the decision to ask the esteemed Sir Herbert Read to serve as head of the jury was a kind of guarantee not only because he was a recognized authority in the artistic world, but also because his anti-communism was appropriate for the Biennial Program. In the postwar debate Read had championed the necessity to uphold the Western cultural system ("culture itself") in the face of "communist agression."[35] Furthermore, this choice made it possible to cover various fronts: the international (or European) with Sir Herbert Read, the North American/Latin American with Gómez Sicre, and the strictly Latin American with representatives from the participating countries.[36]

In spite of the increasingly heated political climate that surrounded the biennial, the event itself took place in a peaceful and enthusiastic context. As in 1945 and 1956, Raquel Forner once again provided the most appropriate image for the opening. Overall, the distribution of the awards was

conducted according to amiable and equitable criteria that allowed each country to take home a prize.[37] Like the implicit program of the biennial, the images also seemed to refer to the epic history of the continent. In particular, these images remitted to a controlled informalism in which the shapes and materials gained significance from Latin American tellurism (exaltation of the landscape). These features were apparent in the almost craftsman-like care with which textures were manipulated, tones were contrasted, and the very titles themselves alluded to natural contents.[38]

Nonetheless, at the awards ceremony, it was "the future" that would emerge as the clear winner. The titles, more than the language or forms used in the works of Forner, pointed to other spaces, other worlds, the imagination, and all that Latin America finally wanted to conquer. In the works *Los que vieron la luna* (Those Who Saw the Moon) and *El astronauta* (The Astronaut), the artist utilized a repertoire of shapes and forms that were appropriate to themes of the moment, feeding into the imaginary of the future and also forming part of the Cold War struggle, such as the space race and the possibility of landing the first man on the moon. These were topics related to the ways of progress, expressed in a risk-free format, addressed by a prestigious artist. Once again, Forner appeared as the ideal candidate for a prize whose objective was not intended to give rise to a new art form but rather to provoke dialogue and the circulation of positive images on a continent that needed to affirm its self-assurance. The work of Forner stood on solid ground. On one hand, it was a response to all "regressive," "anachronistic," and "totalitarian" art. In this sense, just as her work had been recognized in 1956 as symbolic of freedom, now its renovated semi-abstract representations conformed to the requirements of modernization. However, not all the critics agreed that this was the direction in which the art of the future should move. Although Romero Brest was a member of the awards jury and had supported the choice of Forner as prize winner, his preferences veered in other directions. Furthermore, we should recall that within the framework of Romero Brest's previous plan, Forner lacked one of the most necessary credentials to qualify as a model for the new era: that credential was youth.

To maximize the initial achievements of the biennial the works were transported first to the Museum of Modern Art in Buenos Aires and then, shortly thereafter, on a tour of the United States. Presented as New Directions of Art from South America, the exhibition was sent to the American Federation of Arts in New York, to the Pan American Union

9. *Américas* magazine 15, no. 3 (March 1963): 16–17. Exhibition at Pan American Union, 1963, Washington.

in Washington—where the opening was attended by Jacqueline Kennedy, whose photographs appeared in the March 1963 issue of the magazine *Américas* (see figs. 9a–b)—and, finally, to the Kaiser Center and the Museum of Art in Oakland. None of these spaces was an appropriate port of entry to the new avant-garde world scene. The MOMA, that bastion of modern art, was still out of reach for the organizers of the biennial, whose efforts and greatest aspirations were directed at involving that institution in their program.

While the Kaiser Center was concentrating on the model of *inter-American internationalism*, the ITDT, as it displayed the work of Argentine artists beside the most outstanding in international art, was positioned more along the lines of an *internationalism* with *nationalist* features. The 1962 International Prize for Sculpture (see fig. 10) was intended to intensify and stimulate communication, competition, and creative activity. The main idea was to "promote Buenos Aires as a cultural center on the international level and to attract attention to Argentine artistic activity." These objectives could be achieved through "the arrival of world-class foreign critics to evaluate exhibitions," and the "participation of both foreign and Argentine artists in the awards competition."[39]

The winning artist was also expected to participate in the competition for the international prize the following year. This complex formulation

10. Instituto Torcuato Di Tella, Premio Internacional de Escultura (ITDT International Prize for Sculpture), 1962. Archivo ITDT, Museo Nacional de Bellas Artes, Buenos Aires.

of the program implied organizing and carrying out a series of tasks intended to improve the level of competition. In some ways it was an affirmation of certainty that *in just one more year* Argentine art would be of sufficient quality to compete, *on the same level*, with the most exclusive in international art. This view of the future reveals a concept of culture as a process that is always perfectible, as if it involved training for and accomplishing specific goals—goals that corresponded more to the formation of an athlete than an artist. The transformation of the jury also tended to maximize the possibilities for achieving success. In addition to Argan and Romero Brest (see fig. 11), the jury also included James Johnson Sweeney who, until 1961, had been the director of the Solomon R. Guggenheim Museum in New York.[40]

The selected artists, however, did not quite satisfy the aspirations for international representation. The attempt to secure France's participation with the work of the sculptor César failed. Finally, the field contained five countries (the United States, Italy, Brazil, Spain, and England) to which was added, at the last moment, Argentina, including Kosice, who was the artist that won the national prize shortly before the international competition was announced.[41]

The participation of the North American sculptor Chamberlain introduced new aesthetic criteria. Was it necessary to accept that the artist was no longer concerned with composing relations among forms, but merely collected junk? Not even informalism, which allowed for materials drawn from daily life, had gone to such extremes. For the first and only time, the ITDT published the jury's debate over who would be awarded the international prize. The commentaries that each critic made while observing the various works revealed a value system in which such terms as "facilism," "naturalism," "anecdotal," and "improvisational" served to disqualify. One of the points of agreement, in this context, was established with respect to the works of Chamberlain. While Argan found Chamberlain's facilism irritating, Romero Brest's doubts had more to do with his naturalism: "I would be much happier if he had done these same things with old parts, but not so obviously the junk from an automobile that had been in an accident."[42] This degree of *transparence*, or *obviousness*, irritated both Argan and Romero Brest. As we have seen, for the Argentine critic it was very difficult to break with the system of values that he had established during the 1950s. In 1962, for Romero Brest, such concepts as "form" and "composition" were not empty notions. During jury deliberations, the arguments he used in his effort to defend Louise Nevelson ("I believe her

11. Jorge Romero Brest and Giulio Carlo Argan during the Premio
Internacional de Escultura (ITDT International Prize for Sculpture), 1962.
Archivo ITDT, Museo Nacional de Bellas Artes, Buenos Aires.

whole problem is an artistic problem"; "There is a literary aspect, but in a good sense; literary in the sense of meaning, not in terms of literature itself," and "She seeks the meaning of forms") were all intended to recognize the value of composition and form, while at the same time taking into account a certain degree of risk.

After analyzing the submissions of each artist, the jurors agreed that the prize should go to Lucio Fontana, Louise Nevelson, or Pietro Consagra. Although they acknowledged the quality of all their work—and, for this reason, they decided that the $20,000 allotted for acquisitions on behalf of the Di Tella collection would be divided among all their works—it was necessary to choose only one of the artists to receive the prize. Like a lawyer delivering his summation to the jury, Romero Brest offered a series of arguments, explaining the issues at stake and to which the prize should respond. It was important to reward work that was not a promise or an anticipation of what was yet to come, but rather an achievement in itself; it was also important that the work be current rather than conservative; finally, it was necessary, indeed it was crucial, that the Di Tella prize competition itself should gain distinction, a form of recognition, and not serve as the simple confirmation of other prize competitions. It was this last reason that motivated the Argentine critic to propose Nevelson for the prize rather than Consagra (who was championed by Sweeney) in order to avoid the appearance that the ITDT was only ratifying the prize the Italian sculptor had won two years earlier in Venice.[43] Romero Brest's agenda took into account the international repercussions of the prize and for this reason it was necessary to aim for differentiation and distinction.

The competition fulfilled all its objectives with the 1963 edition when the Argentine Rómulo Macció was awarded the international prize by a jury composed of Jacques Lassaigne, William Sandberg, and Romero Brest.[44] The prize competition coincided with the inauguration of a new building for the ITDT, a building that belonged to the family business at 936 Florida Street and that had been remodeled for this purpose. The new headquarters represented a rhetorical commitment to reinforce the experimental and open-spirited program that was directed at the new public the institute hoped to attract.[45] The location offered more spectacular possibilities, particularly for the awards ceremony involving an Argentine artist. Pucciarelli, still in Rome, expressed his surprise and indignation at this unexpected turn of events in a letter to Guido Di Tella: "To say that Slechinsky, Rivers, Saura are not recognized and to reward others who merely produce a mixture of these artists is an act of bad faith. . . . This

is the only time that the Foundation has weakened. . . . That Macció deserves encouragement I have no doubt, but to award him a prize rather than the creators of the 'other imagination' is like saying that Ginastera's *La estancia* is better than Stravinsky's *The Rite of Spring*. It will cost the country a lot of money to keep up this pretension, and attempting to prove it will be very sad indeed."[46]

The unanimous decision to award the prize to Macció was indeed a daring step by the jury and, at the same time, it was the perfect way to end the inaugural ceremony for the new ITDT building on Florida Street.[47] As a crowning touch, Lassaigne lavished Argentine art with praise in the article he published in *Le Figaro* under the title "Il faut compter avec la peinture argentine" (It is necessary to consider Argentine art): "I have to admit that I couldn't have imagined the vitality and the breadth of daily artistic life in this country. . . . It is inconceivable that there has not been an exhibition of contemporary French art in Argentina for 25 years."[48]

This complex network of interrelations, which yielded so many benefits, also functioned in relation to the Di Tella collection. Now, rather than relying solely on the advice of Venturi (which, as we have seen, led to a series of errors), this jury, which awarded prizes and recommended acquisitions, had been converted into something resembling a board of international consultants that functioned within national borders. From the Argentine point of view, these changes tended to increase the commitment of those who wielded influence in the world of international art and consequently they were implicated in the process of maximizing local production, international recognition, and the constitution of the national artistic heritage.[49] What, then, were the appropriate forms for international success?

In 1962 Romero Brest, who promoted the internationalist program but was not unaware of the position of industrialized countries regarding national artistic production, anticipated many of the paradoxes that would complicate the reception of Argentine (and Latin American) art in the international centers. Even though he had participated in the selection of works to be sent to the Venice Biennial, he had not been convinced by the reasons for which he believed Berni had been awarded a prize: "Besides the undeniable quality of his work, no one could possibly overlook the *local tone* which gives the images he paints a strange telluric force. And we already know how much this aspect interests Europeans in particular."[50] The praise for localism was even more evident for Romero Brest when he confirmed that, when faced with the work of the artists included

in the Argentine submission (Mario Pucciarelli, Clorindo Testa, Kasuya Sakai, and Rómulo Macció), the jurors only perceived their indebtedness to European and United States art: "What is most curious in this respect, paradoxically, is that the Europeans frequently and avidly search for relationships, meticulously examining the works, and when they find it they diminish the importance of the work on that very basis."[51] The conflict of views that Romero Brest had pointed out did not prevent him, for the moment, from disregarding the problem and gathering up the prizes as if they were trophies: "The grand prize that Berni brought home from Venice, just like the grand prize that Alicia Penalba brought with her from São Paulo the year before, has begun to earn our art the right to an international existence."[52] Internationalism for Romero Brest, meant success and recognition beyond the national borders, regardless of the style involved.

The Circulating MOMA Exhibitions

For Romero Brest it must have been satisfying that David Rockefeller invited him to become a member of the Inter-American Honorary Sponsoring Committee of the International Council of the Museum of Modern Art.[53] By July 1962 it was clear that the National Museum of Fine Arts was not the institution that would catapult Argentine art into the world. Added to the constant financial hardships that had converted Romero Brest into a door-to-door beggar for funds that scarcely covered the costs of keeping the museum's doors open, there was the affront represented by the museum's acceptance of Bernaldo Cesáreo de Quirós's gaucho paintings, donated while the critic was traveling abroad. These red paintings with nationalist themes, which for certain sectors represented the "true" national spirit, were precisely the opposite of what Romero Brest wanted to support. His resignation was a public gesture that converted him into the epitome of intransigence. However, he had risked nothing. With his prestige intact, and the Rockefeller offer in hand, he accepted the directorship of the CAV at the ITDT.[54]

The Preliminary Proposal for a Five-Year Program of Cultural Exchange between the United States and Latin America, sent by Rockefeller, was an extremely ambitious plan that represented a turning point in the policies guiding the activities of the MOMA in Latin America up until that time. Although it still had no specific program designed for Latin America, the MOMA had assumed responsibility for organizing representation of the

United States at three São Paulo Biennials. The museum had also sent several itinerant exhibitions to South American countries. In the face of these new duties, the MOMA decided to stop organizing the São Paulo submissions (and notified the museum authorities, the State Department, and the U.S. Information Agency to this effect). Aiming to develop a broad and balanced five-year program, the museum began a search for organizations and individuals who could cover the costs of implementing such a program in Latin America and the United States.[55]

The program for the exhibitions was divided into two sections. In the first, the organization of four large exhibitions was to be planned, two to be sent from the United States to Latin America that were larger and of better quality than any exhibition of North American art ever seen in the region before: Modern Paintings from Collections in the United States, which brought together approximately seventy paintings on loan from the largest public and private collections, with important works by leading figures in the principal movements of modern art, and Recent Painting: U.S.A., covering the most recent tendencies of the North American avant-garde.[56] The other two exhibitions were of Latin American art and were supposed to circulate in the United States (Recent Latin American Painting and Modern Watercolors, Drawings, and Prints from Latin America).[57] The last part of the plan, much less pretentious and, therefore, more feasible, was meant to organize a series of small exhibitions to tour Latin America.[58]

The overall scope of the proposals surpassed the predictions and offered Romero Brest and Argentine institutions the long-awaited opportunity to establish exchange programs similar to those which took place among the largest cities of the world, comparable to that which had existed between the United States and Europe during the 1950s. For Guido Di Tella, for whom it had been so difficult to buy his small Jackson Pollock in Europe, all of this must have seemed incredible—and extremely appealing.

Nonetheless, the MOMA program was only partially fulfilled and the most important event for Argentine institutions (a huge exhibition of North American painting) never took place at all.[59] With the exception of the large exhibition of European paintings from North American collections, From Cézanne to Miró, which was held at the MNBA in 1968,[60] the remainder of the exhibitions formed part of the second phase of the plan—the small exhibitions—which were presented at the ITDT as part of a program begun in 1964 that included a total of six shows extending to 1967.[61]

1964: The Year of Recognition

If the test for whether the coveted internationalism had been achieved was the degree to which Argentine art had established its presence abroad, 1964 was an outstanding year. Already at the end of 1963, the Museum of Modern Art in Paris had presented the exhibition L'art argentin "actuel" with the participation of fifty-six artists—selected by Romero Brest, Julio E. Payró, and Héctor Basaldúa—twelve of whom were living in Paris.[62] The opening of this exhibition—the "first of such magnitude" held "beyond our borders,"[63] according to Kosice—was attended by André Malraux who, as Kosice wrote in the daily Buenos Aires newspaper *La Nación*, after examining each work carefully, declared, "With this exhibition, you, the Argentine people, have won the day."[64]

The success of the exhibition was attested to by the impact it had in the Parisian press: articles published in *Le Figaro, Arts, Combat, Le Figaro Littéraire, Lettres Françaises, L'Express*, and *Le Monde* were laudatory and enthusiastic. Gyula Kosice, Argentine organizer of the exhibition, translated the best of every commentary for *La Nación*, declaring that the "elán" of a young country could be felt there in Paris, that some were already speaking of the Buenos Aires school, that the vehemence and conviction of this art distinguished it from that of the rest of the world, that Argentine art was "galloping in the country of the gauchos."[65] But was this the kind of recognition that Argentines wanted at that moment? What kind of success was represented by the applause of a city already toppled from its former position of power? Wasn't this, in any case, the best test for determining that true recognition—which had to be sought in New York—was still beyond their reach?

The exhibition Buenos Aires 64, which hung on the walls of the Pepsi-Cola offices in New York, at first came a little closer to achieving the objectives the Argentines so longed for. Although it formed part of a corporate publicity campaign rather than the artistic circuit, at least it gave exposure to Argentine art in New York. Selected by Hugo Parpagnoli, director of the Museum of Modern Art in Buenos Aires, and intended to present an overview of contemporary art in Argentina, the organization of the exhibition could be characterized as "politically correct."[66] However, the New York critical reviews were not encouraging. Whereas the French had discerned Argentine identity embedded in the works they had seen, the North Americans were unable to discover any features that could be considered characteristic of Argentine art. The comments of

New York Times critic John Canaday could not be ignored: "The Pepsi-Cola show on the whole . . . smacks too strongly of international chic to be either satisfactory as a show or at all representative of Argentine art at the moment."[67] As we shall see, the complex web of disagreements—generated by the initiatives of North American institutions and critical reviews—was continually deadlocked over the conflict between the need for an international style, on the one hand, and traits of national identity, on the other hand—components whose proportions and forms of expression were never clearly established. In this confusing context, conditions were generated both for the favorable reception of Latin American art, as well as for its most absolute condemnation. The demand for *localist internationalism* would turn out to be a challenge that promoters of Argentine art were unable to meet.

In 1964, Kaiser Industries, to its credit, effectively succeeded in "bringing the world" to Córdoba. In addition to bringing together the work of artists from ten South American countries,[68] the events program included exhibitions of European and North American art, an exhibition of engravings, an international choral festival, an inter-American conference for deans of architectural colleges, exhibitions of pre-Colombian and popular art, conferences, concerts, theater workshops, and even a tribute to Michelangelo on the 400th anniversary of his death. It was a broad and varied program to which parallel activities were added that involved both artists and critics from the United States.[69] The combination of North American post-abstraction, contemporary Latin American art, crafts, and *diabladas* (diableries) from Oruru, Bolivia, all of which lasted for eighteen days, brought together interests that solidly conformed to the idea that Kaiser had publicized in its bulletins: to make the biennial "the point of confluence for artistic concerns from almost the entire continent."[70]

The biennial sought to shake up the hierarchies, to mix high with low, popular with erudite—to flaunt the cultural wealth of America. Rather than find itself in the "international" world, the public found itself in America and the particular space into which Kaiser Industries was inserting its activities: Córdoba and all of Argentina. Every participating country provided a jury member, in addition to Gómez Sicre for the OAS, and Umbro Apollonio, director of the Venice Biennial. Considering that only one Argentine artist won an award, the results did not exactly live up to expectations.

In a certain way, the top prize, which was awarded to the Venezuelan artist Jesús Soto, seemed to be more intended to settle a debt with the

Italians rather than to respond to the objectives of the host. Umbro Apollonio appeared satisfied that Soto had been awarded the prize he had not received in Venice.[71] However, it seemed that the complementary prizes were awarded to avert protests from local artists. Thus, the Argentine artist Clorindo Testa was awarded the gold plaque from the government of Córdoba as well as the $1,000 Contemporary Art Prize of America, created especially for the artist by the Venezuelan representative, probably to alleviate a certain sense of guilt.[72]

The prize for abstraction confirmed the established relationship between artistic circuits and international languages. The kinetic art of Soto responded to various requirements pertinent to Latin American art: it was abstract (and, therefore, international), linked to the modernizing model, and incorporated a certain degree of localism. Its loosely woven multicolored cords could be seen as a metaphor for the Venezuelan jungle. Nonetheless, for Marta Traba, this work as well as those of various Argentines betrayed evidence of the "balkanization" of the continent: "The opening up to modernity of Argentina and Venezuela, overwhelmed, respectively, by Polesello and Soto, that is, by their triumphant technique, the victorious object, the thing, the splendid material, and the perfect optical illusion; and, contradictorily, the circumspection of poor but sophisticated countries, such as the aforementioned Uruguay and Chile."[73]

Traba valued painting over work that was easily assimilated into technological models, and in the granting of the prizes she succeeded in awarding a prize for *Toro cóndor*, a work by Alejandro Obregón, which magnificently represented the type of painting that she considered appropriate for Latin America.

Although Argentine art did not win many of the prizes, it had the greatest representation among the works selected to be sent abroad.[74] The decisions were not arbitrary: 32 paintings were chosen from a total of 310 by Robert Wool (who was now president of the Inter-American Foundation for the Arts), Lawrence Alloway (director of the Guggenheim Museum), and Paul Mills (director of the Museum of Modern Art in Oakland). The suitability of these "second juries" seemed to indicate that the decisions of the first (composed of Latin Americans and one European) had been, definitively, mistaken.

In general terms, the second biennial remained on the margins of the avant-garde and the type of experimentation that the Di Tella Institute hoped to accommodate. Romero Brest criticized the conservatism of the

selection, lacking in true "modern" spirit, "oscillating between a made-to-order neo-formalism and a falsely reactionary neo-figurativism. At the Argentine stand, for example, there are no young artists who create 'objects,' that is, those artists who are setting the tone of the moment."[75] He was comparing the biennial to the Di Tella prize competition of that same year at which the international jury had been composed of two figures whose distinct and conflicting aesthetic programs had brought to the country a battle for international control over style and form. The presence at the Di Tella Institute of Pierre Restany, the critic who had organized Nouveau Realisme (and who was now in charge of promoting and selling it from the "J" gallery he directed in Paris),[76] and Clement Greenberg, who had contributed to the international success of abstract expressionism during the 1950s, revived the classic rivalry between the French and North Americans.

The result was a raging dispute for both prizes. The "victory" for the international prize was Greenberg's, who succeeded in awarding it to the North American Kenneth Noland, rather than the French artist Arman supported by Restany, whereas in the case of the national prize, Restany held sway with the deciding vote cast by Romero Brest in favor of Marta Minujín instead of Emilio Renart, who was Greenberg's favorite. However, rather than nationalities, the conflict had more to do with aesthetic models, and the Di Tella prize competition in some way served to compensate for the error that, according to the modernist model championed by Greenberg, had been committed in Venice by awarding the prize to Rauschenberg. This decision had also conflicted with Romero Brest's preferences who, as we have seen, constantly struggled with his aesthetic models and his role as institutional director. It is possible to suppose that, between Arman and Noland, Romero Brest preferred the latter. The text by Greenberg, reproduced in the catalogue for the prize competition (excerpted from his article "Modernist Painting," 1961), could very well have been written by Romero Brest. He would have agreed with the idea that "Modernism has never meant, and does not mean now, anything like a break with the past. It may mean a devolution, an unraveling, of tradition, but it also means its further evolution."[77] To appeal to the idea of progress without ruptures, to consider modernism as an evolutionary tradition, to defend anti-narrative and postular autonomy, and even the revulsive character of modern art, as opposed to the kitsch and vulgarity of popular culture, implied affirming principles that were diametrically opposed to the effusive declarations of Restany: "If I identify Wols'

'meteors' with Amon's neurological cells, and Pollock's dripping 'cathedrals' with elements of the cerebral cortex, it is clear that I have been transformed into one of those Philistines that Maurice Denis refers to: I don't look at painting and I don't see anything more than the theme."[78]

Such declarations must have irritated Greenberg and confused Romero Brest, who reluctantly had to accept that Arman's "accumulated" matchboxes were now art.[79] The new realists, neo-dadaists, and pop artists, according to Restany, delivered "the world to be seen through other eyes," exalting the expressive possibilities of a daily context that was blurred and distorted by use and habit; "they discovered" the industrial, commercial, and urban nature of the twentieth century through appropriation, selection, accumulation, compression, and destruction of the objects that composed it: from a can of preserves to an automobile chassis to a torn poster.[80]

Greenberg defended modernism on the periphery, while what was triumphing in New York was pop art, the anti-modernist style just recently confirmed in Venice. Having lost the grand battle at the international biennial, Greenberg had to settle for the lesser victory of having said, written, and championed what he believed in, albeit at some distance from the artistic center that his critical voice had helped establish in New York City. As he declared in Buenos Aires, for him, pop art could not be considered genuine art: "It is minor art, a fashion, and it is horrible to say this about any kind of artistic expression. The proof is the ease with which it achieved success, without struggle or resistance."[81] For additional proof of this decadence, Greenberg found that these forms had also taken root among the artists of Buenos Aires who were doing similar things to what could be seen in New York and Paris: happenings, assemblages, and installations. His views on the Argentines and their supposed "new art" were no more stimulating than his general condemnation of pop art. Among the works exhibited at the Di Tella Institute, Greenberg had not found anything to get excited about: "There is no originality, it resembles New York twenty years ago. At that time, art in New York was provincial in relation to Paris."[82]

In the Buenos Aires artistic milieu, Greenberg's comments did not dull the general optimism. Once Greenberg's criticism was associated with a style that had been superseded, such as abstract expressionism, his positions ceased to have importance for the artists, the institutions, and the critics. His presence, therefore, was only meaningful insofar as he had been successfully brought to Buenos Aires—like a trophy—to distinguish

between national and international art. Furthermore, his opinions were in open conflict with those of Restany. In contrast to the disdainful gaze of the North American critic, the French representative heaped praise on the Argentines and the following year published "Buenos Aires and the New Humanism," one of the most enthusiastic articles written on the art of Buenos Aires during the 1960s. Restany used the comparison with New York to evaluate a situation that was symptomatic of the near future: "The elements of the New York catalysis have given the Yankee metropolis a style that is broadly competitive with respect to London and Paris. For fifteen years I have been an attentive observer of the international rise of the New York style in all areas of artistic creation. Certain symptoms do not deceive. I have felt them in Buenos Aires but not in other parts of South America."[83]

This tendency to see Buenos Aires as a "Southern New York," in Restany's words, was not new. As indicated by Adrián Gorelik, it was in Latin Europe that, in large part, the speculative relationship between Buenos Aires and New York was constructed, presenting Buenos Aires as the future of the Latin race on the continent of the future. The euphemism employed on the city's 100th anniversary, declaring Buenos Aires the "second most important Latin city after Paris," responded to the necessity of Latin Europe to form part, in some way, of the new phenomenon that was Latin America.

Underlying Restany's enthusiasm was an expansionist element. The art being created by the Argentines (referred to as pop *lunfardo*) was much closer to new realism, under Restany's direction, than to North American pop. His praises, besides making his presence more agreeable than Greenberg's, enabled him to incorporate the Argentines into the Latin pop campaign over which he hoped to preside. Nonetheless, although the praises of the French were helpful to the Argentines, their focus was now on the North American critics, and among them there was no comparable consensus.

In Romero Brest's case, it was probably this prize competition that enabled him to redefine his aesthetic positions. After fulfilling his role as jury member for the event, he would express criticism of the American Art Biennial, considering it regressive relative to the results of the Di Tella competition, and on behalf of the ITDT he accepted the project that would evolve into the *Menesunda*.

Buenos Aires and Córdoba defined their orientations very differently and the distance between their programs is manifest in the images ex-

tolled by the two cities. The Di Tella Institute wanted to contribute to a bubbling cauldron of culture, seeking original and new creations, whereas the biennial tended to recognize ongoing, preexisting activities. This considerable difference of positions was also notable in the attitudes of the directors of the respective cultural institutions, whose actions had crucial impact on the circulation of Latin American artistic images during the 1960s. Although they shared some common aspirations, the programs of Gómez Sicre (who, as we have seen, was a consultant to the biennial) and Romero Brest, respectively, put their faith in very different artistic objects and images.[84]

For many reasons, 1964 was a stellar year for the internationalist project. The Greenberg-Restany battle had converted Buenos Aires into a volatile space with elements that suggested various possibilities: it could indeed be a relevant art center, it had succeeded in attracting a significant number of artists who had participated in the Venice Biennial, and yet it had produced very different results. Taking the preceding into account, all of which was important but ephemeral, the exhibition New Art of Argentina was timely and contributed more important and substantial results. Organized by the ITDT and the Walker Art Center in Minneapolis, it was meant to open almost simultaneously with the Di Tella prize competition. This exhibition reinforced the certainty that success was knocking at Argentina's door. Although Enrique Oteiza, in his address at the opening of the Di Tella competition, had used the term "avant-garde" to refer to the activities the institute hoped to promote, the title of the international exhibition was more prudent and only referred to a "new art."[85]

With selections made by the curator of the Walker Art Center, Jan van der Mark, and, to a less certain degree, by Romero Brest,[86] the exhibition brought together a broad spectrum of works based on a criteria that was not intended to highlight one particular tendency, but rather to bring together and show the most recent in artistic creativity and expression.[87] The result was quite confusing in terms of defining an image of Argentine art: the show included instances of geometric, figurative, neo-abstract, and even pop art. The selection appeared to be more geared toward covering all the pigeonholed styles (as if to say that the new Argentine art lacked nothing) than highlighting what was "new" about Argentine art. North American criticism focused precisely on this point.

In his introduction to the exhibition's catalogue, van der Marck explained that his selection criteria had been guided by the principle of "internationalism." For this reason he had not included works related to

the American indigenous past, given that in Argentine art (in contrast to that of other Latin American countries), the dominant tendency involved international openness.[88] This openness was reflected not only in its permeability to international styles (European and North American influences), but also in terms of the migration of artists abroad:[89]

The phenomenal migration which drains artists of talent from the Buenos Aires community at an alarming rate (thirteen Argentines in this exhibition presently live or work abroad) has at least one beneficial effect: it accelerates the "internationalization" of Argentine art and contributes to the art of other countries. Emigration, which used to be an escape and an indictment of the barrenness of the national climate, now takes on the positive quality of a search for new challenges, stylistic alignment and companionship of ideas. With the increasing facilities of the capital city and the notable sophistication of its artistic climate much that has been carried abroad will no doubt return to Argentina, fuller in fact and potential.[90]

Romero Brest's "Introduction" was even more confident; he did not refer to potentialities, but rather to facts. The most recent Argentine art had characteristics that pointed to its individuality: "The difference between the art of our young generation and that in other countries might seem subtle. Even among us, some say there is actually no difference, but I disagree and say that indeed there is."[91] On the other hand, Romero Brest explained that it didn't seem fair to him to ask a foreign public to understand "indigenous concepts." For this reason, his selection had been oriented toward a broader vision that made room for those artists who had been influenced by the new artistic movements of Europe and the United States. His arguments produced the sensation that his selection was based on what he supposed would have a good reception in the coveted showcases of New York.

Nonetheless, all these strategies, intended to engender a warm reception, did not produce the desired effect. Resistance to the exhibition was marked by numerous difficulties that emerged when trying to establish the tour circuit. The agreement between the institutions stipulated that the Di Tella was to pay for shipping the works to Minneapolis and half the costs of the catalogue, while the Walker Art Center guaranteed circulation of the exhibition throughout the United States and publicity in international magazines. Correspondence between the institutions reveals that, despite the efforts of van der Marck, circulating the exhibition proved difficult. In a letter to Romero Brest, he detailed, step by step, his

search for exhibition space: "James Johnson Sweeney was here the other day for the opening of a Burri exhibition. I talked with him about taking the Argentine exhibition to the Houston Museum. I am sorry to say he was not in the least interested. He brushed off the subject by telling me that he had been in Argentina in 1962 but had seen no more than a handful of works of any interest. Of course, I disagreed with him, related my own experiences and distinct faith in what is happening in Argentina, but to no avail."[92] On March 6, 1964, van der Marck explained further:

Regarding circulation, you may have concluded from our silence that the circulation was our biggest headache and you were right. Both Martin and I sent out numerous letters, concentrating on major museums or population centers in order to give the show the best possible exposure. First, the timing was wrong: most museums plan one year and a half ahead. Then many colleagues took the attitude of "who has ever heard of art in Argentina?" You should be aware of this, because it held things up considerably and we really fought a crusade for Argentine art. Personally, I am confident that nobody is going to ask that silly question again. The exhibition will prove the point and convince even the hardest unbelievers.[93]

In the same letter, after telling Romero Brest that the show had been turned down by the Corcoran Gallery and the Washington Gallery of Modern Art, and by the Guggenheim Museum, the Brooklyn Museum, and the Jewish Museum in New York, as well as museums in Montreal, Toronto, and Los Angeles, he concluded, "I could go on and discuss each of 46 museums we approached, but this would be too tiresome."[94]

Nor was the critical reception very encouraging. In the *New York Times*, John Canaday expressed his misgivings in two reviews loaded with irony. In the first, he targeted the much-vaunted internationalism. Characterizing the exhibition as a "second-rate international mixed bag," he only found value in the neo-figurative works, which he had already seen at the Guggenheim prize competition that same year.[95] Not content with his first, relatively low-key evaluation, the following Sunday in the arts section he published an extensive imaginary dialogue with Romero Brest in which he demolished the Argentine critic's claims, point by point: "Whatever their concepts are, they would be much more rewarding to us than warmed-over unindigenous concepts. You could explain them to us. We need them. Art should be an enlargement of experience, not a repetition of familiar manners ad nauseam. . . . In sending us what you did, you actually sent a bit of what you think is best, and a lot of runner-ups you

thought we would like as international stupids? . . . Mr. Brest, I think you missed a big single-standard opportunity."[96]

This review, which probably ruined Romero Brest's Sunday breakfast—and certainly ruined Squirru's, who happened to be in Washington at that moment—did not prevent the exhibition from becoming a success. It had finally become possible to organize a show of exclusively Argentine works rather than another of the frequent medleys of Latin American artists that toured the United States. Furthermore, the selection process had not been the exclusive domain of a North American curator arbitrarily indicating where the value of Argentine art lay. Finally, this exhibition and the Pepsi-Cola show, taking place almost simultaneously with a series of meetings on and exhibitions of Latin American art in Washington and New York, suggested that the most potent artistic movement in Latin America, at that moment, was taking place in Argentina.[97]

In 1965, the exhibition Argentina in the World revealed a subtle shift in the direction of the internationalist project. At this time, Buenos Aires newspapers and magazines had repeated over and over that Argentine art had finally achieved "export level quality" and that it had succeeded in penetrating the great artistic centers.[98] The exhibition opened in Argentina as proof of the success achieved abroad. Although the tribute also included the achievements of scientists and writers, the sector dedicated to images dominated the show.[99] Reinforcing Romero Brest's story of the evolution of Argentine art, the exhibition was organized in two parts: pre-1949 and post-1949. As we have seen, in Romero Brest's view, this meant dividing Argentine artists along the lines of "those who advanced" and "those who did not advance," and for him, of course, organizing the first part was the most interesting.

One could hardly find a more representative indicator of the criteria used in organizing these hierarchies than the table of values that Romero Brest articulated specifically for selecting artists as proof of Argentine success, establishing a point scale from zero to three to characterize a work's international exposure, its quality, its success, its insertion abroad, and its contemporaneity (see fig. 12). The artists and the art, as well as the whole transcendent undertaking to which Romero Brest had dedicated so many conferences and essays, came to resemble a parade of artists passing before a panel of judges who then raised score cards. In the internationalist project, the artist ceased to be an active agent in the cultural debate and came to form part of a team that was supposed to represent

Artistas argentinos en el extranjero	Progreso	Calidad	Exito	Novid.	Actual.	
Líbero Badii	x	xxx			x	5
Antonio Berni	xxx	xx	xxx		xxx	11
Marcelo Bonevardi	x	xx	x	xxx	x	8
Pablo Curatella M.						sí
Juan Del Prete	x	xx	x	x	x	6
José A. Fernández M.	xx	xx	x	xxx	x	9
Lucio Fontana	xxx	xxx	xxx	xxx	xxx	15
Raquel Forner	x	x	x		x	4
Julio Le Parc	xxx	xxx	xxx	xxx	xxx	15
Rómulo Macció	xx	xxx	xxx	xx	xxx	13
Antonio Seguí	xx	xxx	xxx	xx	xxx	13
Tomás Maldonado	xxx	xxx	xxx	xxx	xxx	15
Marta Minujín	xx	xx	xxx	xx	xxx	12
Alicia Penalba	xxx	xx	xxx	xxx	xx	13
Emilio Pettoruti	x	xx	x	xxx	x	9
Mario Pucciarelli	x	x	x	xxx	x	7
Luis Tomasello	xx	xx	xx	xxx	xx	11
Sesostris Vitullo						sí
Sarah Grilo	x	xx	x	xxx	x	8
Miguel Ocampo		x		xxx		4
Sergio de Castro	x	xx	x	xxx	x	8
Stefan Strocen	x	x	xx	x	x	6
Kazuya Sakai	xx	xx	x	xxx	x	9
Víctor Chab	x		xx		x	4
Rogelio Polesello	x	x	x		x	4
Gyula Kosice	xx	x	xx	xxx	x	9

Menos de 5: Raquel Forner / Miguel Ocampo / Víctor Chab / Rogelio Polesello	Menos de seis: Líbero Badii	Menos de 7: Del Prete / Strocen

16-6-65

12. Jorge Romero Brest, scorecard for artists competing to participate in the exhibition Argentina en el Mundo (Argentina in the World), 1965, Buenos Aires. Archivo ITDT.

the country and bring home trophies and medals. The metaphor Squirru had used in hopes of igniting competitive passion in the cultural sphere by declaring that artists should emulate athletes, disposed to compete so that the country could "export culture,"[100] had now been dramatically translated into the scoring system that determined which Argentine artists had entered "into the world." As Romero Brest himself explained in the catalogue, the determinant factor was international success: "We have had to select the participants, not only for the quality of their work, but also for the exposure they have achieved abroad; to meet this standard and very much to our regret, we have excluded some artists whose quality work we consider to be very positive."[101] Was this, then, the current state of art? This was the tacit question underlying the "regret" expressed by Romero Brest. These criteria, which could not be submitted to criticism and which did not give the public any idea of what the international world accepted and what it excluded, had resulted in the exclusion of such artists as Líbero Badii, who had received the maximum score for quality and the minimum for success.

For Argentine institutions, internationalism came to be a notion that eventually gave rise to a program that affected the internal order more

than the international order, to which it was initially intended to lead. Designed as a mechanism to provoke immediate adhesion and to organize intentions into actions that could be gauged by their objectives, for many sectors of the avant-garde and, moreover, for the projects organized by the institutions, the term "internationalism" was redefined whenever it was necessary to change strategies. Some central actors (particularly Romero Brest) were constantly trying to eliminate the contradictions and objections that the project's fulfillment entailed and, like automatons, they reconstructed, over and over, on the foundations of its previous failures, the project for international success. The interplay that was established between Argentine art institutions and those that organized the inter-American circuit from the United States, closely resembled a kind of parody—a framework in which some pretended to offer recognition while others obstinately strove to interpret it as such.

Nonetheless, in 1965, while enthusiasm was still high, the exhibition awakened dangerous national fervor. In the newspaper *El Mundo*, Córdova Iturburu explained that the section of the exhibition that covered the post-1949 period offered proof of the "chronometricization" of Argentine art—an art that was current and original: "We have completely left the last aftertastes of colonialism behind us in order to become, perhaps in the not so distant future, colonizers."[102] Having seen "proof" of the originality of Argentine art and its international triumph, the task that was originally intended to garner recognition for an overlooked art, was now transformed into an imperial program: in Córdova Iturburu's description, Argentina not only was in the world, it could also conquer it.

Biennial and Anti-Biennial

In 1966, although it was besieged by union conflicts and a crisis that had already affected its various subsidiaries, Kaiser Industries went ahead with its decision to organize a lavish biennial.[103] The company's determination to reach its goal was corroborated by its insistence that Alfred Barr participate as a jury member. The first director of the MOMA, Barr was a prestigious figure, associated with the organization of modern art in New York. However, at that time he was not a central actor in the international art world.[104] He was more of a museum piece himself and, as such, he could be a useful element in the context of a larger plan. This is probably why J. F. McCloud, president of Kaiser Industries, expressed interest in bringing Barr to Córdoba to preside over the jury of the third biennial.

Barr, who might have summarily rejected the invitation five years earlier, now found reasons to possibly accept and, with this in mind, wrote to René d'Harnoncourt, then director of the MOMA, asking his advice and explaining why he thought it might be important to attend: [105]

In my opinion (before I received the invitation) the Córdoba show is the best organized of the 3 L. A. biennials—Sao Paolo, Esso and Córdoba—and the best in quality in Latin-American art. Organized in Córdoba, 500 miles from B. A., it appears to be free of local politics such as handicap Sao Paolo. The Esso show is not as good—I saw it in Washington.

I would be inclined to accept the invitation:

1. I saw the edited show for U.S. circulation at the A.F.A. galleries. It was very good.

2. I'd like to learn more, see more L.A. art which seems to be on the way up.

3. I'd like to do a favor to the New York Kaiser agent William Weintraub because he is leaving, he says, his collection to us and has already given us legally 4 very good paintings (retaining a life interest). He's very eager to have me go.[106]

Between June and December 1965 the correspondence between Barr and McCloud was intense. McCloud found it difficult to give up on something that represented a crowning achievement and eight years of effort to maneuver Córdoba, Argentine art, and Latin American art into the international spotlight. McCloud's first letter already betrayed his anxiety and, although he did not explain why he considered Barr's presence to be indispensable, we can venture to imagine: Barr was so closely associated with the museum's history that he was considered its best representative. Furthermore, as director of collections, he had the power to influence the possible entrance of Latin American works into the museum.[107]

In addition to applying persistent pressure through Weintraub, the representative of Kaiser Industries in New York, McCloud also used subtler, and probably more effective, strategies. In his letter of invitation to Barr on June 5, he explained that the jury panel would no longer be composed of one representative from each country, as it was in previous biennials, but rather by a president and four or five prestigious jurors. Nor would there be a preestablished number of artists from each country but rather the selection of artists would be based solely on the quality of their work.[108] McCloud's arguments drew on the values Barr used—and

for which he was famous—during his term as museum director: selection and quality. His method was effective. After several consultations, Barr accepted the invitation.

The preparations were meticulously carried out as if for an event that would legitimize the art of the entire continent. Nonetheless, even though publicity had circulated widely since the first biennial, North American artists did not participate in the competition or the awards. Clearly, Alloway's comments had exerted powerful influence. In the transcription of a conversation he had with Robert Wool on an airplane while returning to New York after the second biennial, having selected—with Wool and Paul Mils—the works for inclusion in the itinerant show to be sent to Latin America and the United States, Alloway alerted McCloud to the dangers of turning the biennial into an event where internationalism would dilute the Latin American contribution:

If you add North American and European artists to the list, what is going to happen is that, on the one hand, the exhibition will look like all the Bienales and, on the other hand, public discussion will be centered in South America on the foreign contribution, especially on North America. . . there are other ways in which you could extend the Bienale without losing its particularly valuable South American characteristics. One way would be to restrict the exhibition to artists under a certain age, such as 35. . . . I do feel, especially after seeing all this summer's crop of big international shows in Europe, that one of the great strengths of your Bienale is its continental limits. It would be a shame if the specific South American values should be dissipated into an over-familiar internationalism.[109]

To which public were these prize competitions and exhibitions directed? Were they meant for the Latin American, North American, or international stage? What were these events intended to demonstrate? As we have seen, for Kaiser the primary purpose of the biennial was to bring together artistic expressions from all over the American continent with the intention of spreading the message of inter-American brotherhood, displaying it on the walls, and circulating it throughout the continent. However, Alloway's comments demonstrate that for him the internationalization of Latin American art was not an important outcome. Indeed, by the middle of the decade, the term *internationalism* was gradually losing its rallying power.

In 1964 relations between the United States and Latin America entered a new phase. In that year commercial relations between American governments and Cuba were suspended. At the same time, most Soviet

troops were removed from the island and an agreement for control of the airways was reached with the United States. Thereafter, for the United States, the Vietnam conflict was more important than the tensions with Cuba. Given the new international situation, the pressing needs that had given rise to the Alliance gradually decreased in intensity and coherence.

The emphatic and insistent discourse that called for the definitive abolition of "centers," which Gómez Sicre reiterated in the pages of the OAS's *Bulletin of Visual Arts*, revealed, little by little, its fictional structure. Alloway's views distinguished the United States as separate from Latin America, reinforcing the idea of traditional centers. The propaganda value of a touring exhibition in the United States in which North and South American artists were shown on equal footing was now diminished not only because the *need* for it was no longer so acute, but also it was no longer seen as a possibility. "Internationalism" was not an imperative anymore, nor did it reveal possibilities for dialogue, but rather, and more precisely, areas of disagreement, hierarchies, and inequalities. Its discursive formulations could now be dismantled and reordered as the search continued for those "specifically South American values" that were viewed as features of identity.

As already mentioned, the third biennial's criteria were based on selection and quality. In the awarding of the prizes, equity was no longer of primary importance. The distribution of the prizes now depended on the decisions of the five jury members: two North Americans (Alfred Barr and Sam Hunter, director of the Jewish Museum in New York), one European (Arnold Bode, initiator and organizer of the Documenta in Kassel since 1955), one Latin American (Carlos Raúl Villanueva, Venezuelan architect), and one Argentine (Aldo Pellegrini, physician, critic, and founder of Argentine surrealism) (see fig. 13). With respect to the prizes, although Argentine artists were now closer to achieving the long-sought-after recognition (six of the twelve artists received honors though not the most coveted prizes),[110] the Grand Prize, as in the previous biennial, again went to a Venezuelan kinetic artist: Carlos Cruz Diez.

As Romero Brest observed, although the images the biennial hung on its walls had little to do with the activities of avant-garde artists at the moment, the environment was nonetheless invaded by expressions of avant-garde art that provoked numerous situations of scandal and confusion. The numerous happenings staged by artists in peaceful Córdoba created an atmosphere of agitation stirred up by avant-garde attitudes that united artists from Buenos Aires and Rosario.[111] Under the title "First Argentine

13. Arnold Bode, Christian Sörenson, and Alfred Barr in the IKA offices during the jury deliberations for the Third Bienal Americana de Arte (Kaiser), 1966, Córdoba. Archivo Bienales Americanas de Arte, Centro de Arte Contemporáneo, Córdoba.

Festival of Contemporary Forms," this parallel event brought together those "representatives of art-ignored-by-the-Biennial,"[112] introduced by Romero Brest and held on the upper floor of a furniture store in the heart of the city of Córdoba. This show emphasized the distance that existed, in terms of promotion, between the biennial—which tended to legitimize for the museum artwork that everyone could agree was truly "art"—and that which was rewarded and exhibited by the Di Tella Institute.[113]

Between the time Barr decided to accept the invitation and the moment he actually arrived in Córdoba in October 1966 to serve as president of the jury panel, the situation in the country had changed dramatically. The relatively stable democratic climate had given way to diverse pressures that culminated with the coup d'état that overthrew Illia, the Radical president, on June 28, 1966. Under the military dictatorship, presided over by General Juan Carlos Onganía, on July 29 the police violated university autonomy by forcefully entering the buildings and beating and imprisoning hundreds of professors in what would come to be known as "the night of the long sticks." Among those attacked was Warren Ambrose, professor of mathematics at the Massachusetts Institute of Technology and at the University of Buenos Aires. His presence, in addition to a call for international protest published in the *New York Times*, imbued these events with unexpected resonance.[114] The peaceful atmo-

sphere which Barr had referred to in his letter to D'Harnoncourt was now contradicted daily by news reports on the violent occupation of Argentine universities. Barr's collection of newspaper articles and photographs documenting police violence reveal the extent of his concern for the situation in the country he was about to visit.

The biennial could not remain on the margins of these conflicts. The student protests reached the biennial's front door and brought international attention to the new situation in a country that could no longer maintain the utopian tone that boasted of sustained progress. In 1966 neither the financial situation of Kaiser Industries nor its relationship with its workers were simple issues. The workers, who were asking for better salaries and working conditions, could hardly understand or support the enormous costs of the biennials. The internal memos of the company reflect these ongoing tensions: "There is a preconceived idea on the part of the IKA workers and machinists, as well as a general feeling, that the money invested in the Biennial could be used more efficiently. That is, it could be used for programs that are more social in nature. The negative image exists and must be countered."[115]

The directors of the company thought that the most effective way to counter the workers' objections to the biennial was to organize a careful "internal information" campaign to "demonstrate that the worker that produces 600 baguettes per day, does so for a number of important reasons (industrial, economic, social, and, in some ways, cultural). He contributes to putting Argentina on the cutting edge of Latin American culture."[116]

In spite of the political crisis in the country, the economic crisis of the company, and the demands of the workers, in September 1966 the directors of IKA still evaluated the country in a positive light. In a letter to Eduardo Torres, cultural editor for the magazine *Visión*, an informational magazine on Latin America published in the United States, the chief of the Department of Publications in the division of Public Relations for IKA, José Peréz Abella, expressed his personal appreciation of the company and the country: "Personally, I understand that the working attitude of the company is very similar to that adopted by the late President Kennedy for several of his projects; it is also similar to those assumed by President Betancourt of Venezuela, on various occasions, and President Kubitschek of Brazil, among others; and, finally, it is similar to the attitudes of the architect, Belaunde Terry, in Peru. . . . in Latin America, at least, a *new style* has emerged. In our country, the government of Dr. Frondizi made one

of the most audacious attempts to impose a new attitude, independently of the political opinions expressed by his administration and certain well-known episodes."[117]

The sense of optimism and confidence was not only buoyant in the company, the country, and Latin America, it had also infiltrated the military institutions of Latin America, in whose evolution there could also be seen a "symptom of change." Those militarists who exercised a profession until then identified as "obscurantism," "irrationality," or "brutality," now assumed the "inalienable right to think," as Peréz Abella observed: "I have some knowledge of what is happening in the Argentine Armed Forces, and I would dare imagine that in the next ten years the military sectors will constitute groups of the highest intellectual and cultural level, openly competing with the current creative centers of the middle classes."[118]

Such comments not only point to the messianic confidence driving the company, but also the ease with which they could exchange one political system for another, so long as the conditions of "progress" were secure. Nonetheless, neither the propaganda nor the biennial would succeed in averting the crisis that loomed over the company and many other metallurgical companies.

The hypothetical continuity of the biennials was affected first by the financial difficulties of the IKA. In 1967 the directorship of the company passed, in its entirety, to Renault, which had absolutely no interest in continuing the very unprofitable Americanist project. It should also be added that the State had no intention of financially supporting the biennial, which contrasts sharply with the experience of the São Paulo Biennial.[119] From that moment on, the vast project that had aspired to launch Argentine art "into the world" showed signs of gradual disintegration and impossibility.

The Culmination of Internationalism

At the same time as Kaiser Industries was picking up and leaving the country, leaving adrift the paintings, archives, and all that was linked to the inter-American project into which they had invested so much money, good intentions, and massive publicity campaigns,[120] the Di Tella Institute was looking for ways to continue its program, despite the crisis that was also taking its toll on the foundation and the company. In 1966 the international prize had to be discontinued owing to financial complications. The national prize was held, as on previous occasions, with foreign

jurors, but now rather than awarding a grant, a sum of money was established for realization of a new work and its subsequent purchase. Of all the styles that predominated among the submissions—pop, minimalism, geometric abstraction, and lumino-kineticism—the prize went to the pop art of Susana Salgado and Dalila Puzzovio (first and second prizes, respectively), in addition to special recognition for David Lamelas's work in conceptual minimalism. Considering the fact that Alloway, an active and early champion of pop, formed part of the jury, the prize was almost predictable. Relative to the Venice Biennial—which, as we have seen, was Romero Brest's constant frame of reference—the Di Tella prize seemed to be moving in the same direction, but following a little behind. While pop art had been confirmed in Venice in 1964, in Argentina it swept the prizes in 1966.

Analyzed in terms of the art circuits, the result of these prize competitions and biennials was that internationalism could be seen as a virtual tornado of forms circulating among highly standardized spaces with rules, procedures, intentions, and juries that were tiresomely repeated and among which the tendencies that were considered "international" (the different forms of pop art, kineticism, and minimalism, which almost always took place in that order) received all the prizes. Faced with this serialized process, which established what was most current in art, the respective positions were not always in agreement. While the institutions and artists that participated in the programs could maintain a degree of novelty in their work without complications, the magazines that served as a forum for the leftist intelligentsia categorically condemned it. The reasons for this condemnation were based in political conflicts rather than in any analysis concerned with establishing a relationship between the new resources of the language and the social configuration of a new aesthetic sensibility.

The national prize of 1967 demonstrated that Argentine art had changed and that the new generation that emerged with the happenings and pop art now had other priorities. Romero Brest decided that instead of awarding a grant, money would be distributed among the participants who were encouraged to produce experimental works. From that moment until 1969, the national prize was called "Experiences."[121]

At first, owing to the economic crisis, it appeared that the international prize would be more difficult to organize. To overcome this obstacle, Romero Brest proposed taking advantage of the prestige won through the national competition and the Di Tella prize competition by inviting

several foreign galleries to collaborate in the organization of the international event. These galleries would pay the shipping costs and insurance for the art works and the ITDT would provide $3,000 of prize money, the catalogue, and the Buenos Aires customs tariffs. The fact that the galleries would accept such an arrangement shows that the situation had changed considerably since 1960 when Guido Di Tella had to send a portfolio containing photographs to Venturi to see whether Pogliani would agree to exhibit even one of the artists from the prize competition. At this time, activities at the Di Tella Institute were known and acknowledged internationally. Indeed, jurors from the "international team" continually visited the country to participate in prize competitions in Córdoba and Buenos Aires, Romero Brest also traveled and was active as a jury member abroad,[122] publishing his "letters from Buenos Aires" in *Art International*, and Argentine artists, for their part, were now so much a part of the world art "centers" that the curators who visited Buenos Aires to see their work often had to return to their own cities in order to find them.[123] Through diligence and hard work, the artists had learned the protocol for gaining entrance to the international art circuit.

Events seemed to have gone so well that North American galleries began to glimpse the possibility that Buenos Aires might be a good market for their artists and, eventually, a space to which they might turn for a fresh supply of new talent. As interest in Latin American art increased, Argentine artists were seen as offering special qualities: Buenos Aires, the South American version of Paris, embraced aspects of European culture, internationalism, and a necessary quota of exoticism. It is understandable, then, that with all of these expectations, gallery owners would accept these conditions and that Leo Castelli would even offer to organize submissions from other galleries.[124] To make the offer even more attractive, it was proposed that the prize competition should be moved to the Museum of Fine Arts in Caracas, which the North Americans accepted with pleasure as the idea not only promised greater publicity for the work of their artists, but also reduced the costs of shipping the works back to New York.

The positive attitude of the North Americans was not matched by European gallery owners, which is why there were practically no European artists in the exhibition. This aroused the expressed displeasure of the Dutch juror, E. de Wilde, director of the Stedelijk Museum since 1963, who found himself party to an "international" prize in which the participating artists were only from the United States and Argentina. Romero

Brest responded that in Buenos Aires things were done the *same* way as in other parts of the world and that the selection of the competitors had depended on his discretion as well as other practical considerations: "In no previous case, in none of the other institutions with which I have been personally involved, has it been customary to communicate the list of invited artists to the members of the jury. Furthermore, I selected the artists according to the policies I have established for the Center for Visual Arts which is a part of this Institution. Finally, I should tell you that the artists and the galleries have not been selected on the basis of financial considerations, as Samuel Paz told you, but rather because they are especially in line with our interests. Naturally, I would have been honored if the galleries that promote the work of Martial Raysse, Philiph King, and Alain Jacquet had accepted my invitation."[125]

Caught up in making apologies and excuses, and probably considering that this was neither the best occasion nor the best scenario for resolving the artistic battle between Europe and the United States, de Wilde decided to make the trip anyway and to take advantage of the opportunity by going to Peru for a short vacation afterward.[126] Having learned that some gallery owners, artists, and representatives of other North American institutions were coming to the opening of the show (Leo Castelli, Sol Lewitt, Virginia Dwan),[127] the ITDT and other artistic institutions of Buenos Aires decided to prepare for them a star-studded show called Semana de arte avanzado (Week of Avant-Garde Art), with a pre-established circuit intended to highlight everything the young artists of Buenos Aires had to offer to the world.[128]

The Week of Avant-Garde Art, which is recorded in the Center for Visual Arts archives as Semana de los americanos (Week of the Americans), consisted in a series of exhibitions held September 25–30, in which the galleries and museums showed "our foreign friends the avant-garde art of Buenos Aires."[129] Among the "friends" who had come to Buenos Aires were Stanton Catlin, director of the Gallery of Art for the Center for Inter-American Relations,[130] and Lois Bingham, director of the International Art Program, Smithsonian Institution, Washington, who had been specially invited by the ITDT.[131]

In 1967, North American institutions interested in the promotion of Latin American art had set up a complex network of exchanges, interests, and agreements. Soon it was evident that they needed even more powerful institutions, but ones whose functions did not overlap. Consequently,

the Center for Inter-American Relations was established in 1966,[132] which united the initiatives begun by the Council for Latin America (composed of politicians and businessmen, recently created and backed by David Rockefeller) and the IAFA. The main objective of this new center (with Rockefeller presiding over the board of directors) was to examine political and economic issues in inter-American relations and support achievements by Latin American writers, musicians, and artists. The members were drawn from the academic community, the business world, and the arts.

The interests backing the Center for Inter-American Relations were much more powerful than those that had stood behind the IAFA. With greater financial means,[133] they restored the building that, in addition to offices, conference rooms, library, dining rooms, and reception lobby, also boasted of an exhibition gallery.[134] The center's public activities began in September 1967.[135] On September 18, at the opening dinner held shortly before Stanton Catlin was to travel to Buenos Aires, Vice President Hubert H. Humphrey delivered a speech in which he expressed the center's commitment to addressing political issues on the continent:

What concerns me, as I look forward into the next decade, is that progress may not be fast enough to sustain the hopes that have been aroused . . . that the newly awakened millions will reject the alternatives of peaceful change and accept instead the leadership of those who glorify violence and seek not to change society, but to destroy it. . . . I would like to be more confident that the spreading guerrilla movement in some countries, the "radicalization of the left" in others, represent a temporary phase and not a long-range condition.

I would like to be more confident that the increase in gross national product is improving the lives of those who are most in need; that the majority of the coming generation sees in progressive political democracy a system to be preserved and perfected—and not a vestige to be discarded.[136]

His words clearly expressed that confidence in the power of democracy and progress to contain subversion and communism in Latin America was declining rapidly.

When the assorted members of the North American committee arrived in Buenos Aires, what the Argentines had prepared to show them must have been surprising. With the exception of Antonio Berni's installation at the Rubbers Gallery (*Ramona en la caverna*), all the other exhibitions featured dominant styles that were geometric, minimalist structures, and

certain remnants of pop art. The eagerness to demonstrate connections to North American art reached such an extreme that one of the exhibitions (Primary Structures II) was presented as the second part of Sculpture by Younger British and American Sculptors, which had been publicized under the title Primary Structures at the Jewish Museum in New York (1965). Nonetheless, the work of many of the participating artists was widely varied in terms of their conceptual and formal orientations. The exhibition presented elements of spatial and formal conceptualization that deviated from self-referentiality to introduce, as a conceptual reflection on the artistic act, connotations that soon led to proposals linking art with politics.[137] In addition, by exhibiting a significant number of works by avant-garde artists from Rosario,[138] the closeness between them and Buenos Aires artists was further consolidated, a process that had begun at the Festival of Contemporary Forms in Córdoba in 1966. This event yielded consequences that went beyond the organization of this exhibition as we shall see.

Impressed by this display of geometric abstraction, Catlin offered to hold the exhibition Beyond Geometry at the Center for Inter-American Relations in New York which would point to the success of this tendency in Argentina and, at the same time, would serve to pay tribute to the Di Tella Institute on the tenth anniversary of its foundation.[139]

The results of the prize competition also ratified the exchange network that existed beyond the quality of the work itself. The prize granted to Robert Morris must have compensated in some way for all the organizational work carried out by Leo Castelli's gallery. Romero Brest did not neglect to mention this: "It is an additional pleasure for me that a work from your gallery is among those to have won prizes. Thank you for your kind collaboration, Buenos Aires has a chance to see what is being done abroad now."[140]

In 1967 there were reasons to think that Buenos Aires had succeeded in establishing itself as one of the world's artistic centers. There was a continuous flow of well-known figures and committees through Buenos Aires, paying their own way to discover the art in the "new center." Nonetheless, the ultimate confirmation of the Argentine triumph in art sprang from Julio Le Parc's surprising victory (top prize) at the Venice Biennial in 1966. The subsequent exhibition of his work at the ITDT in August 1967 attracted the largest public attendance in the institute's history.[141] This exhibition at the Di Tella presented Argentine art to the public at the

height of its glory and ability to capture international recognition during the 1960s. However, this recognition of Argentine and Latin American art would soon prove to be ephemeral.

The Aporias of Internationalism

As Martin J. Medhurst observed, the Cold War was a war of words, images, and symbolic actions, and rhetorical discourse was one of the most valued weapons—discourse intentionally designed to produce specific effects on specific audiences.[142] In this context, on the postwar artistic scene, "internationalism" rather than exchange, implied the victory of one aesthetic model over another, and this model was fundamentally expressed in terms of abstract art, understood as the quintessential adversary of socialist and fascist "realism."[143]

The various uses and meanings ascribed to this key word—"international"—in the field of art can be helpful in understanding the ways that cultural relations between central and peripheral nations were formed in the Latin American art scene of the 1960s.[144] By examining the semantic background of the term in the context of North American criticism of Latin American art during the period under analysis and the discursive practices formulated with respect to the concept of internationalism, we can observe how North American perspectives regarding Latin American art took form and were modified.

In 1959 a series of exhibitions took place in Chicago, Denver, and Dallas that presented various Latin American art forms. In response to this invasion of images, the visual arts magazine *Art in America* dedicated an entire dossier to what it referred to as the "Renaissance" of Latin American art.[145] With revisionist intentions, the article offered a complete reappraisal of the meaning traditionally ascribed to the word "America" in the United States: "This Pan American issue of *Art in America* reflects an editorial definition of American art in terms of the entire Western Hemisphere. We do not interpret America as synonymous with the United States. America is all the land stretching from Canada's bleak Arctic Circle to the southernmost tip of Tierra del Fuego. It embraces the 50 United States from Alaska to Florida, all of the Caribbean, and Central and South America."[146]

America was not the United States, but rather an integrated continent composed of a group of equal nations. With respect to the char-

acterization of this continent's artistic production, the editors queried the exhibition's visitors about the differences between North and South American art. The responses were surprising: "Their comments focused on the striking lack of basic differences, the extraordinary coincidence of approach and style. . . . As the world shrinks and in truth becomes 'one world,' art will increasingly be accepted as a universal language."[147]

The aspects emphasized by the magazine indicated a point of inflection in the evaluation of Latin American art that was dominant during the 1950s. Following the success of Mexican artists in the United States during the 1930s, when muralism was at its peak, North American art had established the modernist program by eliminating obstacles to understanding forms as it thought they should ultimately be understood: as pure forms, without narrative, indigenous qualities devoid of social content. In this self-construction process, North American art history had expurgated its own past as well as the past of abstract expressionist artists, some of whom had been linked to the Mexican muralists and their political ideology.[148]

In regard to art in the United States the well-known "action painting" artists had formulated a language that eradicated every vestige of contamination from the ideas of commitment and politics that had characterized North American art of the Depression era.[149] Artists had achieved a form of expression through language that avoided all dangerous connections to social rhetoric.[150]

Latin American art had also changed. Whereas artists still identified with the old forms of 1950s social realism, now there was a movement away from the nationalist rhetoric that had characterized Mexican muralism. In the same edition of *Art in America*, Gómez Sicre explained that Latin American art was no longer about the "carnival-type": "Rich in tradition, Latin America is using the international language of art much as it is used in the United States. . . . With reference to two major shows of Pan American art, held this Fall at the Art Institute of Chicago and the Museum of Fine Arts in Dallas, both exhibitions represent the new Latin America without compromise, and without that orthodox, descriptive taste of a souvenir of a holiday across the border or a memento of a honey-moon."[151]

In the early 1960s, Thomas Messer, then director of the Institute of Contemporary Art in Boston, organized the exhibition Latin America, New Departures, for which he selected a group of artists who worked in abstraction or abstractive figuration.[152] The presentation was auspi-

cious and expressed confidence in the new and growing interest in Latin American art:

As recently as half a decade ago, the mention of Latin American art brought, to the general observer of the international art scene, visions of basket-bearing peasant women. This and other clichés had about them the air of the bureau rather than the artist's studio. Even after the names of a few pioneers have become well established in the United States, the existence of an art situation that is active, creatively intelligent, and through its top achievements, notable, has largely been ignored in this country before the late fifties.

In 1959 a Pan American wave swept across the art world in the form of magazine articles and museum exhibitions, giving special attention to the situation in Latin America.[153]

Nonetheless, the road to recognition was not so free of obstacles as the commentaries of Messer would have us believe. To this effect Rafael Squirru, then director of the Department of Cultural Affairs for the Pan American Union, was very clear in an article published in 1964: "Such an article as this one must first answer a long-standing accusation that deeply disturbs our artists, an accusation summed up in a word: derivative. What does this accusation mean? Obviously, used in the pejorative sense, 'derivative' implies lack of authenticity, personality, originality."[154] "All art is in a certain sense derivative," Squirru affirmed.[155] Consequently, artists emulated the way European modernism had operated when, for example, African art forms were appropriated. Latin American art not only exercised the right to draw on the contributions of European culture, but also to appeal to pre-Hispanic art which, indeed, pertained to its own traditions and was not usurped as in the case of the European avant-garde.

Squirru was implying that, although artists are required to play certain roles on the international scene, there was no reason why Argentines should settle for being merely importers of ideas that had originated in the international centers. On the contrary, he attributed to Latin America the right to claim whatever traditions were available, European or non-European, and to develop the expressive material they needed with the same degree of originality as the international centers permitted themselves, to be as varied and well provided in diverse traditions as indeed Latin American art was, in spite of being pejoratively viewed as "derivative." The lack of identity was apparent in the combining, synthesizing, and reworking of elements from different traditions, which constituted its specificity as well as its strength: "The variety of sources that inspire it,

the many rich traditions, the multiplicity of styles, add up to a new Latin American art that is certainly one of the vital forces in the world today."[156] The need to respond to accusations, and to counterattack, demonstrates that discourses celebrating the Latin American "renaissance" were not the only ones in circulation. The terms of the debate were not new, but what was new, or at least not so common, was the intensity and recurrence of stands taken on the question of what was Latin American art and what was not.

The exhibition Magnet: New York, presented in New York in September 1964 and organized as a cooperative project between the Bonino Gallery and the IAFA, gave presence to Latin America and highlighted the political necessity of recognizing it.[157] John Canaday, writing in the New York Times, emphasized the aggressive aspect of Latin American art in New York: "It is not exactly an invasion, but there is at least a strong Latin-American infiltration into the international strongholds so largely cornered by New York galleries."[158] For Canaday there was good reason to make reference to an "invasion": at that very moment, the show Buenos Aires 64 was on exhibition at the Pepsi-Cola office buildings and, not long before, the show New Art of Argentina had opened in Minneapolis. Rather than an invasion by Latin American art, it seemed to be more an invasion by Argentine art.

In the introduction to the catalogue Magnet: New York, Robert M. Wool clearly explained the reasons for this "epidemic" of interest in Latin America that had broken out in the United States. The foremost reason was political: "One reason of course is political necessity: Fidel Castro made us realize that it was imperative to learn something of our so-called neighbor to the South and pay her some attention. Another reason is manifest in this art exhibition: the level, the quality and the contemporaneity of the message that is reaching us through the creative work of Latin America."[159] The motivations for this change in attitude (political imperatives as well as qualitative) did not spring from the same interests, and when Latin America ceased to be a priority, the political reasons also ceased to be dominant.

For the moment, however, North American critics were still making an effort to formulate perspectives on this art that had exploded on the New York art scene, as well as to suggest new directions to pursue in the future. In June 1965 Lawrence Alloway, curator of the Guggenheim Museum, wrote an extensive article on the selection from the Second American Art Biennial,[160] which was on exhibition at the American Federation of Arts

under the title Twenty South American Painters.[161] As seen in the letter he sent to McCloud after participating as juror in the biennial he was now writing about, Alloway was concerned that Latin American art was defining a strategy. Here Alloway had a personal commitment. The prize competition organized by the Guggenheim museum was a space that had been particularly generous toward art from the Southern countries in 1964 by including several Latin American artists in its exhibitions, especially Argentine artists.[162] By giving his article the title "Latin America and International Art," Alloway was diving headlong into the heart of the problem that agonizingly confronted the invasion of South American images in recent years: "When a block of artists from an area regarded as artistically underprivileged moves into wider recognition, a general problem is precipitated for both the movers and the receivers."[163] Such mobility became possible with the breakdown of supremacy and normative strength of the Paris school. The problem had to do with where the emphasis should be placed regarding the new productions, whether it should focus on international features or on localism: "Can or should Latin American art be international in ambition, in style, or does its truth and subject reside in its geography?"[164] The question was not far removed from the questions he had posed to McCloud in his letter the year before. The exhibition he was writing about highlighted the well-known polarity between modernity and local roots. In response to this problem, several artists proposed solutions. Fernando de Szyszlo, for example, used a sophisticated pictorial organization to allude to native gods, Machu Picchu, and to create what Alloway denominated "Inca Cubism." In this way, Latin American art resolved the old conflict between local obligations and international sources. However, the appropriate combination of local and international had no precise recipe and developed the character of a devilish brew whose formula no one could quite establish. How much local content was called for and how much international? How should the mixture be developed? What was its appropriate expression in images?

In 1964 the First Esso Salon of Young Latin American Artists opened in the galleries of the OEA in Washington, organized and financed by the Standard Oil Company of New Jersey, together with its Latin American affiliate companies.[165] Thomas Messer, probably the critic and curator who expressed the most interest in Latin American art in the United States during the 1960s,[166] wrote an enthusiastic review of that body of work which, only a short time ago, had been little more than a "discred-

ited tourist label."[167] Success came after a tough battle which Messer described in military terms: "Their emergence in groups under an imaginary Latin American banner, therefore, seems as inevitable as I believe the ultimate dissolution of this battle formation is."[168]

During the 1960s—for Messer, the "emergent decade" for Latin American art—such countries as Argentina, Mexico, Venezuela, and Brazil had succeeded in creating a climate that promoted "progress" in artistic production. For these nations, having leapt to the international stage, the object was now to achieve the dissolution of groups in favor of a total reaffirmation of the individual artist. Messer proposed a series of steps to follow: After establishing a model that would function locally, it was necessary to form a comparison with the international models, to form alliances that would give rise to establishing a collective image, and, finally, when recognition had been achieved (a moment defined as "victory"), to focus on erasing the group image by trying to break free of the vehicle that had given rise to the initial recognition; thus "the emphasis will return to a point where, in the last analysis, it has always belonged—on individual artist and particular works."[169] Converted into a sort of minister of war, Messer also wanted to play an active role in the ranks of the avant-garde. This sense of urgency would lead him to organize exhibitions and to write on Latin American art with a tone infused with promise.

Messer would have his opportunity to present his version of the achievements of 1965, when he organized the exhibition The Emergent Decade: Latin American Painting. This exhibition formed part of a series of activities that Cornell University organized under the title Cornell University Latin American Year in order to explore the characteristics of contemporary Latin American culture and to compare them to those of North America.[170] The book-catalogue, published by Cornell University, included an introductory essay by Messer, letters from Latin American critics, and a series of images taken by the photojournalist Cornell Capa while accompanying Messer on his schedule and showing the vitality of the artists working in their own environment.

Messer explained that his selections were based on criteria of identity and quality, which made it possible to establish that Latin American art was not merely pictorial sentimentalism suitable for tourist offices.[171] The problem lay in finding the right proportions of what was genuinely Latin American art without renouncing what was universal: "In the end, the problem of the Latin American artist is to find an authentic posture,

one that is equally distant from self-conscious isolation and rootless universality."[172]

However, these discourses, expressing confidence in the future for Latin American art, were not the only ones in circulation. The celebratory and enthusiastic tone that had dominated its reception at the first exhibitions of Latin American art began to give way to a more critical and disillusioned mood. In 1967, shortly after participating as a juror for the Third American Art Biennial organized by Kaiser Industries in the city of Córdoba, Sam Hunter (director of the Jewish Museum in New York) wrote an article capable of undermining all expectations. First, his description of the Argentine sociopolitical context was sufficiently dramatic to discourage not only the desire to view the art produced there, but also the desire to visit the country where it was being exhibited. Organized on the campus of the University of Córdoba, the biennial had been invaded by students protesting the dictatorship of Onganía. The opening of the biennial took place against the backdrop of dramatic events involving tear gas and nationalist speeches by the secretary of culture in which he called for a return to "virtue."[173]

Surprised and excited by this experience, which probably exceeded his wildest imaginings, Hunter revealed to the world that Latin American republics had regressed to their original uncivilized condition. As if that were not enough, his verdict also referred to the once celebrated internationalism and its negative erosion of local and provincial traditions.[174]

Hunter's criticisms, like a well-aimed dart, were directed at the heart of institutional networks that had driven and formulated the internationalist project—international communication, prize competitions with international juries, and international curators: "Lacking the originals, the emerging artists alertly make contact with the 'tradition of the new' through the reproduction and slide lectures of peregrine critics and curators who, like missionaries, descend regularly from the United States, Paris or London to convert the natives to the latest innovations."[175]

In this ironic article, the only art that Hunter seemed to consider valuable out of all that he had observed was the abstract art presented by the kinetic group of Paris and Venezuela, as well as that of the generative artists of Buenos Aires. Here Hunter's views did not differ from those guiding the decisions of other critics and curators who had traveled to South America: to recognize in what they were seeing exactly what interested them in their own countries and in the international context. High-

lighting the work of the youngest Argentine geometric abstraction art-
ists—such as Alejandro Puente and César Paternosto—Hunter pointed
out their similarity to the New York school. According to what may be
inferred from this article, the main problem was that Latin American
countries had not understood internationalism. The result was that, with
the exception of four outstanding countries in this disappointing pano-
rama (Argentina, Brazil, Venezuela, and Chile), all the rest could simply
be dismissed. Hunter's condemnation of internationalism was categori-
cal: "The third biennial exhibition of Latin American Art, sponsored by
Kaiser Industries of Argentina, dramatically demonstrated the erosion of
local traditions and their replacement by an international style emanating
from New York, London and Paris."[176]

This commentary, like a death sentence, clearly reflects the degree to
which the potential of international styles to establish a world without
frontiers had now fallen into discredit and functioned more as a disquali-
fying term. Evidently, in 1967 the situation for Argentina and the rest
of Latin America was no longer what it was at the beginning of the de-
cade. The situation had changed politically. Following the Cuban missile
crisis—once the threat of revolutionary outbreaks in South America had
subsided—the effort to discover and value Latin American art did not
spring from the same almost unconditional premises that had been ex-
pressed in the early 1960s when the Latin American "renaissance" was
being celebrated. Now it was necessary to demonstrate original styles and
signs of identity so that artistic originality could be easily recognized,
which was something that North American critics apparently did not
find, nor did they have sufficient motivation to look for. If Latin Ameri-
can art forms were the same as those that could be found in the major
centers (which were indeed "international"), then what could possibly
be the motivation for wanting to get to know this art? The situation was
doubly irreparable if, as Hunter affirmed, the effects of internationalism
on aesthetic production during the 1960s had succeeded in eroding all the
local traditions.

For Latin American art at the end of the 1960s there no longer seemed
to be any possibility of entering into the great narrative of Western art
history. From the moment that this narrative began to be organized on
the basis of an order in which only the changes and transformations im-
plying advances in the "progressive" evolution of the language of modern
art were considered to be important, there no longer seemed to be any
reason to include in this history a national production that was consid-

ered to be lackluster, or merely imitative. If Latin American art was as international as that which could be found in the major centers, which had generated and transformed the language of modern art—a language to which, moreover, nothing new had been added—then Latin American art could just as well be written out of this history.

7

THE AVANT-GARDE BETWEEN ART AND POLITICS

Violence is now a creative action with new components: it destroys the system of official culture, opposing it with a subversive culture that is part of the modifying process, creating an art that is truly revolutionary.

Revolutionary art is born of a coming to awareness of the current reality of the artist as individual within the political and social context that surrounds him.

Revolutionary art proposes the aesthetic event as the nucleus where all elements that compose human reality come together: the economic, social, and political; a composite of the contributions of the different disciplines, eliminating the separation between artists, intellectuals and technicians; a unifying action for all those who hope to modify the totality of the social structure: that is, a total art form. —Tucumán Arde

Not everyone shared Romero Brest's enthusiasm and certainty that the destruction of the structures blocking development and progress would lead to the creation of a happier world.[1] By the mid-1960s, the international and national situations had provided plenty of reasons to mistrust his convictions. In 1965, the promises of the Alliance for Progress had fallen to pieces: the North American invasion of the Bay of Pigs (1961) and Santo Domingo (1965) were events that demonstrated the impossibility of dialogue without conflict, which the Alliance favored. Further-

more, the coups d'état in Brazil (1964) and, shortly thereafter, in Argentina (1966), showed that the era of the modernizing democracies was at an end in Latin America. In 1964 T. Mann, adjunct secretary of Latin American affairs for the United States, announced a change in North American policy toward Latin America: more important than establishing representative democracy in the region was the need to secure trustworthy allies.[2] The military establishments were seen as political as well as modernizing instruments, and the military coups d'état were seen as the most effective tools for containing the communist advance over the continent.

The revelations published by *The New York Times* between 1964 and 1967, denouncing the methods of cultural espionage employed by the United States, which had been financing foundations and research in Latin America through the CIA, served as yet another detonator of the rupture that in those years led from the theory of modernization to the theory of dependence.[3] Since then, denunciations and suspicions spread throughout the public lives of intellectuals, among whom certain figures served as exemplary models. Whereas Sartre stood out as an example when he refused to go to the United States, Pablo Neruda was condemned for attending the Thirty-fourth PEN Club conference, held in New York in June 1966. The "Open Letter to Pablo Neruda," published by the magazine *Casa de las Américas* (dated July 25, in Havana, Cuba), was a letter of censure signed by more than 120 intellectuals (including Alejo Carpentier, Nicolás Guillén, Juan Marianello, José Lezama Lima, and Roberto Fernández Retamar) and was republished almost immediately by the Uruguayan magazine *Marcha*.[4] Up against such a mobilized front, it would become increasingly difficult for intellectuals to take public positions without being subjected to judgment and suspicion.

In a context that was highly sensitized due to military invasions, dubious financing, and denunciations,[5] which was further exacerbated by the North American military buildup and escalation of hostilities in Vietnam, it was almost impossible not to express an opinion. The charges that leftist sectors leveled against institutions like the Di Tella—accused of importing fashions, favoring colonialism, and depending on financial support from such entities as the Rockefeller and Ford Foundations— quickly intensified.[6]

This surge of accusations gave rise to a dispute for control over international culture (whose bases of operations were seen to be in the United States and Cuba) which also took place among the local intelligentsia.

However, it would be somewhat artificial to divide artistic production at that time into two distinct periods with precise dates (1966, 1968, or 1969, according to various authors),[7] one period being festive and affirmative with respect to the revival process, and the other being overtly critical. That the revival movement at the beginning of the 1960s was not dominated by political concerns is unquestionable. Nonetheless, the politicization of artists was a gradual process that responded to a redefinition of situations that did not correspond exclusively to the political order, but rather to dynamics of the artistic field itself. On the other hand, although it is certain that the Cuban Revolution opened up new horizons for political identities, it was not necessary in the early years to formulate artistic practices that specifically made a "commitment." After the "Message to Intellectuals" delivered by Fidel Castro in 1961 (faithfully republished in Buenos Aires by the magazine *Cuadernos de Cultura* the following year),[8] the revolution had opened up a broad field of uncertainty with respect to the role that art should play in it. For Argentine artists seeking to define a national avant-garde at the beginning of the 1960s, the relationship between art and politics did not represent a problem about which they had to express an opinion: it was not seen as problematic and therefore required no specific program. For the moment, the avant-garde did not include political questions as part of its agenda, which did not mean that artists would not consider critical intentions in their proposals: Kemble's sheet metal works, the allusions to the Cold War permeating the texts for the exhibition Arte Destructivo, Noé's narrative series, and Berni´s collages on Juanito Laguna and Ramona Montiel, were examples of works that expressed a discourse that was very different from the celebratory tone that the first generation of artists, as a group, had adopted as they strove to define a language for a "new art form."

My contention is that the decision to unite the aesthetic avant-garde and the political avant-garde, whose first symptoms were visible midway through the 1960s, but whose clearest expression could be seen in 1968, was not a decision that arose from a unique circumstance originating in the political arena. Rather than the final results, it is necessary to analyze the successive ruptures and repositioning that responded to the national and international political situation, as well as inherent conditions that constituted the field, its degree of institutionalization and, particularly, the debates that, in the area of aesthetics, sought to establish a formula that would overcome all the errors committed during the long and conflict-ridden history of the relationship between art and politics.

The problem has to be considered with respect to at least three different moments: the moment when the *artist* was transformed into intellectual—when the decision was made to *commit* artistic activities to the political situation; the debate that was ignited in the area of aesthetics regarding the correct forms for responding to this commitment; and, finally, the forms—the visual and conceptual repertoires that were formulated in the search for a solution that would supersede the contradictions.

The Artist as Intellectual

"No, we do not want to 'engage' painting, sculpture, and music 'too,' or at least not in the same way." With this negative statement, Sartre liberated artists from the dilemma over commitment.[9]

In his introduction to *Les Temps Modernes*, the French philosopher established the notion of commitment not as providing a political service to a party, but rather as the need to reestablish a social function in literature.[10] The responsibility of the writer lies in analyzing the problems of the present and, to this end, Sartre himself defended the legitimacy of appealing to all literary genres that might make effective communication possible. "The 'engaged' writer knows that words are action. He knows that to reveal is to change and that one can reveal only by planning to change."[11] This inclusion of politics in art should not, however, condemn literature to oblivion.[12]

But "it is one thing to work with color and sound, and another to express oneself by means of words,"[13] Sartre affirmed. With this limitation of the artist's commitment, determined by the specificities of language, the artist was liberated from the need to publicly reflect on his own times in his specific activities.

Raymond Williams defines intellectuals as those sectors that constitute a specialization with respect to a more general body of cultural producers; specifically, "certain types of writers, philosophers, and social thinkers who maintain important but uncertain relations with a social order and its principal classes."[14] He excludes artists, actors, and cultural producers, who cannot be defined as intellectuals (even when they contribute to the general culture) and he also excludes those intellectuals who form part of political, economic, social, and religious institutions.[15]

According to this view, the artist would be doubly excluded, both as intellectual and as committed intellectual. However, this exclusive conceptualization needs to be revised for those cases not only in which artists

decide to commit their works, making them much more explicit constructions, linked to current circumstances, but also for those moments when they assume a public position while seeking to be agents for the circulation of notions concerning the social order through public actions in which they themselves (and not others) are included in the ideological and political sphere.[16] In certain situations the artist may be seen as a social actor with the "ability to guarantee that his ideas will be heard, and, for better or worse, will influence public opinion."[17]

The artists felt they were capable of instigating a crisis in the current values of their society and of contributing to the formation of an alternative order, and they demonstrated a genuine desire to be publicly active in order to affect the established order. They also recognized that they were intellectuals with their own specific aesthetic practices.

The decision to commit contents and forms of artistic creation implied an attack on the concept of aesthetic autonomy in two ways: in terms of its effects on anti-narrativity, and also relative to its pertinence to a sphere ruled by its own institutions and norms. This is the moment when art demands insertion into life: in a sense, the highest aspiration of the avant-garde.

How effective did the artists feel their actions were? What was an acceptable legitimizing framework that would permit art—and the need for art—to function in the service of politics? What was different and characteristic of this moment was that during a period that felt pre-revolutionary, the artists came to view their activities not as an expression of revolution, but rather as a detonator, as one more engine for change.

Another element to consider is the twofold obligation they felt to be revolutionary in both content and form. In this sense, they were not after conquests in a traditional movement like that of the muralists, but rather by drawing upon resources accumulated by the experiences of the local avant-garde, resources that provided them not only with new techniques but also with prestige and power. The degree to which the artists and institutions had gained positions of centrality was unprecedented in terms of public impact: never before had they been able to reach so many people, nor had the mass media focused so much attention on their actions.[18] This centrality and intensified publicity was by no means disdained by the politicized artists.

The conversion of the avant-garde artist into intellectual and into committed artist/intellectual is a process whose first traces appeared by the mid-1960s and soon culminated in 1968. It is interesting to note that the

split that took place at the heart of the avant-garde itself arose from a dispute over how to define an *other* meaning for the avant-garde. The dispute did not involve a debate over styles, nor questions of generation, but rather the need to link their work to politics and, also, the question of the degree to which they should adhere to, or confront, the institutions that had legitimized them up to that time.

There were, of course, external and strictly political factors and influences (such as the U.S. invasions of Santo Domingo and Vietnam, the 1966 military coup d'état in Argentina, the murder of Che Guevara in 1967, and the May 1968 events in Paris), as well as factors inherent to the new structure of the Argentine art world during the 1960s. There were those who wanted to affect the social order by attacking the prestige of the institutions and the avant-garde.

The various terms that came into use in the new symbolic economy of the avant-garde were shaped by controversies over the relation between art and politics. These controversies were generated by leftist groups, by the ways in which writers had become politicized, by the course of the debates on art and revolution in Cuba, by changes in the political situation, by the high degree to which the avant-garde had been institutionalized, as well as by the vast capital of experiences accumulated by artists who identified themselves with the artistic avant-garde of preceding years.

The formation of an autonomous avant-garde that was self-regulated according to its own institutional circuits and agents gave rise to a split and confrontation between one sector (the politicized avant-garde) and the other—accused of being institutionalized and false. As part of this rupture, the artists-turned-intellectuals represented themselves as carrying out a mission of prophetic, intellectual, political, and aesthetic subversion.[19] This visionary rupture occurred in the name of the autonomy they had gained as artists who did not respond to any particular party mandate and thus asserted their independence. Their authority did not at first stem from the political arena, but rather from that of the artistic avant-garde. As affirmed by Bourdieu, it is the autonomy, "the political quietism . . . a lofty withdrawal towards art for art's sake, defined as against 'social art,'" which gives rise to the "strange reversal" through which, "by relying on the specific authority conquered in opposition to politics by pure writers and artists" like Zola—as a paradigmatic example—they could break with their predecessors, despite their political differences, and they could have an effect in the political arena, albeit by using arms that were not political (as Zola was able to do in the Dreyfus case).[20]

A "Plastic" Crime

What were the limits of this politicization of the art world in the 1960s? There is no single answer to this question because the relationship between art and politics—articulated more as a source of tension than as a process without conflict—yielded various possible outcomes and materialized in ways that struggled with the sense of unease produced by the conviction that something was lost when art was linked to politics.

In 1961 the artistic debate no longer only focused on mutually exclusive currents as in the case of abstraction versus realism. The discussion primarily aimed at finding key ways to be simultaneously modern, national, and international. Realism was one of the solutions.

Two dangers were lurking like ghosts: social realism, which was unconditionally rejected (by liberal sectors as well as by the critical intelligentsia) and, for similar reasons but to a lesser degree, Mexican muralism. The term "realism" was central to the aesthetic debate in the early 1960s. However, in the ongoing effort to establish a form capable of providing a response to all the objections raised regarding legitimacy, the disputes were deadlocked. For sectors of the critical intelligentsia, what was necessary was a realism that was committed and, at the same time, modern.

In general terms, socialist realism suffered from a negative image: no one wanted to bear the burden of what all agreed were horrendous productions. It was even more difficult to neutralize the aesthetic of Mexican muralism, a school that had emerged in Latin America in the context of a revolution that relegated the artist to the social position of a laborer, a wage-earner who, having dispensed with his privileges, had accepted the task assigned to him by Vasconcelos, the minister of culture: to paint a lot and do it quickly. The dream of public art, of art outside the confines of the museums, of art that was part of daily life with a presence in the schools, office buildings, and streets—capable of representing on walls the history of the first modern revolution in Latin America—was not a resource that could be discarded easily. Nonetheless, revolutionary art had also been, and was still more than ever, a form of State-sponsored art against which accusations were hurled that it had fallen into the habitual use of repetitive rhetoric and that it conformed to the requirements imposed upon it by an institutionalized revolution.

In the early 1960s, muralism could not be a model for the avant-garde sectors. However, the group Espartaco did adhere to this approach.[21] Although its main representative, Ricardo Carpani, affirmed that "genuine

artistic work only emerges when the artist enjoys complete freedom of choice for his expressive means,"[22] his proposal for revolutionary art in Latin America was based on a series of exclusions—from abstract art, "the expression of the retreating imperialist bourgeoisie,"[23] to socialist realism, "the triumph of the bureaucratic reaction in the Soviet Union."[24] All of his "negatives" left only one option open for revolutionary art: "In the area of the visual arts, the most effective medium for achieving artistic-revolutionary objectives is mural art. Its monumental and public character, its presence in the usual concourse of the common man, necessarily re-establishes the contact, secularly lost, between art and society."[25]

But neither the mural art approach nor the images produced by Carpani, representing workers that seemed to be sculpted from stone, could gain acceptance from the sectors that sought a new art form, though this did not mean that they sought a form that was less national than Carpani's. Luis Felipe Noé, answering a questionnaire in the magazine *Hoy en la Cultura*, thought that muralism might have been effective fifteen years before, but it was impossible to sustain that effectiveness in the present.[26] Mexican painting, according to Noé, had remained closed up in its own view of the world and had not served to broaden the vision of Latin American art. Its principal shortcomings consisted in a "limiting thematic dogmatism of the freedom of expression necessary to contribute a new voice" and, in addition, "a neglect of purely plastic values, which are those that give value to painting as a means of communication."[27] In his view, these shortcomings, however, did not fully justify the aesthetic objection: "Between the fashions of Mexican muralism and Mexican anti-muralism, the truth lies somewhere in the middle."[28] Noé used this argument in support of his view that it was necessary to find key elements for an original art form and, above all, to defend the legitimacy of theme.[29] On the other hand, and beyond all these limitations, muralism had for Noé the great virtue of having established the tradition of commitment in Latin American art.

While Carpani understood that revolutionary art could have a revolutionary effect on the masses,[30] for Noé the possibility of political art—of revolutionary art—could not take place outside of a revolution. In this context, the examples were the Mexican revolution and, more recently, the Cuban revolution: "It is understandable that in the painting of all American countries that have lived through a revolution, there will be a repetition of the Mexican experience. That is what we are seeing in Cuba. Painting that speaks to us of painting will not give rise to revolutions

(this is done with arms), but it is logical that revolutions give rise to political painting because the artist, as I have said, is a child of his environment and his times."[31]

For Noé the main problem consisted in establishing parameters to help define a national avant-garde art form. He wondered how this could be accomplished "once the anecdotal, political, indigenous, archeological, and folkloric had been discarded."[32] In terms of an aesthetic program, the solution he offered was, for the moment, untranslatable: "It is necessary for the men of America to become aware of this problem. Thereafter, they must simply express themselves as men. If they do this, they will create an American art form."[33] Noé sought a national art form that would not ignore international languages. At least in his case, the modernizing impulse did not imply a lack of commitment, even when this was expressed in much less urgent terms than those that had characterized artistic discourses after 1968. In his view, the commitment consisted in finding a national and avant-garde language, but not in putting art at the service of politics.

By the mid-1960s the discussion had reached a new turning point and had given rise to a reformulation of terms that, some years later, would culminate in the artists' facing the inevitable need to choose between art and politics. I would like to establish the particulars of the debate as it was formulated on the Argentine art scene at that moment. To delimit the moment when the relationship of art to politics was translated into unresolved tension will help us gauge the magnitude of what was at stake, and the degree to which what was written and declared may have impacted on the forces giving rise to these definitions.

For all positions—those that defended the legitimacy of forming ties with politics and those that pushed for its complete autonomy—an answer was provided by Picasso and, among all his paintings, *Guernica* laid down the ground rules for all practical purposes. In 1963, Luis Cardoza y Aragón wrote in *Casa de las Américas*, "[In *Guernica*] all the complaints about art and politics, formalism and realism, content, etc., were magnificently and pictorially resolved, providing a great, concrete, and exact lesson. All those who have any doubts should return to it."[34] This painting condensed solutions that were capable of overcoming all objections: it did not work upon empty forms, nor justify itself on the basis of theme, but rather on the basis of establishing, with theme, an artifact, a machine in which reality, albeit dramatic, was rife with the configuration and internal articulation of the work. All heteronomy was, therefore, sub-

servient to autonomy, to the secondary mimesis that was produced in this work.[35]

The fact that this article by Cardoza y Aragón was published in Havana in 1963 and was republished in Buenos Aires the next year, like many other articles discussing the style that was capable of emphasizing the "responsibility" of the artist, reveals that there was a debate about realism taking place in various parts of the continent and that one of its administrative centers was located in Cuba. For the moment, the responses were not expressed in nontraditional terms: the idea was to find a balance between form and content that would avoid the challenges of "formalism" as well as "literality." The discussions had to do with redefining realism while avoiding dogmatic and inefficacious Socialist realism, or overused muralism, both rhetorical styles administered by the State. Picasso was again seen to be the example that could provide the solution. By analyzing the corpus of magazines published by the intellectual left in Latin America during the 1960s, a laudatory ode to the life and work of Picasso emerges time and again: "His painting needs no explanation. It speaks for itself. For my part, I never explain and I never seek acquiescence to my words but rather the reflections of the reader and what is most important to me is his disagreement. The truth and the life of Picasso are one and the same thing. His truth and his life, drawn from his roots and revelations, are the art of Picasso."[36]

Such fragments as the one cited above were reproduced in innumerable magazines, all explaining the same thing: Picasso and *Guernica* provided the best and only solution to the unending controversy over how and to what degree art could mix with politics. What was the problem that this painting resolved? What did it reveal to be wrong with all other solutions?

In 1961 Sartre published the article "The Painter Without Privileges" in *Meditations* for an exhibition by the painter Lapoujade titled *Muchedumbres*. In 1950 Lapoujade was producing abstract and informal paintings. By 1952 he was trying to include expressive vehicles borrowed from socialist realism in abstract art. The series he exhibited—linked to his political convictions in opposition to the war in Algeria—dealt with the issue of torture. In writing about these paintings, Sartre considered a model of realism that could be applied to the exhibition: "After Goya, the killers did not stop killing nor did the good souls stop protesting . . . but such indignation does not reach his paintbrush. The endeavor of Lapoujade is of a very different nature. It is not, to be sure, to freeze art in

order to put it at the service of bourgeois thinking, but rather to question painting itself, from within, about its passion and its extension."[37]

The question was how to determine the degree to which it was possible to demonstrate "the evil some men commit upon others," without either betraying painting in favor of morality, or anger and pain in favor of beauty.[38] Of all the solutions so far provided by the history of art—solutions that inevitably fell into one or the other of these two types of betrayals—there were only two exceptions: Goya and Picasso (*Guernica*):

The most fortunate of artists has benefited from the most amazing good fortune. In fact, the canvas combines incompatible qualities. Effortlessly. Unforgettable rebellion, commemoration of a massacre, and at the same time the painting seems to seek only Beauty. And it discovers it. The coarse accusation remains, but without modifying the calm beauty of the forms. Inversely, this beauty does not betray: it helps. The Spanish war, cardinal moment of World War II, breaks out—precisely—when that painter's life and his painting reach a decisive moment. The negative force of a paintbrush diminished the value of the "figurative," preparing its systematic destruction. . . . An investigative procedure came to be the singular meaning of a rebellion and the denunciation of a massacre. The same social forces had transformed a painter into the negation of the order of those forces, from a distance those same forces had prepared the fascist destruction and *Guernica*. That twist of fate made it possible for the artist not to flatter Beauty. If the crime continues to be odious upon becoming "plastic," it is because it explodes and the beauty of Picasso is perpetually explosive, to borrow an expression from Breton. The miraculous chain of events can not be repeated: when the painter wanted to begin again—after the war broke out in 1939—his art had changed, the world had changed as well, and they did not meet again.[39]

This text deserves to be cited so extensively because it provides one of the most extraordinary formulations of everything *Guernica* was responding to: the point at which form recognized content (political content) and exalted it, the imperturbable balance at which reality was not lost in aestheticism, but rather gained strength through language. This unique solution, which Sartre articulated with such precision, gave rise to various explanations and essays addressing the difficult relationship (between art and reality, or, in its most complicated formulation, between art and politics) of the paradigm example of *Guernica*.

In 1964, a book was translated in Buenos Aires that Louis Aragón described in the preface (with respect to its content and its author) as an "event." *Hacia un realismo sin fronteras* (Toward a Realism Without Bor-

ders), by Roger Garaudy, was published in French one year before it was translated into Spanish in Buenos Aires.[40] In this text, which could be read as a kind of ship's log, Garaudy explained why Picasso was a realist as well as why he was not, and he offered a Marxist reinterpretation of the works of Saint-John Perse and Kafka. In his observations regarding Picasso, Garaudy highlighted certain revolutionary aspects, particularly the important fact of his having departed from and broken with tradition. Cubism was the breakthrough that had enabled painting, "liberated from its tutelage under literature," to conquer its "autonomy."[41] Picasso had taken the next step with *Guernica*: "The significance is in intimate unison with the form. It was necessary for the color to produce pain, the line to produce anger or terror, and the composition to have such mastery that the work should signify both a verdict and a cry of man in the process of overcoming. . . . However, by virtue of its formal expression, that ossuary and chaos inspires in us neither the feeling of defeat nor of desperation."[42]

Guernica was neither literature nor formalism, it triumphed according to all analyses, it overcame all challenges, and at a time when discussions on art and politics were intensifying, the painting was hailed as the only correct response. In addition, Picasso was communist, but not as an ingenuous, opportunistic, or momentarily confused act—as some of his biographers have suggested—but rather because his painting had led him to take that stance:[43] "Picasso became communist in response to something within himself, because his rebellions as an artist, the rhythm of his life, were in harmony with the rhythm of development in the world. Following the ascendant movement of his own progress he found himself in unison with the ascendant movement of our times. This is what he expresses in this transparent formulation: 'I have come to Communism as one goes to one's origins.'"[44]

What Garaudy was saying was that art did not have to yield to the demands of revolution, nor did it have to wait for revolution to take place, because revolutions in art respond to the same principles—the same transformative matrixes—as revolutions in painting or literature.[45] The relationship was not forced, rather it had a natural bond.

The debate over the relationship between art and politics was nothing new, but it had increased in intensity because the situation made it imperative. Whereas in 1961 Noé had been able to avoid the problem, arguing that the politicization of art was only admissible in the context of revolution and, as revolution did not take place, the artist should con-

centrate only on art (though searching for new expressions to establish a national art form), now, on the contrary, it seemed that to "take a position" was unavoidable in the new reality. Roberto Broullón emphasized the scope of this obligation:

Today more than ever the painter must take a position in the critical-historical process he is part of, and this process rests upon a political perspective. As painters, our participation in this perspective is subordinate to the general development of the political struggle and the growth of the revolutionary party (which, as we know, does not exist at the moment). Becoming aware, then, occurs in two stages, with respect to which there may also be partial delays in awareness. One is the aesthetic (or anti-aesthetic) stage, and the other is the political stage. . . . Depending upon the degree of clarity of the participants as they gain this twofold awareness, and also according to the contradictions of the particular historical moment itself, political struggle and artistic struggle may coincide. But this coincidence, specifically in the artistic sphere, will always be MEDIATED (I have in mind "Guernica" as a symbol of Nazi barbarism).[46]

The taking of a position with respect to the sociopolitical process or, in other words, the conversion of the artist into intellectual, did not imply, for the moment, subordinating artistic practices to political demands, which could at best coincide with each other, but only when this coincidence was "mediated." This mediation provided the possibility of establishing language as an autonomous system. What was at stake here, finally, was the notion of autonomy in a double sense: with respect to its connection to the theme (in this sense, *Guernica* was the ultimate and most perfect way to force the language) and with respect to its social function.[47] These two problems—which would be resolved at the end of the period not through resignation but rather through the elimination of contradictions and the radicalization of the paradigm shift—could not for the moment have a satisfying theoretical solution, either through affirmative positions with respect to the change (like the acritical position endorsed by Romero Brest) or through negative ones (like those endorsed, also acritically, by the analyses of the critical intelligentsia). To the limits established by modernist norms were added the challenges of leftist sectors, based in "fashion" and "dependence" theories. Broullón differentiated between the interpenetration of cultures (which was compatible with the concepts of "universalism" and "internationalism," in positive terms) and the economic and political penetration of the most developed countries into the less developed countries: "imperialist" or

"colonial penetration." This latter assault was referred to as "cultural colonialization" or "ideological penetration," and its Trojan horse, securely installed in the Di Tella Institute under the direction of Romero Brest, was represented by the "avant-garde."[48]

All these warnings and precautions, based on objections that originated in both the aesthetic and political spheres, situated the artistic production of the 1960s in a minefield of conflicting challenges. Unable to imagine change and, at the same time, face its inexorable advance, these ideologically opposed sectors (some still subscribing to the modernizing project, others challenging it) opted either to celebrate or condemn this change without trying to critically analyze its components or explain what it entailed. However, their interpretations have one point in common: in both cases their evaluations depended on a system that was in crisis. It was not possible to consider pop art, the happenings, or mass-media art in terms of the modernist canon. It was not a question of evolution or of rupture in order to expand the base. Rather, it was a new situation in which art could no longer be thought of in terms of language or composition. From that moment forward, art would also be viewed as a system whose communicative matrixes did not depend upon surfaces, but rather on other materials that had invaded its territory: popular culture, new technologies, language sciences, and the means of communication. For those who presented themselves or were recognized as representatives of the "avant-garde" (the political avant-garde as well as the purely artistic avant-garde), it was impossible to find a unifying material to organize its significance. This began to develop through appropriations, simulations, and allusions to other realities—through the most absolute heteronomy. Art was no longer a *visual machine* but was converted into a conceptual machine. Reality invaded the territory—brutally, directly, and without the mediation of language—functioning in the work by means of assemblage. Its significance was produced at the point of confrontation.

The Politics of Assemblage

León Ferrari's decision in August 1965, regarding the direction his work had taken until that moment, can be traced back through his previous work. In his obsessive calligraphy, in which he converted graphics into plastic objects and the image became a written narrative, certain precise texts tended to define a sense of ambiguity. Writing the succinct, almost descriptive phrase, "Carta a un general" (Letter to a General) (1963, fig.

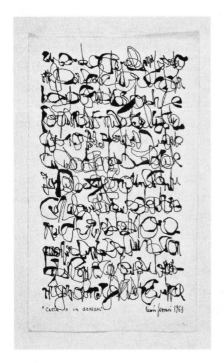

14. León Ferrari, *Carta a un general* (Letter to a General), 1963, ink on paper, 24 × 14 cm. Alicia and León Ferrari Collection.

14) in a succession of cramped and illegible calligraphies, Ferrari offered a slice of reality (confrontations among military sectors occurred daily) and of irony. The action was, above all, an assault on the standards that he himself had established with his first simulated narratives. It was also an action that, on the other hand, had not been easy for him to carry out. Ferrari's notebooks, filled with annotations from those seminal years of his artistic career, reveal that at the same time that he was considering technical questions (for example, what type of ink or paper to use for his calligraphic works), and formal questions (the thickness of the lines or the intensity of the superimpositions), he was also noting possible words to combine with his compositions.[49] Ferrari was considering aspects related to the artistic language and, at the same time, figuring out how to combine his abstract lines with content related to the immediate political situation. He also conceived of his totally abstract wire structures as projects that were "traps for generals": "One of them could be like one of those mouse traps that mice enter but can't escape, cages with a cone at one end. Another could be like those contraptions that are used for trapping foxes or tigers. . . . Another could have a heavy weight suspended by a nylon string that is cut by scissors to set in motion a complicated

mechanism, like those devices that Oski draws."[50] While describing these constructions, Ferrari would continue drawing. What these notebooks provide is a parallel view of how his aesthetic and political concerns were being processed, albeit without being united in a single formal solution. In this sense, they show that politics was not just an addition—something that he added to his work and that skewed the course of his work as a consequence of the politicization of the cultural sphere—but rather a concern for which he was unable to find a satisfactory form precisely because of the materials he was working with. For the moment, he found the best solution in writing, even if that meant combining barely decipherable phrases with other tangled and abstract figures, as well as others that were clearly legible. At the same time as he focused on notably perceptual aspects, he filled them with elements that interrupted the flow of the abstract graphics and that, more than suggesting any precise meaning, seemed to question the location of meaning.

In 1965, when Romero Brest invited him to participate in the national awards competition sponsored by the Torcuato Di Tella Institute, Ferrari realized that this would be a fine opportunity to present a work that engaged with the very discourses that had led to the institutional invitation: the discourses of the avant-garde and internationalism. Romero Brest, who had still not begun to finance projects in which there was a predictable margin of surprise (as he would do two years later with *Experiencias*), surely expected Ferrari to present the type of work that had earned him his incipient and rapid recognition.[51] That is to say, he expected the scribblings and wire sculptures that Ferrari had exhibited on several occasions in Buenos Aires and for which he had been invited in 1964 to participate in Hugo Parpagnoli's exhibition at the Pepsi-Cola building in New York. Ferrari had already earned significant success and recognition, all of which he now risked with his choice of pieces to submit to the Di Tella awards competition.

Instead of combining his abstractions with allusions to reality, presenting them cryptically enmeshed in a tangle of lines and wires, Ferrari decided to work directly with reality itself. The compositional strategy with which he carried out the central operation of his work was rooted in a practice heavily influenced by surrealism and dadaism: the confrontation of two realities in a single and new situation, a procedure that, at this point in time, the art world of Buenos Aires had already seen and from which a local tradition had already been established. The approach was based in the assemblage and confrontation of two realities that were basi-

cally alien to one another: Ferrari took a scale model replica of an FH 107 airplane and mounted the sculpted figure of Christ on it, both of which were suspended in a vertical position, foreshadowing their imminent descent (plate 10). It was a contemporary crucifixion with an immediate referent in Vietnam, a distant and seemingly alien conflict that, with its daily presence in the news media, would become inescapable for the citizens of Buenos Aires. The phrase that served as the title for the piece, *La civilización occidental y cristiana* (Western and Christian Civilization), would soon relate directly to local events. The defense of Western and Christian civilization, which justified the North American military escalation in Asian territory, also served to legitimize decisions made on behalf of Argentine culture.[52] The Vietnam War also updated themes that were important for a continent concerned with developing networks of solidarity opposed to all attempts to infringe upon its right to self-determination: North American military actions in Cuba (1961), Panama (1964), and Santo Domingo (1965) made it necessary to reject all such incursions. The other element upon which the discourse of this piece was based was the conflictive relationship that the artist pointed to in the short phrase that accompanied the reproduction of his work in the catalogue: "The problem is the old problem of mixing art and politics." Ferrari drew upon a repertoire of available materials and strategies and brought them together in a disruptive and unsustainable combination: unsustainable because of the nature of the elements themselves—the avant-garde, politics, and religion—as well as the institutional space where he wanted to exhibit his work.

If there was an element that linked this work to the dadaist or surrealist spirit, to which the critics clearly related it, this element was not so much the mere act of uniting distant realities, but uniting them with a socially disruptive intent.[53] It was a project that required the careful selection of materials and that assigned the object a meaning that was closer to Benjamin's views on surrealism than to those of Duchamp. Whereas Duchamp advocated absolute disinterest in the selection of objects to be used, Benjamin preferred to emphasize the "dialectical embryo" that surrealism had developed.[54]

Ferrari recycled themes and strategies, he selected and revamped procedures, but beyond the resources he used, the rupture was produced by his decision to take these resources to extremes and to exhibit them on the best stage the city had to offer at the time. By proposing a piece that remitted to hyperbole and denunciation because of its size, disposition,

and the themes it combined, to present it with maximum impact in a public space that guaranteed a vast reception, his work was intended to be a controversial act and declaration: an *image-manifesto*. It was this opportunity to present his work to a massive public that incited him to risk all his accumulated prestige in a single gesture, a single act, violating the rules of the game according to the institutional circuit. Although Ferrari would have another exhibit at the Di Tella Institute two years later (which reflects that the central focus of his work at that moment was not to attack or condemn the institutions), there was no place for the works he wanted to exhibit at that time in the institutions.[55] For the activities he wanted to carry out, then, he would have to seek other venues beyond the circuit of the official institutions.

Although this work was not exhibited in public and the only record of its existence is a photograph of the model that appeared in the catalogue, it is interesting to note that for historical and critical studies of the period it represented an important break from the dominant institutional discourses of the period. This point is noted by both Oscar Terán and John King.[56] Ferrari withdrew the piece after Romero Brest offered to show the three other box-works that made up the submission but without the Christ-on-the-airplane, which Romero Brest thought could be troublesome "because of the religious sensitivity of the Institute's personnel."[57] The theme was the same for all the pieces, but the intensity of the three was not even comparable to that of the one. For the critic, withdrawing the piece meant avoiding scandal, for the artist it meant sacrificing the most powerful piece and leaving the others, even though the themes and the objectives were the same: to register a complaint with the most important avant-garde institution, which was about to be buried by an avalanche of accusations.

Although the impact that the two-meter-high, suspended, and threatening Christ-plane would have had on the public cannot be compared to that finally produced by the three box-works that were, in fact, displayed (plate 11), the critics did not overlook them.[58] Almost all the commentaries coincided in expressing their regrets over Ferrari's decision to abandon his calligraphies and wire sculptures, which had earned him so much recognition, to produce that species of "visual outrage" that was so remote from "true art." In this context, the most significant observations, which also came to be the most representative, were those published by Ernesto Ramallo: after denying that the submission embodied artistic value, he expressed amazement that those "artifacts" had been accepted

for exhibition in the "galleries of a serious institution."[59] Beyond the fact that this condemnation contained a call for censorship (which, as noted above, had already taken place), Ramallo was indicating an important aspect of Ferrari's agenda: his intention to engage, not only in terms of the content and rhetoric of his assemblage, but also in terms of conflict, with the institution that was exhibiting his work. The artist's intentions behind the work were further expressed in a letter (an opportune way to deliver a manifesto, which Ferrari began to cultivate from that moment forward), published in the magazine *Propósitos*.[60] If art should not be mixed with politics, then art criticism should not be mixed with it either. This disavowal was based in a political objection, founded upon the rejection of content rather than artistic quality: "The works are good, bad, or mediocre, they are strong or weak, they are innovational or traditional, independently of whether or not there is evidence of political affiliations or objectives pursued by the artist."[61] But if the intention of the critic was to force Ferrari into making a choice, he would choose politics: "It's possible for someone to show me that this isn't art: I would have no problem with that, I would not change my activity, I would just change its name: I would cross out art and I would call it politics, corrosive criticism, or whatever."[62]

The importance of Ferrari's change of position with respect to his labeling of his work is that it was not an isolated case, but rather it formed part of a broad debate involving the entire intellectual sphere and producing a multitude of articles published in magazines dedicated to intellectual discourse. The discussion revolved around finding the perfect formula for uniting art and politics, successfully leaping a precipice flanked by two dangers: socialist realism and aestheticism. And although Ferrari's formula appeared to be very close to the former, what was important was that through the image that continued into the text, he had given rise to a new form of solution.

In 1965, in the only issue published of the magazine *Literatura y Sociedad* (Literature and Society), Ricardo Piglia entered into the debate by addressing a two-sided issue. On the one hand, he tried to define the place of the Argentine new left, distanced from the "old left," which he considered to be irremediably distanced from the Peronist nation and guided by the principle of "combating Nazi-Peronism"; the new left, favored by the Cuban revolution, had initiated a "painful awakening" and proposed once again the need for a national reorganization oriented toward a Marxist Argentina.[63] On the other hand, Piglia also wanted to debate this

leftist position in the cultural sphere. In this sense, at the same time as he wanted to differentiate himself from the dogmatic elements that systematically rejected certain writers on the basis of their political positions,[64] he was opposed to all such precepts: "It is by fighting for a new culture and not by violating the immediate political 'contents' or by alienating literature that we can respond to the reality of our times."[65]

A year before publication of Piglia's magazine, another magazine, *La Rosa Blindada* (The Armored Rose), also actively participated in these debates. The magazine's directors, Carlos Alberto Brocato and José Luis Mangieri, attempted to redefine the controversial category of "socialist realism." The overriding problem was how to differentiate it from the "realist literature produced by the Soviets."[66]

In many ways this magazine was an attempt to resume the scheme of definitions and differentiations in the field begun by the magazine *Contra* in the 1930s. By naming Raúl González Tuñón the "honorary director" and adopting the title of a book of his poems—*La Rosa Blindada*—in which the writer proposed both a political and aesthetic program, the magazine was seeking recognition as the continuation of this program.[67] However, there were clear differences. The paradigm was no longer Russia—the point of confluence during the 1930s—but rather recent world events, such as the Cuban Revolution and the Vietnam War, which seemed to be defining the horizons of identity and future international symposiums for leftist sectors.

La Rosa Blindada fervently attempted to establish a position in the aesthetic debate of the left by assuming programmatic and leadership stances, defending the "specificity of the artistic event" and the "aesthetic emotion." But at the same time they hoped art would go beyond what was exclusively formal. To this effect, Carlos Gorriarena wrote an article on the 1964 ITDT international award, taking a position that did not differ from the traditional leftist challenge to the institution but rather focusing his analysis on the text published in the catalogue by Pierre Restany as well as the works placed on exhibit. The French critic recognized in the pop artists and the new realists the power of "taking action" over creating "beautiful objects," employing to this end strategies of appropriation, selection, accumulation, and the destruction of materials taken from reality. With this procedure, the artists held up the world to be seen "through other eyes," exalting the "expressive possibilities of a hazy daily context, blurred by overuse and by habit."[68] Trying to find connections between this text and the work exhibited at the Di Tella Institute, Gor-

riarena did not find the power of "taking action" that the French critic attributed to the works.[69] Only with considerable effort could Gorriarena find anything resembling criticism in the jumbled pile of cigarette packs submitted by Arman. His "inventories," exempt of "perceptible secondary intentions," were acceptable at best as "exercises in good taste" or as an "ingenious game"; the "domesticated" dadaism of Rauschenberg, not in the least bit "challenging," made it impossible for him to see anything comparable to social criticism or controversy in the works.[70] Gorriarena demanded more and the box-works that Ferrari exhibited a year later fulfilled those demands. Thus, it is nothing short of surprising that, while Ferrari's box-works did not cease to attract attention and, on certain occasions, to be attacked by newspapers and magazines of the liberal sectors, the publications of the intellectual left hardly mentioned them. From this it may be deduced, as a quick and obvious conclusion, that the weight of the institution and the arguments that gave rise to its invalidation—particularly that it received foreign financing and that it served as a center for the importation of "fads"—appeared to be much more powerful than the works that were actually exhibited there.

In 1965, the connection between art and politics was being disputed on the Buenos Aires art scene as a choice between familiar options. While the sectors represented by the group Espartaco proposed a separation from the artistic institutions in order to form unions for the production of murals drawing on the language of Mexican muralism, others decided to use the spaces provided by these very institutions to question the system. To occupy a space that at that moment was capitalizing on the fact that the public gaze—both nationally and internationally—was fixed on the Argentine cultural movement, implied occupying a position that leftist sectors, at least in 1965, had rejected.

The work of Ferrari was still an individual manifesto that had not yet risen up as a representation of any group. His program, more than a summons, was an intervention. Shortly thereafter, the Vietnam War provoked activist attitudes such that any form of participation meant taking a position relative to world events, regardless of whether the form of a particular work of art was connected or not to the organizing theme.[71] Three years later, the exhibit Experiencias 68 at the ITDT, presented options that were comparable to those submitted by Ferrari in his assemblage, both in terms of confrontation and the use of the institutions. But in 1968 the situation was definitely different, and to take a position was a much more generalized act because the atmosphere had become intensely

politicized and it was impossible to discuss anything outside of a political context, including art.

The Avant-Garde Between the Two Boundaries

The First Argentine Festival of Contemporary Forms was held in Córdoba in 1966 as a response to and to compete with the aesthetic program of the American Biennial of Art, organized by the IKA. It was not only significant because it demonstrated that there was not just one but many forms of understanding "new" art, but also because it was in this contentious atmosphere that the first significant contact took place between sectors militating for an avant-garde art movement in Rosario and Buenos Aires. To "militate" was a notion that was increasingly appropriate for characterizing the avant-garde in the latter half of the 1960s. The idea was to convert the avant-garde into a force of confrontation and to infuse it with a sense of innovation. As indicated, this process of politicization that was a latent concern for some artists was becoming a more evident form in the late 1960s when interest in renovating the language of art was competing with a concern for making art an active instrument in the transformation of society.

Interaction between avant-garde sectors in Rosario and Buenos Aires gave rise to discussions on the significance of art. As the artists developed forms of interchange they were also hastening, aesthetically and politically, the rupture that was to take place in 1968.

In Rosario this process at first took place very autonomously, revolving in large part around the studio of Juan Grela, an artist with renown in Buenos Aires. Since the 1940s, Grela had been invigorating the art scene in Rosario with discussions on international art, drawing on up-to-date information to which he had access through his own bookstore.[72] Juan Pablo Renzi emphasized the importance of this library where artists could find a repertoire of images from which they could make their own selections.[73] As a student of Grela's, who hierarchized formal rigor and understood that all literary elements were pernicious for visual art, Renzi admired fauvism and cubism but was less interested in surrealism. It is understandable that an artist like Renzi, who declared that he had been shocked the first time he saw Matisse's *Portrait of Madame Matisse (Green Stripe)* (reproduced in one of the many books in which Payró attempted to explain in Spanish what modern art was), should sign the manifesto "A propósito de la cultura mermelada" (Regarding the Marmalade Cul-

ture) in 1966.[74] With the publication of this text, a group of emerging artists announced themselves and the strategies of differentiation they had adopted (their group identity, manifesto, reviews), and their lack of a program—or the adoption of a program that was so typical that it could hardly be understood as leading the way toward the new avant-garde they wanted to embody. The ideas expressed in the text reveal a model of aesthetic activity closer to the classic canon of modernism than to the experimentalism that had jolted the Buenos Aires art scene and other cities that the artists wanted to measure up to.

The definition of a conventional and sugarcoated culture, opposed to real problems of creation, the use of terms such as "decorative" or "superficial," or urging the adoption of deep rather than external meanings for the latest tendencies, speak of the artists' concern for going beyond tradition, without negating it, to probe its very foundations. It is on the basis of this model that the choices made by the artists of Rosario can be understood. The happening was seen as a mental process and not as a spectacle; the spectator was a thoughtful participant rather than a manual operator; minimalism rather than pop or nouveau réalisme;[75] Kenneth Noland and Sol Lewitt, rather than Oldenburg and Rauschenberg. Within modern art they chose the analytic option which, in an evolutionary sense, involved the system of painting proposed by Seurat, the aniconism of Malevich, and even encompassed the analytic proposition of conceptualism.[76]

For Renzi it was possible to generate an avant-garde, but this implied maximizing the rupture within the avant-garde traditions without negating them; the break had to include continuity of the system rather than radical substitution. Renzi felt that there was a language in which he wanted to inscribe his search with the intention of continuing the avant-garde process. From this perspective, politics was understood as one more element for radicalization of the artistic system rather than as an option that closed art down.

The avant-garde artists of Rosario worked in a context of twofold competition: struggling against the international art scene as well as that of Buenos Aires. At the same time, they perceived the need to consider local tradition. This helps explain why an artist like Renzi should be so interested in keeping up to date on the latest forms of expression on the international art scene and, at the same time, why he should seek to publicize the value of the work of Schiavoni, an artist closely associated with the strong realist tradition of his own city.

Within the artistic panorama of the 1960s, Rosario is an exceptional

case as it offers an isolated view of a different moment in the development of the avant-garde movement in Argentina. Its constant measuring up against the twofold backdrop of the national and international art scenes, the perceived need to accelerate the process because it felt it was lagging behind both, and the modernist approach to the parameters of action were all active elements giving rise to the fusion that took place between certain avant-garde groups from Rosario and Buenos Aires.

At the Córdoba Biennial the ways in which certain groups could establish collaboration between artists from Rosario and Buenos Aires began to take shape. Among these artists were Pablo Suárez, Ricardo Carreira, Juan Pablo Renzi, Oscar Bony, Eduardo Costa, Aldo Bortolotti, and Eduardo Favario. They also organized their first coordinated happening, *En el mundo hay salida para todos* (In the World There Is a Way Out for Everyone), which was the product of the heated conversation and exchanges that they engaged in for those two days. The packed audiences and the participation of students who delivered speeches, brought together for the first time both aesthetic and political actions.

The arrival of Rosario's art in Buenos Aires as part of an orchestrated series of exhibitions with the participation of all sectors during the Week of Avant-Garde Art (1967) was organized to coincide with the visit of a North American group. Although what was put on exhibit for the foreign visitors was quite similar to what they could find in international art spaces, as mentioned above, the artists from Rosario still felt that their work was significantly different from what was being produced in Buenos Aires as well as on the international scene. Rather than the simple affirmation of that sentiment, what is remarkable here was their enthusiasm not to omit any of the elements they perceived as necessary for maximizing the expressive conditions of their own time: to depart from the latest "advances" in international art—and Buenos Aires art—and, at the same time, to try to surpass them both. On this basis they developed a collaborative and competitive relationship with groups from Buenos Aires which generated a powerful mobilizing energy as well as conditions that culminated in the events of 1968, the closing moments of a process.

What is certain is that in 1968, during a period in which much of the artistic production did not materialize in the form of supports but rather in actions, the artists disputed a multitude of projects that, although many were never carried out,[77] they nonetheless had the importance of generating a space for the discussion of ideas whose objective was still to give rise to an avant-garde movement. The point at which the artistic

and the political avant-gardes intersected was defined through the union of different interests, each perceiving this transitory alliance as the response to different concerns. Ferrari's concern for injecting his calligraphies with political references was not the same as Renzi's for achieving an avant-garde with such a high degree of public impact that it could not be ignored: "We were becoming aware of the relationship between the aesthetic avant-garde and the political avant-garde and of the possibilities for uniting them, because we saw that . . . there were very bold works that were assimilated and accepted, but when they had a political content they were resisted."[78] This kind of statement leads to the following question: Was the foremost objective to create an avant-garde art movement or to unite the avant-garde with politics and the objective of making the avant-garde project more effective and potent?

The degree of rupture that took place in 1968 cannot be fully explained in terms of the desire for politicization, but in terms of the search for greater experimentation *in addition* to which the artists aimed toward politicization. Finally, the solutions did not *exclusively* arise from political needs, but from the condensation and superseding of all the resources of symbolic strategies that had been accumulated through avant-garde experimentation which was put to the task of considering aesthetic actions as an energy capable of collaborating in the transformation of the social order. The conclusion they finally drew was that art did not have to wait for revolution in order to acquire political significance, but rather art could also aspire toward integrating forces capable of provoking revolution.

Art as a Collective and Violent Action

> Our concern was . . . that art should enter through the eyes and the different senses, and that it should be a source for reflection, an impact that would endure in the thought processes, and that was the entire conceptual basis for our production. —Juan Pablo Renzi

The year 1968 was incandescent. Everything created the sensation that in different cities of the world a crucial moment was being played out, capable of determining the course of history. The actions of students and workers were linked from one city to another in the urban insurrections that broke out in the streets of Paris, Berlin, Madrid, Rio de Janeiro, Mexico, Montevideo, and Córdoba.[79] In Argentina various elements in-

dicated that the enthusiasm of the 1960s was coming to an end. The military coup d'état that had brought General Onganía to power, at the same time as it coercively intervened in the intellectual and cultural spheres, now took its previous modernizing messianism to extremes in the economic sphere, based in a close association between the armed forces and big business. The modernization project of Argentine capitalism, now directed by the repressive government, heightened the social, cultural, and political crisis and created the conditions under which, in 1969, society decidedly shifted against the government, culminating in the popular insurrection commonly known as the Cordobazo.

In 1968 everything seemed to indicate that, at least for the moment, Argentine art would not reach the longed-for international arena. After Leo Castelli's exploratory trip in September 1967, and the group "disembarkation" of the team from the International Council of the Museum of Modern Art in New York in May 1968, the situation provided increasingly clear evidence that Buenos Aires would not shine like Paris or New York.

That year the collective work that was created by a group of artists from Rosario, Buenos Aires, and Santa Fe, under the title *Tucumán arde* (Tucumán Is Burning) (figs. 15a–i), was presented in a context of multiple confrontations and tensions. On the one hand, there were divisions provoked by deep splits in the political, social, and economic spheres, in response to the impossibility of a model that the country had been futilely pursuing and upon which it had squandered tremendous amounts of energy. On the other hand, there were those divisions that resulted from the successive splits that had taken place among the leaders of the artistic avant-garde, generated by a series of chain reactions that, in 1968, had converted the artistic sphere and its institutions into a virtual battlefield.

At the start of 1968 it was evident that if the avant-garde wanted to continue being a disruptive element, if it hoped to upset the established order, it could no longer act within the framework of the institutions. In this context, an extremely important point of friction occurred on May 23 when, faced with the forced removal of a work of art by the police at the Experiencias 68 exhibition, organized by the ITDT, the artists collectively destroyed their works in the doorway of the institute. This act implied a major public rupture (intensely publicized) relative to the institution that had been the privileged scene of the avant-garde in previous years. What

is remarkable is that the police action was not in response to the works that were overtly political and that referred directly to the Vietnam War, submitted by Jorge Carballa and Roberto Jacoby.[80] In this case, what had been censored, beyond the works themselves, was the response of the public, the spontaneous response by those attending the experiences to write statements and slogans of erotic and political content on the walls of the simulated bathroom, a work by Roberto Plate. The public, which had been a central element in the design of institutional strategies for the Di Tella Institute throughout the decade, was considered an active element and could become decisive for those who were determined to make art a factor capable of affecting reality.

Furthermore, this act also became a central ingredient in the creation of a work that no longer aspired to mere contemplation. This was confirmed on June 30 when Eduardo Ruano and his friends entered the Museum of Modern Art during the opening of the *Ver y Estimar* awards competition and, as they shouted, "Yankees out of Vietnam!," they broke the glass display case in which Ruano himself had carefully and almost adoringly arranged a photograph of John F. Kennedy. The public impact of this act was, in the eyes of Renzi, much more potent than what could be achieved with an avant-garde work intended to be exclusively artistic.[81]

The moment of greatest conflict in this escalating crisis was the Braque Award competition (1968), organized by the French embassy at the National Museum of Fine Arts. In an open response to the conditions set by the French government, intended to avoid statements or positions that alluded to the May events, the artists—among them, many of the competitors—invaded the galleries of the museum on July 16 and ended up in jail after declaring their support for "the French students in their struggle against the fascist regime" and for the Argentine painter Julio Le Parc who had been expelled from France for expressing his solidarity with the French movement.[82]

These actions were not very elaborate, they were based more on effect than on design or complicated concepts, but the consequences were tremendous. As indicated above, the reasons why it was desirable to unite the artistic and political avant-gardes were not the same in all cases. Whereas for Renzi the need to radicalize the avant-garde was of utmost importance, for others, such as Ferrari, the political component was paramount. This is not to say that Renzi only cared about the avant-garde in some pure form. As he himself affirmed,

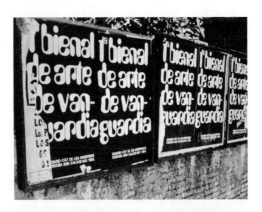

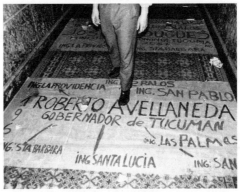

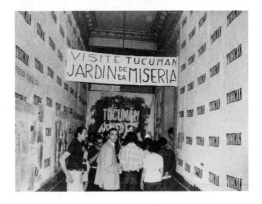

15. *Tucumán Arde* (Tucumán Is Burning), Rosario, 1968. Graciela Carnevale Archives.

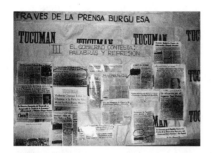

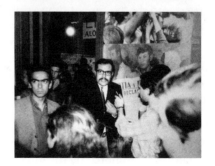

The revolutionary ideology at that moment, generally Marxism, coincident with certain positions such as those of the May 1968 events in France or the Cuban Revolution, which gave rise to the idea that precise revolutions were possible in Latin America, that is, a combination of the political avant-garde attitude and the aesthetic avant-garde form, we believed to be a very important point and that there was no reason for them to be kept separate. That is what distinguished us from the first avant-garde of the Di Tella Institute, which was most closely associated with pop art, in the sense that they understood that one could be on the right and form part of the avant-garde. We maintained that one could not think along rightist lines and form part of the avant-garde, and furthermore if one was on the left, that also had to be expressed explicitly.[83]

From Renzi's perspective, Ferrari's position was problematic: "Although he had avant-garde attitudes, he thought the ideological problem was most important."[84] It is understandable, then, that this avant-garde, which was searching for a dual identity, should respond to interests that were not in all cases exactly the same, either in an aesthetic or a political sense.

What is certain is that for various groups searching for a more radical engagement, all the confrontations with the institutions had led to a situation in which they could no longer calmly return to those very institutions. In August, artists from the cities of Rosario and Buenos Aires met in the First National Conference on Avant-Garde Art to discuss the main points for future action, among which was "the refusal to participate with the institutions established by the bourgeoisie for the absorption of cultural phenomena" (awards, art galleries) and "the insertion of artists into the 'culture of subversion' to accompany the working class on the road to revolution."[85]

If there was an urgency to create collective art that impacted directly on reality and denounced political, social, and economic situations that troubled the country, a propitious place to begin was the province of Tucumán with its seething crisis. Its problems were seen as a paradigm case of a self-confident government that implemented projects tending to favor the large monopolies. This was part of the program known as "cleansing," promoted by the military government, but in fact the objective was to "rationalize" production, destroying small and medium businesses while protecting the large sugar industries. These policies resulted in the closing of sugar refineries and rising unemployment. Meanwhile, like a tragicomic ironic twist, the government publicized that Opera-

tion Tucumán was a project for accelerated industrialization. In fact, the operation implied replacing the national bourgeoisie with North American capital. The main goal of the artists' project was to denounce the distance between reality and publicity. For this reason they conceived of their action as an instrument of counter-information.

Since publication of *Understanding Media* by Marshall McLuhan in 1964, the power of the media had been a standing problem.[86] The importance and power of the media, its capacity to construct events that everyone would accept as real even though they had never existed, was the central theme in the happening realized by Eduardo Costa, Raúl Escari, and Roberto Jacoby. They released information to the newspapers about a happening that never took place and that, therefore, only existed in the media.[87] The experiment gave rise to the manifesto "An art of the mass media" that they signed in July 1966. Jacoby, considering the option of an art that would take advantage of the possibilities of the mass media, wrote a text in which he acclaimed the program *Tucumán Arde*:

We know very well that the mass media are fundamental in the control of a society and that they are therefore manipulated—no less than writing was in another time—by the groups that hold power today. . . . On the one hand, this situation requires that future artists have a very profound understanding of the material with which they will be working. On the other hand, they must have connections with social groups with sufficient power to guarantee that their cultural messages are heard. . . . Furthermore, the age-old conflict between art and politics ("Art should reflect reality." "All art is political." "Art is not political," etc.), which has never quite been overcome by merely introducing political "contents" into art, perhaps could be superseded by the artistic use of a medium as political as mass communication.[88]

In this way, different experiences and needs, initiated in different spaces, times, and institutions, came together in a collective action in which, practically as a single decision, all the accumulated resources of the entire previous decade were at stake. On the other hand, although the avant-garde wanted to form part of politics, this did not imply subordination to a political program. All of these commitments were transitory. From the perspective of art, this experience, saturated by all the discourses of aesthetic dematerialization, took place more as a process than as a visualizable object.

With no connections to the artistic institutions, and seeking to develop their work in a place where they might achieve maximum effectiveness,

the artists decided to put their plan into action from the headquarters of the CGTA (General Workers' Union of Argentina). This choice implied positioning themselves in a more conflictive and divided setting than that of the arts. From the moment the CGTA launched the May 1st Program in 1968, its opposition was made clear with respect to the Vandor wing of Peronist unionism, which placed its faith in a renewed military-labor alliance. This renovated anti-vertical and combative CGTA, in addition to openly repudiating the military regime, intended to join with this new social force generated by the alliance of the worker's movement, university students, and activist clerics.[89]

In *Tucumán Arde* the artists created a controversial combination of information and reports borrowed from the social sciences, advertising, and an organization of actions whose features were based in the political practices of leftist sectors. Through this experience the artists sought to reinvent a concept of the avant-garde that drew upon techniques and procedures developed over an entire decade of experimentalism, using the new materials provided by the mass media and its power to reconfigure the concept of current popular culture. The main goal was to achieve effectiveness, and to that end they combined all the provocative elements they had at their disposal. The purpose was to create an overloaded informational and counter-informational installation intended to unmask the cover-up campaign led by the official press, and to "create a subversive parallel culture" that would wear down "the official apparatus of culture."[90]

In the discussion on which media were appropriate for achieving these objectives there were terms that did not enter into the debate. The modernist paradigm that the aesthetic reflections of Romero Brest and Julio E. Payró had established in the local critical press in the early 1950s was no longer an active term in the discussion. At this point in time it was not possible to sustain that the basis of artistic legitimacy depended on the autonomy of the language. On the contrary, now reality itself was the clay with which hands had to work without aesthetic prejudice. Against an aesthetic of negativity, they proposed an aesthetic that sustained heteronomy and commitment as values. The avant-garde, then, no longer had to renew itself only through its forms, but also through its messages. To this effect, Ferrari wrote, "Art shall be neither beauty nor innovation. Art shall be effectiveness and perturbation. The accomplished work of art shall be one that has, within the medium utilized by the artist, an impact

equivalent to that of a political attack in a country that is in the process of being liberated."[91]

The contents of art had to be clearly defined. What was urgent was not the replacement of one style by another, but rather the questioning of the organization of the artistic scene, its institutions, and the symbolic strategies of the dominant classes.[92] In the exhibition's introductory text the artists affirmed that, from that moment on, the aesthetic creation should be a collective and violent action: "Violence is, now, a creative action with new contents: to destroy the system of official culture, opposing it with a subversive culture that is part of the modifying process, creating a truly revolutionary art."[93]

The action developed in various stages.[94] First, research and amassing of material was carried out in the province of Tucumán. A group of researchers from CICSO (Center for Research in the Social Sciences) produced a detailed report on the Tucumán economy which served the artists as a point of departure for their own research.[95] Before traveling to Tucumán, they carried out a publicity operation organized in two stages. In the first stage they covered the walls of the cities of Rosario and Santa Fe with the word "Tucumán." Just before traveling, they added the words, "is burning."[96]

The purpose of the trip was to gather testimonial material that would serve as evidence in the exhibition. In the research and documentation stage, to gain the support they needed to proceed, the artists carefully carried out their actions on both the official and clandestine levels. While some of the artists established contacts with officials in the cultural sector (to whom they explained that they wanted to produce an "artistic-cultural report" on the province of Tucumán), others were busy photographing, filming, and taping interviews with workers and labor leaders in order to penetrate the real world of the sugar refineries and the laborers.

On November 3, the first exhibition opened at the headquarters of the CGTA in Rosario. In the street, the posters announced the exhibition somewhat ironically as the First Avant-Garde Art Biennial. The name itself—its reference to the most prestigious biennials organized by the most important institutions—situated the exhibition firmly in the center of the dispute over the meaning of the term "avant-garde." The authentic artistic avant-garde, it suggested, was not the one that sidled up to those who wielded power, but rather the one that stood together with the unions and the workers. The materials they had gathered through their

work in the field—films, tapes, photographs—were displayed with the posters, streamers, and explanatory graphics on the various floors of the workers' headquarters.

The way the information was presented to the spectators—who were not traditional art viewers, but rather militants and workers who passed through the CGTA building—reflected two central concerns: to unmask the official press by juxtaposing information it provided with information gathered from reality and, on the other hand, to provide sufficient guarantees that what the artists were exhibiting was, indeed, the truth. The photographs taken at the locations of the events being denounced, together with statistical information collated by sociologists, corresponded precisely to this program. The objective was to trap the visitors in a bombardment of images and sounds, to play on their sentiments and consciences, to provoke them to "take a position." Among the resources they employed were the insistence and reiteration of publicity campaigns: the signs displaying the word "Tucumán," with which they had filled the streets, now plastered the walls, one beside the other, from floor to ceiling, at the entrance and throughout the building. On one of the walls there was also an assemblage of newspaper clippings (composed by Ferrari) showing that, if one compared the news that appeared daily in different sections of the newspaper, the truth fell to pieces. On the one hand, there were sections dedicated to the auspicious official campaign, celebrating the economic conversion of the province and affirming that "We can carry out this revolution with liberty," and "One of the concerns of the Argentine Revolution is the good administration of justice." On the other hand, other sections of the newspaper reported the death of a worker at the hands of the police. With this news assemblage Ferrari wanted to demonstrate the duplicity of the official discourse. In light of these juxtapositions, the information was meant to provide a new and revelatory dimension. The purpose of this clash between images and words was to provoke a change of conscience in the spectators. On the floor (which all visitors had to necessarily walk across) were displayed synoptic charts that revealed the connections between the government and the sugar refineries. Films and slides of the sugar refineries were projected onto screens, interviews were played over the sound system, and the spectators were required to express their opinion on what they had seen. At the same time, the spectators' responses were projected and incorporated as live and active material, forming part of the informational installation. The objective was to utilize the feedback of the interviewed public as part

of the exhibition itself. The discourse of signs saturated the space with reiteration, the juxtaposition of images and words, the rhetoric of political posters, the flag, and billboards: "Visit Tucumán, the garden of misery," "No to the Tucumanization of our nation," "There is no solution without liberation." Finally, to ensure that as they exited the spectators could confirm that everything they had seen was the "truth," groups of workers and university students distributed eighteen-page pamphlets put together by sociologists in which the causes of the situation in Tucumán were explained.

Whereas the exhibition remained for two weeks in Rosario, in Buenos Aires, where it was organized at the Federación Gráfica Bonaerense (Buenos Aires Graphics Federation), it was quickly canceled under pressure from the government and the police. As the ultimate expression of the rupture that had taken place in the artistic sphere, it was not a critic who spoke at the opening of the exhibition, but the charismatic voice and figure of Raimundo Ongaro, secretary general of the CGTA: "We have walked all over this country, all over our land. We have been to the soup kitchens. We have seen the degree of humiliation and degradation they represent. Our words cannot convey the entirety of the drama. . . . Thanks to these artists it is possible for more workers all over the country to learn what is happening in Argentina. . . . They have the tanks, the machine guns, the dogs. Today all we have is this small piece of canvas and this modest building, but it is enough to show these images for them to be filled with fear, because they know they are helpless against the awakening of consciences that we are bringing together for our liberation."[97]

Numerous studies have highlighted the relationship between *Tucumán Arde* and conceptualism or, more exactly, its "ideological" variant.[98] This connection, however, should be made explicit. Owing to many of its main characteristics—the exploration of the interaction between languages, the centrality of the spectator's required involvement, its unfinished nature, the value given to the communicative process, the importance of documentation, the dissolution of the idea of the author, and the questioning of the artistic system and the institutions that legitimize it—*Tucumán Arde* is closely related to the repertoire of conceptual art. However, this does not refer to that tautological and self-referential form of conceptualism within which, from a certain point of view, the reconfirmation of the modernist paradigm might be situated.[99] Language does not refer to language, to the specificity of the artistic event, but rather, in this case, the contextual relations are so strong that reality is no longer only viewed as

a space for reflection but is conceived as a possible field for action that is oriented toward the transformation of society. In this sense, what is produced is practically a scaling down of the original meaning of the conceptual resources, eliminating all the subtleties and plays on language. For this reason, to analyze the strategies of this work in the context of conceptualism tends to be reductivist and an oversimplification. Nonetheless, this does not mean that the artists who created this work were unfamiliar with the conceptual repertoire or that they had not worked with it.[100] It was the historical moment that made it necessary to consider other elements. To this effect, Rubén Naranjo explains: "Previously, it might have been enough for us to represent a large sugar cube that could be observed, with texts included, and to exhibit it at the Di Tella Institute. This could have satisfied us: the realization of a primary structure that required the active participation of the spectator and that carried with it the implicit, unmistakable, denunciation of an objective situation."[101]

The rich history of experiences produced by the artistic scenes of Buenos Aires and Rosario during the 1960s represented a trove of resources that the artists could not ignore. This is not to say that only those experiences that required the participation of the spectator in the environments and happenings of Buenos Aires were significant (such as the work *Le Parc* presented at the Di Tella Institute in 1967). It is also necessary to consider the impact of these works on the public, the mass media, and even the power that these media demonstrated in relation to art and upon which artists like Jacoby focused so intensely, as we have seen.[102] All these elements, working together, under the pressure of an urgent political and social situation that made the artists feel necessary, combined for the formulation of a new program that was much more effective than the repertoire of procedures proposed by Duchamp.

On the other hand, when we analyze the abundant production of texts and manifestos that accompanied this work-action, the absolute confidence of the artists that they could have an impact on the consciences of the spectators is remarkable. The actions undertaken with increasing intensity by armed organizations proves that their convictions were not on the margins of those groups that mobilized other social forces. If we evaluate this experience in terms of spectator attendance, the exhibition did not attract any more visitors than the exhibitions at the ITDT.[103] The rupture with the official institutional circuits of culture did not necessarily imply that they would be able to attract a larger public, although it was certainly different.

With *Tucumán Arde*, the aesthetic and political avant-garde radicalized all its options. The experience was so intense and, in some cases, traumatic, that it led many of the participants to conclude that it was no longer possible to seek a transformation of reality through art, even when this involved avant-garde art. For some artists the only remaining option was to abandon art in order to transform society through political struggle. The *collective* and *violent* actions carried out by the masses demonstrated that it was only in the streets—every day—that the greatest aspirations of their programs could finally be realized.

Conclusions

The 1960s were years of transformations and radical convictions. The powerful conviction that it was necessary to force the system into crisis in order to change the way things were—almost regardless of the consequences—was matched by the certainty that anything was possible. The political, economic, social, and cultural contexts were marked by recurrent features, particularly the predisposition to formulate programs whose main goal was to provoke and direct change. The future was a nebulous objective, but held the promise of a more perfect world: so extraordinary and perfect that whatever the cost to the present world, in terms of energy, this could be justified on the basis of what was to follow.

In the Argentine art world, the general conditions of the period reached a degree of very specific radicalization. The recent tensions in the history of Peronism (those that Luis Felipe Noé wanted to condense and compress on the surface of his canvases) heightened the sense of urgency to formulate defined and exact projects that would make it possible to maximize all the necessary forces for their realization. For liberal sectors, the Peronist years were a total loss. The hopes of reestablishing the rhythm of history (according to how they wanted to write it), and of breaking the parameters that until then had guided cultural development, explain to a certain degree the urgency of the artistic projects. Analysis of the institutional experience—the MAM, MNBA, ITDT, the Kaiser biennials—reveals the degree to which the objectives had been formulated for the first time in Argentine history as part of an effort to establish the expression of national art forms internationally.

How should Argentine art be in order to reach "international" status? What were the images that would help gain this kind of recognition? In stylistic terms, what was the formula for success? These questions, formulated in various ways, constituted the long-standing problem. Argentine institutions—practical, efficient, and imaginative—left it up to the artists and, eventually, the critics to provide the answers while the institutions focused on designing policies. For the most part "internationalism" became a search for recognition and equal exchange between Buenos Aires and the capitals of the art world. In aesthetic terms, submissions sent abroad could be characterized as lacking a definite or singular form. In general, the idea was to show whatever was most recent and might be well received in the major art centers that wielded the stamp of approval over what was considered new and innovative. The result was that the submissions resembled general sales catalogues rather than representatives of a collection of exclusive models, which is what they were meant to be. The prevailing view that avant-garde productions pertained to successive "fads" did not generate an effective market for the artwork. More precisely, what was generated was a market of awards in which recognition and ephemeral prestige was contested, demonstrating that, at least for the moment, international recognition for the principal art spaces in Buenos Aires would not be forthcoming. The perception of Buenos Aires as an important art center, which surprisingly led many people to feel that New York was closer than they had previously believed, was suddenly shattered and the distances came to seem infinite.

In general, the style that North American institutions—which formed part of the inter-American project—tended to favor and to recognize as "international" was abstraction. Examples to this effect are Rogelio Polesello's winning of the competition organized by the Esso Corporation, as well as the exhibition Beyond Geometry, organized by the Center for Inter-American Relations as a tribute to Argentine art and the ITDT.

Nonetheless, we cannot deduce absolute consequences from these events. Although there is no doubt that the preference of some North American institutions for abstraction over realism should not be seen as separate from the confrontation that had already taken place (and been won) by abstraction in its first battle at the start of the Cold War, the triumph of abstraction immediately following World War II did not have the same significance. In the dispute between abstraction and realism (which schematically corresponded to the confrontation between capital-

ism and communism), the challenge in Latin America was presented not so much by socialist realism but rather Mexican muralism. However, to demonstrate the impossibility of a movement like muralism was not, at this point in time, a genuine victory. In the 1960s no one could convincingly argue that mural art was an innovative or legitimate option. Nor was it a victory to defend and champion the success of abstraction. This was a battle that had been won fifteen years earlier on the international art scene. All these views were already too well known to stimulate a genuine confrontation of images. Whereas Clement Greenberg affirmed that what was dominant on the international art scene at that time was a "Babylon" of styles, abstraction had lost all its power to show anything truly important. Abstraction could not be championed as a groundbreaking style, nor as representing the latest in avant-garde art, nor as a solution that might define the evolutionary direction of modernism. The success of representationalism, theme, figurativism, and even the most banal aspects of reality, which had been established on the New York art scene with the triumph of pop art, eliminated all the significance that abstraction could have had as an ideological weapon in the first stages of the Cold War. Absent the need to establish a single legitimate style, abstraction could compete under the same conditions as realism. Therefore, I do not consider it appropriate to attribute more than relative importance to the support given by North American institutions to abstraction in their policies toward the visual arts in Latin America during the 1960s.

In this decade Latin America reentered history with great hope and conflict. In the face of the communist menace, Cold War rhetoric with respect to the visual arts was not characterized by the circulation of particular images, by the imposition of a specific style, or by an attempt to demonstrate the superiority of the United States on the international artistic scene, unlike the case in Europe and, more specifically, in Paris. At this point in time, the reality of U.S. power was so widely recognized and unquestioned that to prove and assert this supremacy would have been a waste of energy. In this context, it is significant that no truly important and representative exhibition of North American avant-garde art had appeared in Buenos Aires. The efforts of the United States were more geared to establishing a propaganda system that constantly expressed evidence of its good neighbor policy. The U.S. discourse was saturated with notions such as "exchange," "friendship," "interest," and "pluralism." The series of conferences intended to favor dialogue, to acknowledge Latin American

problems, and to praise cultural productions constituted a central aspect of the North American strategy for neutralizing the impact of the Cuban Revolution on the Latin American artistic and intellectual milieux.

However, the Cuban Revolution did not immediately attract visual artists in the same way that it attracted writers and intellectuals. Although Argentine artists were able to support the revolution, they still did not have to concern themselves with a commitment in terms of practice. Up until the mid-1960s, Cuba did not have enough appeal to divert artists from the route that led them to seek recognition in New York. More precisely, they would travel first to Paris, then to New York, and, after 1965, to Havana. In terms of an aesthetic-visual program, there was not much at first to debate regarding the revolution. Not even in Cuba itself had there been any urgency to define a "style of the revolution." The idea was that the revolution, by modifying the conditions for production, would generate its own style. All that was necessary was to wait for this style to emerge.[1]

This situation began to change in the mid-1960s when artists started going to Havana to exhibit their work or to participate on jury panels. In 1966, the Argentine artist Lea Lublin traveled to Cuba to participate as jurist in the Casa de las Américas awards competition for lithography. She then decided to stay in Havana for a short time where, as reported by the magazine *Casa de las Américas*, "she wandered a little bit, everywhere."[2] The article goes on to describe the conversion process she underwent, as a direct consequence of her time *living in the revolution*. This "wandering everywhere" (which preempted the possible accusation that she had been shown only those places that the revolution could afford to reveal) resulted in Lublin's altering the thematic focus of her work. Over and beyond this change, what truly demonstrated her commitment to the revolution was the public attitude she had adopted and which *Casa de las Américas* did not neglect to point out: "We'd been talking in the Havana Riviera. Twenty-four hours later Cuba was in a state of alert. And, faced with the possibility of leaving the threatened country, Lea Lublin decided to remain among us, and was even prepared to take up arms if necessary."[3]

After the mid-1960s, the politicization of art began to appear as a problem. At first, its expression assumed the form of taking a position (such as opposition to U.S. intervention in Vietnam or Santo Domingo) whereby the artists pronounced their commitment through public statements rather than the forms or themes of their work. The effectiveness

of this attitude seemed to wane as the conditions for revolutionary uprising became increasingly extreme. In the face of rising politicization in the cultural sphere, it was necessary not only to adhere to revolutionary principles, but also to find revolutionary forms. In this respect, it is interesting that discussion was focused not only on the use of art as a political instrument, but also on the different ways that the artistic avant-garde could be joined with the political avant-garde.

Initially, the form of expression for this new situation consisted in challenging the artistic institutions for being unable to accommodate a *true* avant-garde. However, as mentioned, the conditions for uprising in this new situation did not only depend on the politicization of the milieu. The very existence of this challenge and its visibility were only possible because of the degree of institutionalization that the artistic milieu had already achieved by the end of this period.

In 1968 the revolution felt so real, so imminent, that it seemed impossible not to respond to its call. Between 1965 and 1968, artists risked all the success and recognition they had managed to accumulate. When it was necessary to convert art into a revolutionary arm, many decided to send their paintings and art itself onto the battlefield.

One question I have intentionally left unanswered is whether or not there was an avant-garde in Argentina during the 1960s. Rather than responding affirmatively or negatively, I have chosen to present material for considering the conditions that led to the artists' sense that it was necessary to generate an avant-garde and the programs they developed for that purpose. In this context, I have tried to reconstruct the traditions they turned to and to indicate those traditions with which they disagreed, to indicate which materials and poetics they turned to and how, among artists, a milieu of interchange emerged. Above all, what I have tried to do is to avoid an approach that might view the avant-garde in essential or absolute terms, falling back on preestablished definitions to which the objects would have to conform in order to be considered "avant-garde" or not. On the contrary, my intention was to consider the way in which the various actors positioned themselves historically with respect to the avant-garde, considering it, above all, a problem to be resolved.

The approaches to modernization, internationalization, and politicization of the artistic milieu that I have considered here were not exclusive to the Argentine art world. They can be observed in other Latin American countries. The need to study the artistic process during the 1960s from a national perspective may be justified in terms of the degree to which

these groups were radicalized in the case of Argentina. In no other Latin American country was there such a degree of institutionalization in relation to the necessity to generate a form of international recognition. This fact was lived by all those who were committed to the internationalist project, which turned out to be a resounding failure whose causes and responsible agents are still being researched. The history of this period is always characterized by its moments of energetic enthusiasm as well as the bitter aftertaste of defeat.

In conversations with actors of this period it is common to encounter a constant flow of contradictory statements and accusations as these actors search for those who might be held up as responsible. For the artists, the opportunity to establish Argentine art on the international scene was so immediate and tangible that they find it hard to understand the reasons for the ultimate failure. In their evaluations, the responsibility primarily falls to the international lack of comprehension for the revitalizing process taking place in Argentina at the time, to the inability of Argentine institutions to take adequate and necessary steps to introduce national art to the international art scene and, particularly, to the incompetence of the Argentine critical milieu to recognize the value of local art, to analyze it, and to defend it.[4]

According to the main actors of the period, such as Enrique Oteiza, in the specific case of the closings of the ITDT art centers, the causes were political and economic and, in large part, related to the interests of the Di Tella family. The climate of creative freedom after 1958 that made the reinstatement of democracy possible came to a violent end with the coup d'état of 1966. The culturally reactionary military authorities could not allow the existence of a space for free expression along the lines of the Di Tella Institute. Whereas Guido Di Tella argues that the cause of the closings was the impossibility for continued financing of the activities at the centers,[5] Oteiza affirms that they closed because that was the condition set by the military government in return for saving the Di Tella family's businesses from financial ruin and, thereby, the State absorbed the Di Tella debts. From this perspective, there appears to have been an agreement between the family and the government that led to a private decision that affected the future of an institution that formed part of public life. Oteiza believes that there never should have been acquiescence regarding the voluntary closing of the Di Tella Institute. Instead, the military forces should have been obliged to implement the decision as a public act of authoritarianism and censorship. Paradoxically, such an

outcome would have been the crowning moment in the history of the Di Tella institute had it been closed by the dictatorship in the same way that the Bauhaus was closed down by the Nazis. According to this view of events, Argentina would have experienced its own splendid version of the Weimar Republic.[6]

From Romero Brest's perspective, the definitive causes of the closing were neither related to financial nor political factors, but rather to transformations in the artistic milieu, modified by the experimental attitude of the artists and his own decision not to give in to this transformation. According to Romero Brest, at the time of the closing of the institute, it was necessary to restructure the CAV. His proposal was to install a television studio in the rear gallery of the institute in order to explore the possibilities of this communication medium in the experimental and "modern" context:[7] "However, when I presented the project to the authorities of the ITDT, the economic-financial downslide was just beginning and they told me that there was no money even to begin such a new project. Perhaps, and only perhaps, if I had been satisfied to continue as before, we could have avoided the closing of the CAV. Could I be satisfied? It would have meant giving in to more academicism."[8]

During this ambitious decade, the projects were so extreme in nature that the only acceptable outcome was their complete "realization." This circumstance helps explain why, faced with the impossibility of realizing these projects, their creators and organizers preferred to abandon them rather than modify them. For example, following the last Kaiser biennial, the project was terminated for lack of continued support. It might also be considered, as suggested, that the biennial was never envisioned as an ongoing program, but rather as a project in three stages that would culminate when all Latin American countries came together to participate under the same conditions in a comparison of artistic quality. Had this been achieved, continuation of the biennial would have been a possibility, but it was not considered an integral component of the initial project. However, even in these terms, the project was never fully realized as the dialogue never became horizontal. The North American institutions always maintained control of the artistic circuits and their mediating power.

Nonetheless, analysis of the period reveals that, culturally, Argentina was not merely a poor and vulnerable country, subject to the will and caprice of the foreign empire. Indeed, the strategies designed by Argentine institutions were consistent, well formulated, and, to a certain degree, ag-

gressive, but conditions for international success were seriously impeded by the context of economic, political, military, and social crisis that characterized the end of the period. The causes for the period's abrupt closure were, first and foremost, structural, and they were linked to the national crisis. On the other hand, this context cannot be viewed in isolation from the international situation. The failure of the Alliance for Progress, together with the worsening of the economic, social, and political crises, weakened the possibility of conceiving gradual development for Latin America and gave rise to the belief that urgent revolutionary change was necessary. Under these circumstances, the government of the United States did not hesitate to seek new allies, but was no longer interested in vulnerable politicians, nor representatives of the new industrial bourgeoisie caught up in the project of modernization, but rather the armed forces and dictatorships that dominated Latin American political systems during the 1960s. The end of the golden age of the 1960s in Argentina, as in other parts of Latin America, was linked to international conditions that made the possibilities for transformation seem credible during this period.

For those artists who hoped to insert their work into the promising whirlpool of revolutionary change, the tendency toward politicization consisted in commitment not only of their work but also of their very lives. The extreme degree to which their hopes were dashed confronted them with the painful sight of their art running through their fingers as the illusion of the revolution was devoured by a reality that was not only transformed, but was increasingly dominated by evidence of that defeat.

With respect to the possibility of Latin America's playing a leading role in the narrative of Western artistic modernity, as promised by the Inter-American discourse of the 1960s, this did not take place either. Once the term, "international," as applied to Latin American art, became equivalent to "epigonic" and "derivative," the word functioned increasingly as a mechanism of exclusion and subalternization with respect to the grand history of modern art, written in terms of changes and transformations in the evolution of the artistic language.

If Latin American art was as international as that which was found in the centers that had generated and transformed the language of modern art (a language to which, on the other hand, only a few "condiments" had been added), then it could just as well remain on the fringes of that history. No comment could speak more eloquently in this respect than the exhibit presented until 1999 in the galleries of the Museum of Modern

Art in New York, that temple of modern art into which Latin America has only been incorporated insofar as it can be read as an additional ingredient to the modernist narrative: Frida Kahlo as the Latin American contribution to surrealism; Orozco, Rivera, and Siqueiros as frames of reference for explaining the early Pollock; Tamayo for highlighting the errors and supersession of muralism; Matta insofar as he contributes elements for understanding the latter Pollock; and Wifredo Lam as a reformulation of cubism through African elements in Latin America. All of these works—constituting a scant representation of twentieth-century Latin American art shown to the public[9]—are exhibited in the museum's halls prior to entering the main gallery where, as if mounted on an altar, the paintings are displayed of Jackson Pollock—the principal figure of the New York school and the culmination of the North American avant-garde.[10]

This spectacle of ideology hung on the walls—this selection of Latin American art and its distribution in this paradigmatic modern art sanctuary—demonstrates the degree to which conceptualizations of Latin American art within the modernist paradigm (the main legitimizing agent of Western art) dominate the discourses of power from the vantage point of those who determine and interpret the position of Latin American art, both in the "internationalist" 1960s and the "globalized" 1990s.

With respect to the attitude toward these objects as museum and collection pieces, the storerooms of Argentine museums also fail to do justice to the memory of the mythical and splendid character of 1960s art. It is as if the fire into which Rubén Santantonín hurled his work had consumed much more of the period's artistic production. In 1980 Romero Brest published the book *Rescate del arte* (The Rescue of Art), a kind of "imaginary museum" in which the "true" works of Western art from the past 100 years were brought together.[11] The repertoire of images the critic used for constructing the argument of his book practically negates all that he had championed during the decade of the 1960s: "Experimentalism, that charge of iconoclasm that tends to upset established values" no longer corresponds to their time, Romero Brest argued.[12]

The title of his book, marked by the redemptive impulse to "rescue" art, a task for which he considered himself to be singled out, resurrected his longing to occupy center stage. The book also demonstrates that, in spite of everything that had happened, in 1980, in a country rocked daily by violence, death, and disappearances, Romero Brest had not lost his desire to present Argentine art to the rest of the world. In the text, the

critic proposes a tour of what could be the galleries of a museum, but not those that truly exist in Argentina, but rather those he wishes Argentina possessed. In this imaginary museum, Romero Brest repeats operations that are similar to those he employed for reconstructing the more incisive and rhetorical history of European painting in the twentieth century. Whereas previously he had only ventured to introduce a few Latin American artists into the history of modern art (Orozco, Rivera, Siqueiros, and Portinari), he now presented the history of European, North American, Latin American, and Argentine art as part of a single narrative of transformations and advances. At the same time, in his selection of "great paintings" from European art, he included several works pertaining to the Di Tella collection, which are currently included in the collection of the National Museum of Fine Arts.

Romero Brest's book confirms his own iconoclasm, his centrality, and his mediating power in the construction of history. In addition to attempting to confirm for the public and himself the degree to which his centrality was legitimate, the critic also brought to a close the failed promises of those brilliant years—promises such as when Gómez Sicre, from his office in the OAS, stimulated the imagination of Latin Americans by describing a map upon which the cities of Latin America were included on an international art tour. In his book, Romero Brest described the walls of a Museum of Modern Art in which Latin American and Argentine art formed part of the "great history" of international modern art, without being relegated to secondary status. Of course, the walls upon which he hung his paintings were paper walls that only served as covers to his book.

We know the final result of this ambitious collective project. Buenos Aires did not succeed in forming part of the circuit that at that time—and even now in these times of globalization—ran through the "centers" of the Western avant-garde, though it had good reason to think it possible. The death of Santantonín on April 20, 1969, can be seen as one of the many moments in which not only individuals but also society itself had to confront evidence of the impossibility and the shattering of a project to which they had been intensely committed.[13] Other forces—also collective, but now socially and politically revolutionary—would seek to construct the foundations of a new hegemony in subsequent years.

Notes

Introduction

1. The exhibition, organized jointly by the Center for Visual Arts of the Torcuato Di Tella Institute and the Walker Art Center in Minneapolis, toured several cities in the United States. See chapter 6.
2. Berman, *Todo lo sólido se desvanece en el aire*, and also "Brindis por la modernidad," 67–91; Bell, *The Cultural Contradictions of Capitalism*.
3. Jameson, "Periodizing the 60s," 178–209.
4. Gilman, "La situación del escritor latinoamericano," 171–86.
5. Terán, *Nuestros años sesentas*, and Sigal, *Intelectuales y poder en la década del sesenta*.
6. See the debate between Silvia Sigal y Oscar Terán published as "Los intelectuales frente a la política," 42–48.
7. Rose, "Response to Crisis in American Art," 24–35; Lippard, *A Different War*.
8. Marcuse et al., *On the Future of Art*.
9. Córdova Iturburu, *80 años de pintura argentina*; Pellegrini, *Panorama de la pintura argentina contemporánea*.
10. López Anaya, "Arte argentino entre humanismo y tardomodernidad."
11. Romero Brest, *Arte en la Argentina*.
12. King, *El Di Tella*, 183.
13. Under the auspices of the Ministry of Foreign Relations and Culture, in 1965 two exhibitions were organized under the explicit title *Argentina en el mundo* (Argentina in the World), presented in the Eduardo Sivori Museum

(1965) and in the Torcuato Di Tella Institute (1965–66). These shows brought together those artists who had "distinguished themselves abroad" and presented them to the local public as a demonstration of the success achieved by national artists. See chapter 6.

14. García Canclini, "Estrategias simbólicas del desarrollismo económico," 96–136.

15. In this context García Canclini cites the work of Shifra Goldman, to whom I refer below.

16. Foucault, *The Archeology of Knowledge*, 124–25.

17. Ibid., 106–17.

18. Ibid.

19. Adams, "'Calidad de exportación,'" 709–24.

20. King, *El Di Tella*.

21. Traba, *Dos décadas vulnerables*.

22. See Egbert, *El Arte y la Izquierda en Europa*.

23. This is how they were defined in the presentation of the Argentine submission at the 1956 Venice Biennial.

24. This is something that had already been proclaimed by Harold Rosenberg in his article "On the Fall of Paris," published by the *Partisan Review*. Clement Greenberg also took this position in his criticism. On the construction of a new artistic hegemony on the international art scene during the Cold War, there is a great deal of material compiled in North American historiography. In addition to articles by Eva Crockcroft and Max Kozloff, to which I will refer below, see also Guilbaut, *How New York Stole the Idea of Modern Art*.

25. Anderson, "Internationalism: A Breviary."

26. Goldman, "La pintura mexicana," 33–44; and Goldman, *Contemporary Mexican Painting in a Time of Change*.

27. Kozloff, "American Painting During the Cold War," 43–54; and Cockcroft, "Abstract Expressionism, Weapon of the Cold War," 39–41.

28. Cockcroft, "Los Estados Unidos y el arte latinoamericano," 184–221.

29. Angel, "La presencia latinoamericana," 222–63.

30. Bourdieu, *Campo del poder y campo intelectual*; *Sociología y cultura*; *Las reglas del arte*.

31. Gramuglio, "La summa de Bourdieu," 38–42.

32. Altamirano and Sarlo, *Literatura/Sociedad*.

33. Williams, *Marxismo y literatura*, 137–39 and *Cultura: Sociología de la comunicación y del arte*, 175–76.

34. Mostly as jurors for literary competitions organized by the magazine *Casa de las Américas*, created in 1959 and thereafter holding an annual competition.

In the fourth issue of the magazine (January–February 1961) a "List of Activities" for *Casa* was also published, providing information on conferences and poetry readings by numerous writers (Carlos Fuentes, Miguel Angel Asturias, Ezequiel Martínez Estrada, Rafael Alberti, Pablo Neruda).

35. Habermas, "Modernidad: Un proyecto incompleto," 27–31.

36. Poggioli, *Teorie dell'arte d'avanguardia*; Garaudy, *60 oeuvres qui annoncerent le futur*; Rosenberg, "Collective, Ideological, Combative."

37. Bürger, *Theory of the Avant-Garde*.

38. Berman, *Todo lo sólido se desvanece en el aire*, 1.

39. Adorno, *Teoría estética*.

40. Greenberg, "Avant-Garde and Kitsch," 34–49. The relation between the aesthetic of the 1960s (specifically pop) and Greenberg's article is brought up by Alloway in "The Arts and the Mass Media." In a later text he comments: "Examining Clement Greenberg's article, 'Avant-garde and Kitsch,' I rejected Greenberg's reduction of mass communication media to surrogate culture . . . directed at those who have no sense of the value of authentic culture . . . The idea consists in a continuous spectrum of Pop 'fine art' in which there is coexistence between the durable and the disposable, the temporal and the atemporal," "The Development of British Pop Art," in Lippard, ed., *El pop art*, 36. See Crow, "Modernism and Mass Culture in the Visual Arts," 233–66. On this point and with respect to a criticial review of pop art and its international diffusion, see Huyssen, *After the Great Divide*.

41. This implies considering the historicity of the concept of autonomy as well as the concept of avant-garde, that is to say, to consider that the relation between artistic objects and these categories can be modified and that it is necessary to study this relation as a changing formulation of meaning. In this regard, see Bürger, *Theory of the Avant-Garde*, especially the section "The Historicity of Aesthetic Categories" in chapter 2.

42. That is to say, "the relations through which art is produced, distributed, and received," Bürger, *Theory of the Avant-Garde*, 76; Habermas, "Modernidad: Un proyecto incompleto."

43. Williams, "La política de la vanguardia," 7–15.

44. Crow, *The Rise of the Sixties*, 11.

45. Berman, *Todo lo sólido se desvanece en el aire*, 335–36.

46. In addition to the institutional dynamicism that characterized the visual arts milieu, it is important to note the creation of the sociology program at the University of Buenos Aires in 1958, the Editorial Universitaria de Buenos Aires in the same year, the Consejo Nacional de Investigaciones Científicas y Técnicas in 1957, the National Fund for the Arts, and the National Institute

of Cinematography. There was also intensive development of the mass communications media and the appearance of influential new weekly magazines, such as *Primera Plana*. The "boom" for the Latin American narrative and the "boom" in readership broadened editorial powers and considerably increased the number of editions published. The bars (Chaberey, Florida, Coto, Moderno), together with bookstores and film clubs, joined the cultural dynamic of the period and acted as spaces for generating debates and controversies.

47. Landi et al., "Intelectuales y política en Argentina," 4–8.

48. Cf. Bourdieu, "Campo intelectual y proyecto creador," 161–63. These are what Altamirano and Sarlo describe as "beacon" writers insofar as they had greater visibility and were able to leave their "mark" on the period. For his writing and his actions, for his "position" as well as his "authority," Romero Brest is a central element for defining the "dominant problematic" of the period, with respect to his influence in the visual arts. Cf. Altamirano and Sarlo, *Literatura/Sociedad*, 84.

49. I have taken this concept of the "introduction" from Francis Frascina and his compilation of essays, *Pollock and After*, 3–20. Both Payró and Romero Brest wrote on the problem of modern art. For example, Payró, *Pintura moderna* and *Los héroes de color* and Romero Brest, *La pintura europea, 1900–1950* and *Qué es el arte abstracto*.

50. Romero Brest, "El arte argentino y el arte universal," 4–16.

51. After being dismissed from his position as professor at the University of La Plata in 1947, Romero Brest continued his activities along alternative avenues other than the official circuits, for example, in *Ver y Estimar* (1948–55) and in the courses on aesthetics and history of art, which he gave at the Fray Mocho bookstore and later at the School for English Language Studies.

52. Crow, *The Rise of the Sixties*, 11.

53. Williams, *Marxismo y literatura*, 150–58.

54. In addition to the works cited of Guilbaut and Crow, see Clark, *The Absolute Bourgeois*; *Image of the People*; and *Painting of Modern Life*; and Mitchell, *Iconology: Image, Text, Ideology*; *Picture Theory*.

55. See Masotta, *El pop art*; *Happenings*; *Conciencia y estructura*.

56. Herrera, "En medio de los medios," 71–114.

57. Longoni and Mestman, *Del Di Tella a "Tucumán Arde."* The book provides a comprehensive study of the politicization of the artistic avant-garde of the 1960s, with valuable material containing interviews and documentation.

58. Katzenstein and Giunta, eds., *Listen, Here, Now!*

1. Modern Art on the Margins of Peronism

1. Borges, "Anotación del 23 de agosto de 1944," 24.

2. The Argentine artists set out more radical and well-formulated programs for abstract art than those found in other Latin American countries at the time. After 1944, with the publication of the magazine *Arturo*, groups were formed that, from the beginning, gave rise to intense debates over abstract geometric art and launched various magazines and manifestos. One of the first such groups exhibited in the house of Dr. Enrique Pichon Rivière on October 8, 1945; it was called Art Concret Invention, featuring music, painting, sculpture, and concrete elemental poems (Ramón Melgar, Juan C. Paz, Rhod Rothfuss, Esteban Eithler, Gyula Kosice, Pichon Rivière, Renate Schottelius, among others). Shortly thereafter, the group called Movimiento Arte Concreto Invención (Arden Quin, Rod Rothfuss, Kosice, among others) exhibited in the house of the photographer Grete Stern on December 2. The Asociación Arte Concreto Invención was formed in November 1945 after the split of the initial group and just before the Pichon Rivière exhibition. The Movimiento Arte Concreto Invención was first exhibited on March 18, 1946, in the Peuser Gallery and it published the *Manifiesto Invencionista*. After that time, there were two established groups: Madí, presided over by Kosice, and the Asociación Arte Concreto Invención, presided over by Maldonado. See Perazzo, *El arte concreto in la Argentina*. In various ways these groups influenced groups that emerged in Brazil in the early 1950s.

3. These tensions can be observed, for example, in the history of the Salón Nacional during those same years. Cf. Giunta, "Nacionales y populares," 153–90. See also Perazzo.

4. Cf. Torre, ed., *El 17 de octubre de 1945*, 23–81.

5. Declaration of the artists in the catalogue of the Salón Independiente. The Salón exhibit took place September 17–30, 1945. One hundred forty-four artists participated from the most diverse aesthetic orientations, such as Antonio Berni, Norah Borges, Juan Carlos Castagnino, Lucio Fontana, Raquel Forner, Alicia Penalba, Emilio Pettoruti, Lino Eneas Spilimbergo, Demetrio Urruchúa, Abraham Vigo, and so on. The Salón Nacional was unable to compete with the Independiente in terms of the relevance of the artists exhibited.

6. "Será inaugurado hoy el primer salón de artistas independientes," *La Prensa*, September 17, 1945, 11.

7. Berni, "El Salón Independiente," *Antinazi*, September 27, 1945, 7.

8. Ibid.

9. "A numerous group of artists will not send their works to the Annual Salón," *La Prensa*, August 23, 1945, 10. The declaration was signed by, among others, Raquel Forner, Lucio Fontana, Antonio Berni, Enrique Policastro, Juan Carlos Castagnino, and Demetrio Urruchúa.

10. After the series *Mujeres en el mundo* (1938), the figure of the woman is the vehicle of suffering. In 1939, with *Ni ver, ni oír, ni hablar*, the woman nullifies her feelings before the horrors of war. Cf. Burucúa and Malosetti Costa, "Iconografía de la mujer y lo femenino," 2.

11. "Actos de homenaje a Sarmiento en el Luna Park sugerido por la Confederación de maestros," *La Nacion*, September 12, 1945, 1.

12. Braden was the main author of *Libro Azul o Consultation Among the American Republic with Respect to the Argentine Situation*, written after his opposition to Farrel and published before the elections which Perón won using the slogan "Braden or Perón." Braden's book profoundly irritated Latin Americans. On postwar relations between the United States and Argentina, see Connell-Smith, *Los Estados Unidos y la América Latina*; Gil, *Latin American–United States Relations*; and Rapoport and Spieguel, *Estados Unidos y el peronismo: La política norteamericana en la Argentina: 1949–1955*.

13. The unions and the CGT were not absent during those decisive days. Juan Carlos Torre demonstrates this through his use of the "Actas del Comité Central Confederal de la CGT" (The minutes of the Central Confederal Committee of the CGT). He also carefully analyzes how the relations of power were interwoven between military, political and labor union sectors. See Torre, ed., *El 17 de octubre de 1945*.

14. "XIV Salón de Arte de la Plata," *La Nación*, April 15, 1946, 6.

15. Coombs, "The Past and Future in Perspective," in American Assembly, *Cultural Affairs and Foreign Relations*, 142.

16. This exhibition circulated through museums in New York, Mexico, Havana, Caracas, Bogotá, Quito, Lima, Rio de Janeiro, Santiago, Montevideo, and Buenos Aires.

17. Nelson A. Rockefeller to General George C. Marshall, August 28, 1942, 1, NA, RG 229, OIAA Department of Information, Content Planning Division, Box 1429, Folder: "Content Liaison." Cited in Cobbs, *The Rich Neighbor Policy*, 40.

18. "Preliminar," *Watercolors—United States, 1870–1946*, 13. The exhibition and the article were carried out under the direction of D. S. Defenbacher, director of the Walker Art Center, Minneapolis, Minnesota. Hermon More and Lloyd Goodrich of the Whitney Museum cooperated in the selection of paintings.

19. King, *Sur: Estudio de la revista argentina*, 123.

20. María Rosa Oliver was an active promoter of inter-Americanism on the tour, financed by this Office, which took place in August and September 1944, in Mexico, Colombia, Ecuador, and Chile. Her confidence in the brotherhood between Latin America and the United States was resisted in Mexico, as she comments in her Confidential Report of October 4 to Rockefeller. In this report, Oliver describes her activities, analyzes the political situation, and the general attitude of those countries toward the United States. She repeatedly compares the rejection of the United States that she encountered with the rejection of the Argentines, and repeatedly, the reasons are the same: economic power, cultural level, a feeling of superiority toward other nations. The report also emphasizes the place of Argentina in Latin American culture: "From Mexico City to Santiago de Chile three parts of the books in the book shops are published in Argentina. So are the magazines in the newspaper sta[tions]. A third of the films shown are Argentine." She referred to this presence as a way of comforting the sponsors who may have been concerned about the spread of fascism: "Fortunately there is nothing to fear from this cultural expansion: it is essentially democratic and liberal. It represents the opposite of that for which the present Government stands. It is the Argentina of Sarmiento. The Argentina of Rosas cannot be 'sold' over the borders. It would be bad policy, in every sense, if U.S. publishers tried to prevent this cultural expansion. Via Buenos Aires the best U.S. literature is distributed in all Latin America in excellent translations. Other 'latinos' believe that the American books chosen by the European-minded Argentines must all be very good and not published for propaganda reasons." María Rosa Oliver, "Report Latin American Trip (Confidential)," October 9, 1944, folder 45, box 7, Countries series, RG III 4 E, Nelson A. Rockefeller Papers (NAR Papers), Rockefeller Family Archives, Rockefeller Archive Center, North Tarrytown, New York (hereafter designated RAC). The letter was written in English.

21. Rockefeller offered his resignation to Truman as assistant secretary of state on August 25 and Spruille Braden was named in his place. The replacement is attributed to the unease generated by Rockefeller's support of Argentina's participation in the San Francisco Conference, contrary to the firm position of Secretary of State Cordell Hull. The designation of Braden clearly confirmed the stiffening of relations with the United States that characterized the first years of Peronism. "Braden es nombrado en reemplazo de Rockefeller," *La Nación*, August 26, 1945, 1.

22. Rockefeller to Maria Rosa Oliver, September 22, 1945, folder 45, box 7, RG 4 (NAR Papers), Rockefeller Family Archives, RAC.

23. See note 2.

24. "Opinión," *Asociación de Arte Concreto-Invención*, Buenos Aires, November 1945, in Maldonado, *Escritos preulmianos*, 37.

25. Cf. Guilbaut, "Rideau d'art et rideau de fer," 92–115.

26. As indicated by King, "*Sur* would always tear the literary competence from the hands of the committed and take it to a world of abstract, universal values." Cf. King, *Sur: Estudio de la revista argentina*, 84.

27. Lozza affirms that Hlito and Maldonado were also affiliated with the Communist Party. Raúl Lozza, interview with the author, 1988.

28. "Manifiesto Invencionista," *Arte Concreto Invención*, no. 1 (1946): 8.

29. "Nuestra militancia," in ibid., 2.

30. "Los Amigos del Pueblo," in ibid., 2.

31. On this point Maldonado was firm in his disagreement with Torres-García who, for his part, according to Hlito, had been a fundamental element in the formulation of his own aesthetic. See Hlito, *Escritos sobre arte*, 204. The debate between Arte Concreto Invención and the Taller Torres-García can be examined in *Removedor*, nos. 14 and 16 (1946) (magazine of the TTG), and in *Arte Concreto Invención*, no. 2 (1946). The lack of aesthetic radicalness of *Sur* can also be confirmed in the selections made by its director. As pointed out by Beatriz Sarlo, in the face of the extremist program of modern architecture, Victoria Ocampo chose modern *good taste*, although she adored Le Corbusier and disdained the Argentine architect Bustillo, she nonetheless chose the latter to design her modern house. Cf. Sarlo, "Victoria Ocampo o el amor de la cita," 164–84.

32. Regarding these questions, see Giunta, "Eva Perón: Imágenes y públicos," 177–84, and Gené, "Política y espectáculo," 185–92.

33. Cited by Neiburg, *Los intelectuales y la invención del peronismo*, 161. Neiburg develops the history of this institution which, founded in 1930, was, until the end of Peronism, a parallel space to the university in which was active an important sector of intellectuals, politicians, economists, and even cultural directors (such as Romero Brest) who, during the Libertadora, occupied central positions on the scene: figures such as José Luis Romero, Risieri Frondizi, Gino Germani, and the future president of the nation, Arturo Frondizi. The CLES was maintained by money originating from courses and from the support of patrons, among which was Torcuato Di Tella, who, as we will see below, had a central role in the industrial and cultural development of the country. In addition to Payró and Romero Brest, other founders of this department were Leopoldo Hurtado, Erwin Leuchter, and the painter Atilio Rossi. The department put out a bulletin in which Romero Brest published

numerous articles during the war years and collaborated with the antifascist periodical *Argentina Libre*.

34. Provoked not only by expulsion from official circles, but also by limitations imposed by press controls, or, more directly, by the incarceration of many intellectuals, for example, that of Victoria Ocampo in early 1953. See King, *Sur: Estudio de la revista argentina*, 170.

35. See James, "17 y 18 de Octubre de 1945," 117–18.

36. See Mangone and Warley, *Universidad y peronismo (1946–1955)*.

37. It was announced that he had been dismissed on March 15 "for reasons of professorial convenience" from the departments of the Colegio Nacional and, on March 24, from the Escuela Superior de Bellas Artes, both of the Universidad Nacional de La Plata. "Curriculum," Caja 1, Sobre 6, documento A, Archivo Jorge Romero Brest, Instituto de Teoría e Historia del Arte "Julio E. Payró," Facultad de Filosofía y Letras, Universidad de Buenos Aires (hereafter cited as C1-S6-A, Archivo JRB, UBA).

38. Romero Brest is quoted as saying, "I don't know if it was as a neurotic or to demonstrate that the Law did not interest me, but at first in my youth I felt very distant from politics, remaining neutral during my years at the university (1926–1933), although the student struggles were already heated. I felt myself an aristocratic thinker and I did not want to sully the purity of my attitudes.

 The situation changed because of the Revolution of 1930, which produced a conversion in me toward disdained politics—although it was only a personal attitude—and toward the left, leading me into feverish readings of Marx, Engels, and Lenin, as well as anyone else who promoted their ideas. But I was never a communist, nor did I consider affiliating myself with any particular party.

 I did so later (in 1945) joining the Socialist Party, in response to repeated urging from my friend, Arnaldo Orfila Reynal, when the struggle against Perón led me to think it was necessary. But my actions in the Party were practically insignificant and years later I took advantage of the Party's split to dissociate myself." Romero Brest, "A Damián Carlos Bayón, discípulo y amigo," C1-S6-A, Archivo JRB, UBA.

39. "El futuro reserva un papel rector al socialismo nos dice Jorge Romero Brest," *La Vanguardia*, February 19, 1946, 5.

40. He delivered this conference in socialist centers on June 9, 11, and 16, 1946; he repeated it in the Casa del Pueblo in Montevideo on September 11, 1948. See Romero Brest, "Acerca del llamado 'Arte social,'" C1-S6-A, Archivo JRB, UBA.

41. Ibid., 3–4.

42. Ibid., 6. In subsequent pages he returns to this point: "The great paradox in art consists in the artist's having to submerge himself in reality to be able to extract from it, not the commonplace or fleeting, but rather the permanent and eternal. 'And the contemporary artist will see himself unable to be inspired by the just idea if he wants to defend the bourgeoisie in his struggle with the proletariat,' Plekhanov wrote. This is a mistake of Marxist theory: the contemporary artist does not defend either the bourgeoisie or the proletariat, he is alienated from both; he only attempts to construct, perhaps on false foundations, I admit, a universal and absolute world, for which reason he flees from allegory." Ibid., 8.

43. Ghioldi, "Carta," 1.

44. Ibid.

45. *Altamira* functioned until the end of 1946. The word "free" in the title implied taking a position on the current political situation. The group was formed on the initiative of Gonzalo Losada, a well-known publisher, Spanish Republican, and president of the institution. The teaching was organized in workshops directed by various professors: in painting, Jorge Larco, Emilio Pettoruti, Attilio Rossi, and Raúl Soldi; in sculpture, Lucio Fontana; in history of art, Jorge Romero Brest.

46. Courses began in Chile and Uruguay in 1943. In Buenos Aires, when he was dismissed from his official positions, he began to teach privately, organizing the Cursos de Estética e Historia del Arte (Courses in Aesthetics and History of Art) at the Fray Mocho bookstore, which was closed by the police in 1948. Subsequently, his courses and conferences in Latin America were discontinued.

47. For example, the exhibitions Así Eran los Rojos and Retaguardia Roja, organized in June 1943 by the delegation from Madrid, an exhibition with a strong propaganda element, was presented as a "testimony" to the "atrocities" of the "red zone." There were also artists in Spain who were developing a theme related to the war and the Franco regime: Eduardo Lagarde, Mariano Bertuchi, Torre Isunza, who produced painted and sculpted representations of Franco. See Llorente Hernández, *Arte e ideología en el franquismo*, 115–69. In the case of Germany, the sadly famous exhibition Degenerate Art, held in 1937–38, might also be mentioned in this context.

48. Eva Perón was in Europe from June 6 to August 23, and the exhibition at the National Museum of Fine Arts was held from October 12 to November 30, 1947.

49. Enrique Azcoaga emphasized these absences by comparing this exhibition

with the one organized for Paris in February 1936. "La Exposición de Arte Español Contemporáneo en Buenos Aires" (The Exhibition of Contemporary Spanish Art in Buenos Aires), *Indice de las Artes*, no. 15, X-1947, cited in Llorente Hernández, *Arte e ideología en el franquismo*, 126.

50. Ibid.

51. "We are pleased to disconnect art from political contingencies, to remember the sane liberal phrase, 'art has no frontiers.' Let it be understood that this refers to true art, art that is free by definition: it does not refer to certain type of pseudo-art that covers, without subtlety, propaganda in one way or another, and of which, it is worth mentioning, the Spanish did not send us any examples." Payró, "Exposición de arte español contemporáneo," *Sur* 159 (January 1948): 119.

52. Ibid., 121.

53. Ivanissevich was a doctor specialized in clinical surgery, administrator of the University of Buenos Aires from 1946 to 1949, ambassador to the United States, secretary of education, and minister of education from 1948 to 1950. His prestige in the academic world earned him an image that was appropriate for the aspirations that Perón had for the scientific development of the country. For Ivanissevich, what was fundamental in culture was its spiritual content; he divided society between those who loved their country and those who were unpatriotic, and to highlight his position, he arrived at conferences wearing the Argentine flag. For someone who maintained that freedom "decreases the more we become civilized," the expressive freedom that modern art called for had to be, in itself, an "aberration," in the terminology the minister was fond of using. Cf. Puiggrós, *Peronismo: Cultura política y educación*, 121–27.

54. See Córdova Iturburu, *Pettoruti*, 100.

55. "Inauguróse ayer el XXXIX Salón de Artes Plásticas," *La Nación*, September 22, 1949, 4.

56. The exhibition was in November 1937 in Munich and opened in February 1938 in Berlin, subsequently touring various cities in Germany and Austria. The text, written by Fritz Kaiser, who had worked in the direction of the Reich's propaganda bureau since 1935, is reminiscent of the antimodernist "Cleansing of the Temple of Art," published in 1937 by Wolfgang Willrich. The catalogue included reproductions of works by Nolde, Dix, Schmidt-Rottluff, Kirchner, Schwitters, Metzinger, and so on. The works had been confiscated during the campaigns against degenerate art in 1937 when Goebbels issued Hitler's order to look for examples of degenerate art in the museums for an exhibition. Cf. Baron, *"Degenerate Art."*

57. "Inauguróse ayer el XXXIX Salón de Artes Plásticas," *La Nación*, September 22, 1949, 4.

58. Ibid.

59. This explains that in 1950–51, for a bust of Eva Perón, Pirovano would choose Sesostris Vitullo, an abstract Argentine sculptor residing in Paris. Naturally, this did not produce the desired success: the functionaries of the embassy could accept the abstract sculptures that the artists exhibited at the National Museum of Modern Art in Paris, but they could not permit that these sharp-edged forms, so alien to their model, should represent the face of the woman they were elevating to the status of "saint." When the bust of Eva Perón was unveiled at the Argentine embassy in Paris, it was immediately removed and it disappeared from the scene until 1997 at which time it was exhibited for the first time in Buenos Aires.

60. He reflected on this in his speech: "A person said to me, while looking at a catalogue of so-called abstract art: this surprises me and makes me laugh, but I won't say anything because 'many sophisticates' have recommended it to me. There is a lack of moral courage to say what one feels. But it is necessary to react and to make the nation react. It is no longer possible to repeat without flagrant falsehood: 'you don't like it because you don't understand it.'" *La Nación*, September 22, 1949, 4. We may suppose that the catalogue he was referring to was that of the exhibition Del arte figurativo al arte abstracto, or perhaps that of De Manet a nuestros días, both held in Buenos Aires in 1949.

61. See Payró, "De Manet a nuestros días," 82–86. The French Organizing Committee was composed of representatives from the museums of France: Jean Cassou and Bernard Dorival (from the National Museum of Modern Art in Paris), André Chamson (from the Museum of the Petit Palais in Paris), Philippe Erlanger (from the French Association of Artistic Action), Roger Seydoux (chief of the Service for Cultural Exchange of the French Ministry of Foreign Affairs) and Gastón Diehl, as commissary general.

62. Payró, "De Manet a nuestros días," 86. Things were not as simple as Payró had presented them. In 1948 the Communist Party was very powerful in France and had a strong influence on artists. Naturally this exhibition did not include works by, for example, André Fougeron, who had converted to "new realism" and had become a "new star of the Communist Party," championed by Louis Aragon. On the debate between realism and abstraction in France, see the article by Guilbaut, "Poder de la decrepitud y ruptura de compromisos," 87–145.

63. Cf. Guilbaut, "Rideau d'art et rideau de fer."

64. Payró, "Exposición en el Instituto de Arte Moderno," 86–87.

65. This was the case for the magazines published by the artists—*Arte Concreto Invención*, *Perceptismo*—as well as for the newspaper *La Nación* and the magazines *Ver y Estimar* and *Sur*.

66. On the organization of this exhibition in Brazil, see Guilbaut, "Dripping on the Modernist Parade," 807–16. Although there were many artists in Buenos Aires who were militantly in favor of abstraction, none of them participated in Degand's exhibition, whereas such artists as Waldemar Cordeiro, Cícero Días, and Samson Flexor did participate in São Paulo. Of these artists, only Cícero Días would participate in the Buenos Aires exhibit.

67. The exhibition was held from April 24 to May 19, 1951.

68. The attempts to incorporate all the novelties of modern art "from impressionism until the present day" were particularly intense and active during the 1920s and Payró was one of those most dedicated to its diffusion. In 1926, at the exhibition of modern French painting held in Belgium, where he was living, he wrote an article, published in *La Nación*, in which he outlined the entire genealogy of modern painting, from Impressionism to fauvism and cubism. See Wechsler, "Recepción de un debate," 47–57. Payró would continue battling on behalf of modern art in following years: In 1941 he published in Buenos Aires *Pintura moderna* and in 1951 *Los héroes del color: Cezanne, Gauguin, Van Gogh, Seurat*.

69. Torre, *Joaquín Torres-García*, 6.

70. The consequences of this situation were visible in subsequent interpretations of this artist's work. The most brilliant response in this regard is that of Juan Fló in his essay, "Torres García in (and from) Montevideo," 23–43.

71. Torre, *Joaquín Torres-García*, 11.

72. The problem of terminology was apparently something that obsessed both these men. Guillermo de Torre, after expressing his skepticism over the possibility of reaching an agreement in this regard, brought up a preceding debate in which they had both participated: "Remember what happened with the barbaric term, surrealism—I find no other adjective to describe that impossible word in our language. Even you—in a prefatory note to the catalogue of the Batlle Planas Exhibition, published by the Institute of Modern Art—and I, for my part, a short time before—in a page of my book on Apollinaire and the theories of cubism—have denounced the term, which only ignorance and laziness have sustained, and have proposed its proper form: *superrealism*." Torre, "Respuesta a Julio E. Payró," 95.

73. Payró, "¿Arte abstracto o arte no objectivo? Carta abierta a Guillermo de Torre," 91.

74. Whereas in 1947 "French soil" seemed to have, for Payró, the power to pro-
voke audacity and inspiration in foreign artists, by 1952 "the light of artistic
genius" had been extinguished in his eyes. Upon assessing the artistic pro-
duction of Buenos Aires, he found that it did not surpass in mediocrity what
was being produced at that moment in Paris: "It is enough to see the latest
Salón of Independent artists, in Paris, to recognize with relief that our paint-
ing, even in its worst manifestations, could not possibly surpass such a dis-
play of insignificance, grossness, and atrocity." It is apparent that Payró's loy-
alty to Paris was not unlimited. See Payró, "Los pintores franceses y el estilo
del siglo XX," 393–403, and "Exposiciones recientes y tendencia profunda en
el arte contemporáneo," 143–47.

75. It might be supposed that the "identification" factor played an important role
here: like the Altamira circle in Spain, which was working in favor of mod-
ern art from the margins of the Franco regime, the sectors supporting *Sur*
and *Ver y Estimar* had to operate from outside the official scene of Peronism.
Coverage of the Parisian front was the responsibility of Damián Bayón, who
was residing in Paris at that time and was conducting a survey with Massimo
Campigli and Léon Gischia, whose results were published by *Ver y Estimar*.
See Bayón, "Encuesta sobre el arte abstracto," 45–53.

76. Gyula Kosice, Martín Blaszko, Yente, Ennio Iommi, Raúl Lozza, Fernán-
dez Muro, Tomás Maldonado, Curatella Manes, Miguel Ocampo, Aníbal
Biedma, Alfredo Hlito, etc. See the catalogue of the exhibition *La pintura y
la escultura argentinas de este siglo* (National Museum of Fine Arts, 1952–53).
Here, the "didactic" sense of the exhibition echoed the spirit of the French
exhibition De Manet a nuestros días.

77. Payró, "Un panorama de la pintura argentina," 159.

78. Ibid., 162.

79. Among others, Martín Blaszko, Sarah Grilo, Alfredo Hlito, Gyula Kosice,
Raúl Lozza, Tomás Maldonado, Antonio Fernández Muro, Miguel Ocampo,
Lidy Prati, Julián Althabe, Claudio Girola, Ennio Iommi. See the catalogue
titled *Second Biennial of São Paulo of 1953*, pp. 67–71. The submission, accord-
ing to the catalogue, was organized by the Sub-Secretary of Diffusion of the
Argentine Ministry of Foreign Affairs.

80. Romero Brest, "El arte argentino y el arte universal," 12.

81. Ibid.

82. Romero Brest, "Punto de partida," *Ver y Estimar* 1 (April 1948): 3.

83. Romero Brest, "El arte argentino y el arte universal," *Ver y Estimar*, 1 (April
1948): 11.

84. The list was published in issue 10 (May 1949): Damián Carlos Bayón, An-

gelia Beret, Raquel B. de Brané, Rodolfo G. Bruh, Lía Carrera, Angelina Camicia, Clara Diament, Raquel Edelman, Isolina Grossi, Beatriz Huberman, Amalia Job, Samuel E. Oliver, Alfredo E. Roland, Blanca Stabile, and Martha Traba.

85. The list appeared in the above-cited issue 10 and was added to in successive issues. In issue 24, the collaborators were: Rafael Alberti (Buenos Aires), José Pedro Argul (Montevideo), Francisco Ayala (Puerto Rico), Bernard Berenson (Florence), Max Bill (Zurich), Córdova Iturburu (Buenos Aires), Léon Degand (Paris), Robert L. Delevoy (Brussels), Bernard Dorival (Paris), Angel Ferrant (Madrid), Wend Fischer (Dusseldorf), Sebastián Gasch (Barcelona), Siegfrid Giedion (Zurich), Mathias Goeritz (Mexico), Ricardo Gullón (Santander), René Huyghe (Paris), Diogo de Macedo (Lisbon), Sergio Milliet (São Paulo), Hans Platschek (Montevideo), Franz Roh (Munich), Antonio Romera (Santiago de Chile), Francisco Romero (Buenos Aires), José Luis Romero (Buenos Aires), Guillermo de Torre (Buenos Aires), Margarita Sarfatti (Rome), Gino Severini (Paris), Vantongerloo (Paris), Lionello Venturi (Rome), Eduardo Westerdahl (Tenerife), and Bruno Zevi (Rome).

86. It is worth noting the importance on the international map, as defined by the magazine, of Angel Ferrant, Mathias Goeritz, and their Escuela de Altamira in Santillana del Mar and their contact with that tip of the iceberg. The magazine dedicated several articles to these artists and the Altamira conferences.

87. With José Luis Romero, he would join with the other resistance front which he formulated in his magazine *Imago Mundi* (1953–56), in an attempt to establish a Shadow University as defined by Romero himself. The magazine, on whose editorial board sat Romero Brest, had aspirations that were comparable to those that motivated *Ver y Estimar*. According to Oscar Terán's analysis, *Imago Mundi*, concerned about defending itself against the adverse conditions, set a general tone with a double meaning: an indeterminate time frame from which to confront Peronism, and an international republic of knowledge that defined its interlocutory space. See Terán, "*Imago Mundi*," 3–5. It is important to emphasize the degree to which these intellectuals organized a network of institutions for the formation of anti-Peronist ranks in various cultural spheres.

88. His participation, as he relates it, appears to have been crucial from the moment that he proposed granting first prize to Max Bill. See Amarante, *As Bienais de São Paulo, 1951–1987*, 24–25.

89. "Concurso Internacional de Escultura," *Ver y Estimar* 27 (April 1952): 42.

90. Payró, "Un panorama de la pintura argentina," *Sur*, 219–20 (January–February 1953).

91. For this multifocal view of the "great master" of modern art, a number of paintings were brought together for a formal analysis, "Inventario de Picasso en Buenos Aires" (The Inventory of Picasso in Buenos Aires), which surveyed his presence in Argentine collections and offered a tempestuous essay by Martha Traba, "Angulo Eluard-Picasso." See no. 2 of the magazine *Ver y Estimar* (May 1948). Other issues presented medieval art (no. 5), Gauguin (nos. 7–8), the sociology of art (no. 9), Angel Ferrant (no. 10), cubism, and Mathias Goeritz (no. 20).

92. Romero Brest, "Picasso el inventor," *Ver y Estimar* 2 (May 1948): 4–5.

93. Ibid., 22.

94. Romero Brest, "Reflexiones sobre la historia del cubismo," *Imago Mundi*, no. 1 (September 1953): 52–63.

95. Ibid., 58.

96. Ibid., 60.

97. Romero Brest, "Alabanza de Portinari," *Ver y Estimar* 4 (July 1948): 41.

98. *Ver y Estimar* 11–12 (June 1949): 6.

99. In 1948, Damián Carlos Bayón did not appear to be very enthusiastic about the movement as reflected in his comments on the exhibition of the concrete artists at the Van Riel Gallery: "a heterogeneous group" in which there are "reminiscences of all the forerunners [Mondrian, Max Bill, Vantongerloo], but certainly not the same critical attitude. . . . In general, this group reveals immaturity, haste to exhibit their work, a lack of self-criticism." Bayón, "Arte abstracto, concreto, no figurativo," *Ver y Estimar* 6 (September 1948): 60–62. In issue 2 of the second series of *Ver y Estimar* (December 1954): 15, Blanca Stabile published a chronology of the movement from 1944 to 1952, "Para una historia del arte concreto en la Argentina."

100. He published it in 1951 as *Qué es el arte abstracto*, with the publisher Columba de Buenos Aires.

101. Romero Brest, *Pintores y grabadores rioplatenses*, 9.

102. The first edition consisted of 10,000 copies. The importance of the book was that, rather than being a version of modern art translated from the French, it was a critical synthesis written by a Latin American in Spanish. On the other hand, it was an inexpensive edition, in small format, which facilitated its distribution.

2. The Revolución Libertadora

Forner epigraph from "Vivimos doce años de exilio en nuestra propia patria," interview with Raquel Forner by Ana Rovner, *El Hogar*, December 23,

1955, pp. 10 and 150. Ocampo epigraph from "La hora de la verdad," *Sur* 237 (November–December 1955): 3–4. Massuh epigraph from "Crónica del desastre," *Sur* 237 (November–December 1955): 107–8.

1. Cf. Portantiero, "Economía y política," 301–46. The proscription of Peronism along with the exclusion of the workers defined a fictional illegitimate, functionally unstable political scene that shaped the political panorama of the 1960s. See also Romero, *Breve historia*, 179–83.

2. "Inauguróse ayer el salón de Bellas Artes con la asistencia de Aramburu y Rojas," *El Mundo*, December 6, 1956, 8.

3. "El Salón Nacional de Bellas Artes se abre," *La Nación*, December 5, 1956, 6. Cf. Giunta, "Nacionales y populares," 153–90.

4. Romero Brest, "Palabras liminares," 7–8.

5. The characterization was no different from what could be found in many of the texts published in the number 237 issue of *Sur*, November–December 1955 (for example, the prison memories of Victoria Ocampo and the poetry of Silvina Ocampo). Cf. Terán, *Nuestros años*, 46. Federico Neiburg uses the term "invention" to analyze, from a nonsubstantialist perspective, the construction of Peronism as a social and cultural phenomenon. From this point of view, the question is not what Peronism was, but rather how it was represented by different sectors. Cf. Neiburg, *Los intelectuales*, 16–17.

6. As pointed out by Oscar Terán, the critical sectors of the intelligentsia, opposed to Peronism, began a reevaluation process after he was overthrown, which provoked controversies that can be examined in *Sur* and *Contorno*. Cf. Terán, *Nuestros años*, 33–62; Sarlo, "Los dos ojos de Contorno," 3–8; Cernadas, "Notas sobre la desintegración," 133–49. The idea of refoundation had relevance in the insitutional field (for example, in the university). In the arts field the discourse appeared to draw closer to the refoundation of institutions than to the kind of revision carried out by intellectuals, which does not depend on government support, but which would be the case for film and, to a certain degree, the visual arts.

7. "Se otorgaron 48 premios en el Salón Nacional de Artes Plásticas, que ha reconquistado la libertad," *La Razón*, December 4, 1956, 12.

8. The exhibition consisted of 113 works by 72 artists covering Argentine art from the nineteenth and twentieth centuries. This was the first megaexhibition of Argentine art to be held since 1939 (Fine Arts in Argentina, organized by the Argentine committee for the World's Fair and Golden Gate, held in New York). The selection committee was composed of Julio E. Payró, José Marco de Pont, and Alberto Pando, the cultural affairs advisor to the

Argentine embassy in Washington. The selection summarized the history of Argentine art. The most contemporary works were abstract, although, following the dissolution of the Asociación Arte Concreto Invención, they did not include radical geometric works, but rather those of the group of Modern Artists of Argentina, formed in 1952 (see chapters 1 and 2), with more accessible abstraction (Hlito, José Fernández Muro, Sarah Grilo, Miguel Ocampo, and Clorinda Testa). The exhibition toured Washington, Louisville, San Francisco, and Chicago.

9. "Exposición de arte argentino en los Estados Unidos," *La Prensa*, April 17, 1956, 4.

10. "Today in Society: Diplomatically Speaking: Argentines, Syrians Give Receptions," *Evening Star*, April 18, 1956.

11. Cf. Cockcroft, "Abstract Expressionism."

12. "La Argentina en la Bienal de Venecia," *La Nación*, July 16, 1956, 4.

13. Ibid. The selection included various tendencies, which *La Nación* classified as figurative (Leopoldo Presas, Ideal Sánchez, Santiago Cogorno, Luis Seoane, and Carlos Torrallardona), concrete (Alfredo Hlito, Miguel Ocampo, Sarah Grillo, José A. Fernández Muro), abstract (Manuel Álvarez, Víctor Chab, Armando Coppola, Victor Magariños, Francisco Maranca, Clorindo Testa, and Oscar Herrero Miranda), and independent (Rafael Onetto, Carlos A. Uriarte, Leónidas Gambartes, Ernesto Farina, Raúl Russo, Ana M. Payró, Alicia Giangrande, and Leonor Vassena). The sculptors were Gyula Kosice, José Alonso, Líbero Badii, Martín Blaszko, Alberto Carlinsky, and Noemí Gerstein. Emphasis added.

14. Those signing were Raquel Forner, Horacio Butler, Héctor Basaldúa, Juan Batlle Planas, Raúl Soldi, Emilio Centurión, and Alfredo Bigatti. Because of this submission, Horacio Butler resigned from his post as administrator of the Escuela Superior de Bellas Artes.

15. "Los artistas y la Bienal de Venecia," *La Nación*, April 30, 1956, 6.

16. Ibid. The letter was signed by, among others, Víctor Chab, Raúl Russo, Noemí Gerstein, Kosice, Rafael Onetto, Martin Blaszko, Libero Badii, and Clorindo Testa.

17. Romero Brest, "Palabras liminares."

18. As Renato Poggioli explains, what had been exceptional until that moment had suddenly become the new norm; the objective is to establish continuous processes of standardization, to convert something of general use into a rarity and novelty and then move on to another rarity as soon as the previous one has become common. Fashion, in the art field, generally translates new or strange aesthetic forms into acceptable forms, a process that is re-

newed each time the new translation is generalized. Cf. Poggioli, *Teorie dell'arte*, 91–92.

19. "Los artistas y la Bienal de Venecia," *La Nación*, April 30, 1956, 6.

20. For example, the *Ver y Estimar* prize competition, organized from 1960 to 1968 for young artists, and the Braque prize, which was first held in 1963 in order to present "the latest tendencies in current art"—as affirmed by Samuel at the prize presentation in 1968. Also the ITDT national prize, which, although it began in 1960 purporting that its main criteria was the "seriousness" of the work and the "inventive capacity," by 1963, it was also taking into account the age of the participants. Cf. the ITDT prize competition catalogues from 1960 and 1963.

21. Bulletin of the MNBA, no. 1 (June 1956): n.p.

22. The law established a series of norms (such as the obligation to show nationally produced films in all the theaters), which, together with the percentage earmarked for the MNBA, stirred reactions from the film companies. Cf. "Solicitada: Atentado," *La Nación*, July 12, 1957, 11; and "Por la Nueva Ley Cinematográfica se concederían al Museo Nacional entre 3 y 4 millones de pesos: Su director reservó ya 13 obras de arte nacional," *La Razón*, July 4, 1957, 7.

23. "Reabrióse el Museo con la Exposición de Brasil," *La Nación*, June 26, 1957, 6.

24. According to the Brazilian representatives, the exhibition featured the most important Brazilian submission ever sent abroad.

25. Under his direction the following exhibitions were held: in August 1957, the exhibition Diez Años de Pintura Italiana (Ten Years of Italian Painting); in April 1958 Ben Nicholson y los Jóvenes Escultores Británicos (Ben Nicholson and the Young British Sculptors); in June the exhibition dedicated to Honoré Daumier on the 150th anniversary of his birth; in July the exhibition of Figari; in August–September the exhibition of Vasarely; in June 1959 the Santamarina collection; in March 1960 the exhibition of contemporary Japanese painting; in August Espacio y Color en la Pintura Española Actual (Space and Color in Spanish Painting Today); in September the exhibition of sculptures by Bourdelle and an exhibition of 1960s Chilean painting; in September 1961 a retrospective of Eugenio Daneri's work; in May 1962 Arte Alemán Actual (German Art Today); in October an exhibition of Finnish architecture; in April 1963 an exhibition was organized by the National Association of Women Artists, U.S.A.; and in May Figuras de Buda en el Arte Oriental (Figures of Buddha in Oriental Art). In 1961 and 1962 the ITDT international prize competitions also took place.

26. After the fall of Perón, Radicalism split into those who followed Balbín,

openly identified with the government of the Libertadora, and those who supported Arturo Frondizi, aligned with a rapprochement toward Peronism, based in the traditional national and popular program of Radicalism and its constitutive opposition to the "democratic unions." In 1956 the Unión Cívica Radical split into the UCR Intransigente and the UCR del Pueblo. In 1957, beset by financial problems, the provisional government began to organize elections. Arturo Fondizi, with a modern discourse and clear references to the structual problems of the country in national and popular terms, offered an alternative for progressive forces and for a broad sector on the left. Combined with his negotiations with Perón, this enabled him to win the elections in February 1958. His developmentalist discourse, associated with foreign investment and bringing together forces capable of constructing a modern country, including the national bourgeoisie, the unions, and the military, did not succeed however in achieving the reconciliation necessary for success. Frondizi was committed to a fast restructuring of the national scene. First he had to fulfill his electoral promise to Peronism—a 60 percent increase in salaries, amnesty, and the lifting of the proscription on Peronism, among other measures—and then he immediately negotiated with foreign corporations regarding the exploitation of petroleum reserves and authorization for the administration of private universities. The central element of his economic policy called for laws to attract foreign capital and to promote industrialization, laws that were ratified in 1958 and guaranteed foreign investors freedom to transfer profits and repatriate capital. A special regimen was established for investments in sectors that were considered key for this new developmental stage: iron and steel, petrochemicals, cellulose, automobiles, energy, and petroleum. As a result, foreign investment, which amounted to $20 million in 1959, rose to $248 million in 1959 and to $348 million in the two subsequent years. The production of steel and automobiles increased spectacularly and self-sufficiency in petroleum production was almost achieved. Inflation and difficulty in the balance of payments led to a Stabilization Plan that gave rise to liberal plans for devaluation, wage freezes, and suppression of state controls and regulations. These liberal policies were directly opposed to the initial developmentalism. Conflicts heated up between the unions and the government. Faced with labor strikes, the government responded by seizing control of the unions and using the army for repression (this was implemented by the plan CONINTES). Consequently, 1959 was a turning point. In March 1962, Frondizi was deposed by the military and replaced by the president of the senate, José María Guido. Romero, *Breve Historia*, 183–93.

27. Foglia, *Arte y mistificación*.

28. Ibid., 7–8.

29. Ibid., 52.

30. Founded in 1951, the Bonino Gallery was central in the Argentine art world until its closing in 1979. With consultants such as Payró, Córdova Iturburu, and Manuel Mujica Láinez, the gallery exhibited during the 1950s numerous artists, including Victorica, Pettoruti, Battle Planas, Juan del Prete, Jorge Larco, and abstract artists (such as those who belonged to Grupo de artistas modernos, formed under Aldo Pellegrini) and from the interior of the country (such as the group Litoral of Santa Fé, with Leónidas Gambartes and Juan Grela). During the 1960s, the Bonino joined the internationalist project, opening galleries in Rio de Janeiro (1960) and in New York (1963). The relations between the institutions that Foglia perceived were not products of his imagination. In fact, in addition to providing works for museums to purchase, the Bonino Gallery had connections with the majority of the artists included for exhibition by the Di Tella prize competition. The Pogliani Gallery in Rome, where the first Di Tella prize winner had been exhibited, already had commercial ties to the Bonino Gallery. Cf. Giunta, "Hacia las 'nuevas fronteras,'" 277–84.

31. Foglia, *Arte y mistificación*, 40–41.

32. Rafael Squirru explains how important it was for him that the decree declared the founding of the Museum of Modern Art of Buenos Aires [MAM] (similar in name to the Museum of Modern Art, New York) and not "of the city of Buenos Aires." Rafael Squirru, interview by the author, April 29, 1995.

33. The decree of the foundation of the Museum of Modern Art was signed by the mayor of the city of Buenos Aires, Eduardo Madero, on April 11, 1956.

34. From September 28, 1956, to February 21, 1957, the exhibit visited twenty-three different ports, touring Africa, Asia, and the United States. Squirru describes the hazardous circumstances under which the exhibit was organized: "In fact, much is owed to Cecilio Madanes because [he] was traveling with a film company and taking advantage of the trip. So, I don't know how we made contact, but he offered to act as organizer if we put together the exhibit. So I, at that time completely in favor of everything, immediately organized the show with a sign that ran the length of the boat, 'Yapeyú,' from end to end, and proclaimed, 'Floating exhibit of modern art' . . . and we even put some works up for sale. In some of the ports into which the ship docked, news arrived through Cecilio, saying 'great success of Barragán in India, and of Torres Agüero in Japan.'" Rafael Squirru, interviewed by the author, April 29, 1995.

35. Until the opening of its building in 1960, the museum organized more than

forty exhibits in different galleries around Buenos Aires (Lirolay, Peuser, H, Witcomb, Rubbers, Van Riel, Valázquez) and in the Museo Eduardo Sívori; however, it did not organize exhibits in the Bonino Gallery, which was more connected to the MNBA, a more prestigious space than the MAM. During these four years, Squirru also organized various exhibitions abroad (in Mexico, Tokyo, Montevideo, the United States, etc.).

36. Squirru, *MAM 10 años, 1956–1967*, exhibit catalogue (Buenos Aires: Museo de Arte Moderno, 1967), n.p.

37. See "Decreto de la creación del Museo de Arte Moderno de Buenos Aires," Archives of the MAM, Carpeta: Resumen de actividades, 1957–80.

38. The catalogue featured an introduction by Squirru and a text explaining the group. This new geometry, based on the general principle of giving movement to the point and straight line, "generating" on the plane a directional and projecting movement, was an "efficient" geometry inasmuch as it gained acceptance and recognition within the institutional circuits. In contrast to the 1940s, when the first geometric artists did not achieve much public impact and general acceptance for their work, this new geometry circulated with ease.

39. This idea of the interrelationship of the arts was an important point within the model of the new institutions. Nonetheless, the ITDT was able to realize this goal more than the MAM.

40. Regarding the tensions between different conceptions and formations of the avant-garde, see chapter 4.

41. Galatea was located on Viamonte Street, between Florida and San Martín. The owner was Félix Gatignon, a sophisticated book dealer who had been in contact with the surrealists: "He sells French books cheaper than in Paris. He punctually receives *Les Temps Modernes*, which the native existentialists purchase with reverence." Goldar, *Buenos Aires*, 89. The magazines published by Pellegrini were also sold there. The Jockey Club was at Florida and Viamonte, near the Facultad of Filosofía y Letras of the Universidad de Buenos Aires, where the editors of *Sur* held their meetings. This was the circuit of the 1950s Buenos Aires intelligentsia.

42. Llinás, *Fiat Lux*, 99 and 101.

43. Pellegrini, *La valija de fuego*; Molina, *Costumbres errantes*; Llinás, *Panta Rhei*.

44. Letter from Julio Llinás to Aldo Pellegrini. Paris, December 22, 1952. Julio Llinás Archives.

45. Ibid. This description of a consumptive Europe and a weakening myth was

not free of arrogance and irreverance, and perhaps this is the reason that, upon rereading his letter, Llinás decided not to send it.

46. Tzara, "El surrealismo." Cf. Bozo, *André Breton*, 347.

47. Sartre, "Situation of the Writer in 1947," 175.

48. Ibid., 177–78.

49. *Cobra*, founded in 1948, included artists from Copenhagen, Brussels, and Amsterdam (hence its name). Christian Dotremont directed the magazine and Jaguer was the editor. *Rixes* was founded in 1949 by Max Clarac-Sérou, Iarolslav Serpan, and Jaguer. In October–November 1951 an new initiative was undertaken that would later become affiliated with the program championed by *Phases*: the Movimiento Nucleare, in Milan, whose first exhibition (of Dangelo and Baj) was held in October of that year in the Santa Fedele Gallery in Milan.

50. Edited by the painter C. O. Hulten, founder of the "imaginista" group, which for many years was the antennae of the north for *Phases*. Jaguer cites a large number of magazines associated with *Phases*: "In close relation to *Phases*, a dozen magazines have appeared, among which we should mention *Salamander*, *Kalejdoskop*, and *Dunganon* in Sweden, *Il Gesto*, *L'esperienza moderna*, and *Documento Sud* in Italia, *Edda* in Belgium, *Boa* in Argentina, *Melmoth* and *Chrome* in England, *Sarabeus* and *l'Oeuf philosophique* in Canada, and *Droomschaar* in the Netherlands, as well as *Ellébore* in France." Jaguer emphasizes that all were a result of "the initiative of one individual—often the same creator of written and painted images, and of a small local group," always "underground" and generally "without any long-term plan." Jaguer, conference address, October 1992, 11. Mimeograph, Julio Llinás Archives.

51. Ibid., 4.

52. For an analysis of the Parisian artistic milieu in 1952, see Guilbaut, "Poder de la decrepitud."

53. The magazine also had correspondents in Germany (K. O. Gotz), Belgium (T. Koenig), Canada (R. Giguere), Denmark (U. Harder), the United States (H. Phillips), Spain (A. Tàpies), Italy (S. Dangelo), Japan (S. Morita), Mexico (M. Goeritz), Sweden (I. Laaban), and Switzerland (F. Ganz).

54. After the publication of the only two issues of the magazine *Qué* in 1928 and 1930, its founder, Aldo Pellegrini, sought to establish a surrealist group in Argentina, the first in the Spanish-speaking world. According to Pellegrini, he founded the magazine in 1926 when he read the first issue of *La Révolution Surrealiste* and Breton's *First Manifesto* and decided to form a kind of surrealist fraternity with his companions at the Facultad de Medicina (David

Sussman, Mariano Cassano, Elías Piterbarg, Ismael Piterbarg, and Adolfo Solari), who produced experiences of automatic writing. "The activities of this group," Pellegrini relates, "totally separate from literary currents at the time (we only admired Oliverio Girondo and Macedonio Fernández), culminated in the publication of the two issues of the magazine *Qué*." Cf. Solá. In 1952, Pellegrini was a well-known figure on the surrealist circuit, Jaguer affirms that he was very curious to meet him, especially as they shared the same interests in experimentation. Pellegrini had not hesitated to form alliances with Maldonado, Hlito, and Madí, from which emerged the magazine *Ciclo*: a paradoxical alliance between poets and surrealists (Pellegrini was co-director with Enrique Pichon Riviêre and Elias Piterbarg) and a radical abstractionist, Tomás Maldonado. As Jaguer himself explains, "For Pellegrini, publishing a new magazine that was open to other avant-garde tendencies was not contradictory to his fidelity to surrealism." Jaguer, conference address, October 1992, 7. Mimeograph, Julio Llinás Archives.

55. Llinás had formed part of two previous surrealist magazines: *A partir de cero* (three issues appeared from November 1952 to November 1956) and *Letra y Línea* (four issues were published from October 1953 to July 1954).

56. Among the concrete artists were Maldonado, Hlito, Prati, Iommi, Girola; among the second group were Fernández Muro, Sarah Grilo, Miguel Ocampo, Hans Aebi. The first exhibition was held in the Viau Gallery.

57. They were exhibited in 1953 at the Museum of Modern Art of Rio de Janeiro and at the Stedelijk Museum of Amsterdam. In 1955, on the initiative of Arden Quin and Pellegrini, the Asociación Arte Nuevo was founded, which brought together independent concrete artists (Gregorio Vardánega, Virgilio Villalba, Jorge Souza) and a large number of free formal abstractionists who had been earning recognition. Later, the Asociación Arte Nuevo became a bastion for the informalists. Cf. Pellegrini, *Panorama*, 60–61.

58. Pellegrini, "Arte surrealista y arte concreto," 9–11.

59. Ibid.

60. Jaguer, conference address, October 1992, 6. Mimeograph, Julio Llinás Archives.

61. Before publication of the magazine, these artists had been exhibited in 1957 at the Pizarro Gallery as *7 Pintores Abstractos*. They produced paintings that may be classified within lyrical abstraction: Osvaldo Borda, Víctor Chab, Rómulo Macció, Martha Peluffo, Josefina Robirosa, Kasuya Sakai, and Clorinda Testa.

62. Llinás to Jaguer, April 17, 1958. Julio Llinás Archives.

63. Jaguer to Llinás, August 5, 1958. Julio Llinás Archives.

64. In reference to Martha Peluffo who, at that moment, was Llinás's wife. Llinás to Jaguer, August 20, 1958. Julio Llinás Archives.

65. Ibid.

66. "Malraux propuso colaboración técnica y científica," *Clarín*, September 9, 1959, 12.

67. Ibid.

68. It should be remembered that Malraux's words were not received in silence: In Chile, for example, communist students interrupted him, calling for the independence of Algeria. "André Malraux: Llegará esta noche a nuestro país," *Clarín*, September 6, 1959, 9.

69. In 1959, *Clarín* published an article by Raymond Aron, "La diplomacia de los viajes." This intellectual, associated early on with the Congreso para la Libertad de la Cultura, invoked the famous book *One World*, by Wendell Wilkie (1942), enthusiastically reviewing the "tourist frenzy" that had Nikita Khrushchev and Eisenhower busy in a "pacific competition" to see who could travel more and faster around the world: "It is just to prove that suddenly travel diplomacy is worth more than cannon shots. The great powers probably continue being what they are, with their interests and priorities, but at least they have better manners." Aron, "La diplomacia de los viajes." It should be noted that travel diplomacy was not the exclusive domain of powerful countries. Arturo Frondizi also traveled to the United States and visited Kennedy in order to negotiate better terms for economic exchange as promised by the new inter-American relations.

70. *Clarín* explained that, upon his arrival, Malraux was guided toward one work in particular, but immediately rejected "that way of viewing" and paused to observe the works of each of the exhibitors, expressing special interest in learning about the chronology of the paintings and sculptures, to consciously appreciate the evolution of each artist. Later he stated that this exhibition had confirmed "that young Argentine painting exists." Cf. "La joven pintura argentina existe," *Clarín*, September 10, 1959, 5.

71. Ibid.

72. "La pintura argentina ante la crítica de Nueva York," *Clarín*, literary supplement, April 3, 1960, 3.

73. Llinás, "La gran mentira," *Boa*, no. 3 (July 1960): 1.

74. Ibid.

75. Ibid.

76. Ibid.

77. José Pierre, "El último cuadrado," *Boa*, no. 3 (July 1960): 12.

78. Georges Mathieu exhibited in the Bonino Gallery from November 23 to

December 12, 1959. A portion of the work in the exhibition he had produced in Raquel Forner's studio. According to Adolfo Nigro, who was attending the Manuel Belgrano school at the time, while Mathieu splashed paint onto the canvas, the students threw him coins. The result was a small scandal from which Mathieu was rescued by Alfredo Bonino. Interview with Adolfo Nigro by the author, January 1999.

79. Williams, "¿Cuándo fue el modernismo?," in *La política del modernismo*, 52.

80. One example is the virtual translation machine organized by Victoria Ocampo in her magazine. For an analysis of this dimension of the figure of Ocampo, see Sarlo, "Victoria Ocampo," 93–194.

81. Kemble, "Autocolonización cultural," 10.

82. The participants were Nicolás Rubió, Jorge López Anaya, Jorge Martín, Mario Valencia, and Vera Zilzer. In Nelly Perazzo's text, "Aportes para el estudio del informalismo en la Argentina," testimonies can be found that enable a reconstruction of the exhibition and a summary of the exhibitions held from 1957 to 1961 (in *El grupo informalista argentino*, exhibit catalogue). See also López Anaya, "El informalismo: la gran ruptura," and, by the same author, *El arte en un tiempo sin dioses*, 147–79.

83. The first exhibition of Movimiento informalista was held, under this title, in July 1959 at the Van Riel Gallery and featured eight artists: Enrique Barilari, Alberto Greco, Kenneth Kemble, Olga López, Fernando Maza, Mario Pucciarelli, Towas, and Luis Alberto Wells. The most representative exhibition was held at the Museo Sívori (sponsored by the Museum of Modern Art) in November 1959, featuring the same eight artists in addition to Roiger, a photographer who had been introduced to the group by Greco.

84. In 1958 Chillida and Tápies received two of the international prizes at the Venice Biennial.

85. Luis Felipe Noé, interview by the author, December 30, 1998.

86. Regarding dadaism, Romero Brest wondered, in his history of European painting, "Did they carry the destruction of the outside world to profound areas or did they stop halfway, surreptitiously introducing fragments of forms and incomplete but isolated shapes that correspond to imperfect ideas?" Nonetheless, his doubts about dadaism dissolved in the face of surrealism: "I don't want to exaggerate, out of controversial enthusiasm, the importance of dadaism, which was only a point of departure, but I cannot keep quiet when I contemplate the impoverishment of the efforts of its putative offspring, surrealism." Cf. Romero Brest, *La pintura europea*, 209 and 204, respectively. The basic problem that Romero Brest encountered in these movements was

that neither of the two had contributed to establishing a language for modern art. On the contrary, they had represented an oppositional force.

87. Marcelo Pacheco's curatorship of the Kemble exhibition aimed at highlighting this aspect. Cf. Pacheco, *Kenneth Kemble*.

88. Kemble maintained: "[Informalism] gave rise to a series of revelations and discoveries that were genuinely Argentine, that came out at the exhibitions. Let's say, I copied Burri at that time, as well as Motherwell, but he copied me or he followed me towards something different." Cf. Giunta, "Historia oral," 77–96, 86.

89. Kemble, untitled, in *Kenneth Kemble*.

90. Mostly the group of artists that Pierre Restany categorized together as nouveau réalisme. I will return to this point below.

91. The review published in *La Nación* on Berni's 1959 exhibit at the Van Riel Gallery shows how irritating his subjects could be, even more so when he incorporated them into collage: "Strictly engaged with the figurative tendency with social projections . . . This attitude has kept him among the ranks of figurative painters even today, and we are already familiar with the angry horror of those who participate in this same ideology, seeing those who reflect their enthusiastic independence through the infinite manifestations of so-called 'degenerate art.' For this reason, Berni's exhibit, which just opened at the Van Riel Gallery at Florida 659, does not cease to attract attention—and a lot of it. In response, two possibilities might be supposed: first, that it has been created in order to confuse; and, second, that the artist created the work out of confusion. Both the first supposition (that of organized 'impact') and the second (that of innocent confusion) derive from the contradictory character of the elements that constitute the exhibit in which there are, one after another, a vast array of anachronistic collages that bring to mind Adunaero Rousseau; a series of abstract geometric compositions; an oil painting—'La res'—which brings to mind the explosive reds of Quirós; and one of the typical poor families that Berni enjoys fixing on the canvas. The continuing bad taste and generosity of materials runs through these works and is astonishing in these difficult times. Here and there, Berni—what is good in Berni—shows through the pastes, smears, and glued elements as more or less satirical. But it is difficult to find." "Berni," *La Nación*, May 9, 1959, 4. Berni, however, consummated his formula for success when he combined subject and collage in his series *Juanito Laguna*, which was exhibited for the first time at the Witcomb Gallery in 1961.

92. Cited in Derbecq, "Alberto, el mago de Buenos Aires," 279.

3. The "New" Art Scene

Parpagnoli epigraph from "Pintura y escultura," 395–401.

1. Terán, *Nuestros años sesentas*, 129–49.
2. One month later, however, the government severed relations with Cuba.
3. Romero, *Breve Historia*, 193–97.
4. VV.AA., *Argentina 1930–1960*, 7.
5. Halperín Donghi, "Crónica del período," 88.
6. Parpagnoli, "Pintura y escultura," 396.
7. Ibid., 397.
8. Ibid.
9. Ibid., 400.
10. Altamirano, "Desarrollo y desarrollistas," 75–94.
11. Cited in King, *El Di Tella*, 27.
12. As indicated by Altamirano, this was the difference between the views of CEPAL (Comisión Económica para América Latina), which trusted in slow and gradual financing of development, and the "drastic and rapid" program which, according to Frigerio's perspective, should be promoted once the necessary foreign investment is obtained in order to produce the desired results. Cf. Altamirano, "Desarrollo y desarrollistas."
13. Di Tella visited the following galleries: Marlborough, Hannover, Kahnweiler, Maeght, Sydney Janis, Rosengard, Pierre Matisse, Knoedler, Studio Fachetti, and Galerie de France. The artists he asked about and for whose work he noted prices were Picasso, Miró, Léger, Klee, Matisse, Rouault, Kandinsky, Fautrier, Dubuffet, Chagall, Pollock, Gorky, Kline, Rothko, Saura, Jacques Villon, Modigliani, Mannesier, and Julio González. Cf. "Visita marzo 1960 — Londres-París-Suiza-New York, con Lionello Venturi," Archivo Instituto Torcuato Di Tella, Centro de Artes Visuales (hereafter cited as Archivo ITDT, CAV), Caja 22, Colección 1960–1970.
14. Established in 1905 in Argentina, Torcuato Di Tella began his family business manufacturing spiral mixers (bread-kneading machines). By 1923 he was in business with such companies as Wayne Pump, from whom he obtained a license to manufacture gas pumps; he also began foundry activities, manufacturing ovens, mixers, and other bread-baking accessories. In the 1930s he expanded the company, opening offices in London and companies in Brazil, Chile, and Uruguay. In 1942 he established his corporation in New York. When Torcuato died in 1948, the company was manufacturing commercial and domestic refrigerators, washing machines, fans, as well as gas pumps,

oil pumps, compressors, and so on, and the company was in the process of expanding. In 1951, SIAM (Sociedad Industrial Americana de Maquinarias Di Tella) was manufacturing between 70 and 80 percent of the domestic refrigerators sold in Argentina. In 1958, when Di Tella joined the board of directors, the company began production activities in automobile and truck assembly with contracted licenses from the British Motor Corporation, thus it was incorporated into one of the strongest forces for industrial development of the 1960s. At that time, as we will see below, Kaiser "jeeps" were already being assembled in the country. Cf. Cochran and Reina, *Espíritu de empresa*, and also Di Tella, *Torcuato Di Tella*. With respect to the foundation, Di Tella explained that it was decided that it would receive a percentage (10 percemt) of SIAM's shares and would administer the funding for the Torcuato Di Tella Institute, which was founded at the same time as the foundation. Cf. King, *El Di Tella*, 36.

15. The Torcuato Di Tella Foundation was established with the explicit objective of "collaborating, through financial and intellectual means, with the material and spiritual development of Argentina." To this end, "the bases for enabling the institution as a powerful and dynamic instrument of influence in the evolution of Argentina" were established, with "the collaboration of a group of international specialists." *La Fundación Torcuato Di Tella*, exhibition catalogue of Colección Torcuato Di Tella, Premio Pintores Argentinos, Muestra individual de Alberto Burri (Buenos Aires: MNBA, 1960).

16. Altamirano, "Desarrollo y desarrollistas."

17. The archives of the Torcuato Di Tella Institute (Archivo ITDT) contain the correspondence Lionello Venturi maintained between with Torcuato Di Tella, and later with Guido Di Tella. Venturi recommended to Torcuato which paintings to buy and he explained, in great detail, why a painting was good or not. Torcuato would not buy without Venturi's approval. This impassioned correspondence reveals that Venturi was not infallible in his decisions. When the time came to decide which works would be included in the catalogue of the collection in the early 1960s, Venturi decided to exclude the Giovanni da Bologna, the Tommaso da Modena, the copy of the portrait of Rafael, the Van Dyck, the Guardi, and the Daumier, paintings which had been bought on Venturi's advice (Venturi to Guido Di Tella, April 24, 1961). On the exclusion of this last work, Di Tella expressed his surprise: "I am surprised by what you told me about the Daumier, since I remember that when you saw it in Buenos Aires, you thought it positively genuine. . . . The Daumier watercolor that you now object to was bought at Barón Cassel,

which you considered a quite acceptable origin." Di Tella to Venturi, Buenos Aires, May 5, 1961. Archivo ITDT, Caja 2, Correspondencia Di Tella/Oteiza/Romero Brest 1954–66.

18. During the war, Venturi lived in New York. Torcuato Di Tella supported the Italian exiles living in France who, during the Mussolini regime, formed the movement Italia Libre (1938) represented throughout America. Torcuato's opposition to Peronism at first made the company's situation difficult. This did not, however, preclude SIAM from being included on the list of companies investigated by the Revolución Libertadora for having supported the deposed regime, accusations of which the company was absolved. See Cochran and Reina, *Espíritu de empresa en la Argentina*, 268–70.

19. Regarding the impact of his books in Buenos Aires, Torcuato Di Tella commented, "Today his latest book has arrived in Buenos Aires, 'Storia della critica d'arte,' of the Giustizia e Libertá collection. No sooner had it arrived than it quickly sold out and I bought the last copy." Di Tella to Venturi, Buenos Aires, October 24, 1946. Archivo ITDT, CAV, Caja 22, Colección 1943–1959. In 1949 Julio E. Payró translated his book *Historia de la crítica de arte*, published by Poseidón, and in 1953 Romero Brest translated *Pintores modernos*, which was published by Argos.

20. Venturi, *La Colección Torcuato Di Tella*, Catálogo de la Colección Di Tella, Buenos Aires, Centro de Artes Visuales, ITDT, 1965, 6. It is interesting that Torcuato was evaluating, at the same time, the purchase of works from very different periods. In 1947 he asked Venturi for his opinion on works by Gauguin, Tintoretto, Tiépolo, Rubens, Guardi, and Daumier. He bought the Van Dyck in 1947 and paid £680 sterling for it, apparently a good price at the moment: "Why do you think the Van Dyck is such a good investment?" he asked Venturi. "Many people have told me that to buy very old paintings one has to ask for X-rays and infrared analysis to discover if they are fake. Do you think it is worth the trouble?" (Buenos Aires, June 5, 1947). Venturi responded, "Don't trust X-rays and infrared: they're useful but only in the hands of experts. Otherwise, they cause the most serious errors. Because they believed the results of X-rays, two years ago the non-experts at the Boston Museum bought a fake Piero della Francesca for 80,000 dollars. . . . Your Van Dyck is not false, because even in the photograph its quality is clearly visible. About the price, that's what this is about: the value of an object does not depend on its name, but rather the 'importance' of the object. A full portrait by Van Dyck, if it is beautiful, can cost 50,000 dollars; a head alone will never be bought for a great collection because it isn't important, even if it is beautiful. This is the case with the Cézanne. You have a beautiful Cézanne, but it is

not important, you paid 8,000 dollars if I remember correctly. But you can't have an important Cézanne, that is, a full landscape or a full still life, for less than 50,000 dollars. I think the originality of your collection resides in having chosen objects for their artistic quality and not for their importance, which always has a social significance" (Venturi to Di Tella, Rome, 21 June 1947. Archivo ITDT, CAV, Caja 22, Colección 1943–1959). Nonetheless, when editing the catalogue, Venturi decided not to include this painting.

21. Venturi told him in a letter: "When you get back, you will have to decide between Manet, Monet, Degas, Gauguin, Seurat and Toulouse-Lautrec. Even with small paintings, and at relatively limited cost, one can have a top-notch collection. It's question of making choices." Venturi to Di Tella, New York, April 16, 1943. Archivo ITDT, CAV, Caja 22, Colección 1943–1959.

22. Letter from Venturi to Di Tella, Rome, April 28, 1948. Archivo ITDT, CAV, Caja 22, Colección 1943–1959.

23. The collection was continued by Torcuato's widow, María R. de Di Tella, and their son, Guido.

24. Letter from María R. de Di Tella to Venturi, Buenos Aires, May 17, 1951. In this letter they also informed him of the paintings they had seen (Neroccio, Antonello da Messina, Toulouse-Lautrec, Greco, Rembrandt, Rafael). Archivo ITDT, CAV, Caja 22, Colección 1943–1959.

25. Letter from María R. de Di Tella to Venturi, Buenos Aires, August 6, 1951. Archivo ITDT, CAV, Caja 22, Colección 1943–1959.

26. Letter from María R. de Di Tella to Venturi, Buenos Aires, November 3, 1951. In this letter she also sent him the list of works included in the collection and where they were purchased. The collection consisted in works by Giovanni da Milano, Perugino, Tintoretto, Tiziano, Rubens, Van Dyck, Guardi, Pissarro, Sisley, Renoir, Manet, Cézanne, Degas, Daumier, Gauguin, and Rouault. In 1953, Venturi recommended the acquisition of the *Virgin with Child* by Fra. Angelico: "It would be a jewel for your collection." Venturi to the Di Tella family, Rome, February 21, 1953. Archivo ITDT, CAV, Caja 22, Colección 1943–1959.

27. Letter from Guido Di Tella to Venturi, Buenos Aires, March 17, 1959. Archivo ITDT, CAV, Caja 22, Colección 1943–1959.

28. Ibid.

29. Letter from Venturi to Guido Di Tella, Rome, April 5, 1959. Archivo ITDT, CAV, Caja 22, Colección 1943–1959.

30. Picasso, Matisse, Modigliani, Fautrier, Kandinsky, Hartung, Miró, Manessier, Chagall, Poliakoff, Afro, Santomaso, Corpora, Vedova, Burri, Tàpies, Kline, Gorky, Rothko, Mathieu, and Dubuffet.

31. Both paintings were included among the four color panels added to the catalogue for the presentation at the MNBA in October of that year, together with the Manessier and the Afro.

32. Di Tella sent Venturi a telegram on July 19 and a letter on July 21 in which he referred to the possibility of buying it from Mrs. Pollock: "I am quite tempted to have a Pollock, I now think it would be an essential part of the collection. However, as I wrote in my telegram, it all depends on the price and the conditions for payment that Mrs. Pollock may demand." Archivo ITDT, CAV, Caja 22, Colección 1960–1970.

33. In early 1961, Guido Di Tella sent a letter to Bonino telling him about his last trip to New York and commenting, with a certain degree of sarcasm, about his visit to Sidney Janis, where he went in search of works by Pollock and de Kooning: "As usual they don't have anything important by Pollock, who we should therefore exclude from the series, at least for my objectives, since I very much doubt his intentions to send an important painting to Argentina." Letter from Guido Di Tella to Bonino, Buenos Aires, February 2, 1961. Archivo ITDT, Caja 2, Correspondencia Di Tella/Oteiza/Romero Brest 1954–66.

34. For these acquisitions, Di Tella did not want to spend more than $40,000. Ibid.

35. Ibid. It is noteworthy that Di Tella would want to acquire North American paintings and that he always sought advice from Venturi, to whom he sent photographs of the works before buying them.

36. Di Tella bought painting number 188, of 1947, from the Thompson Collection, for $37,000. Di Tella was also interested in number 187, for which they were asking $14,000. In his letter of March 3, Venturi advised him to buy the first, which in his judgment best represented the artist. Venturi to Di Tella, March 3, 1961. Archivo ITDT, Caja 2, Correspondencia Di Tella/Oteiza/Romero Brest 1954–66.

37. Bonino and Di Tella formed temporary partnerships for the acquisition and commercialization of the work. Di Tella acquired works in the exhibitions of European artists that the gallery owner held in Buenos Aires, such as the Mathieu that Di Tella bought in 1959. In December 1959 they reached an agreement establishing that Di Tella would have credit at the gallery for an amount equal to the price of a SIAM Di Tella automobile. Letter from the Bonino Gallery to Guido Di Tella, December 30, 1959. Archivo ITDT, CAV, Caja 22, Colección 1943–1959.

38. Di Tella was surely thinking of Burri or Vedova, who had a salon at the Venice Biennial at that moment.

39. At the same time as the foundation established the Torcuato Di Tella Institute (July 22, 1958), which began its activities on August 1, 1960. The ITDT was created for the purpose of "promoting high-level study and investigation of scientific, cultural, and artistic development in the country." The resources were drawn from the annual contribution of the foundation (also an entity for the public good, but different from the institute), which administered a capital fund whose profits constituted the contribution to the institute. To this was added contributions from private and foreign (both public and private) organisms. Cf. *Memorias Instituto Torcuato di Tella*, 1960–1962.

40. Later, the following centers were added: the Centro de Investigaciones Neurológicas, the Centro Latinoamericano de Altos Estudios Musicales (to which a contribution was made by the Rockefeller Foundation), the Centro de Investigaciones Sociales, the Centro de Investigación Audiovisual, the Centro de Investigaciones en Administración Pública, the Centro de Investigaciones en Ciencias de la Educación, and the Centro de Estudios Urbanos y Regionales. Maria Robiola de Di Tella was president of the ITDT, Guido Di Tella was vice president, and Enrique Oteiza was the executive director. Cf. *Memorias Instituto Torcuato di Tella*, 1968.

41. From 1960 to 1963 the CAV was administered by an Advisory Board composed of Giulio Carlo Argan (professor at the University of Rome), Ricardo Caminos (professor at Brown University), Guido Di Tella, Enrique Oteiza, and Jorge Romero Brest.

42. Letter from Bonino to Guido Di Tella, undated. Archivo ITDT, CAV, Caja 22, Colección 1960–1970.

43. See chapter 2.

44. Letter from Di Tella to Venturi, Buenos Aires, June 22, 1960. Archivo ITDT, CAV, Caja 22, Colección 1960–1970.

45. Guido Di Tella's idea was that an independent institute would better serve the interests of progress in research. Small institutes, independent of the unstable Argentine universities that were subject to political changes, would be much more productive spaces; excellent small centers based on the MIT model. Cf. King, *El Di Tella*, 36.

46. The monthly grant amounted to $350.

47. Letter from Venturi to Di Tella, Rome, July 14, 1960. Archivo ITDT, CAV, Caja 22, Colección 1960–1970. It is possible to wonder how much Pogliani's preferences, which both Venturi and Romero Brest were well aware of, might have influenced their performances as jurors for the prize competition.

48. The exhibition featured twenty-one works pertaining to the years 1952 to 1960, and included a very large piece, *Gran Blanco*, 150 × 250 cm.

49. Romero Brest was not among those critics who supported informalism. Alberto Greco considered that the support Romero Brest denied him from the beginning had limited his possibilities on the local art scene. In 1958, one year before the appearance of local informalism, Romero Brest had expressed confidence in Vasarely who, in his judgment, represented another important step forward for concrete art: "the most outstanding, in my judgment, of the French avant-garde painters. Direct heir to the two great artistic movements of the first half of this century—cubism and neoplasticism—Vasarely is characterized by his measured spirit of adventure—investigation and creation—and for his sensitive respect for tradition." Romero Brest, *Vasarely*, exhibition catalogue (Buenos Aires, MNBA, August–September 1958), n.p. His defensive arguments provide insight into Romero Brest's discomfort regarding informalism and the anxiety he felt towards pop art.

50. Letter from Di Tella to Venturi, July 21, 1960. Archivo ITDT, CAV, Caja 22, Colección 1960–1970. The catalogue he sent to him was that of Fernández Muro, Grilo, Ocampo, Sakai, and Testa, who exhibited at the MNBA in July 1960.

51. Letter from Pucciarelli to Di Tella, Rome, May 26, 1961. Archivo ITDT, CAV, Caja 1, Premio ITDT 1960.

52. Letter from Pucciarelli to Di Tella, Rome, May 2, 1962. Archivo ITDT, CAV, Caja 1, Premio ITDT 1960.

53. In contrast to the 1960 prize competition, with ten artists, in 1961 fifteen artists were invited: eleven Argentines (Juan Carlos Badaracco, Aníbal Carreño, Víctor Chab, Sarah Grilo, Mario Heredia, Rómulo Macció, Luis Felipe Noé, Kasuya Sakai, Antonio Seguí, Clorindo Testa, and Jorge de la Vega), two Chileans (José Balmes and Pierre Eppelin), and two Uruguayans (Hilda López and Américo Spósito). First prize (an exhibit and a monthly grant of $350 for ten months to reside in a city in Europe or the United States) was won by Clorindo Testa. Second prize (acquisition for 100,000 pesos) was won by Rómulo Macció for his work *Cabeza*. One of the works by the winning artist would also be acquired by the Art Center of the Institute. The Di Tella Institute, Bonino Gallery, and the National Museum coordinated their efforts: at the same time that he won the Di Tella prize, Clorindo Testa had an exhibition hanging in the Bonino Gallery. Romero Brest, for his part, in addition to organizing the salons of the museum for the prize competition, also acted as juror.

54. From the end of the 1950s to the early 1960s, Fernández Muro was probably the artist whose work was included in the most exhibitions of Latin American art both in Europe and the United States.

55. Letter from Di Tella to Giulio Carlo Argan, Buenos Aires, February 15, 1961. Archivo ITDT, CAV, Caja 1, Exposición Tapies en Buenos Aires.

56. For the ITDT it was not only important to promote change, but also to verify its impact on the community. The formation of a new public was a central goal on the institute's agenda. Together with the Department of Sociology at the University of Buenos Aires, the ITDT conducted a survey of the public that visited the exhibition. The objective was to explore the impact of mass communication. In developed countries, literacy, social mobility, urbanization, the mass media and mass communication had broken the limits between high and popular culture. The survey was intended to explore whether this process was also taking place in Buenos Aires. The survey was conducted among a highly educated public, that read either *La Nación* or *La Prensa*, listened to the radio, prefered classical music to popular music, that assiduously attended museums and art galleries, had television but claimed not to watch it: this was a public that was more closely associated with the 1950s than the 1960s and was most definitely not the public that the Di Tella was trying to appeal to. The aim was to expand this public, and the ITDT soon secured a central position in the mass media. See Gibaja, *El público de arte.*

57. [Jorge Romero Brest], *4 evidencias de un mundo joven en el arte actual,* MNBA exhibition, August 1961, n.p.

58. In addition to Squirru, the other participants in the organization were Héctor Blas González, Director General of Culture, and Aldo Armando Cocca, Secretary of Culture for the City.

59. Squirru, introduction for the *Primera exposición internacional de arte moderno* (Buenos Aires: Museo de Arte Moderno, 1960), n.p. The text was in Spanish, English, and French.

60. "Muestra Internacional de Arte Moderno," *La Nación,* November 5, 1960, 12.

61. MOMA Archives, International Council Papers [V.50.3 ICE-F-47-60].

62. "Representing Advanced N. American Art," *Buenos Aires Herald,* [November] 11, 1960.

63. Parpagnoli, "Arte argentino y extranjero en el Salón Internacional," *La Prensa,* November 22, 1960, 20.

64. Ibid.

65. Ibid.

66. Ibid.

67. Squirru, introduction for the *Primera exposición internacional de arte moderno: Argentina 1960* (Buenos Aires: Museo de Arte Moderno, November 1960).

68. The exhibition brought together 548 works of painting and sculpture.

69. The catalogue featured texts by Córdova Iturburu, "Panorama general: 1810–1960"; José León Pagano, "La pintura y la escultura en el siglo XIX"; Enrique Azcoaga, "La época impresionista"; Lorenzo Varela, "Los primeros vanguardistas"; Ernesto B. Rodríguez, "Del superrealismo a la abstracción"; Samuel Paz, "Los diez últimos años de pintura y escultura en Argentina, 1950–1960."

70. The touring exhibitions traveled through the country from October 1960 to January 1961.

71. Paz, "Los últimos diez años de pintura y escultura argentina," n.p.

72. Iturburu, "Panorama general, 1810–1960," *150 años de arte argentino*, catalogue cit.

73. Ibid.

74. Kemble, "Proyecto para la organización de una muestra circulante de la joven pintura y escultura argentinas en los Estados Unidos," 2. Archivo ITDT, CAV, Caja 14, Asuntos relacionados con el exterior.

75. The artists were of various nationalities. Italian: Badaracco, De Benedetto, Macció, Polesello, Pucciarelli, Testa; Spanish origin: Carreño, Fernández Muro, de la Vega, Noé, Seguí, Torras; Syrian-Lebanese: Chab; English: Kemble; Japanese: Sakai; Irish: Wells. Ibid.

76. Ibid., 2–4.

4. The Avant-Garde as Problem

Kemble epigraph from Kenneth Kemble, interview with author, August 1995. Garaudy epigraph from *60 oeuvres qui annoncerent le futur*, 292. Santantonín epigraph from Rubén Santantonín to Marta Boto, Buenos Aires, December 23, 1961, Rubén Santantonín Archives. Verbitsky epigraph from *Villa miseria también es América*, 29–30.

1. Diana Wechsler points out that in 1924, the year in which Pettoruti had his first solo exhibition at the Witcomb Gallery, seen as an anti-institutional and avant-garde gesture, he also sent works to the National Salon. Cf. Wechsler, "Buenos Aires, 1924," 231–40.

2. In 1966 Juan Pablo Renzi, Eduardo Favario, Emilio Ghilione, among other artists of the city of Rosario, signed the manifesto "A propósito de la cultura mermelada" (Speaking of the Marmalade Culture), in which they expressed their opposition to conventional and "official" culture, to that kind of painting that, "making a show of a 'modern' appearance, represents the most recalcitrant academic attitude." For these artists, such painting represented an obstacle and a hindrance to the creative process.

3. Kemble, "Autocolonización cultural."

4. Ibid.

5. Luis Felipe Noé, untitled text published in the catalogue for the 1963 Di Tella Prize competition, p. 54.

6. Squirru, "Con un poco de promoción el país puede exportar cultura," *Primera Plana*, no. 12 (January 29, 1963): 30.

7. Among those that "did not advance," because they did not understand where industrial society was going, he included artists such as Alicia Penalba, Libero Badii, and such "surrealists" as Xul Solar and Antonio Berni. Cf. Romero Brest, *El arte en la Argentina*, 44–48.

8. Crow analyzes various examples, ranging from the classical *Olympia*, in which Manet appeals to a classical allegorical theme, to pornography, and to the abstractionism of Mondrian in *Boogie-Woogie*, where the formal pursuit collapses in the face of the impact produced by the city, the neon lights and black North American music. Cf. Crow, "Modernism and Mass Culture in the Visual Arts."

9. Cf. Greenberg, "Avant-Garde and Kitsch."

10. Ibid., 255.

11. Alberto Greco to Lila Mora y Araujo in 1960. Reprinted in Rivas, *Alberto Greco*, 282.

12. Noé, "Homenaje a Alberto Greco." With all his irreverence, Greco quickly managed to attract attention and to irritate. This is probably the reason why, having been a central figure in the activities organized in 1959, he was not now a part of the group exhibitions that were intended to formulate an avant-garde.

13. After *Las Monjas*, Greco went to Europe (where the artists of the Nueva Figuración were already gathering) and he would only return to Buenos Aires for a short time in 1964. Noé proposes that his subsequent suicide, in 1965, had its origins in 1961. Cf. Noé "Homenaje a Alberto Greco."

14. Delia Puzzovio relates that on a Friday, when they met for the traditional meeting at the Moderno Bar, Greco announced to everyone that he was going to commit suicide. When he did not appear on Saturday, she and Marta Minujín went to look for him at the Lepanto Hotel: "The owner saw two girls and wouldn't let us through. We had to tell him about the suicide. The opening for 'Las Monjas' had been scheduled for the following Monday. . . . In the bathroom there was a shirt draped over the toilet, dripping tar and red paint. It was really powerful. . . . All covered with paste and pitch, a terrible thing. All the paintings for the exhibition were there, still fresh. He hadn't committed suicide, but something terrible had happened there that night in

that room." Cf. Delia Puzzovio, interview with Francisco Rivas, 1989, cited in Rivas, *Alberto Greco*, 284.

15. Ignacio Pirovano, cited by Noé in "Homenaje a Alberto Greco."

16. The group had its first exhibition, Otra figuración (Another Representation), at the Peuser Gallery from August 23 to September 6, 1961. Motivated by the need to establish something similar to a front for the defense of representation, they invited other artists (Antonio Seguí, Miguel Dávila, Jorge López Anaya, Juan Carlos Distéfano, and Jorge Demirjian) who did not accept the invitation. On this occasion, Rómulo Macció, Luis Felipe Noé, Jorge de la Vega, Ernesto Deira, Sameer Makarius, and Carolina Muchnik exhibited their work. After 1962 the group only consisted of the first four. During the four years of joint activities (until the last exhibition in 1965), Bonino exhibited (on two occasions in Buenos Aires and once in Rio de Janeiro), at the MNBA, at the Comisión Nacional de Bellas Artes of Montevideo, Uruguay, at the Museo de Arte Moderno de Rio de Janeiro, and at the Sociedad Hebraica Argentina. To this should be added the solo exhibitions, also at the Bonino Gallery. The term "Nueva Figuración" (which the artists always resisted, preferring the term "Otra Figuración") was used in 1961 by the French critic Michel Ragon to refer to the work of such artists as Pierre Alechinsky, Asger Jorn, Francis Bacon, and Paul Rebeyrolle.

17. "Retratos con líneas y palabras," *La Nación*, December 8, 1960, 19.

18. The myth of the avant-garde was also constructed with a public character, which the artists' activity began to assume, little by little. The media actively participated in this process. In 1961, *La Nación* dedicated a page of the arts and leisure section to a description of the studio shared by Macció, Noé, de la Vega, and Greco (it was in an old hat factory belonging to Noé's grandfather on the Avenue Independencia between Bolívar and Defensa). However, more important than the text were the photographs that illustrated the article in which aspects associated with an avant-garde group are translated into images: informality, group work, neglect of what is decorative and superfluous. Cf. "El informalismo de lo formal," *La Nación*, December 3, 1961, sec. 3, 7.

19. Noé traveled on a grant from the French government, Macció and Deira on grants from the Fondo Nacional de las Artes; De la Vega was the only one who financed his own travel expenses.

20. Kemble, "Argentina's Band of the Damned," *Buenos Aires Herald*, September 25, 1961, 2. In 1960 at the Van Riel Gallery, Santantonín exhibited a series of abstract paintings and some collages. In 1961, together with Luis Wells, he exhibited for the first time at the Lirolay Gallery a group of works that he

called "things." After this exhibit, close to his forty-second birthday, Santantonín was recognized as an innovative artist. For a decade that practically made youth a market commodity, his entrance onto the avant-garde scene was, undoubtedly, belated. Obviously, Kemble referred to the "damned" artists as those who, owing to the radical nature of their projects, were not accepted by society.

21. Santantonín, "Hoy a mis mirones," prologue to the exhibition at the Lirolay Gallery, September 18–30, 1961.

22. The Moderno, located on the corner of Calle Paraguay and Calle Maipú, came into its own at the end of the 1950s. Ernesto Goldar describes it as the place for belated existentialists and beatniks. Goldar, *Buenos Aires*, 88–90. On the influence of Sartre on the Buenos Aires intelligentsia, see also Terán, "Introducción por la filosofía," in *Nuestros años sesenta*, 17–19. In 1959–60, Oscar Masotta began to give courses on Sartre in the Coto, attended by Alberto Ure o Steimberg (for this information I am indebted to Beatriz Sarlo). Carlos Correas describes Masotta as an intellectual voluntarily separated from his university career who, since then, had adjusted to being an outsider figure: more or less deviationist, more or less esoteric, more or less avant-garde and rebel. He is described as someone who reads, contrasts, and reconciles various authors and who defines himself according to his changing and cutting-edge intellectual interests. This position explains why Masotta has been one of the few intellectuals who was concerned with analyzing expressions of pop art. According to Correas, this analysis of pop may be explained as much for its eagerness to compete in the intellectual market (trying to be the "most contemporary" thinker in Argentina) as for the search for institutional support on the part of the Di Tella Institute (at that moment he also had the support of the university where, from 1964 to 1967, he had a research appointment). Cf. Correas, *La operación Masotta*, 97–108.

23. Translated into Spanish and published in Buenos Aires by Losada in 1947, a year after the first edition in French by Gallimard.

24. Sartre was part of the culture of the period, of a specific set of common experiences. This is what Raymond Williams defines as "structures of feeling," that is, the way in which the producers and public of specific cultures live the concrete experience in which their semantic figures are constructed. Cf. Williams, *Marxismo y literatura*, 150–58, and Altamirano and Sarlo, *Conceptos de sociología literaria*, 39–42. As Beatriz Sarlo indicated in her comments on this book, Sartre could be known to people without actually reading his work through his "iconic words" such as "existence," "nothingness," "freedom," "choice," "gesture," "contingency." Correas explains that "the first

Spanish edition of Sartre's *"Que'est-ce que la littérature? [What Is Literature?]* was our canon. Only half-glimpsed (or, if the serious reader prefers: half-"researched"), we scanned the text to extract words and phrases for the controversies and for our first critical writings. We accepted, or, more precisely, we were ignorant of the qualities of the translator, Aurora Bernárdez. Years later, comparing the translation to the original French, I noticed the errors and transgressions of Aurora Bernárdez. Our sacred text turned out to be a brazen fraud inflicted upon us by the negligence of the Losada publishing house." Cf. Correas, *La operación Masotta*, 24–25.

25. From 1966 to 1967 Masotta, who Juan José Sebreli describes as intellectually "voracious," made the transition from existentialism to structuralism, which confirms that at the beginning of the 1960s Sartre was still an important referent for intellectuals as well as artists. Cf. Sebreli, "El joven Masotta," 69–70.

26. Cf. Boschetti, *Sartre y "Les Temps Modernes,"* 38.

27. Santantonín, manuscript notes, November 19, 1961. Rubén Santantonín Archives.

28. Both authors were strong influences in Buenos Aires. The transcriptions of some of the courses given by Romero Brest during the 1950s and 1960s show that he spoke about a combination of recurring books and authors: *Imagination*, by Sartre, *Phenomenology of Perception*, by Merleau-Ponty, and such authors as Aldous Huxley, *The Doors of Perception*, and Eduardo Nicol, *Metafísica de la expresión*. Although we do not know if Santantonín attended any of these courses, this knowledge, as indicated above, circulated and was discussed in various ways and appeared in various forms in the work of some artists. Santantonín was probably the most receptive and the clearest in this respect, in his writing, his objects, and his constructions. Masotta also refers to the phenomenological aspect of Santantonín's work. Cf. Masotta, *El "pop art,"* 21.

29. Merleau-Ponty, *Phenomenology of Perception*, ix.

30. Santantonín, typed notes, 1963. Rubén Santantonín Archives.

31. Ibid.

32. Santantonín, "Arte-cosa rodante (1ª vez in América)" [Traveling thing-art (1st time in America)], typed notes, 1963. Rubén Santantonín Archives.

33. Santantonín, manuscript notes, December 31, 1961. Rubén Santantonín Archives.

34. Kemble, "Rubén Santantonín," 119–21, 121.

35. Santantonín, manuscript notes, undated. Rubén Santantonín Archives.

36. Kemble in Buccellato, *Greco-Santantonín*.

37. E. B., "Pinturerario," *Caballete*, no. 18 (June 1964): 8–9, 8.

38. The debate between Santantonín and the magazine *Primera Plana* is interesting, where his response to the magazine's classification of his work as pop art was printed in the magazine (January 14 and 21, 1964): "not accepting the classification of pop art implies the rejection of a paternity that does not exist, of a subordination that Argentines submit us to all too often."

"Thus, once again, we have a paradox in our own house: while a cultural submission for the United States, with a high degree of susceptibility—commendable in my opinion—does not include among the works to be sent to that country works by artists that might 'resemble' theirs, we label, we relate (we are always offspring), we categorize, in short, we limit ourselves." Santantonín, "Arte," Readers' Letters, *Primera Plana*, 2, no. 67 (February 18, 1964): 62.

39. I am referring in particular to an early work by Oldenburg, *"Empire" (Papa) Ray Gun* (1959), constructed of wet paper on wire structure and painted with industrial pigments (MOMA). Even though this work is reminiscent of Santantonín's in certain formal ways, especially because it is suspended, the very referential nature of its title differentiates it.

40. However, in this exhibition those works by Millares that might remind us of Santantonín were not included.

41. Santantonín, manuscript notes, November 8, 1961. Rubén Santantonín Archives.

42. Ibid., October 30, 1961.

43. Ibid., November 20, 1961.

44. Santantonín, "Arte cosa" [1963], unpublished mimeograph. Rubén Santantonín Archives.

45. In addition to his exhibitions at the Lirolay Gallery (1961, 1962, 1964), he was invited to the Ver y Estimar and the Di Tella prize competitions in 1963, to the Seventh São Paulo Biennial, also in 1963, and the exhibitions of Argentine art, New Art of Argentina, at the Walker Art Center of Minneapolis, and Buenos Aires 64, in the Pepsi-Cola building in New York, both in 1964.

46. This affirmation is backed up by the fact that, although the authors of *La Menesunda* were Santantonín and Minujín, it was the latter that attracted the attention of the mass media who practically identified her as the sole author of the work. Obviously, her youth and "unprejudiced" attitudes were closer to the idea of country and culture that various sectors envisioned for the future. Santantonín, older and more distant from that "reckless" image, did not offer the appropriate model for these ends.

47. The exhibition was held November 20–30 and, furthermore, it was Kemble who promoted the idea with the participation of Luis Alberto Wells, Silvia

Torras, Jorge López Anaya, Jorge Roiger, Antonio Seguí, and Enrique Barilari.

48. Kemble, "Arte Destructivo."

49. Kemble, interview with the author, February 1994. For an exhaustive description of the process through which this exhibition was conceived and the objects that were exhibited, based on statements of the artists themselves, see Giunta, "Historia oral e historia del arte," 77–96. Hereafter, when citing the artists' statements, I refer to this article.

50. The first manifesto is dated November 4, 1959 and the last one is dated June 1964. It is interesting that in these, as in Kemble's text, there are references to nuclear war, but the fundamental difference is that, while *Arte Destructivo* was presented as an experiment that sought to explore the existence of violence in society and, eventually, to operate as a cathartic space, for Metzger, *Arte Auto-Destructivo* (Auto-Destructive Art) is a theory for social action, intended not only to reveal the existence of violence and destruction in society, but also to combat it from a leftist political position. Metzger, *Damaged Nature, Auto-Destructive Art*.

51. From 1959 to 1961 Ortiz produced the ideas that he developed in the *Manifiesto Destructivista* (Destructivism: A Manifesto), written in 1961–62 (although it was not published at that time). During this period he produced his *Hallazgos arqueológicos* (Archaeological Finds), working with destroyed mattresses and furniture. Cf. Stiles, *Rafael Montañez Ortiz*.

52. Kemble states: "We started to destroy poetry, music, literature. For example, we combined a text by Aristotle with Picasso, one person read one part and another followed, completely improvised. We also took a text by Goethe: one person read the vowels, another the consonants. Then we joined them together and read them at the same time. I also invented a chorus." Jorge Roiger also remembers: "We made music. We recorded some music on a tape-recorder and we used an old organ and we passed a saw over the strings, it was terrible, but it created quite an atmosphere. The show . . . you entered and that music was playing and the sounds, like cries and . . . the light was dim. . . . We had reddish light in one place and dim blue light in another." Cf. Giunta, "Historia oral," 82–83.

53. Ibid., 84.

54. Ibid., 83.

55. Ibid., 84.

56. In the critical appraisals, as we have seen, a criteria of "selective tradition" was in constant operation (cf. Williams, *Marxismo y literatura*, 137–38), and frequently the present was evaluated from the perspective of a preconfig-

ured past according to which the new artistic representations were identified and classified. And that past was the historical international avant-garde, not Argentine art. Although there was an international resurgence of dadaism, a movement that had not developed in Argentina, local critics considered the movement to belong to the 1920s but not, for example, the exhibition and symposium that was held at the MOMA in New York in 1961 under the title The Art of Assemblage. At the symposium some of the participants were figures that had entered the art scene during the 1920s, such as Duchamp and Huelsenbeck, together with critics and artists who had emerged at the end of the 1950s, such as Rauschenberg, Alloway, Shattuck, and the moderator and curator of the show, William D. Seitz. For information on this gathering, see the compilation of studies edited by by John Elderfield, *Essays on Assemblage*. With respect to the possibilities for a social usage of assemblage, as emphasized by Roger Shattuck ("Introduction: How Collage Became Assemblage," in Elderfield, *Essays on Assemblage*, 120), these had already been pointed to by Seitz in his text for the catalogue of the above-mentioned exhibition. It is interesting to note, on the other hand, that while the selective machine of Argentine criticism continued to look back to prewar art, that of the artists themselves was formulated on the basis of elements provided by postwar poetics.

57. López Anaya, in Giunta, "Historia oral," 90.

58. At the beginning of the 1960s, the Sheraton Hotel was erected on the site of Parque del Retiro.

59. However, there were still certain residual aesthetics: The armchair and the bathtub were placed on pedestals as if they were sculptures; the destroyed paintings were hung on the walls, the coffins were leaned against a rectangle of canvas fastened to the wall. The montage could be seen as ironic with respect to a "serious" exhibition, or as an impossibility in terms of a distribution of objects that broke with the established format.

60. In fact, for the artists this was an experience that exhausted itself and they did not consider its continuation. Giunta, "Historia oral," 92.

61. Wells, in ibid., 87.

62. Among other things, the trip enabled Noé to see the originals and discover that the paintings were not as brilliant as they appeared in the Skira reproductions. For the artists of Buenos Aires, trained through study of standardized copies in the format and colors of books, finding themselves faced with the originals and readjusting what they had learned was a task from which they could extract important conclusions. For example, Noé relates that it was during his trip that he could really "see" how much material the informalist

paintings contained, which, in the reproductions, had appeared much flatter. Luis Felipe Noé, interview with the author, November 30, 1998.

63. Motivated by the same investigative interest, de la Vega created his *Formas liberadas* (Liberated Forms), also in Paris, in which he shattered the unity of traditional space by using a variety of broken stretchers and stained canvases (fastened to the stretchers).

64. Cf. Noé, *Antiestética*, 33.

65. In 1963 Rafael Squirru was named director of the Department of Cultural Affairs of the OAS, a post he filled for seven years. Hugo Parpagnoli, critic for *La Prensa* and *Sur*, was designated director of the MAM.

66. Marta Minujín to Hugo Parpagnoli, Paris, March 22 [1962]. Archives of the MAM, folder 31, p. 23.

67. As we have seen, Minujín had formed ties with artists of the nouveau réalisme and to foreigners living in Paris, such as the Japanese Domoto, who had ties to Michel Tapié; Zoo-Wou Ki, of Chinese origin, who had been residing in Paris since 1948; and Kalinowski, who was from Düsseldorf.

68. Marta Minujín to Hugo Parpagnoli, Paris, March 22 [1962]. Archives of the MAM, folder 31, p. 23.

69. The exhibition was organized by Germaine Derbecq (a French woman by birth who was a naturalized Argentine citizen through marriage to the sculptor Pablo Curatella Manes) who directed the Lirolay Gallery in Buenos Aires. This exhibition was held from February 9 to March 1, 1962, at the Creuze Gallery. Many of the most active avant-garde artists of the 1960s participated: De la Vega, Heredia, Minujín, Noé. There were also kinetic artists, such as Le Parc, Sobrino, and García Rossi, and abstract artists, such as Tomasello, Silva, and Vardánega.

70. Bayón, "Curatella Manes y veinticinco artistas argentinos en París," *La Nación*, April 29, 1962, Arts and Leisure section, 2.

71. Marta Minujín to Hugo Parpagnoli, Paris, March 22 [1962], Archives of the MAM, folder 31, p. 23.

72. Alberto Greco to Lila Mora y Araujo, Paris, 1962, cited in *Alberto Greco*, 284 and 288.

73. Whereas Yves Klein used women in his anthropometries to impress their bodies onto the canvases, Manzoni placed people on pedestals, converting them into "works of art." Cf. Restany, *Yves Klein*, and Celant, *Piero Manzoni*, 274.

74. Greco wrote: "Life Art is the adventure of the real. The artist teaches the spectator to observe not with the painting but rather with his finger. He teaches

how to see, in a new way, what happens in the street. Life Art surrounds the object but the found object is left where it lies, it is not transformed or improved, it is not taken to any art gallery. Life Art is direct contemplation and communication. The idea is to do away with the predetermination of galleries and exhibitions. We have to place ourselves in direct contact with the living elements of our reality: movement, time, people, conversations, odors, rumors, places and situations. Arte Vivo Movimento Dito—Alberto Greco. 24 July, 1962"—11:30 AM. In *Alberto Greco*, catalogue of exhibition held at the IVAM Centre Julio Gonzalez—Generalitat Valenciana, 1991–1992, 291.

75. Mari Carmen Ramírez considers Greco to be one of the points of origin for the anti-institutional avant-garde in Latin America. Cf. Ramírez, "Tactics for Thriving on Adversity." An Italian version of the manifesto *Arte Vivo-Dito* still exists, dated July 29, 1962, which, according to Greco, was used to plaster the streets of Genoa. At the 1962 Venice Biennial, where Berni received the top award for prints, Greco presented a work in which he released several live mice at the feet of Antonio Segni, then president of the Italian Republic, on the day of the opening. This event, as might be imagined, produced a scandal. From there he went to Rome where he engaged in an intense graffiti campaign, writing "La pintura e finita. Viva el arte Vivo-Dito. Greco" (Painting is finished. Long live arte Vivo-Dito. Greco). His stay in Rome ended in the scandal *Cristo 63*. In the theater El laboratorio, located in an old garage of a large house not far from the Vatican, Greco produced a parody of the Passion of Christ with a text that was half-improvised, half-extracted from chapter 2 of Joyce's *Ulysses*. During the performance, Greco appeared nude and his photograph was published on the cover of *Telesera*, an independent newspaper in Rome. Cf. *Alberto Greco*, 289–94.

76. Frigerio, "Actualité de l'art argentin."

77. Marta Minujín to Hugo Parpagnoli, Paris, May 7, 1963. Archives of the MAM, folder 31, p. 16.

78. Marta Minujín, "Destrucción de mis obras en el Impasse Ronsin—Paris. Junio de 1963," mimeograph. Marta Minujín Archives. Impasse Ronsin was a space that in 1900 was intended for the workers at the World's Fair. In 1916 Constantin Brancusi moved into the space and from that time forward numerous artists had their lodgings there. Tinguely arrived in 1954 and stayed there for ten years. Although Minujín's studio was on Rue Delambre, it was clear that the destruction of her work would only have an impact if it took place in the Impasse Ronsin. Cf. Laugier, "Impasse Ronsin," 440–41.

79. For a period of time they shared Noé's studio on Calle Carlos Pellegrini

between Charcas and Santa Fé. As in Paris, Deira and Macció worked in one room and Noé and De la Vega worked in the other room. In 1963 Fernando Arce produced and directed a ten-minute, 35-millimeter film about the group-work that took place in this studio titled *Cuatro pintores hoy* (Four Painters Today).

80. The exhibition at the Bonino Gallery had enormous impact. The best account is provided by Ernesto Deira, who relates that, given its success, Bonino offered the artists an additional fifteen days, an offer that they accepted but with the condition that they could change the exhibition: "Those were ten feverish days. The Carlos Pellegrini studio was burning red-hot. . . . I would arrive at eight o'clock and would leave at four in the morning, which is when someone else would arrive, and the others had been there since six. We would work all day but, in addition, with the studio full of people from the public, coming and going with us and cheering us on as if we were athletes. We hung the paintings while the paint was still fresh. Yes; this must have been the only such case in the entire world." On the basis of this exhibition, Romero Brest, who had not approved the first exhibition held at the Peuser Gallery, offered them the MNBA and introduced them. "Each work was 2.60 cm × 1.95 cm: eighty such paintings. Enough to explode the museum!" Cf. Ernesto Deira, "A veinte años de una revolución en la pintura argentina que volverá a vivirse," interviewed by Pedro Larralde and published in *Convicción*, November 10, 1986. Cited in *Deira, Macció, Noé, de la Vega*, 36.

81. For Noé, the prize was his passport to New York. With this competition, the institute opened its space on Calle Florida.

82. Parpagnoli, "Dos pintores del concurso Di Tella," 118.

83. Ibid., 118–19.

84. Denis, *Teoría estética*.

85. In Vicente Zito Lema, "Luis Felipe Noé: Conciencia de una aventua," 73.

86. This book gathered the results obtained by the Comisión Nacional de Investigaciones (National Investigative Commission), established by executive decree in October 1955 to investigate the irregularities committed during the deposed Peronist regime. The commission, overseen by the Senate and composed of five members (one from each branch of the armed forces), concluded its investigations in April 1956. Cf. *Libro negro de la segunda tiranía*, Buenos Aires, 1958.

87. Luis Felipe Noé, interview with the author, November 30, 1998.

88. Noé lived at the intersection of Calle Juncal and Calle Esmeralda, across from the Plaza San Martín, and from there he witnessed the Peronist demonstra-

tions, which he also attended out of sheer fascination for, and attraction to, the spectacle. At one demonstration, Perón broke with the church and demonstrators carried dummies of hanged priests. These were images that, according Noé, were much more powerful than any artistic influence. Interview cited.

89. Regarding the works *Introducción a la esperanza* and *El incendio del Jockey Club*, Noé states: "They are dated 1963, but they were not conceived from a militant political point of view since what really interested me then was to understand the break-up of visual structures as a reflection of a reality that, for its part, was also breaking up." In Zito Lema, interview cited, 73.

90. During a ceremony on April 25, 1953, two bombs exploded, causing deaths and injuries. Perón pledged to identify the culprits and bring them to justice, but in response to demands for vengeance, he responded: "As to the repression that you advise me to apply, why don't you do it?" (*La Nación*, April 16, 1953). During the night, groups of young Peronists attacked the central offices of the Socialist Party, the Casa del Pueblo, destroying the facilities and burning the building, including the archives and library. They also attacked the offices of the Radical Party and the Democratic Party and totally destroyed the Jockey Club. Cf. Potash, *El ejército y la política en la Argentina*, 212–13.

91. The Socialist Party possessed the second largest library in the country and the Jockey Club had an important collection of European paintings (with works by Goya, Monet, Corot, Sorolla, and Bouguereau). Noé did not include reproductions of the burnt paintings, but rather paintings that represented the general idea of "European painting": a horse race by Toulouse-Lautrec, an allusion to the Jockey Club, and paintings from eighteenth-century France and England as a way of evincing the European sense of good taste that the club represented for the cultural elite of Buenos Aires. The work was intended to be reminiscent of the popular subjects of Greuze and portraits of gentlemen, such as Van Dyck and Joshua Reynolds. Cf. de Maistre, *Le groupe argentin*, 104.

92. Cf. ITDT Prize catalogue, 1963, 64.

93. In 1958 Berni took photographs of the "villas miserias" (slums) and returned to the collage: a technique and themes that he combined for his series, Juanito Laguna, which he exhibited for the first time in 1961 at the Witcomb Gallery. In 1962 he was awarded first prize for Print and Drawing at the Thirty-First Venice Biennial for a group of large woodcuts on the theme of Juanito Laguna. He presented this series in Paris and began the series on Ramona

Montiel, a prostitute whose life he narrated through a set of collages and woodcut-collages, using materials from the Paris flea market. Cf. Buccellato, "Antonio Berni: Historia de dos personajes."

94. "Una extraña forma de teatro en Nueva York: El happening," *Primera Plana*, 1, no. 1, (November 13, 1962): 31–34.

95. Le Parc, "El Grupo de Investigación de Arte Visual repite," 56.

96. Santantonín, "Arte-cosa rodante (1ª vez in América)" [Traveling thing-art (1st time in America)], unpublished. Rubén Santantonín Archives.

97. Ibid.

98. Ibid.

99. Minujín, "Destrucción de mis obras en el Impasse Ronsin—Paris."

100. Santantonín, "Descripción de 'La Menesunda,'" mimeograph. Rubén Santantonín Archives.

101. Romero Brest, "Arte 1965: Del objeto a la ambientación," June 11, 1965, mimeograph, Caja 1, Sobre 6, JRB Archives, UBA, 29.

102. Ibid., 24.

103. Ibid., 30. The newspaper media carefully recorded the public's reactions and published them under sensationalist headlines: "Buenos Aires inundado por un escándalo que tiene bastantes dosis de inocencia: ¿Mito o fraude? ¿Arte vivo o arte de vivos?" (Buenos Aires inundated by a scandal with a high dose of innocence: Myth or fraud? Life art or scam art?) (*Atlántida*, August 1965); "Algo para locos o tarados" (Something for kooks or nuts) (*Careo*, June 2, 1965); "Opiniones: Marta Minujín contra el caballete" (Opinions: Marta Minujín against the easel) (*Confirmado*, September 7, 1965).

104. Romero Brest, "Arte 1965," 31. After Romero Brest's conference, Eduardo González Lanuza gave another conference as a response in the Proar Gallery. "I had to restrain myself from interrupting him," González Lanuza stated, and later he unsuccessfully requested that he be permitted to respond from the same podium, Romero Brest declined, claiming that he was not a "friend of controversy." The words the writer used to characterize the *Menesunda* ("trash," "reactionary art," and an art form that by virtue of its desire not to perpetuate itself attacked the very meaning of art itself) were accompanied by his opinion about Romero Brest's decision to "suspend judgment" regarding the new art: "How can he agree to be a juror in Paris and São Paulo if he has suspended judgment?" Cf. "Sobre la 'Menesunda' habló ayer el escritor E. González Lanuza," *Clarín*, June 26, 1965, 15.

105. Pablo Suárez, David Lamelas, Rodolfo Prayón, Floreal Amor, and Leopoldo Maler collaborated on *La Menesunda*.

5. Decentering of the Modernist Paradigm

Romero Brest epigraph from *Política artísticovisual en Latinoamérica*, 7. Masotta epigraph from "Los medios de información de masas y la categoría de 'discontinuo' en la estética contemporánea," in Oscar Masotta et al., *Happenings*, 51.

1. See Romero Brest, "Relación y reflexión sobre el 'Pop Art,'" 1967, mimeograph, Caja 2, Sobre 2, JRB Archives, UBA. Romero Brest probably saw Oldenburg's hamburger at the exhibit of North American artists *New Realists*, which was held in the spring of 1963 in the Ileana Sonnabed Gallery in Paris during his eleventh visit to Europe.

2. See chapter 1 for more on this topic.

3. For a discussion of Clement Greenberg's position during the 1960s, see Howard, "Modernism on the Margins," 841–56. Evidently, in the neo-Kantian model that Greenberg had proposed in "Modernist Painting," in which he identified modernism with the intensification of the tendency toward self-criticism as proposed by Kant, assemblage art, which was so highly acclaimed at the exhibition organized by the MOMA in 1961, did not fit in anywhere. Inasmuch as Greenberg maintained that "Modernist painting requires that a literary theme be translated into strictly optical, two-dimensional terms, before being converted into a theme of painterly art, which means that it will be translated in such a way that it completely loses its literary character," it is clear that the brutal way in which artists were incorporating reality into their work could only be met with his complete rejection. It is interesting that Greenberg always emphasizes that modernism is not a rupture with the past. The avant-garde does not signify revolution for Greenberg, but rather continuity—the prolongation of standards of quality over time. Cf. Greenberg, "Modern Painting," 85–93, and "Louis and Noland," 94–100.

4. Greenberg, "Avant-Garde Attitudes: New Art in the Sixties," conference address at the University of Sidney, Australia on May 17, 1968. Published in O'Brian, ed., *Clement Greenberg: The Collected Essays*, 292–303, 292.

5. Ibid., 298.

6. Romero Brest, "Arte 1965: Del objeto a la ambientación," June 11, 1965, mimeograph, Caja 1, Sobre 6, JRB Archives, UBA.

7. Romero Brest, *Ensayo sobre la contemplación artística*.

8. Ibid., 34.

9. Sartre, *Imagination*, 146.

10. Romero Brest, *Ensayo sobre la contemplación artística*.

11. Romero Brest, "La imagen y el imaginar," *Américas*, 12 (December 1966): 30–33.

12. Ibid.

13. Romero Brest, *La pintura del siglo XX (1900–1974)*, 344.

14. Romero Brest, "Relación y reflexión sobre el 'Pop Art,'" 1967, mimeograph, Caja 2, Sobre 2, JRB Archives, UBA.

15. This was the same question he formulated in 1960 when, considering informalism, he taught the course *El ser y la imagen—Ensayo sobre la pintura más actual* (Being and the Image—Essay on Current Painting), a title that revealed the influence of existentialism on his way of thinking. As Romero Brest himself explained in these courses, his way of thinking was strongly influenced by Heidegger and Sartre. *CS-SI*, mimeograph, 137, JRB Archives, UBA.

16. Romero Brest's uneasiness was very much the same as that described by Arthur Danto in 1984 in his restatement of the Hegelian view toward the "end of art" in which Danto referred to Andy Warhol's work *Brillo Box* as emblematic of that end. The work was exhibited in the Stable Gallery in 1964. Of course the explanations given are very different, considering that Romero Brest wrote his essay in 1967, whereas Danto was writing in 1984. See Danto, *After the End of Art: Contemporary Art and the Pale of History*, 21–39.

17. Romero Brest, "Relación y reflexión sobre el 'Pop Art,'" 1967, mimeograph, Caja 2, Sobre 2, JRB Archives, UBA, 3.

18. The French delegation, presented by Jacques Lassaigne, was composed of Roger Bissière (tapestry and painting), Julio González, Jean Ipoustéguy, Réné Brô, and Bernard Dufour. The North American delegation—whose organizer was Alan Salomon—was composed of Morris Louis, Kenneth Noland, Robert Rauschenberg, and Jasper Johns ("Four Germinal Painters") and by John Chamberlain, Claes Oldenburg, Jim Dine, and Frank Stella ("Four Younger Artists"). For an analysis of the strategies employed by the United States so that Rauschenberg would receive the highest honors at this Biennial, see Monahan, "Cultural Cartography: American Designs at the 1964 Venice Biennal," 369–416.

19. Romero Brest, "Relación y reflexión sobre el 'Pop Art,'" 1967, mimeograph, Caja 2, Sobre 2, JRB Archives, UBA, 4.

20. Ibid., 4–5.

21. Romero Brest's travels were the primary source of his education—they were his "academy." Indeed, it was his first visit to Europe that convinced him not to use his recently earned law degree, but rather to begin to develop his passion for traveling and observing, which he would never abandon. With the

image before him, his thoughts would take flight; his reflective method now, as on many previous occasions, was to form associations between diverse impressions.

22. Romero Brest, "Relación y reflexión sobre el 'Pop Art,'" 1967, mimeograph, Caja 2, Sobre 2, JRB Archives, UBA, 5.

23. Ibid., 6. The paintings were *Nymphe Surprise* by Manet (1861), acquired in 1914 by the Comisión Nacional de Bellas Artes, and *La "Toilette" de Venus* by Bouguereau (1873), donated to the museum by Federico Leloir in 1932.

24. The disheveled fabrics, the half-closed eyes, the sensation of witnessing a moment of intimacy render Manet's nymph considerably more sensual that Bouguereau's Venus, whose nudity was too comfortable and fictitious. This provocative sensuality, which was a central point of controversy surrounding the *Olympia*, was not, however, the aspect that the Argentine critic wanted to emphasize in setting up the comparison. For more on the socially threatening nudity of the *Olympia*, see Clark, *Painting of Modern Life*, 79–146.

25. Whereas Bouguereau was inspired by the *Crouching Venus*, a Greek sculpture of the Hellenistic period housed at the Louvre, Manet used his wife, Susana Leenhoff, as his model. Cf. the notes on Bouguereau's painting (by Celia Alégret and José Emilio Burucúa) and on Manet (by José Emilio Burucúa) in the catalogue of the *Exposición del Museo Nacional de Bellas Artes de la República Argentina: Arte Francés y Argentino en el Siglo XIX* (Exhibit of the Museum of Fine Arts of the Argentine Republic. French and Argentine Art of the 19th Century), presented in various museums in Japan between 1990 and 1991, 211 and 219, respectively.

26. Greenberg organized this exhibit in 1964 at the Los Angeles County Museum. Cf. Greenberg, "Post Painterly Abstraction," 63–65.

27. Cf. Greenberg, "Avant-Garde Attitudes."

28. Cf. Alloway, "The Arts and the Mass Media," 84–85.

29. Cf. Greenberg, "Avant-Garde and Kitsch," and Alloway, "The Development of British Pop Art," in Lippard, ed., *El pop art*, 27–67, 36.

30. Romero Brest, "Relación y reflexión sobre el 'Pop Art,'" 1967, mimeograph, Caja 2, Sobre 2, JRB Archives, UBA, 7.

31. Ibid.

32. Ibid., 8.

33. Ibid.

34. Ibid., 10.

35. Cf. Calas, "Iconos pop," in Lippard, ed., *El pop art*, 166.

36. Romero Brest, "Relación y reflexión sobre el 'Pop Art,'" 1967, mimeograph, Caja 2, Sobre 2, JRB Archives, UBA, 10.

37. "The affinity can be drawn only so far, as I am not trying to maintain that the painted Campbell's soup can, the tube of toothpaste, the multiple images of Marilyn Monroe, the poster, the comic, 'are there' with The Discus Thrower or the Doriforo." Cf. Romero Brest, *La pintura del siglo XX (1900–1974)*, 421.

38. Ibid., 16. Emphasis added.

39. Ibid.

40. Ibid., 19.

41. Ibid., 22.

42. Romero Brest, "Dejad que los chicos vengan a mí," *Atlántida* (August 1968): 61–62.

43. If we only consider his production in the artistic field. In the area of visual productions he also wrote on the comic strip. Cf. Masotta, *Técnica de la historieta*, and *La historieta en el mundo moderno*.

44. Masotta, *El "pop-art,"* 16.

45. Masotta, *Conciencia y Estructura*, 237–38.

46. According to the references he included in his texts and the letters consulted here, Masotta was in New York from the end of 1965 to April 1966 and again at the beginning of 1967.

47. Masotta, "Prologue" to *El "pop-art,"* in Katzenstein, ed., *Listen, Here, Now!* 175. In his first approach to pop art, Masotta consulted seventy or eighty magazine issues, such as *Art International, L'Oeil, Metro, Cimaise, Quadrum, Aujourd'hui,* and *Arts*. In addition, he examined slides and catalogues provided to him by Romero Brest and Silvia Ambrosini at the Instituto Di Tella. Cf. *El "pop-art,"* 18.

48. Cf. note 22 in chapter 4 of this book. On the position of Masotta in the debate among intellectuals during the 1960s, see Sarlo, *La batalla de las ideas (1943–1973)*. Specifically on Masotta, see Longoni and Mestman, "After Pop, We Dematerialize," 156–72. and Longoni, "Oscar Masotta: Vanguardia y revolución en los sesenta," preliminary study to the republication of Masotta's writings on art published as *Revolución en el arte: Pop-art, happenings y arte de los medios en la década del sesenta*. This book brings together a complete bibliography of works on and by Masotta, among which Robert Jacoby's contributions are outstanding.

49. Masotta, *El "pop-art,"* 30.

50. Masotta, "Prologue" to *El "pop-art,"* in Katzenstein, ed., *Listen, Here, Now!*, 174–75.

51. Masotta, *El "pop-art,"* 71 and 102.

52. Ibid., 174.

53. Sarlo, *La batalla*.

54. Masotta, *El "pop-art,"* 68.

55. Ibid., 11.

56. Although it is included in the bibliography of *El "pop-art,"* Masotta probably read Sontag's *Against Interpretation* during his first trip to New York.

57. Masotta, "Tres argentinos en Nueva York," in *Happenings*, 101–10.

58. Letter from Masotta to Romero Brest, New York, January 2, 1966. Archivo JRB, FFyL-UBA, Caja 24, 593.

59. Ibid.

60. Ibid.

61. Ibid.

62. Ibid.

63. Oscar Masotta to Romero Brest, [Buenos Aires], December 1966. Archivo JRB, letter 501. Neither Masotta nor Romero Brest, who also applied to the Guggenheim, received grants.

64. Ibid.

65. Masotta et al., *Happenings*, 9–11.

66. In fact, Masotta begins his text by alluding to the implicit accusation by Kimovsky regarding the intellectuals who designed the happenings when he referred to them as "either happenings or leftist politics." Masotta et al., *Happenings*, English version in Katzenstein and Giunta, eds., *Listen, Here, Now!*, 191–201.

67. Ibid., 200.

68. Ibid., 208–16.

69. Ibid., 214.

70. An audience of eighty people divided in two parts was transported to two sites in the city. Some were to see a helicopter and others were to arrive late: They would only learn of what happened from what they were told. It is an oral non–mass communicational work.

71. This was a television transmission of a poster that said, "This message announces the appearance of a poster whose text we are transmitting." Simultaneously there appeared on the screen a sign with different lettering and showing the same words that appeared on the poster: "This poster will appear on Channel 11 Television on July 20."

72. Masotta et al., *Happenings*, in Katzenstein, ed., *Listen, Here, Now!*, 211.

6. Strategies of Internationalization

Kennedy epigraph from "The Inter-American Committee, Inc.," n.p., folder 1, box 49, Inter-American Foundation for the Arts 1963–1965, Series 4 (Grants), RBF Archives, RAC. Gómez Sicre epigraph from "Nota editorial," *Boletín de Artes Visuales* 5, May–December 1959, 1–3, 2. Di Tella epigraph from King, *El Di Tella*, 10. Restany epigraph from "Buenos Aires y el nuevo humanismo," *Planeta* 5 (May–June 1965): 119–29, 123 (first published in *Domus*, April 1965). Kemble epigraph from Giunta, "Historia oral e historia del arte," 85.

1. From 1947 to 1968 the art gallery of the OAS held approximately 370 exhibitions of Latin American artists, generally young ones. Cf. June 22, 1994, OAS Records Transmittal and Receipt, from Museum to OAS Records Center, Room ADM-B3, Archives OAS, Washington.

2. Cf. Berger, *Under Northern Eyes*, 67.

3. Dwight Eisenhower to Milton Eisenhower, December 1, 1954, 1. FGV, CPDOC, Eisenhower Library Documents, Code 3, 54.12.01. Cited in Cobbs, *The Rich Neighbor Policy*, 3–4. Until 1960, in contrast to United States policy toward Europe, the government had cooperated very infrequently with the Latin American elite. Postwar U.S. governments were generally convinced that free trade and laissez-faire economies were the best systems and antidotes to communism.

4. Point 10 stated, "We want an expanded opportunity to learn more about Latin American culture, better access for our young people . . . to your music, your art, and the thought of your great philosophers." Cited in McKammon Martin, *Kennedy and Latin America*, 53–54.

5. Cf. Escobar, "Imagining a Post-Development Era?," 20–56.

6. Cf. Berger, *Under Northern Eyes*, 74.

7. Ibid., 14.

8. With respect to the modernization theory, the books of Walt Whitman Rostow were fundamental, especially *The Stages of Economic Growth: A Non-Communist Manifesto*, and, with a specific relation to Latin America, John J. Johnson's book *Political Change in Latin America: The Emergence of the Middle Sectors*.

9. The American Assembly was established at Columbia University by Dwight D. Eisenhower in 1950 in order to analyze various problems and produce reports to generate conclusions and recommendations. According to the index of the publications, these problems were primarily related to economics and international relations: *United States–Western Europe Relationships* (1951), *Economic*

Security for Americans (1953), *The United States and the Far East* (1956), *The United States and Africa* (1958), *The United States and Latin America* (1959), *Arms Control* (1961), and so on.

10. "The Soviet Union, in spite of withholding royalties, has for years won friends among foreign writers by translating their books systematically, often into several languages and usually long before other countries had discovered them, if indeed they ever did." Cf. W. McNeil Lowry and Gertrude S. Hooker, "The Role of the Arts and the Humanities," in American Assembly, *Cultural Affairs*, 47. Both authors were members of the Ford Foundation Program in Humanities and the Arts.

11. N. Shuster, "The Nature and Development of U.S. Cultural Relations," in American Assembly, *Cultural Affairs*, 16–17.

12. Cf. Lowry and Hooker, "The Role of the Arts and the Humanities," 42.

13. Coombs, "The Past and Future in Perspective," in American Assembly, *Cultural Affairs*, 139–71.

14. Ibid., 157.

15. On May 16, 1955, the *New York Herald Tribune* published a full-page advertisement denouncing the lack of parameters in modern art and, moreover, in abstract expressionism. Cf. Huntington Hartford, "The Public Be Damned?" *New York Herald Tribune*, May 16, 1955, 82.

16. This meeting was attended by such personalities as Rafael Squirru, former director of the MAM in Buenos Aires and now director of cultural affairs for the OAS, and Arthur Schlesinger Jr., special assistant to the president and celebrated author of *The Vital Center: The Politics of Freedom*, which had been fundamental for the rise of postwar liberal ideology in the United States as well as for sustaining freedom policies. Cf. Guilbaut, *How New York Stole the Idea of Modern Art*, 188.

17. "The Inter-American Committee, Inc.," 18, folder 1, box 49, Inter-American Foundation for the Arts 1963–1965, Series 4 (Grants), RBF Archives, RAC.

18. Ibid., 15.

19. Ibid., 10.

20. An internal report of the RBF explains: "As you know, Rodman Rockefeller is Chairman of the Executive Committee and Treasurer of the Inter-American Committee. David Rockefeller is Chairman of the Inter-American Honorary Sponsoring Committee of the Museum of Modern Art. Both organizations are, apparently, trying to raise funds from many of the same people in South America. David is very eager to have this conflict resolved and asks that you discuss this conflict and asks that you discuss this with Rene d'Harnoncourt." Cf. DSC to DD, Re: The Inter-American Committee, December 20, 1963,

folder 1, box 49, Inter-American Foundation for the Arts, 1963–1965, RG 4, RBF Papers, Rockefeller Family Archives, RAC. The correspondence reveals how important these issues were for the Rockefellers as well as the tensions existing among these institutions and even among the Rockefellers themselves.

21. "Memorandum of Understanding Between the Museum of Modern Art and the Inter-American Committee." Dana S. Creel to RBF files, January 3, 1964, "Memorandum," folder 1, box 49, Inter-American Foundation for the Arts 1963–1965, Series 4 (Grants), RBF Archives, RAC. Finally, on January 10, 1964, the RBF authorized the IAC the $30,000 that had been requested to cover administrative costs. Cf. Robert M. Wool to Dana S. Creel, January 14, 1964, folder 1, box 49, Inter-American Foundation for the Arts, 1963–1965, Series 4 (Grants), RBF Archives, RAC.

22. The central offices were located at 39 West 55th Street, New York.

23. In 1943 Sergio Millet, director of the São Paulo Municipal Library and a central proponent for the founding or this museum, traveled to the United States and published the book *Pintura Norte-Americana*. In 1946 Nelson Rockefeller made the first donation for the founding of a museum of modern art in São Paulo. Rebollo Gonçalves, *Sergio Millet, crítico de arte*, 81. Aracy Amaral points to the subsequent activities of the cultural attaché Sprague Smith, who hoped that the future museum would model its existence and functions on the Museum of Modern Art in New York. To this end he offered to send Millet statues, plans, and the members list from New York, emphasizing the importance of legal regulations, particularly to facilitate the organization of international exhibitions. He also expressed that in New York they were anxious to establish active cooperation with Brazil, which was considered of central importance for cultural development in the hemisphere. Sprague Smith to Sergio Millet, November 30, 1946, archives of the Biblioteca Municipal Mario de Andrade, São Paulo. Cited in Amaral, *Museo de Arte Contemporanea*, 14.

24. The exhibition was organized by a Belgian critic residing in Paris, Leon Dégand, who chose a selection of abstract paintings. Cf. Amaral, *Museo de Arte Contemporanea*, 17–18 and Guilbaut, "Dripping on the Modernist Parade," 807–16.

25. Goldman, "La pintura mexicana en el decenio de la confrontación"; Cockcroft, "Abstract Expressionism, Weapon of the Cold War."

26. The son of a German immigrant, Kaiser built his fortune from nothing. In 1906, at the age of twenty-four, he left the comforts of the East to expand his industries in the inhospitable Western United States. In the construction

industry he built highways throughout the United States as well as in Cuba, and during World War II, he became a national hero for manufacturing the Liberty ship. However, in the postwar era, he could not compete in the automotive industry, which required huge amounts of capital for redesigning models. To minimize losses, in 1953 he bought Willys-Overland Motors and its profitable line of jeeps. Seeking other ways to minimize losses he traveled through Latin America for twenty-seven days, meeting with Getulio Vargas and Juan Perón, with whom he signed an agreement in 1954 to establish his firm in Argentina. Kaiser, like Rockefeller, saw himself as a man who promoted development (both men could be situated within the model of "innovative corporationism"). Kaiser believed that his activities had to contribute to the well-being of the area in which he established his business, which provides insight into understanding the wide variety of activities he pursued. Cf. Cobbs, *The Rich Neighbor Policy*, 190–234.

27. Brennan, *El Cordobazo*, 56.

28. After the fourth Salon IKA, in 1961, the competition became biannual until 1963, when the fifth and last competition was held.

29. The correspondence between Gómez Sicre and Luis Varela (general secretary of the biennial) reflects this relationship: "You know that I obtained my project through a close connection with the Organization of American States and with what they are doing with respect to the cultural plan," Varela wrote to Gómez Sicre in a letter dated June 8, 1962. Archivos Bienal Americana de Arte, Centro de Arte Contemporáneo, Córdoba (I Bienal: José Gómez Sicre OAS). Hereafter cited as ABAA, CACC.

30. Apparently, Gómez Sicre expressed his concerns to the organizers of the biennial. In an internal letter dated October 6, 1961, Tibor Teleki (manager of public relations) explained to Luis Varela, "As you will remember, on your return to Chile, I mentioned to you that Mr. Gómez Sicre was concerned about the name of our Biennial, because of the considerable communist infiltration at the São Paulo Biennial, which he also expressed at the Ernesto Ramallo hearing." ABAA, CACC (I Biennial: José Gómez Sicre, OAS).

31. Interview with José Gómez Sicre, in *Del arte*, no. 4 (October 1961): 1, 3.

32. Ibid.

33. In a letter to Walton Cloke of Kaiser Industries in Washington, Luis Varela (public relations manager of Kaiser Argentina) offered the following assessment: "From my point of view, this project is already well known and is being considered here today as *the* event dedicated to American art and to the establishment of better relationship among the American countries. This is most important now when we are trying to close our ranks in the face of

communist threat." Luis Varela, to Walton Cloke, January 31, 1962. Archive ABAA, CACC (I Biennial: correspondence).

34. "La Bienal como manifestación artística es un índice del despertar del interior del país," *La voz del interior*, July 24, 1961.

35. Cf. Read, *Al diablo con la cultura*, 7.

36. The rest of the jury included Augusto Borges Rodríguez (Brazil), Luis García Pardo (Uruguay), Antonio Romera (Chile), Romero Brest (director of the Nacional Museum of Fine Arts), and Squirru (director of the Museum of Modern Art in Buenos Aires).

37. With the exception of Argentina—the host country—which took fourth prize (Rómulo Macció) and fifth prize (Antonio Seguí), every participating nation took one prize. First prize went to Brazil (Manabú Mabe), second prize went to Chile (Ernesto Barreda), and third prize went to Uruguay (José Gamarra). Words of praise were forthcoming from the biennial's director, Luis M. Varela, who told the press that the show had been an "Americanist event." Cf. "Se expidió el Jurado de la Bienal de Arte Realizada en Córdoba," *La Razón*, June 25, 1962, 12.

38. For example, the works by Antonio Seguí, *Para una zoología americana*, *Estudio de Paisaje americano*, and *De Tikal con sol*.

39. *1963, Memoria Instituto Torcuato Di Tella*, Centro de Artes Visuales, Buenos Aires, ITDT, 1963, n.p.

40. As we will see, bringing international juries to the country was no guarantee: Sweeney had traveled to Argentina, but found nothing interesting. Consequently, in 1964 he did not support the exhibition New Art from Argentina.

41. The participants were Louise Nevelson and John Chamberlain for the United States; Lygia Clark for Brazil; Pietro Consagra, Lucio Fontana, Nino Franchina, and Gió Pomodoro for Italy; Pablo Serrano for Spain; and Eduardo Paolozzi, William Turnbull, and Kenneth Armitage for England. To these artists were added Gyula Kosice, who was awarded the national prize, shared with Noemí Gerstein, Julio Gero, Naum Knop, Aldo Paparella, Enrique Romano, Eduardo Sabelli, and Luis Alberto Wells.

42. *Discusión de un jurado, Premio Internacional de Escultura Instituto Torcuato Di Tella, 1962* (Buenos Aires: Editorial del Instituto, 1963).

43. In 1960 Pietro Consagra received the Grand Prize for Sculpture at the Thirtieth Venice Biennial.

44. That year artists who had won prizes in previous years were included in the international competition: Clorindo Testa, Mario Pucciarelli, as well as Macció.

45. The building had been a Wagnerian theater in the 1930s. Enrique Oteiza explains what the idea was: "In the remodeling of the building, undertaken by the architects Francisco Bullrich, Alicia Cazzaniga, and Clorindo Testa, meticulous attention was paid not only to functional aspects, but also to formal-symbolic aspects. They tried to avoid monumentalism, the facade, beyond which was the hall, was transparent and simple, inviting one into a broad and attractive space where information was readily available. The rooms of the Visual Arts Centers, Audiovisual Experimentation, and Advanced Musical Studies were interconnected but each had a clear identity." Cf. Oteiza, "El cierre de los centros de arte del Instituto Torcuato Di Tella," 92–93. The youth of the employees, the priority given to experimentation in theater, painting, music, and graphic design, sought to feed the machine of innovation that the institute wanted to set in motion, also taking into consideration the physical conditions of the space: "Although the renovations were done with very little money, . . . the fact that the space was small enabled us to do something that could not be done in Paris, New York, or other places [where everything was separated]. In contrast, we had a small space for everything. This produced a powerful interactive effect among our techno-artistic groups." Enrique Oteiza, interview with the author, July 13, 1995.

46. Pucciarelli to Guido Di Tella, Rome, September 11, 1963. Archivo ITDT, CAV, Caja 1, Premio ITDT 1960.

47. The jury included jurors from France (Jacques Lassaigne) and Holland (William Sandberg). Pucciarelli mentions that in addition to Alechinsky, Rivers, and Saura, the other participants included Janez Bernik, R. B. Kitaj, Maryan, Platschek, Achille Perilli, Paul Rebeyrolle, Testa, and Pucciarelli himself. The national prize was awarded to Noé for *Introducción a la esperanza* and the other participants were Roberto Aizenberg, Osvaldo Borda, Aníbal Carreño, Ernesto Deira, Rogelio Polesello, Rubén Santantonín, Antonio Seguí, Silvia Torras, and Jorge de la Vega.

48. Lassaigne, "Il faut compter avec la peinture argentine," *Le Figaro*, September 1963, 12.

49. In the 1963 prize competition the jury acted in the same way, recommending the acquisition of works by Antonio Seguí, Aníbal Carreño, Rómulo Macció, Antonio Saura, and Pierre Alechinsky.

50. Romero Brest, "La Argentina en la 31ª Bienal de Venecia," 15. Emphasis added.

51. Ibid.

52. Ibid.

53. The list of those invited to form part of the committee included: from Argen-

tina, in addition to Romero Brest, Manuel Mujica Láinez; from Brasil, Paulo Bittencourt, Assis Chateaubriand, and Francisco Matarazzo Sobrinho; from Chile, Agustin Edwards and Flavian Levine; from Colombia, Hernan Echevarría and Gabriel Serrano Camargo; from Ecuador, Galo Plaza; from Peru, Manuel Mujica Gallo and Felipe A. Thorndike Jr.; from Venezuela, Alfredo Boulton and Eugenio Mendoza; from the United States, J. Peter Grace, Edgar F. Kaiser, Robert W. Purcell, Arthur K. Watson, and L. E. D. Welch. The president and vice presidente were David Rockefeller and Manuel Ulloa, respectively. The MOMA project was organized on three levels: (1) To cooperate with the International Council of the Museum of Modern Art in the planning of the various exhibitions to be shown in their countries and in those to be sent from their country to the United States; (2) to assist in their countries in organizing the actual presentation of these exhibitions; and (3) To raise in each country a certain portion of the funds needed to realize the entire project. Cf. "The Museum of Modern Art New York: Preliminary Proposal for a Five-Year Program of Cultural Exchange between the United States and Latin America," June 1, 1962; and the letters of Nelson Rockefeller and Manuel Ulloa to Jorge Romero Brest, dated respectively July 30, 1962, and January 15, 1963. ABAA, CACC.

54. After Romero Brest resigned as director of the MNBA, Samuel Oliver took charge.

55. The budget was calculated at $350,950. They only considered transportation to and from Latin America. The local costs for installation, transportation to the site of the exhibition, and publicity were left to the institutions hosting each show. "The Museum of Modern Art New York. Preliminary Proposal."

56. The proposal included this clarification: "similar to THE NEW AMERICAN PAINTING shown in Europe in 1958–59, but more comprehensive." Cf. "The Museum of Modern Art New York. Preliminary Proposal."

57. The first exhibition, composed of twelve to sixteen important artists, was organized as a series of individual exhibits that would be shown in New York and then would travel for a year to five or six important museums in key cities in the United States (the project mentioned Washington, Chicago, San Francisco, and Dallas). The second exhibition was to include works from a wide variety of media and artists, to be shown for two years in fifteen to eighteen institutions, featuring a different itinerary from the first exhibition.

58. *Small Bronzes by Modern Artists*; *Abstract Drawings and Watercolors: U.S.A.*; *Twentieth-Century Master Prints*; *Recent Printmaking: U.S.A.*; *Visionary Architecture*; *Roads*; *Twentieth-Century Industrial Design*; *Masterworks of Photog-*

raphy; *The Artist in his Studio*. "The Museum of Modern Art New York. Preliminary Proposal."

59. In 1965 Waldo Rasmussen, executive director of traveling exhibitions, described to Samuel Paz the group of exhibitions they were organizing (Lettering by Modern Artists, Contemporary Painters and Sculptors as Printmakers, Visionary Architecture, Roads) and informed him that in 1966 they would launch the large exhibition of North American painting they had promised earlier. Waldo Rasmussen to Samuel Paz, August 19, 1965. CAV, Caja 5, Exposiciones. Archivo ITDT. In a subsequent letter, Paz, expressing interest in the idea, reminded Rasmussen: "I'd like to hear something more about the exhibition of American Painting you referred to in your letter of August 19, which I think can be very interesting for us." [Samuel Paz] to Waldo Rasmussen, November 10, 1965. Archivo ITDT, CAV, Caja 5, exposiciones.

60. The exhibit was held from May to June and then went to the Museum of Contemporary Art at the University of Chile in Santiago and the Museum of Fine Arts in Caracas.

61. The exhibitions were: in 1964, Josef Albers: Homenaje al Cuadrado; Jacques Lipchitz, Esbozos en bronce; Henri de Toulouse-Lautrec, 1864–1964; in 1965, Lettering by Modern Artists (first exhibited in La Plata); in 1966, Contemporary Painters and Sculptors as Printmakers; and in 1967, Motherwell and Gorky. One condition the MOMA established was that the institution hosting the exhibition had to pay the costs of transportation and for the catalogues.

62. The exhibition was held at the museum from December 1963 to February 1964.

63. Kosice, "El arte argentino actual en el Museo Nacional de Arte Moderno de París," *La Nación*, April 12, 1964, section 3, 3.

64. Ibid.

65. Ibid.

66. It was correct in several ways: The criteria for selection had not been established from outside but rather inside the country, and, futhermore, Parpagnoli's selection had pleased the young artists by including seventy-two works by nineteen artists, all representative of the different lines of "new art," from geometric art to expressive forms that were more related to pop or "thing" art (Ary Brizzi, Zulema Ciordia, León Ferrari, Luis Gowland Moreno, Pablo Mesejean, Nemesio Mitre Aguirre, Marta Minujín, Delia Puzzovio, Emilio Renart, Josefina Robirosa, Rubén Santantonín, Carlos Squirru, Carlos Uria, Luis A. Wells, Antonio Berni, Osvaldo Borda, Alberto Heredia, Luis Felipe Noé, and Berta Rappaport). The exhibition was held in September 1964.

67. Canaday, "Art: A Hit Scored by 28 Painters Lured from Latin America," 52.

68. Bolivia, Brazil, Colombia, Chile, Ecuador, Paraguay, Peru, Uruguay, Venezuela, and Argentina. Twelve painters from each country participated with three works each. The awards jury consisted of twelve members, one from each participating country—Aldo Pellegrini, Oscar Cerruto, Geraldo Ferraz, Antonio Romera, Carlos Rodríguez, Marta Traba de Zalamea, Josefina Pla, Juan Manuel Ugarte Elespuru, Luis García Pardo, Inocente Palacios—one member from the OAS (José Gómez Sicre), and one member representing European critics, Umbro Apollonio, director at that time of the Venice Biennial and whose presence was meant to guarantee "the high quality of the judgments passed by the jury." *Informativo* 8, Bienal Americana de Arte, August 19, 1964. ABAA, CACC (II Bienal).

69. Among the parallel activities was a group called Diabladas which came from Oruro, Bolivia, as well as an exhibition of post-abstract artists from northern California—Diebenkorn, Tony de Lap, David Park, Elmer Bischoff, Ron Davis, Fred Martin, Clark Murray, Mel Ramos, and William Wiley—about which Paul Mills, the director of the Museum of Art in Oakland, California, and John Coplans, art critic and editor of *Art Forum*, gave a conference. Pierre Restany (who was a member of the jury for the Di Tella prize competition) also gave a conference on "Arte Actual." *Gacetika*, no. 72 (September–October 1964). ABAA, CACC (II Bienal).

70. Ibid. The large shows coordinated by diverse disciplines were already a tradition in the exhibitions organized to be sent abroad, for example, by the MOMA during and after World War II. But the model that appeared to be in operation in this case was, more exactly, that of the São Paulo Biennial which, in its seventh edition in 1963, also coordinated exhibitions of visual arts, theater, competitions for architecture, books, graphic arts, and so on.

71. In addition to the scandals surrounding the prize awarded to Rauschenberg, other comments were forthcoming concerning the controversial edition of the Venice Biennial. As acknowledged by Giorgio de Marchis, the biennial had not only brought to light the importance of pop art, but also what could be considered its opposite, op art, represented by the group Recherche Visuelle and by Soto. Even though he had won a prize, it was not one of the top prizes. See Giorgio de Marchis, "The Significance of the 1964 Venice Biennale," 21–23. The magazine *Todo* situated Soto in the midst of the Venice Biennial scandals: "When Jesús Soto presented his controversial kinetic constructions in Venice, last June, his temperamental Leftism produced an abrupt episode: indignant over the visible pressure applied by the American delegation, he convinced several artists to withdraw their works as a protest

over the presumed awarding of the top prize to the North American artist Robert Rauschenberg. Nonetheless, his desperate maneuver against the influence of the dollar quickly lost momentum. All considered, Soto was fortunate: within a few days he happily received second prize at the Venice Biennial." Cf. "Bienales: Premios para América con el orden invertido," *Todo*, October 1, 1964. For more about this controversial biennial, see also Guilbaut, ed., *Reconstructing Modernism*.

72. "Inocencio Palacio, juror from Venezuela, seeing that the host delegation had not won a prize, donated from his own pocket the necessary amount to create a distinction that was awarded to C. Testa." Cf. "Balance del año artístico de 1964," *La Razón*, January 2, 1965, 12.

73. Traba, *Dos décadas vulnerables*, 54–55.

74. Thirty-two works were selected by twenty artists, seven of whom were Argentines (Ernesto Deira, Jorge de la Vega, Rómulo Macció, Eduardo MacEntyre, Rogelio Polesello, Antonio Seguí, Clorindo Testa); four Venezuelans (Jacobo Borges, Cruz-Diez, Gerd Leufert, Jesús Soto); three Chileans (Eduardo Bonatti, Guillermo Nuñez, Eugenio Tellez); two Uruguayans (José Gamarra, Hermenegildo Sábat); two Colombians (Alberto Gutiérrez, Nirma Zarate); and two Peruvians (Fernando de Szyszlo, Arturo Kubotta). While this selection of artwork traveled northward, opening in Mexico City and continuing to tour cities in the United States, a second selection toured the interior of the country, mounted in a train belonging to Ferrocarriles Argentinos (Argentine Railways).

75. Romero Brest, "L'art actuel del'Amerique Latine en Argentinie," 26–29.

76. The group was formed in 1960 by eight artists—Arman, François Dufrênne, Raymond Hains, Yves Klein, Martial Raysse, Daniel Spoerri, Jean Tinguely, Jacques Mahé de la Villeglé—and one critic, Pierre Restany, who wrote about the group and organized their most important collective exhibitions. In the confrontation between new realism and pop, the battle was won by pop. The new European currents appeared to be developments of the new North American visual culture. See Ameline, *Les nouveaux réalistes*.

77. Greenberg, "La continuidad del arte," catálogo Premio ITDT 1964, 8 (in "Modernist Painting," *Arts Yearbook* [New York, 1960]). Cf. O'Brian, *Clement Greenberg*, vol. 4, 92.

78. Restany, "El Arte, virtud moral, al fin!," catálogo Premio ITDT 1964, 13.

79. The correspondence preceding the prize competition suggests that this confrontation was imminent. Informed that in place of Argan, who could not accept, the other juror would be Greenberg, Restany wrote to Romero Brest: "En choisissant M. Clement Greenberg vous avez fait appel à un critique de

qualité que je tiens en haute estime, même si je ne partage pas toujours ses idées." For his part, Greenberg wanted to clearly express his position, which is why he wanted his article from *Arts Yearbook* to be included in the catalogue: "I hope it will do, as a statement of my position, for the catalogue. I purposely made it short because people don't seem to read art texts very carefully, and the longer they are the less carefully they get read." Pierre Restany to Romero Brest, Paris, April 13, 1964, and Clement Greenberg to Romero Brest, New York, May 27, 1964. Archivo ITDT, CAV, Caja 3, exposiciones año 1964.

80. Restany, "¡El Arte, virtud moral, al fin."

81. "El premio Di Tella a la plástica nacional," *La Nación*, October 3, 1964, 6.

82. Ibid.

83. Restany, "Buenos Aires y el nuevo humanismo," 122–23.

84. There seems to have been a profound antipathy between them. Hal Babbitt mentioned to McCloud that Gómez Sicre was disturbed by the suggestion that Romero Brest would be present for the opening of the first biennial at the Unión Panamericana: "This really bothered him because apparently he and Romero Brest do not coincide in their views on comtemporary art in South America." Hal Babbitt to McCloud, October 1, 1962. ABAA, CACC (I Bienal: Correspondence).

85. In the speech Enrique Oteiza gave on the day of the prize competition's opening, he declared: "In its artistic activities, the Institute is committed to the adventure of participating in the development of a vital avant-garde movement, with character, and to form part of the world today. We are interested in living artists, because as an institution we are turned toward the future; and among the living we prefer those who perceive contemporary problems and who are open to the unknown." Archivo ITDT, CAV, Caja 3, exposiciones año 1964.

86. Apparently the selection was not a simple proposition. To this effect Oteiza wrote to the director of the Walker museum: "We understand that the selection will be made jointly by the curators of Walker Art Center and Mr. Romero Brest. We accept of course the idea that your people should have the upper hand considering the selection will be shown at your place and in other Museums in the States. I am certain there will be no problem whatever with Mr. Romero Brest" (E. Oteiza to Martin Friedman, Buenos Aires, November 4, 1963. Archivo ITDT, CAV, Caja 2, exposiciones año 1964). Friedman answered: "We are agreeable to Mr. Brest's highly valued cooperation as far as making the selections. However, as you yourself already pointed

out, we must reserve ourselves the right of final decisions for a very discriminating American audience. I am sure that Mr. Brest himself will be the first to understand." M. Friedman to E. Oteiza, Minneapolis, November 15, 1963. Archivo ITDT, CAV, Caja 2, exposiciones año 1964.

87. The exhibition was confirmed at the end of 1963 with the visit to Buenos Aires of Martin Friedman, director of the Walker Art Center. According to Juan J. Mathé, secretary of the Argentine embassy in Washington, Friedman at first thought of holding an exhibition of Mexican art but after long conversations with him and Rafael Osuna, representing Gómez Sicre, he changed his opinion. The participation of the Di Tella Institute was added a little later. Juan J. Mathé to Enrique Oteiza, Washington, November 12, 1963, Archivo ITDT, CAV, Caja 2, exposiciones año 1964. The exhibition brought together fifty-six works by twenty-six artists. It opened with dances by Graciela Martínez. Attending the opening were Squirru, Gómez Sicre, and the Argentine ambassador.

88. Van der Marck, Foreword.

89. In the gazette presenting the exhibition, it was promoted in the following terms: "The Argentine equivalent of American style 'Pop-Art' and French 'New Realism' can be found in the works of Antonio Berni, Ruben Santantonin, Marta Minujin. The new Argentine art is internationally oriented and now the strongest single contribution to the field of contemporary art in any of the Latin American countries. Its focal point is Buenos Aires, although nine of the artists in this exhibition currently live in Paris, three in New York and one in Rome. The strength of Argentine art first became apparent abroad at the thirty-first Venice Biennial in 1962. In December, 1963, an exhibition of recent art from Argentina opened at the Musée National d'Art Moderne in Paris. For the United States public, the Walker organized exhibition will be the first to illustrate the rapid evolution of Argentine art during the last three years." Undated gazette, Archivo ITDT, CAV, Caja 2, exposiciones 1964.

90. Van der Marck, Foreword.

91. Romero Brest, Introduction.

92. Van der Marck to Romero Brest, Minneapolis, February 18, 1964. Archivo ITDT, CAV, Caja 2, exposiciones año 1964.

93. Van der Marck to Romero Brest, Minneapolis, March 6, 1964. Archivo ITDT, CAV, Caja 2, exposiciones año 1964.

94. Ibid. With respect to the agreed-on article, van der Marck managed to have *Art International* publish it accompanied by several reproductions. Cf. Van der Marck, "New Art of Argentina," 35–38 (with reproductions of Fernán-

dez Muro, Noé, Testa, Peluffo, Deira, Segui, Berni, Cancela, Tomasello, Demarco, and Kosice).

95. Deira, Macció, Noé, and De la Vega. Cf. Canaday, "Art: Argentina's Blue Plate Special," *New York Times*, September 9, 1964, 49.

96. Canaday, "Hello, Sr. Brest. A Dialogue on Art, Half Imaginary," *New York Times*, September 13, 1964, Art X., 27.

97. The joining of forces that I have pointed to in various instances can be verified again in this case: In Juan J. Mathé's letter to Samuel Paz he emphasizes the excellence of the conditions under which the exhibition will be presented in Washington, which coincided with the exhibition of the Esso Prize and with the selection of the Kaiser Biennial. Washinton, April 7, 1965, Archivo ITDT, CAV, Caja 2, exposiciones año 1964. In 1965, Donald B. Godall wrote to S. Paz from the University of Texas about the coincidence of initiatives: "The exhibition that was presented in Minneapolis is now in our galleries and is being warmly received. It is parallel to the Magnet show, by Latin American artists living in New York, which was exhibited by Bonino last August and is touring with the Inter-American Foundation for the Arts. The enthusiasm these shows radiate, together with the general exhuberance of the Argentine group, has strongly attracted our attention." Donald B. Goddall to Samuel Paz, University of Texas, February 10, 1965, Archivo ITDT, CAV, Caja 2, exposiciones año 1964.

98. Squirru, "Con un poco de promoción el país puede exportar cultura," 30.

99. In 1963 the United Nations established that 1965 would be the year of international cooperation. For its celebration, the Ministry of Foreign Relations and Culture organized a meeting of artistic, scientific, and athletic works in the galleries of the Teatro General San Martín, carried out by Argentines who had earned distinctions abroad. More than 500 works were presented by authors translated and edited abroad, musical compositions that had earned international recognition, and photographs by world-famous artists. The idea of the exhibitions of Argentine art (until 1949 and after 1949) was to give local exposure to artists who had earned recognition abroad.

100. See chapter 4.

101. Romero Brest, introduction to the exhibition catalogue, *Argentina en el mundo: Artes visuales 2*, ITDT, 1965–1966.

102. Córdova Iturburu, "Argentina en el mundo," *El Mundo*, January 2, 1966, 30.

103. In 1962–63, the company experienced a major crisis that worsened in 1965 when it bought the Siam Di Tella automobile factory.

104. He was the first director of the Museum of Modern Art in New York, serving from its foundation in 1929 until 1943. In 1947 Barr was named director of

collections for the museum while René d'Harnoncourt became director of the museum in 1949.

105. On this topic Barr wrote at least three more letters: to Elizabeth Bliss Parkinson, president of the International Council and the Board of Trustees; to James Thrall Soby; and to William H. Weintraub, all three dated July 14, 1965. For all of them he included his correspondence with McCloud—the invitation and Barr's explanation of his difficulties accepting it—and he requested their opinions regarding this issue. MOMA Archives: Alfred H. Barr Jr. Papers [AAA: 2193; 366, 367, 368].

106. MOMA Archives, AHB Papers [AAA: 2193; 356].

107. In fact, during the biennial A. Barr selected works that the musuem purchased later. The acquisitions included works by Jorge Eielson of Peru, Rodolfo Mishaan of Guatemala, and Eduardo MacEntyre, Rogelio Polesello, and César Paternosto of Argentina.

108. MOMA Archives, AHB Papers [AAA: 2193; 344].

109. Lawrence Alloway to James McCloud, New York, October 16, 1964. ABAA, CACC (II Bienal).

110. As in the previous prize competitions, the main prizes were for abstraction: Cruz-Diez won the top prize, the Gran Premio Bienal Americana de Arte; the Argentine César Paternosto won first prize. Ernesto Deira—another Argentine—won second prize; Abraham Palatnik, Brazilian, won third prize; Rodolfo Opazo, Chilean, won fourth prize; and the Argentine Eric Ray won fifth prize. Jorge de la Vega was awarded the special prize for Argentine painters and Marcelo Bonevardi, from Córdoba, won the special Ministry of Foreign Relations Prize.

111. In the mid-1960s an active generation of avant-garde artists was formed in the city of Rosario. I return to this topic in chapter 7.

112. *Primera Plana*, no. 200 (October 25, 1966): 76.

113. Some of the works in the anti-biennial are described by Fantoni, "Tensiones hacia la política."

114. Reproduced in Morero, *La noche de los bastones largos*, 93–94.

115. "Difusión imagen institucional—Bienal Americana de Arte." ABAA, CACC (III Bienal: Internal memorandum).

116. Ibid.

117. This probably refers to his refusal to vote for the expulsion of Cuba. [J. Pérez Abella] to Eduardo Torres, Córdoba, September 17, 1966. ABAA, CACC (III Bienal).

118. Ibid.

119. In 1963 the São Paulo Biennial separated from the Museum of Modern Art to

become a foundation supported by parties in the municipal, state, and federal government, with fixed resourses. See Amarante, *As Bienais de São Paulo/1951 a 1987*, 129.

120. Because of this crisis, the automotive division had been sold to Kaiser. For the moment, although there had been a reduction in the institute's activities, the liquidation of the cultural project had not been proposed. That year only the Premio Nacional (the national prize competition) was held, with a jury composed of Romero Brest, Otto Hahn, and Lawrence Alloway.

121. In a letter written to Samuel Paz, who was traveling in the United States and Europe preparing the international prize competition, Romero Brest explained to him that the decision to change the name to "Experiencias" had been strongly influenced by the opinions of such artists as Mesejean-Cancela, Stoppani, and Rodriguez Arias who were not very willing to participate in the prize competition. Romero Brest to Samuel Paz, Buenos Aires, May 30, 1967, Archivo ITDT, CAV, Caja 9, exposiciones.

122. Since 1951 Romero Brest had participated in several international juries: 1951, the First São Paulo Biennial; 1953, Concurso para el Prisionero Político Desconocido (the Unknown Political Prisoner Competition), ICA of London; 1953, the Second São Paulo Biennial; 1961, the Sixth São Paulo Biennial; 1962, the Thirty-First Venice Biennial; 1965, the Young Artists Biennial of Paris; 1966, Festival of Lima; 1966, Jury for the Foundation for the Arts of Lima; 1966–67, Tokyo Print Biennial. To this should be added, of course, the Di Tella international prizes beginning in 1962.

123. Thomas Messer, speaking to the magazine *Visión* about his tour of Latin America, explained that when he arrived in Latin American countries looking for the top artists, they were not to be found in their own countries; he had to go to Paris, London, or New York to find them. *Visión*, December 11, 1964.

124. Cf. Romero Brest to A. Bonino, Buenos Aires, January 27, 1967. Archivo ITDT, CAV, Caja 9, exposiciones. The galleries and artists that participated were: Fischbach Gallery (Allan d'Arcangelo); Park Place Gallery (Dean Fleming); Richard Feiten Gallery (Charles Hinman and Bridget Riley); Dwan Gallery (Sol Lewitt); Leo Castelli (Robert Morris); Betty Parsons (Robert Murray); André Emmerich (Jules Olitski); Charlette Gallery (León Polk Smith); and Robert Elkon (John Wesley).

125. Romero Brest to E. De Wilde, Buenos Aires, June 12, 1967, Archivo ITDT, CAV, Caja 9, Exposiciones.

126. E. De Wilde to Romero Brest, Amsterdam, June 22, 1967, Archivo ITDT, CAV, Caja 9, Exposiciones.

127. Virginia Dwan (who sent the Sol Lewitt piece) expressed her enthusiasm to Romero Brest: "I, personally, am very excited about this show and will be coming down for my first trip to South America, stopping off at São Paulo. Quel aventure!" At the end she added, "Do you know the writer, Borges?" Virginia Dwan to Romero Brest, June 23, 1967, New York. Archivo ITDT, CAV, Caja 9, Exposiciones.

128. Romero Brest explained to one of the gallery owners: "I know you are planning to come and I want to inform you that I have coordinated and organized some other exhibitions with the directors of the Museo Nacional de Bellas Artes, the Museo de Arte Moderno, the Sociedad Hebraica Argentina, and of the galleries, in order to provide an idea of what is happening among the young artists of this country." Romero Brest to Richard Feingen Gallery, Buenos Aires, August 29, 1967, Archivo ITDT, CAV, Caja 9, Exposiciones.

129. Romero Brest, *Semana del Arte Avanzado en la Argentina*.

130. Stanton Catlin had been assistant director of the exhibition Art of Latin America Since Independence (organized by Yale University and the University of Texas at Austin, accompanied by a symposium), for which Argentina had lent works through the ITDT. On July 1, 1967 Catlin left Yale to become director of the art gallery of the Center for Inter-American Relations, in New York.

131. Romero Brest invited her to Argentina after the opening of the São Paulo Biennial. Romero Brest to Lois Bingham, Buenos Aires, July 19, 1967, Archivo ITDT, CAV, Caja 9, exposiciones.

132. It was established in a building donated by the Marquesa de Cuevas, located at 680 Park Avenue (today the offices of the Americas Society).

133. On May 1 of that year $1,350,000 had accumulated from various sources ($500,000 from fifty corporations and $850,000 from the Rockefeller family) for the first year; for the specific program of development for the institution, the Ford Foundation donated an initial $500,000 and $1,000,000 for each subsequent year. Considering the difference in figures managed by the IAFA, it is clear that this new institution was seen as having unique importance. Cf. "From Agenda & Docket for RBF Annual Meeting—5//18/67, Request: A grant for general purposes, including building renovation and furnishing, Appendix I," folder 2, box 24, Center for Inter-American Relations 1966–67, Series 4 (Grants), RBF Archives, RAC.

134. In its plan for operations, the center cooperated with other institutions, such as the Council on Foreign Relations, the Foreign Policy Association, and the MOMA.

135. The direction of the center was composed of honorary trustees: Hon.

Hubert H. Humphrey, Hon. Nelson A. Rockefeller, Hon. Jacob K. Javits, Hon. Robert F. Kennedy, Hon. John V. Linowitz, Marquesa de Cuevas; officers: David Rockefeller, chairman of the Board; William D. Rogers, president; William H. McLeish, executive director; Jack B. Collins, vice president-development; William S. Ogden, treasurer; Forrest D. Murden Jr., secretary. The Board of Directors was composed of twenty representatives from the world of culture, industry, and finance, including René d'Harnoncourt, Lincoln Gordon (assistant secretary of state for Inter-American Affairs), Edgar F. Kaiser, and Thomas C. Mann, among others. Many of these personalities had long careers in inter-American affairs. William H. Macleish, executive director, had organized the Latin American Program at Cornell in 1965 and previously had been active with *Visión*. Cf. "Inter-American Unit Names Aide," *New York Times*, May 17, 1968, folder 2, box 24, Center for Inter-American Relations 1966–67, Series 4 (Grants), RBF Archives, RAC.

136. Homer Bigart, "Humphrey Finds Latin Parallel to U.S. Racial Strife," *New York Times*, September 19, 1967, folder 2, box 24, Center for Inter-American Relations 1966–67, Series 4 (Grants), RBF Archives, RAC.

137. For example, the work of Juan Pablos Renzi, *Grados de libertad de un espacio real*.

138. There were also artists from Mar del Plata, such as Mercedes Esteves and Marta I. Edreira, who exhibited their work in other galleries. The artists who exhibited in Rosario 67 at the Museum of Modern Art were: Osvaldo Mateo Boglione, Aldo Bortolotti, Graciela Carnevale, Rodolfo Elizalde, Noemí Escandell, Mario Alberto Escriña, Eduardo Favario, Tito Fernandez Bonina, Carlos Gatti, Ana María Gimenez, Martha Greiner, José Maria Lavarello, Lía Maisonnave, Rubén Naranjo, Norberto J. Puzzolo, and Juan Pablo Renzi. Some were also in the exhibition Estructuras Primarias II: Aldo Bortolotti, Graciela Carnevale, Noemí Escandell, Eduardo Favario, and Juan Pablo Renzi.

139. The exhibition was held from March 21 to May 12, 1968. This exhibition was a reduced version of an exhibit held at the CAV under the same title (Más allá de la geometría: Extensión del lenguaje artístico-visual en nuestros días) from April 20 to May 14, 1967.

140. Romero Brest to Leo Castelli, Buenos Aires, September 6, 1967. Archivo ITDT, CAV, Caja 9, exposiciones.

141. Julio Le Parc told Denise René that in the first six days of the exhibition there were 44,126 visitors. Julio Le Parc to Denise René, Buenos Aires, August 11, 1967. Archivo ITDT, CAV, Caja 8, exposiciones 1967.

142. Medhurst, "Rhetoric and Cold War: A Strategic Approach," in Medhurst et al., *Cold War Rhetoric*, 19.

143. Cf. Cockcroft, "Los Estados Unidos y el arte latinoamericano," 184–221.

144. Cf. Williams, *Keywords*.

145. Editorial, "Where Is America?," *Art in America*, 47 (3) (fall 1959): 20.

146. Ibid.

147. Ibid., 21.

148. Such artists as Gorky, Pollock, De Kooning, Baziotes, Gottlieb, Rothko, and Guston (representatives of the lastest Western avant-garde) had participated in the Federal Art Project which was dependent on the Work Progress Administration, implemented in 1935 during the New Deal, and had been Communist Party sympathizers. Articles like "On the Fall of Paris," by Harold Rosenberg, and "The Decline of Cubism," by Clement Greenberg, formed part of the ideological apparatus that helped spread the conviction throughout the world that Paris was no longer the artistic center of the West and that it was now in New York.

149. For someone like Irving Sandler, who wrote a book with a title so suggestive as *The Triumph of American Painting*, American artists were like communist puppets during the Depression years. Cf. Sandler, *El triunfo de la pintura norteamericana*, 37–40.

150. In the process of constructing the narrative of the history of North American art, Clement Greenberg, although he was not the only figure to work in this context, was the most radical and the most influential with respect to subsequent criticism and the teaching of art. The definition of modernism as a self-critical project formulated upon a set of uncompromising practices was clearly inscribed within the project of Western civilization and the aesthetic tradition establishd by Kant and the Enlightenment. Greenberg emphasized the idea of continuity and tradition that establishes an order of discoveries and transformations in which one form of expression supercedes another. This emphasis on continuity was a central element in the argument he proposed to the new American artists as heirs and conquerors of a pictorial tradition bred in Europe. Although he knew that this artistic supremacy was not far removed from politics and economics, after his article "Avant-Garde and Kitsch" he was not going to perform an analysis of the relationships between culture and political power. Cf. O'Brian, ed., *Clement Greenberg: The Collected Essays and Criticism*, vol. 4. See also T. G. Clark, "Clement Greenberg's Theory of Art."

151. Gómez Sicre, "Trends—Latin America," 23.

152. Among the first, Alejandro Otero (Venezuela), Manabú Mabe (Brazil), Fernando de Szyszlo (Peru), Alejandro Obregon (Colombia), and José Antonio Fernadez Muro, Sarah Grilo, Miguel Ocampo, Kazuya Sakai, Clorindo Testa, all from Argentina. In abstract representation there were only Ricardo Martínez from Mexico and Armando Morales from Nicaragua. Notice the importance of the Argentine representation in what might be supposed to have been a vision of Latin America.

153. Messer, *Latin America: New Departures*, n.p.

154. Squirru, "Spectrum of Styles in Latin America," 81–86. Squirru was, on the other hand, the founder and first director of the Museum of Modern Art in Buenos Aires from 1956 to 1962.

155. Ibid.

156. Ibid., 86.

157. Among the projects the IAFA supported was also the inter-American year that was prepared in 1964 and celebrated in 1965 at Cornell University. Cf. Robert M. Wool to Dana S. Creel, Rockefeller Brothers Fund, August 28, 1964, folder 1, box 49, Inter-American Foundation for the Arts 1963–1965, Series 4 (Grants), RBF Archives, RAC.

158. Canaday, "Art: A Hit Scored by 28 Painters," 52.

159. Wool, "The Attraction of Magnet," n.p.

160. Alloway, "Latin America and International Art," 65–77.

161. Involved in the controversies over the establishment of modern art in New York during the early years of the Cold War, the American Federation of Arts had fallen into vague traditionalism and did not form part of the New York avant-garde scene. It was not, therefore, the best avenue for entering the demanding New York artistic scene.

162. In the 1960 prize competition the countries represented were Argentina (José Antonio Fernández Muro, Alberto Greco, Juan del Prete, Mario Pucciarelli, Clorindo Testa), Brazil (Maria Leontina, Lygia Clark, Manabú Mabe, Loio Persio, Flavio Shiro Tanaka), Chile (Emilio Hermansen, José Balmes, Pablo Buchard, Rodolfo Opazo, Iván Vial), and Colombia (Fernando Botero, Ignacio Gómez-Jaramillo, Enrique Grau Araujo, Alejandro Obregón, Armando Villegas López). The Latin American representation at the 1964 prize competition took into consideration more countries but, at the same time, was more selective: It included artists from Chile (Roberto Matta, Ricardo Yrarrazabal), Cuba (Wifredo Lam), Mexico (Arnold Belkin, Francisco Ikaza, David Alfaro Siqueiros, Rufino Tamayo), Peru (Fernando de Szyszlo),Venezuela (Alejandro Otero), and Argentina (Ernesto Deira, José A. Fernández Muro, Rómulo Macció, Luis Felipe Noé, Jorge De la Vega). The 1967 selection was

quite different: The only Latin American artist included was Edgar Negret from Colombia.

163. Alloway, "Latin America and International Art," 65.

164. Ibid., 65–66.

165. The prize competition brought together artists from eighteen Latin American countries (among which, of course, Cuba was not included), and was held as part of the celebrations for the seventy-fifth anniversary of the American System. First there were exhibitions and national prizes and later the prizes were displayed in the OAS. The top international prize—like at the Kaiser biennials—went to an abstract artist: Argentine Rogelio Polesello.

166. Messer organized the 1961 exhibition Latin American New Departures in Boston and The Emergent Decade at Cornell. The latter, as we shall see, was a great challenge.

167. Messer, "Latin America: Esso Salon of Young Artists," 121.

168. Ibid.

169. Ibid.

170. The congress was organized from mid-1965 to mid-1966. There were six conferences scheduled on such topics as "The Role of the City in the Modernization of Latin America" and "The Next Decade of Latin American Economic Development." Also, the artists and intellectuals invited to Cornell included De la Vega and Octavio Paz. Cf. MacLeish, "Cornell's Latin American Year," 102–5. MacLeish, director of the Latin American Year at Cornell, later became executive director of the Center for Inter-American Relations.

171. Messer, "Introduction," xiv–xv. Emphasis added.

172. Ibid., xv.

173. Hunter, "The Cordoba Bienal," 85.

174. Ibid.

175. Ibid., 86.

176. Ibid., 84.

7. The Avant-Garde Between Art and Politics

Tucumán Arde epigraph from declaration of the Rosario exhibition, 1968. Cf. Longoni and Mestman, Del Di Tella, 192.

1 Romero Brest, "Arte 1965: Del objeto a la ambientación," June 11, 1965, mimeograph, Caja 1, Sobre 6, JRB Archives, UBA.

2 Cf. Halperín Donghi, Historia contemporánea de América Latina, 412.

3 In 1964 an internal revenue investigation carried out by representative Wright Patman demonstrated that since 1959 the J. M. Kaplan Foundation of New

York had been receiving funds from the CIA covertly, money that had been funneled through other private foundations used as fronts. On September 4 the *New York Times* published an editorial attacking the espionage methods used by the government. In April 1966 five articles in the *New York Times* investigated CIA activities and, in one of them (dated April 27), it was revealed that the CIA had financed investigation centers in Latin America which, in turn, received support from the Agency for International Development, the Ford Foundation, and such universities as Harvard and Brandeis. Through similar channels the CIA had also supported Cuban exile groups, communist refugees in Europe, and anti-communist and liberal intellectual organizations such as the Congress for Liberty and Culture. On May 6 the weekly magazine *Marcha* of Montevideo began to publish the complete translation of the *New York Times* material and, accompanying the notes, Angel Rama published four articles in which he explained the relationship between the CIA and the Congress for Liberty and Culture-ILARI and the magazine *Mundo Nuevo*. The series of articles, as might be expected, had an impact on the leftist Latin American intelligentsia as well as on artists. Cf. Mudrovcic, *Mundo Nuevo*, 28–33. Also see Coleman, *The Liberal Conspiracy*, 219–22.

4. Mudrovcic, *Mundo Nuevo*, 68–70.

5. To the revelations published in the *New York Times* were soon added the "Camelot" plans in Chile, "Simpático" in Colombia, and "Job 430" and "Marginalidad" in Argentina.

6. Beginning in 1963 the ITDT published in its memoirs a section of "Financial information on the Torcuato Di Tella Institute," in which it recorded its expenses and resources. The contributions of the cited foundations were: 1963: Ford: $23,116,452.45 (destined for the Centro de Investigaciones Económicas); Rockefeller, $16,376,566.25 (destined for the Centro Latinoamericano de Estudios Musicales); and Harvard, $557,975 (destined for the co-financing of the project Aspectos sociales y Culturales del Desarrollo). All these contributions represented more than 50 percent of the ITDT's total resources. These contributions fell to 25 percent in 1964, a similar percentage to that of 1965 (although now contributions were added from the Department of Public Health, Education and Welfare, the Agency for International Development, the Inter-American Bank, the American Economic Association, and the OAS). In 1966 the contributions of these institutions rose, reaching more than 30 percent. Cf. Memorias del Instituto Di Tella, years 1963–68.

7. While Oscar Terán proposes that it was in 1966, Silvia Sigal sees the rupture as taking place in 1969. In the artistic field, if one had to set a date, it would

be 1968, when the institutions were confronted. Cf. Terán, *Nuestros años*, and Sigal, *Intelectuales y poder*.

8. Castro, "Palabras a los intelectuales," 13–43.

9. Sartre, "What Is Writing?" in *What Is Literature?*, 1. It is not coincidental that Sartre begins the text by responding to the many questions put to him. For example, "The worst artists are the most engaged. Look at the Soviet painters"; "And in poetry? And in painting? And in music? Do you also want them to be committed?" Ibid., xvii.

10. Ibid., 13.

11. Ibid., 17.

12. Ibid., 25.

13. Ibid., 2.

14. Williams, *Cultura*, 201.

15. Ibid.

16. Cf. Borricaud, *Essai sur les intellectuels*, 8 (cited in Sigal, *Intelectuales y poder*, 19).

17. Maldonado, *¿Qué es un intelectual?*, 22.

18. According to the visitors statistics recorded in the records for the ITDT, attendance increased year by year: 1963, 112,466 people; 1964, 149,000 people; 1965, 214,195 people; 1966, 271,326; 1967, 353,885; and 1968, 152,042.

19. Cf. Bourdieu, *The Rules of Art*, 129.

20. Ibid, 130–31. As indicated by Bourdieu, "the defender of Dreyfus is the same person who defended Manet against the Académie, the Salon and the bourgeois good taste, but also—and in the name of the same faith in the artist's autonomy—against Proudhon and his 'humanitarian,' moralizing, and socializing readings of painting." Ibid., 131.

21. Following the "historic" generation of Argentine muralists (Berni, Spilimbergo, Castagnino, Urruchúa), muralism did not reemerge until the end of the 1950s. In 1957 Ricardo Carpani created his first mural, *Mosona con YPF* (Movimiento de Solidaridad Nacional [National Unity Movement] and the State Petroleum Industry celebrating their fiftieth anniversary together) at the Sociedad Rural exposition center. In 1959, he and other artists (Mollari, Sánchez, Esperilio Bute, Carlos Sessano, Raúl Lara, and, later, Elena Diz and Pascual Di Bianco) founded Movimiento Espartaco (Spartacus Movement), to which he belonged until 1961.

22. Carpani, *Arte y revolución en América Latina*, 72–73.

23. Ibid., 71.

24. Ibid.

25. Ibid., 53.

26. Noé, "La pintura en Latinoamérica," response to a questionnaire in *Hoy en la Cultura*, 14.

27. Ibid.

28. Ibid.

29. Noé said, "On this problem of self-expression, it would seem that they deliberately wanted to ignore the majority of Argentine painters who were liberated from theme. Consequently, they have never had an awareness of the problem being treated here." Ibid.

30. For Carpani, revolutionary art, in addition to being public, had to have a revolutionary political intention as its underlying theme, in contrast to those "social artists" who offered a "sentimental and tearful" vision. The workers' struggle provided "stupendous and suggestive thematic material for the artist who was positive and efficient in political agitation. Adequate for our reality and the tasks required to achieve revolutionary objectives." Cf. Carpani, *Arte y revolución*, 67.

31. Noé, "La pintura en Latinoamérica."

32. Ibid.

33. Ibid.

34. Cardoza y Aragón, "Picasso," 16–21.

35. Cf. Adorno, *Teoría Estética*, 253–54.

36. Cardoza y Aragón, "Picasso," 18.

37. Sartre, "El pintor sin privilegios," 281–98, 282.

38. Ibid., 282.

39. Ibid., 284.

40. Garaudy, *Hacia un realismo sin fronteras*.

41. Ibid., 46. In the interview published by the North American magazine *New Masses* and republished by *L'Humanité* on September 29 and 30, 1944, under the title "Pourquoi j'ai adhéré au parti communiste," Picasso explained: "My adhesion to the Communist Party is the logical consequence of my entire life, of all my work. . . . How could I have doubted? Fear of committing myself? But on the contrary I have felt freer, more complete." In the chronology established by Sarah Wilson, in Hulten, *Paris-Paris*, 308.

42. Garaudy, *Hacia un realismo sin fronteras*, 57–58. Emphasis in original.

43. In this context, the biography by Pierre Cabanne could be mentioned as an example, when considering that Picasso's affiliation with the French Communist Party on October 4, 1944, was almost an act of opportunistic convenience: "Certain that Picasso cannot be suspected of insincerity when he talks of love for his country and the feelings that motivated him to affiliate himself

with the party, but above all, just like during the occupation, the only thing he wants is to be able to work in peace, and in those times of violence and changing administrations, who could protect him better and more efficiently than the communists?" Cf. Cabanne, *El siglo de Picasso*, 153.

44. Garaudy, *Hacia un realismo sin fronteras*, 62.

45. On this principle, Garaudy read Saint-John Perse in Cuba: "Recently on a trip to Cuba, I took only two books: two volumes of the poetry of Saint-John Perse. Until then I had seen revolutions that had already taken place; for the first time I found myself in Cuba in a revolution in-progress with rhythms panting from combat. And when, at night, after the daily work routine, I re-read Perse's poetry in my room, poems animated by a deep faith in man, I found the rhythm quite cheerful and quite imperious, capable of driving the advance of revolution." Ibid., 101.

46. Broullón, "Apuntes sobre el vanguardismo," 109. This magazine, directed by Ricardo Piglia and Sergio Camarda, published only once, was one of the few incursions into the area. The publication of articles by Sartre, Gramsci, della Volpe, and Lukács established an authoritative criteria that ran through all such leftist Latin American publications.

47. For a discussion of the concept of autonomy, see Gilman, "La autonomía," 131–39.

48. Broullón, "Apuntes sobre el vanguardismo," 109–10.

49. For example, such words as "generals, captains, sergeants, corporals, . . . US dollars, petroleum, Esso, against the wall, *ministrejos, ministritos* [ministers], IMF, OAS, The Press." León Ferrari, November 28, 1962, Notebooks, no. 1, 15 (obverse side), León Ferrari Archives.

50. Ferrari, August 28, 1963, Notebooks, no. 2, 4 (front and obverse sides). León Ferrari Archives.

51. Ferrari exhibited in Buenos Aires in 1962. Although he was not part of the group of young artists (practically a prerequisite during that decade that valued youth so highly), he still managed to earn a reputation as an innovative artist.

52. Lieutenant General (retired) Juan Carlos Onganía, defining the political objectives of the self-proclaimed "Argentine Revolution," also appealed to "Western Christian civilization" in which he included the "national culture." This slogan also helped justify his repeated incursions into the cultural field, oriented toward avoiding that "under the imprecise concept of art, there should be attacks against our customs and traditional norms." Cited in Avellaneda, *Censura, autoritarismo y cultura*, 78–80.

53. This was the idea that André Breton emphasized in the Second Manifesto on

Surrealism: "Everything remains to be done, every means must be worth trying; in order to lay waste to the ideas of *family, country, religion.*" Cf. Breton, *Manifestos del Surrealismo*, 128.

54. "Before these visionaries and sign interpreters, no one had noticed how misery (and not just social but rather architectural, interior misery, enslaved things and things that enslave) becomes revolutionary nihilism. . . . The ruse that dominates this world of things (and it is more honest here to speak of a ruse rather than a method) consists in converting the historic gaze into a political gaze." See Benjamin, "El surrealismo: La última instantánea de la inteligencia europea." Ricardo Ibarlucía also emphasizes this difference in "Benjamin y el surrealismo," 154.

55. At the exhibition Surrealismo en la Argentina, held in June 1967 at the ITDT.

56. While King (*El Di Tella*, 63) emphasizes the reactions provoked by the work ("The only outburst of fury was caused by the anti-Vietnam painting [*sic*] by Ferrari and his Christ crucified on an F 107 fighter plane"), Terán (*Nuestros años*, 155) stresses the importance on the connection established between the artistic and political avant-gardes. Basing their observations on the reproduction in the catalogue, both writers describe the work as a painting and do not mention that in the end it was not exihibited.

57. Letter from the artist to the author, August 7, 1993.

58. These were three boxes of equal size (70 cm × 100 cm): *Cristo murió* (Christ Died), *15 votos en la OEA* (15 Votes in the OAS), and *La Civilización occidental y cristiana bombardea las escuelas de Long Dien, Cauxé, Linn Phung, Mc Cay, Han Tanh, An Minh, An Hoa y Duc Hoa* (Western and Christian Civilization Bombards the Schools of Long Dien, Cauxé, Linn Phung, McCay, Han Tanh, An Minh, An Hoa and Duc Hoa). In all three the relationship between politics, violence, and religion is explored.

59. "It has to be admitted," wrote Ramallo, "that it is at the very least curious that a serious institution permitted the exhibition in its galleries of those artefacts, which convey an attitude of disdainful—and perhaps corrosive—criticism, intended to pass judgement on nothing less than Western and Christian civilization." E. R. [Ernesto Ramallo], "Los Artistas Argentinos en El Premio Di Tella 1965," 11.

60. Ferrari, "La respuesta del artista," *Propósitos*, October 7, 1965.

61. Ibid.

62. Ibid. In his letter Ferrari also profoundly questioned the manipulations of reality by the communications media. This criticism deserves note because

of the importance it was to have on later experiences, especially on the work *Tucumán Arde*. See Sacco et al., *Tucumán Arde*, and Longoni and Mestman, *Del Di Tella*.

63. His referents are the group Contorno and the new awareness regarding what Ismael Viñas had described as the painful but indispensable necessity to turn oneself inside out like a glove in relation to the position taken in the face of Peronism. On the group Contorno and the position it sought to define, see Sigal's chapter, "Un punto de origen: Contorno," in *Intelectuales y poder*, 134–40.

64. The case usually discussed was generally that of Borges: "The problem is," said Piglia, "to analyze what specifically makes 'El Muerto' [The Dead One] a great story *in spite of* Borges's political views and concept of the world." Piglia, "Literatura y sociedad," 1; emphasis in original.

65. Ibid., 11.

66. Brocato, "Defensa del realismo socialista," 3.

67. On González Tuñon's action and the political-cultural debate during the 1930s, see Sarlo, *Buenos Aires una modernidad periférica*, 138 and ss.

68. Restany, "El Arte, virtud moral, al fin!," in the catalogue for the Premio Nacional ITDT in 1964, 14.

69. They were Yaacov Agam, Arman, Enrico Baj, Lee Bontecou, Chryssa, Alberto Gironella, Jasper Johns, Julio Le Parc, Luis Felipe Noé, Kenneth Noland, Robert Rauschenberg, Takis, and Joe Tilson.

70. Gorriarena, "Tres pintores, tres tendencias," 20–22.

71. The example would be the exhibition Homenaje al Vietnam (Homage to Vietnam), held at the Van Riel Gallery in 1966 which brought together different aesthetic and political views: from Nueva Figuración (New Representation) to the artists of the Di Tella Institute, ranging from geometric abstractionists to critical realists.

72. As a member of the group Litoral, Grela was well known in Buenos Aires after the first exhibition by the group at the Bonino Gallery in the early 1950s. Juan Pablo Renzi describes the climate in the workshop and the degree to which it functioned as a library of images in which he and such other artists as Bortolotti, Favario, and Gatti, obtained information on contemporary art. See Fantoni, *Arte, vanguardia*, 26–29.

73. Ibid., 30.

74. This is understandable because this portrait was a central work of modern art in which features could be found as prescribed by the manifesto: anti-decorativism, anti-narrativity, anti-academicism, an example of "serious, pro-

found, creative" painting that these artists called for. For a chronology of the process of the Rosario avant-garde see Fantoni's contribution to "Rosario: Opciones de la vanguardia," 296–98.

75. And when they did take an interest in this group, they were predictably attracted to Piero Manzoni and Yves Klein, rather than Arman or Spoerri. See Fantoni, *Arte, vanguardia*, 33.

76. Cf. Mena, *La opción analítica en el arte moderno.*

77. Such as Renzi's *1000 litros de agua, 1000 litros de aire* (1,000 Liters of Water, 1,000 Liters of Air). Ibid., 51.

78. Ibid., 54.

79. Cf. O'Donnell, "Estado y alianzas en la Argentina," 523–54.

80. The work of Carballa (*El poder de las llaves* [The Power of Keys]) was a lined panel in black velvet with reversible door: On one side it said "Vietnam" and there were three dried doves; the other side was covered with glass beads. The viewer had access to one or the other side by using one of the keys provided. Jacoby's presentation included, under the general title *El mensaje* (The Message), a black board with the text "Mensaje en el Di Tella" (Message in the Di Tella), a teletype device that transmitted daily international political information (strikes, the Paris May, etc.), and the photograph of an African American protesting against racism.

81. Fantoni, *Arte, vanguardia*, 54.

82. Cf. Sacco et al., *Tucumán Arde*, 49–51.

83. Fantoni, *Arte, vanguardia*, 57.

84. Ibid., 59.

85. Chronology, 1969 (mimeograph), León Ferrari Archives.

86. McLuhan, *Understanding Media.*

87. See Herrera, "La experimentación con los medios masivos" 249–54, and, by the same author, "En medio de los medios."

88. Jacoby, "Contra el happening," 129–30.

89. See Brennan, *El Cordobazo*, 163–64.

90. First document of the group. Cited in Sacco et al., *Tucumán Arde*, 60–61.

91. Ferrari, "The Art of the Meanings," paper presented at the Primer Encuentro de Artistas de Vanguardia (First Conference of Avant-Garde Artists), Rosario, August 1968. Cf. Katzenstein and Giunta, eds., *Listen, Here, Now!*, 311–16.

92. García Canclini, "Estrategias simbólicas," 136.

93. Gramuglio and Rosa, Tucumán Arde, declaration of the exhibition in Rosario, 1968. Cf. Longoni and Mestman, *Del Di Tella.*

94. The artists, sociologists, and social communicators who participated were, from Rosario, Noemí Escandell, Graciela Carnevale, María Teresa Gramuglio, Marta Greiner, María Elvira de Arechavala, Estela Pomerantz, Nicolás Rosa, Aldo Bortolotti, José Lavarello, Edmundo Giura, Rodolfo Elizalde, Jaime Rippa, Rubén Naranjo, Norberto Puzzolo, Eduardo Favario, Emilio Ghiloni, Juan Pablo Renzi, Carlos Schork, Nora de Schork, David de Nully Braun, Roberto Zara, Oscar Bidustwa, Raúl Pérez Cantón, Sara López Dupuy; from Buenos Aires, León Ferrari, Roberto Jacoby, Beatriz Balbé; and from Santa Fé, Graciela Borthwick, Jorge Cohen, and Jorge Conti.

95. A team composed of Silvia Sigal, Miguel Murmis, and Carlos Waisman.

96. Renzi explains the origin of the title: "The idea for the name, *Tucumán Arde* (Tucumán Is Burning), derives from 'Arde París' (Paris Is Burning), a movie that was in the theaters, and it was proposed by Margarita Paksa. A very good idea, that we decided to use for its power, its efficiency, even though Margarita did not participate in the entire process, she didn't put her signature on the work, as they say." Juan Pablo Renzi in Fantoni, *Arte, vanguardia*, 61. The movie was *Paris brûle-t-il?* by René Clement, filmed in 1966.

97. Reproduced in Sacco et al., *Tucumán Arde*, 75.

98. In this regard, see Marchan Fiz, *Del arte objetual al arte de concepto*, 267–71; for more on conceptualism in Latin America, see Ramírez, "Blueprint Circuits," 156–67; Barnitz, "Conceptual Art and Latin America, 35–48; Ramírez, "Tactics for Thriving on Adversity," 53–71; on conceptualism in Argentina, see Giunta, "Arte y (re)presión," 3:875–89, and "Las batallas de la vanguardia entre el peronismo y el desarrollismo," 2:58–118.

99. In this regard see Buchloh, "From the Aesthetic of Administration to Institutional Critique," 41–53.

100. Evidence of this is, for example, the works of Renzi after 1966, such as *Cubo de Hielo y Charco de Agua*.

101. Cited in Sacco et al., *Tucumán Arde*, 63.

102. Ferrari indicates this relationship among the local experiences and the formulation of a new aesthetic program. Ferrari, "The Art of the Meanings," in Katzenstein and Giunta, eds., *Listen, Here, Now!*

103. If we use Renzi's figures as a gauge, of approximately 1,000 spectators daily, the maximum would be 25,000, whereas the exhibition Le Parc at the Di Tella Institute (the exhibition with the highest attendance) had received 159,287 visitors.

Conclusions

1. See Claudia Gilman on the promotion of a specific form of literary production on behalf of the revolution, "Las 'literaturas de la política' en Cuba," 153–61.

2. Pogolotti, "Conversación con Lea Lublin," 201.

3. Ibid., 202.

4. A summary of these views may be found in the article by Kemble, "Autocolonización cultural."

5. Cf. Guido Di Tella, interview with King, in *El Di Tella*, 204–5.

6. Cf. Oteiza, "El cierre de los centros," 77–108.

7. Romero Brest, *Arte visual en el Di Tella*, 207.

8. Ibid. See also the interview with King in *El Di Tella*, 214–24.

9. It should be noted that the MOMA has an extensive collection of Latin American art, largely acquired with funds from the Rockefeller Foundation, which remains in storage and has almost never been exhibited.

10. See Carol Duncan and Alan Wallach on relations between space and ideology, as well as on "ceremonial space" and "ritual labyrinth" oriented toward including the spectators in the story of Western modern art, "MOMA: Ordeal and Triumph on 53rd Street," 48–57. In the exhibitions held during the year 2000, with which the MOMA closed the millennium (Modern Starts: People, Place, Things; Making Choices; and Open Ends), the works of the collection were removed from their traditional niches and organized according to the curatorial script of the exhibits, which included a much broader representation of Latin American art. Currently the MOMA is expanding its facilities and plans a new focus for the collection. It remains for the future to consider the place to be occupied by Latin American art in the new selection of works exhibited publicly.

11. Romero Brest, "¿Qué arte rescatar?," in *Rescate del arte*, n.p.

12. Ibid.

13. When did the 1960s end for Argentine visual arts? There are various possible dates: 1965 was the year Greco committed suicide, Noé stopped painting, and Ferrari chose politics over art; 1966 was the year Santantonín decided to burn his work; 1968 saw the artists confronting the very institutions with which they had until recently been working. The data are all *symptomatic* with respect to the conclusion of a process which, as I have pointed out from the beginning of this book, cannot be established on the basis of any single event.

Bibliography

Archives

Argentina Archives

Archivo Jorge Romero Brest, Instituto de Teoría e Historia del Arte "Julio E. Payró," Facultad de Filosofía y Letras (FFYL), Universidad de Buenos Aires

Archivo Bienales Americanas de Arte, Centro de Arte Contemporáneo, Córdoba

Archivo del grupo Arte, cultura y política en los años '60, Instituto de Ciencias Sociales "Gino Germani," Facultad de Ciencias Sociales, Universidad de Buenos Aires

Fundación Forner-Bigatti, Buenos Aires

Instituto Torcuato Di Tella (ITDT), Universidad Di Tella, Buenos Aires

Museo de Arte Moderno de Buenos Aires (MAM), Buenos Aires

Museo Nacional de Bellas Artes (MNBA), Buenos Aires

Archives of Argentine Artists

León Ferrari

Kenneth Kemble

Julio Llinás

Marta Minujín

Luis Felipe Noé

Rubén Santantonín

Juan Pablo Renzi

Latin American Archives

Archivo Bienal de São Paulo, São Paulo

Archivo Mathias Goeritz, Mexico City

United States Archives

Archives of American Art, Washington: Alfred Barr Jr.; René d'Harnoncourt;
 Clement Greenberg
Museum of Modern Art, New York
Organization of American States, Washington
Rockefeller Archive Center, North Tarrytown, New York

Magazines

Análisis	*Del Arte*
Arte Concreto Invención	*Imago Mundi*
Artinf	*Literatura y Sociedad*
Boa	*Mirador*
Cabalgata	*Mundo Nuevo*
Casa de las Américas	*Pluma y Pincel*
Confirmado	*Primera Plana*
Continente	*Propósitos*
Contrapunto	*La Rosa Blindada*
Convicción	*Sur*
Cuadernos de Cultura	*Ver y Estimar*
Criterio	*Visión*

Newspapers

Antinazi	*La Opinión*
Buenos Aires Herald	*La Prensa*
Clarín	*La Razón*
El Líder	*La Vanguardia*
El Mundo	*Le Quotidien*
La Nación	

Interviews (1995–1999)

Enrique Barilari	Luis Felipe Noé
Oscar Bony	Enrique Oteiza
León Ferrari	Jorge Roiger
Kenneth Kemble	Juan Carlos Romero
Julio Llinás	Rafael Squirru
Jorge López Anaya	Pablo Suarez
Raúl Lozza	Luis Wells
Adolfo Nigro	Guillermo Whitelow

Books and Articles

"Muestra Internacional de Arte Moderno." *La Nación*, November 5, 1960.

"André Malraux: Llegará esta noche a nuestro país." *Clarín*, September 6, 1959.

Acuña, Marcelo L. *De Frondizi a Alfonsín: La tradición política del radicalismo*. Buenos Aires: CEAL, 1984.

Adams, Beverly. "'Calidad de exportación': Institutions and the Internationalization of Argentinean Art 1956–1965." In *Patrocinio, colección y circulación de las artes: XX Coloquio Internacional de Historia del Arte*, ed. Gustavo Curiel. Mexico City: Instituto de Investigaciones Estéticas-UNAM, 1997: 709–24.

Ades, Dawn. *Art in America: The Modern Era, 1820–1980*. New Haven: Yale University Press, 1989.

Adorno, Theodor. *Teoría estética*. Buenos Aires: Orbis-Hyspamérica, 1983 (*Asthetische Theorie*. Frankfurt am Main: Suhrkamp Verlag, 1970).

Alloway, Lawrence. "The Arts and the Mass Media." *Architectural Design* 28 (February 1958): 84–85.

———. "Latin America and International Art." *Art in America* 53, no. 3 (June 1965): 65–77.

Altamirano, Carlos. "Desarrollo y desarrollistas." *Prismas: Revista de historia intelectual* 2, (1998): 75–94.

Altamirano, Carlos and Beatriz Sarlo. *Conceptos de sociología literaria*. Buenos Aires: CEAL, 1990.

———. *Literatura/Sociedad*. Buenos Aires: Edicial, 1993.

Alvarado, Maite and Renata Rocco-Cuzzi. "Primera Plana: El nuevo discurso periodístico de la década del 60." *Punto de Vista* 22 (December 1984): 27–30.

Amaral, Aracy. *Museo de Arte Contemporanea da Universidade de São Paulo: Perfil de um Acervo*. São Paulo: Techint, 1986.

———. *Arte para quê? A preocupação social na arte brasileira, 1930–1970*. São Paulo: Nobel, 1987.

Amarante, Leonor. *As Bienais de São Paulo/1951 a 1987*. São Paulo: Projeto, 1989.

Ameline, Jean-Paul. *Les Nouveaux Réalistes*. Paris: Centre Georges Pompidou, 1992.

American Assembly. *Cultural Affairs and Foreign Relations*. Englewood Cliffs, N.J.: Prentice Hall, 1963.

Anderson, Perry. "Internationalism: A Breviary." *New Left Review* 14 (March–April 2002).

Angel, Félix. "La presencia latinoamericana." In *El espíritu latinoamericano: Arte y artistas en los Estados Unidos, 1920–1970*, ed. Luis R. Cancel. New York: Museum of Arts of the Bronx and Harry N. Abrams, 1989: 222–63.

Aron, Raymond. "La diplomacia de los viajes." *Clarín*, November 13, 1959.

Avellaneda, Andrés. *Censura, autoritarismo y cultura: Argentina 1960–1983*. Buenos Aires: CEAL, 1986.

Barnitz, Jacqueline. "Conceptual Art and Latin America: A Natural Alliance." In *Encounters/Displacements*, ed. Marí Carmen Ramírez and Beverly Adams. Austin: Archer M. Huntington Art Gallery, 1992: 35–48.

Baron, Stephanie, ed. *"Degenerate Art": The Fate of the Avant-Garde in Nazi Germany*. Los Angeles: Los Angeles County Museum of Art, 1991.

Barr, Alfred H. Jr. "Introduction." In *The New American Painting*. New York: Museum of Modern Art, 1958: 15–19.

Bayón, Damián Carlos. "Arte abstracto, concreto, no figurativo." *Ver y Estimar* 6 (September 1948): 60–62.

———. "Encuesta sobre el arte abstracto." *Ver y Estimar* 26 (November 1951): 45–53.

Bell, Daniel. *The Cultural Contradictions of Capitalism*. New York: Basic Books, 1976.

Benjamin, Walter. *Sobre el programa de la filosofía futura*. Barcelona: Planeta-Agostini, 1986 (*Illuminationen: Ausgewählte Schriften*. Frankfurt am Main: Suhrkamp Verlag, 1961).

———. *Tentativas sobre Brecht: Iluminaciones III*. Madrid: Taurus, 1987 (*Versuche über Brecht:. Iluminationen III*. Frankfurt am Main: Suhrkamp Verlag, 1978).

———. *Imaginación y sociedad: Iluminaciones I*. Madrid: Taurus, 1989 (*Illuminationen I*. Frankfurt am Main: Suhrkamp Verlag, 1969).

———. "O surrealismo: Loretione instantanea de la inteligencia europea." In *Imaginación y sociedad: Iluminaciones I*. Madrid: Taurus, 1989.

———. *Discursos interrumpidos I*. Buenos Aires: Taurus, 1989 (*Illuminationen: Ausgewählte Schriften I*. Frankfurt am Main: Suhrkamp Verlag, 1977).

Berger, Mark T. *Under Northern Eyes: Latin American Studies and U.S. Hegemony in the Americas, 1898–1990*. Bloomington: Indiana University Press, 1995.

Berman, Marshall. *Todo lo sólido se desvanece en el aire: La experiencia de la modernidad*. Buenos Aires: Siglo XXI-Catálogos, 1989 (*All That Is Solid Melts into Air: The Experience of Modernity*. New York: Simon and Schuster, 1982).

———. "Brindis por la modernidad." In *El debate modernidad pos-modernidad*, ed. Nicolás Casullo. Buenos Aires: Puntosur, 1989: 67–91.

Berni, Antonio. "El Salón Independiente." *Antinazi*, September 27 1945, 7.

Borges, Jorge Luis. "Anotación del 23 de agosto de 1944." *Sur* 120 (October 1944): 24.

Borricaud, F. *Essai sur les intellectuels et les passions démocratiques*. Paris: puf, 1980.

Boschetti, Anna. *Sartre y "Les Temps Modernes."* Buenos Aires: Nueva Visión, 1990.

Botana, Natalio R. et al. *El régimen militar: 1966–1973.* Buenos Aires: Ediciones La Bastilla, 1973.

Bourdieu, Pierre. "Campo intelectual y proyecto creador." In *Problemas del estructuralismo,* ed. Jean Pouillon et al. Mexico City: Siglo XXI, 1967: 161–63.

———. *Campo del poder y campo intelectual.* Buenos Aires: Folios Ediciones, 1983. ("Champ du pouvoir, champ intellectuel et habitus de classe." *Scoliès,* 1 [1971]).

———. *Sociología y cultura.* Mexico City: Grijalbo, 1990 (*Questions de sociologie.* Paris: Les Éditions de Minuit, 1984).

———. *La distinción: Criterio y bases sociales del gusto.* Madrid: Taurus, 1991 (*La distinction.* Paris: Les Éditions de Minuit, 1979).

———. *Las reglas del arte.* Barcelona: Anagrama, 1995 (*Les règles de l'art: Genése et structure du champ littéraire.* Paris: Éditions du Seuil, 1992).

Bozo, Dominique. *André Breton y el surrealismo.* Exhibition catalogue. Madrid: Museo Nacional de Arte Reina Sofía, 1991.

Brennan, James P. *El Cordobazo.* Buenos Aires: Sudamericana, 1996.

Breton, André. *Manifiestos del surrealismo.* Barcelona: Labor, 1980.

Brocato, Carlos Alberto. "Defensa del realismo socialista." *La Rosa Blindada,* December 3, 1964, 3.

Broullón, Roberto. "Apuntes sobre el vanguardismo." *Literatura y Sociedad* 1 (October–December 1965): 107–11.

Buccellato, Laura, *Greco-Santantonin.* Buenos Aires: Fundación San Telmo, 1987.

———. "Berni, Historia de dos personajes: Juanito Laguna y Ramona Montiel." In *Antonio Berni.* Madrid: Telefónica de España, 1995: 11–15.

Buchloh, Benjamin H. D. "From the Aesthetic of Administration to Institutional Critique." In *L'art conceptuel, une perspective.* Paris: Musée d'Art Moderne de la Ville de Paris, 1989: 41–53.

Bürger, Peter. *Theory of the Avant-Garde,* translation from the German by Michael Shaw. Minneapolis: University of Minnesota Press, 1984 (*Theorie der Avantgarde.* Frankfurt am Main: Suhrkamp Verlag, 1974).

———. *Crítica de la estética idealista.* Madrid: Visor, 1996 (*Zur Kritik der idealistischen Ästhetik.* Frankfurt am Main: Suhrkamp Verlag, 1983).

Burucúa, José E. and Laura Malosetti Costa. "Iconografía de la mujer y lo femenino en la obra de Raquel Forner." In *Homenaje a Raquel Forner.* Buenos Aires: Galería Jacques Martínez, 1992.

Burucúa, José E. et al. *Exposición del Museo Nacional de Bellas Artes de la República*

Argentina: Arte Francés y Argentino en el Siglo XIX. Buenos Aires: MNBA, 1990.

Cabanne, Pierre. *El siglo de Picasso: Parte III: La guerra*. Madrid: Ministerio de Cultura, 1982 (*Le siècle de Picasso, Tome III: Guernica et la guerre (1937–1955)*. Paris: Gallimard, 1975).

Camnitzer, Luis. "The Museo Latinoamericano and M.I.C.L.A." Mimeograph, unpublished, 1991.

Canaday, John. "Hello, Sr. Brest: A Dialogue on Art, Half Imaginary." *New York Times*, September 13, 1964, Art X.: 27.

———. "Art: A Hit Scored by 28 Painters Lured from Latin America." *New York Times*, September 23, 1964, 52.

Cardoza y Aragón, Luis. "Picasso." *La Rosa Blindada*, October 1, 1964, 16–21 (first published in *Casa de las Américas* 3, nos. 20–21 [September-December, 1963]).

Carpani, Ricardo. *Arte y revolución en América Latina*. Buenos Aires: Coyoacán, 1961.

———. *La política en el arte*, Buenos Aires: Coyoacán, 1962.

———. *Arte y militancia*. Madrid: Lee y Discute, 1975.

Casanegra, Mercedes. *Jorge de la Vega*. Buenos Aires: Gaglianone, 1987.

———. *Luis Felipe Noé*. Buenos Aires: Gaglianone-alba, 1988.

Castro, Fidel. "Palabras a los intelectuales." *Cuadernos de Cultura* 55 (January–February 1962): 13–43.

Casullo, Nicolás. *París 68: Las escrituras, el recuerdo y el olvido*. Buenos Aires: Manantial, 1998.

Cernadas, Jorge. "Notas sobre la desintegración del consenso antiperonista en el campo intelectual: *Sur*, 1955–1960." In VV.AA., *Cultura y política en los años" 60*. Buenos Aires: Instituto de Investigaciones "Gino Germani," Facultad de Ciencias Sociales y Oficina de Publicaciones del cbc-uba, 1997: 133–49.

Clark, T. J. *The Absolute Bourgeois: Artists and Politics in France: 1848–1851*. London: Thames and Hudson, 1973.

———. *Image of the People: Gustave Courbet and the 1848 Revolution*. London: Thames and Hudson, 1973.

———. "Clement Greenberg's Theory of Art." *Critical Inquiry* 9, no. 1 (1982): 139–56.

———. *Painting of Modern Life: Paris in the Art of Manet and His Followers*. Princeton, N.J.: Princeton University Press, 1984.

Cobbs, Elizabeth A. *The Rich Neighbor Policy: Rockefeller and Kaiser in Brazil*. New Haven, Conn.: Yale University Press, 1992.

Cochran, Thomas C. and Rubén E. Reina. *Espíritu de empresa en la Argentina*. Buenos Aires: Emecé, 1965.

Cockcroft, Eva. "Abstract Expressionism, Weapon of the Cold War." *Artforum* 12, no. 10 (June 1974): 39–41.

———. "Los Estados Unidos y el arte latinoamericano de compromiso social." In *El espíritu latinoamericano: Arte y artistas en los Estados Unidos, 1920–1970*, ed. Luis R. Cancel. New York: Museum of the Arts of the Bronx and Harry N. Abrams, 1989: 184–221 (*The Latin American Spirit: Art and Artists in the United States, 1920–1970*).

Cohn-Bendit, D., Jean-Paul Sartre, and Herbert Marcuse. *La imaginación al poder, París Mayo 1968*. Barcelona: Argonauta, 1982.

Coleman, Peter. *The Liberal Conspiracy: The Congress for Cultural Freedom and the Struggle for the Mind of Postwar Europe*. New York: Free Press, 1989.

Connell-Smith, Gordon. *Los Estados Unidos y la América Latina*. Mexico City: F.C.E., 1977 (*The United States and Latin America: An Historical Analysis of Inter-American Relations*. London: Heinemann Educational, 1974).

Córdova Iturburu, Cayetano. "Panorama general, 1810–1960." In *150 años de arte argentino*. Buenos Aires: Museo Nacional de Bellas Artes, 1961.

———. *Pettoruti*. Buenos Aires: Academia Nacional de Bellas Artes, 1980.

———. *80 años de pintura argentina*. Buenos Aires: Librería La Ciudad, 1981.

Correas, Carlos. *La operación Masotta (cuando la muerte también fracasa)*. Buenos Aires: Catálogos, 1991.

Crow, Thomas. "Modernism and Mass Culture in the Visual Arts." In *Pollock and After: The Critical Debate*, ed. Francis Frascina. New York: Harper & Row, 1985: 233–66.

———. *Modern Art in the Common Culture*. New Haven, Conn.: Yale University Press, 1996.

———. *The Rise of the Sixties: American an European Art in the Era of Dissent*. New York: Harry N. Abrams, 1996.

Danto, Arthur. *After the End of Art: Contemporary Art and the Pale of History*. Princeton: Princeton University Press, 1997.

Deira, Macció, Noé, de la Vega: 1961 Nueva Figuración 1991. Buenos Aires: Centro Cultural Recoleta, 1991.

Denis, Maurice. *Teoría estética*. Buenos Aires: El Ateneo, 1944 (*Théories, 1890–1910, du symbolisme et de Gauguin vers; un nouvel ordre classique*. Paris: L. Rouart and J. Watelin, 1920).

Derbecq, Germaine. "Alberto, el mago de Buenos Aires." Reprinted in Francisco Rivas (organizer), *Alberto Greco*. Valencia: ivam, Centre Julio González, 1991–92.

Di Tella, Torcuato S. (with the collaboration of Horacio Caggero). *Torcuato Di*

Tella: Industria y algunas cosas más. Buenos Aires: Asociación Dante Alighieri, 1993.

Duncan, Carol and Alan Wallach. "MOMA: Ordeal and Triumph on 53rd Street." *Studio International* 194, no. 988 (January 1978): 48–57.

Egbert, Donald Drew. *El Arte y la Izquierda en Europa: De la Revolución Francesa a Mayo de 1968*. Barcelona: Gustavo Gili, 1981 (*Social Radicalism and the Arts, Western Europe: A Cultural History from the French Revolution to 1968*. New York: Knopf, 1970).

Elderfield, John, ed. *Essays on Assemblage*, Studies in Modern Art 2. New York: Museum of Modern Art, 1992.

Escobar, Arturo. "Imagining a Post-Development Era? Critical Thought, Development and Social Movements." *Social Text* 31/32 (1993): 20–56.

Fantoni, Guillermo. "Tensiones hacia la política: Del Homenaje al Viet-nam a la Antibienal." *SiSi* 2, no. 2 (1990).

———. "Rosario: Opciones de la vanguardia." In VV.AA., *Cultura y política en los año '60*. Buenos Aires: Instituto de Investigaciones "Gino Germani," Facultad de Ciencias Sociales y Oficina de Publicaciones del cbc-uba, 1997: 287–98.

———. *Arte, vanguardia y política en los años '60: Conversaciones con Juan Pablo Renzi*. Buenos Aires: El Cielo por Asalto, 1998.

Ferrari, León. *Palabras ajenas*. Buenos Aires: Falbo, 1967.

Fló, Juan. "Torres-García in (and from) Montevideo." I *El Taller Torres-García: The School of the South and Its Legacy*, ed. Mari Carmen Ramírez. Austin: University of Texas Press, 1992: 25–43.

Flores Ballesteros, Elsa. "Notas sobre la poética de 'Tucumán Arde.'" In *Tucumán Arde*, ed. Graciela Sacco, Andrea Sueldo, and Silvia Andin. Rosario: Sacco-Sueldo, 1987: 9–12.

Foglia, Carlos A. *Arte y mistificación*. Buenos Aires: Author's edition, 1958.

Ford, Aníbal and Jorge B. Rivera. "Los medios de comunicación en la Argentina." In *Medios de comunicación y cultura popular*. Buenos Aires: Legasa, 1985: 24–45.

Foucault, Michel. *The Archeology of Knowledge and the Discourse on Language*. New York: Pantheon Books, 1972 (*L'Archéologie du savoir*. Paris: Gallimard, [1969] 1977).

———. *Microfísica del poder*. Madrid: La Piqueta, 1980 (*Un Microphysique du pouvoir*).

Frascina, Francis, ed. *Pollock and After: The Critical Debate*. New York: Harper & Row, 1985.

Frigerio, S. "Actualité de l'art argentin." *Les Beaux-Arts* 966 (February 23, 1962).

Garaudy, Roger. *Hacia un realismo sin fronteras: Picasso—Saint-John Perse—Kafka*.

Buenos Aires: Lautaro, 1964 (*D'un realisme sans rivages—Picasso—Saint-John Perse—Kafka*. Paris: Plon, 1963).

———. *60 oeuvres qui annoncerent le futur*. Geneve: Albert Skira, 1974.

García Canclini, Néstor. "Vanguardias artísticas y cultura popular." In *Transformaciones* 90. Buenos Aires: CEAL, 1973.

———. *Arte popular y sociedad en América Latina*. Mexico City: Grijalbo, 1977.

———. "Estrategias simbólicas del desarrollismo económico" (1979). In *La producción simbólica: Teoría y método en sociología del arte*. Mexico City: Siglo XXI, 1986: 96–136.

———. *Culturas híbridas: Estrategias para entrar y salir de la modernidad*. Mexico City: Grijalbo, 1990.

Gené, Marcela. "Política y espectáculo: Los festivales del primer peronismo: El 17 de octubre de 1950." In *Arte y recepción*. Buenos Aires: Centro Argentino de Investigadores de Artes, 1997: 185–92.

Ghioldi, Américo. "Carta." *La Vanguardia*, April 22, 1947, 1.

Gibaja, Regina E. *El público de arte*. Buenos Aires: Eudeba-ITDT, 1964.

Gil, Federico G. *Latin American-United States relations*. New York: Harcourt Brace Jovanovich, 1971.

Gilman, Claudia. "Las 'literaturas' de la política en Cuba." In *Literatura y poder*, ed. De Paepe et al. Lovaina: Leuven University Press, 1995: 153–62.

———. "La situación del escritor latinoamericano: la voluntad de politización." In V V.AA., *Cultura y política en los años '60*. Buenos Aires: Instituto de Investigaciones "Gino Germani," Facultad de Ciencias Sociales y Oficina de Publicaciones del cbc-uba, 1997: 171–86.

———. "La autonomía, como el ser, se dice de muchas maneras." In V V.AA., *Nuevos territorios de la literatura latinoamericana*. Instituto de Literatura Hispanoamericana: Facultad de Filosofía y Letras, Oficina de Publicaciones del cbc-uba, 1997: 131–39.

Giunta, Andrea. "Pintura en los 70: Inventario y realidad." In VV.AA., *Arte y Poder*. Buenos Aires: CAIA-FFyL, 1993: 215–24.

———. "Arte y (re)presión: Cultura crítica y prácticas conceptuales en Argentina." In VV.AA, *Arte, historia e identidad en América: Visiones Comparativas*. Mexico City: Instituto de Investigaciones Estéticas-UNAM, 1994: 875–90.

———. "Destrucción-creación en la vanguardia artística del sesenta: Entre *Arte Destructivo* y 'Ezeiza es Trelew.'" In VV.AA., *Arte y Violencia*. Mexico City: Instituto de Investigaciones Estéticas-UNAM, 1995: 59–81.

———. "Hacia las 'nuevas fronteras': *Bonino* entre Buenos Aires, Río de Janeiro y Nueva York." In VV.AA., *El arte entre lo público y lo privado*. Buenos Aires: Centro Argentino de Investigadores de Artes, 1995: 277–84.

———. "Imagen y poder en el espacio urbano: Buenos Aires 1966–1976." In VV.AA., *Cidade: Historia, Cultura e Arte: V Congresso Brasileiro de Historia da Arte*. São Paulo: Universidade de São Paulo, 1995: 107–14.

———. "Bienales Americanas de Arte: Una alianza entre arte e industria." In VV.AA., *Patrocinio, colección y circulación de las artes: XX Coloquio Internacional de Historia del Arte*, ed. Gustavo Curiel. Mexico City: Instituto de Investigaciones Estéticas-UNAM, 1997: 725–56.

———. "Eva Perón: Imágenes y públicos." In VV.AA., *Arte y recepción*. Buenos Aires: Centro Argentino de Investigadores de Artes, 1997: 177–84.

———. "Historia oral e historia del arte: El caso de *Arte Destructivo*." In VV.AA., *Estudios e investigaciones* 7. Instituto de Teoría e Historia del Arte "Julio E, Payró," Facultad de Filosofía y Letras, Universidad de Buenos Aires, 1997: 77–96.

———. "La política del montaje: León Ferrari y 'La Civilización Occidental y Cristiana.'" In VV.AA., *Cultura y política en los años '60*. Buenos Aires: Instituto de Investigaciones "Gino Germani," Facultad de Ciencias Sociales y Oficina de Publicaciones del cbc-uba, 1997: 299–314.

———. "*Tucumán Arde*: Una vanguardia entre el arte y la política." In *I Bienal de Artes Visuais do Mercosul*. Porto Alegre, 1997: 520–31.

———. "Bodies of History. Avant-Garde, Politics and Violence in Contemporary Argentine Art." In *Cantos Paralelos/ Parallel Cantos: Experimental Art from Argentina*, ed. Mari Carmen Ramírez. Austin: Jack S. Blanton Museum of Art, University of Texas at Austin, 1999: 130–65.

———. "Las batallas de la vanguardia entre el peronismo y el desarrollismo." In *Nueva Historia Argentina: Arte, Sociedad y Política II*, ed. José Emilio Burucúa. Buenos Aires: Sudamericana, 1999: 57–118.

———. "Nacionales y populares: Los Salones del peronismo." In *Tras los pasos de la norma: Salones Nacionales de Arte en Argentina, 1911–1989*, ed. Marta Penhos and Diana B. Wechsler. Buenos Aires: Archivos del Centro Argentino de Investigadores del Arte 2—El Jilguero, 1999: 153–90.

Goldar, Ernesto. *Buenos Aires, vida cotidiana en la década del '50*. Buenos Aires: Plus Ultra, 1992.

Goldmann, Kjell. *The Logic of Internationalism: Coercion and Accommodation*. London: Routledge, 1994.

Goldman, Shifra. "La pintura mexicana en el decenio de la confrontación: 1955–1965." *Plural* 85 (October 1978): 33–44.

———. *Contemporary Mexican Painting in a Time of Change*. Austin: University of Texas Press, 1981.

Gómez Sicre, José. "Introduction." In *Gulf-Caribbean Art Exhibition*. Houston: Museum of Houston, 1956.

———. "Trends—Latin America." *Art in America* 47, no. 3 (fall 1959): 22–23.

———. "Nota Editorial." *Boletín de Artes Visuales* 5 (May–December 1959): 1–3.

Gorriarena, Carlos. "Tres pintores, tres tendencias: Premio Internacional Di Tella 64." *La Rosa Blindada*, December 3, 1964, 20–22.

Gramsci, Antonio. *Cultura y literatura*. Barcelona: Península, 1972.

———. *Los intelectuales y la organización de la cultura*. Mexico City: Juan Pablos Editor, 1975 (*Gli intellettuali el'organizazione della cultura*. Rome: Riuniti, 1971).

Gramuglio, María Teresa. "La summa de Bourdieu." *Punto de Vista* 47 (December 1993): 38–42.

Greenberg, Clement. "Avant-Garde and Kitsch." *Partisan Review* (fall 1939): 34–49.

———. "The Decline of the Cubism." *Partisan Review* 15, no. 3 (March 1948): 366–69.

———. "Post Painterly Abstraction." *Art International* 8, nos. 5–6 (summer 1964): 63–65.

———. "Avant-Garde Attitudes: New Art in the Sixties" (1968). In *Clement Greenberg: The Collected Essays and Criticism*, ed. John O'Brian, vol. 4. Chicago: University of Chicago Press, 1995; 292–303.

———. "Modernist Painting" (1960) and "Louis and Noland." In *Clement Greenberg: The Collected Essays and Criticism*, ed. John O'Brian, vol. 4. Chicago: University of Chicago Press, 1995: 85–93 and 94–100.

Guilbaut, Serge. *How New York Stole the Idea of Modern Art*. Chicago: University of Chicago Press, 1983.

———. "Rideau d'art et rideau de fer: Perspectives de la critique d'art en 1948." In *Extra Muros: Art suisse contemporain*, ed. Edmond Charrière, Catherine Quéloz, and Dieter Schwartz. La Chaux-de-Fonds: Musée des Beaux-Arts, 1991: 93–115.

———. "Poder de la decrepitud y ruptura de compromisos en el París de la Segunda Posguerra mundial." In *Sobre la desaparición de ciertas obras de arte*, ed. Serge Guilbaut. Mexico City: Curare-Fonca, 1995: 87–145 (Fragment published as "Bram Van Velde en Amérique: La Peinture Invisible," in *Bram Van Velde*. Paris: Musée National d'Art Moderne, Centre Georges Pompidou, 1989).

———. "Dripping on the Modernist Parade: The Failed Invasion of Abstact Art in Brazil, 1947–1948." In *Patrocinio, colección y circulación de las artes: XX Coloquio Internacional de Historia del Arte*, ed. Gustavo Curiel. Mexico City: Instituto de Investigaciones Estéticas-UNAM, 1997: 807–16.

————, ed. *Reconstructing Modernism: Art in New York, Paris and Montreal 1945–1964*. Cambridge, Mass.: MIT Press, 1992.

Habermas, Jürgen. "Modernidad: Un proyecto incompleto." *Punto de Vista* 21 (August 1984): 27–31.

Hadjinicolau, Nicos. "On the Ideology of Avant-Gardism." *Praxis* 6 (1982): 39–70.

Halperín Donghi, Tulio. "Crónica del período: Treinta años: Tres revoluciones." In VV.AA., *Argentina 1930–1960*. Buenos Aires: Sur, 1961.

————. *Historia contemporánea de América Latina*. Buenos Aires: Alianza Estudio, 1986.

————. *La larga agonía de la Argentina peronista*. Buenos Aires: Ariel, 1994.

Herrera, María José. "La experimentación con los medios masivos de comunicación en el arte argentino de la década del sesenta: El 'happening para un jabalí difunto.'" In VV.AA., *El arte entre lo público y lo privado*. Buenos Aires: Centro Argentino de Investigadores de Artes, 1995: 249–54.

————. "En medio de los medios: La experimentación con los medios masivos de comunicación en la Argentina de la década del 60." In VV.AA., *Arte argentino del siglo XX*. Buenos Aires: FIAR, 1997: 71–114.

Hlito, Alfredo. *Escritos sobre Arte*. Buenos Aires: Academia Nacional de Bellas Artes, 1995.

Howard, David Brian. "Modernism on the Margins: Clement Greenberg's 'Safari' to Western Canada in 1962." In *Arte, historia e identidad en América: Visiones comparativas*, ed. Gustavo Curiel, Renato González Mello, and Juana Gutierrez Haces. Mexico City: Instituto de Investigaciones Estéticas-UNAM, 1994: 841–56.

Hulten, Pontus, ed. *Paris-Paris, 1937–1957*. Paris: Centre Georges Pompidou-Gallimard, 1992.

Hunter, Sam. "The Cordoba Biennial." *Art in America* 2 (March–April 1967): 84–89.

Huyssen, Andreas. *After the Great Divide: Modernism, Mass Culture, Postmodernism*. Bloomington: Indiana University Press, 1986.

Ibarlucie, Ricardo. "Benjamin y el Surrealismo." In VV.AA., *Sobre Walter Benjamin, Vanguardias, historia, est ética y literature: Una visión latinamericana*. Buenos Aires: Alianza-Goethe, 1993: 150–64.

Jacoby, Roberto. "Contra el happening." In *Happenings*, ed. Oscar Masotta et al. Buenos Aires: Jorge Alvarez, 1967: 129–30.

James, Daniel. *Resistencia e integración: El peronismo y la clase trabajadora argentina:1946–1976*. Buenos Aires: Sudamericana, 1990 (*Resistance and Integration:*

Peronism and the Argentine Working Class, 1946–1976. New York: Cambridge University Press, 1988).

———. "17 y 18 de Octubre de 1945: El peronismo, la protesta de masas y la clase obrera argentina." In *El 17 de octubre de 1945*, ed. Juan Carlos Torre. Buenos Aires: Ariel, 1995: 117–18.

Jameson, Fredric, "Periodizing the 60s." In *The Sixties Without Apology*, ed. Sonya Sayres et al. Minneapolis: University of Minnesota Press with Social Text, 1984: 178–209.

Johnson, John J. *Political Change in Latin America: The Emergence of the Middle Sectors*. Stanford, Calif.: Stanford University Press, 1958.

Katzenstein, Ines, and Andrea Giunta, eds. *Listen, Here, Now! Argentine Art in the Sixties: Writings of the Avant-Garde*. New York: Museum of Modern Art, 2004.

Kemble, Kenneth. "Arte Destructivo." In *Arte Destructivo*. Buenos Aires: Galería Lirolay, 1961.

———. "Autocolonización cultural: La crisis de nuestra crítica de arte." *Pluma y Pincel* 9 (August 2, 1976): 10.

———. "Rubén Santantonín." In VV.AA., *Arte Argentino Contemporáneo*. Madrid: Ameris, 1979: 119–21.

———. *Kenneth Kemble: Collages, Relieves y Construcciones 1956–1961*. Buenos Aires: La Galería, 1979.

King, John. *El Di Tella y el desarrollo cultural argentino en la década del sesenta*. Buenos Aires: Gaglianone, 1985.

———. *Sur: Estudio de la revista argentina y de su papel en el desarrollo de una cultura 1931–1970*. Mexico City: FCE, 1989 (*Sur: A Study of the Argentine Literary Journal and Its Role in the Development of a Culture 1931–1970*. Cambridge: Cambridge University Press, 1986).

Kozloff, Max. "American Painting During the Cold War." *Artforum* 11, no. 9 (May 1973): 43–54.

Landi, Oscar, A. Canitrot, M. Cavarozzi, and R. Frenkel. "Intelectuales y política en Argentina." *Debates* 4 (October–November 1985): 4–8.

Laugier, Claude. "Impasse Ronsin." In *Paris-Paris, 1937–1957*, ed. Pontus Hulten. Paris: Centre Georges Pompidou-Gallimard, 1992: 440–41.

Le Parc, Julio. "El Grupo de Investigación de Arte Visual repite: Basta de mistificaciones." In *Premio Nacional e Internacional ITDT 1964*. Buenos Aires: ITDT, 1964: 56.

———. *Julio Le Parc, experiencias: 30 años, 1958–1988*. Buenos Aires: Secretaría de Cultura de la Nación, Dirección de Artes Visuales, 1988.

Lippard, Lucy. *Six Years: The Dematerialization of the Art Object*. London: Studio Vista, 1973.

———. *A Different War: Vietnam in Art*. Seattle: Whatcom Museum of History and Art, 1990.

———, ed. *El pop art*. Barcelona: Destino-Thames and Hudson, 1993 (1966).

Llinás, Julio. *Panta Rhei*. Buenos Aires: Cuarta Vigilia, 1950.

———. *Fiat Lux: La batalla del hombre transparente*. Buenos Aires: Atlántida, 1994: 234–35.

Llorente Hernández, Angel. *Arte e ideología en el franquismo (1936–1951)*. Madrid: Visor, 1995.

Longoni, Ana. "Oscar Masotta: Vanguardia y revolución en los sesenta." Preliminary study to Oscar Masotta, *Revolución en el arte: Pop-art, happenings y arte de los medios en la década del sesenta*. Buenos Aires: Edhasa, 2004.

Longoni, Ana, and Mariano Mestman. *Del Di Tella a "Tucumán Arde": Vanguardia artística y política en el '68 argentino*. Buenos Aires: El Cielo por Asalto, 2000.

———. "After Pop, We Dematerialize: Oscar Masotta, Happenings, and Media Art at the Beginnings of Conceptualism," in *Listen, Here, Now! Argentine Art in the Sixties: Writings of the Avant-Garde*, ed. Ines Katzenstein and Andrea Giunta. New York: Museum of Modern Art, 2004: 156–72.

López Anaya, Jorge. "El informalismo: La gran ruptura." In *El informalismo*. Buenos Aires: Librería Fausto, 1969.

———. "Arte argentino entre humanismo y tardomodernidad." In *Una visión de la plástica argentina contemporánea, 1940–1990*. Buenos Aires: Fundación Patio Bullrich, 1990.

———. *El arte en un tiempo sin dioses*. Buenos Aires: Almagesto, 1995.

MacLeish, William H. "Cornell's Latin American Year." *Art in America* 3 (May–June 1966): 102–5.

Maistre, Agnès de. *Le Groupe Argentin Deira, Macció, Noé, de la Vega, 1961–1965, ou la figuration eclectique*. Université de Paris IV, La Sorbonne Institut d'Art et d'Archéologie, 1987 (unpublished).

Maldonado, Tomás. *Escritos preulmianos*. Buenos Aires: Infinito, 1997.

———. *¿Qué es un intelectual? Aventuras y desventuras de un rol*. Barcelona: Paidós, 1998.

Mangone, Carlos, and Jorge A. Warley. *Universidad y peronismo (1946–1955)*. Buenos Aires: CEAL, 1984.

———. *El manifiesto: Un género entre el arte y la política*. Buenos Aires: Biblos, 1993.

Marchan Fiz, Simón. *Del arte objetual al arte del concepto*. Madrid: Akal, 1988.

Marchis, Giorgio de. "The Significance of the 1964 Venice Biennale." *Art International* 8, no. 9 (November 1964).

Marcuse, Herbert. "Art as a Form of Reality." In VV.AA., *On the Future of Art*. New York: Viking Press, 1971: 123–34.

———. *El hombre unidimensional*. Buenos Aires: Hyspamérica, 1984 (*One-Dimensional Man*. Boston: Beacon Press, 1954).

———. *Contrarrevolución y revuelta*. Mexico City: Cuadernos Joaquín Moritz, 1986 (*Counterrevolution and Revolt*. Boston: Beacon Press, 1972).

———. *Ensayos sobre política y cultura*. Barcelona: Planeta-Agostini, 1986.

Masotta, Oscar. *El "pop-art."* Buenos Aires: Nuevos Esquemas, 1967.

———. *La historieta en el mundo moderno*. Buenos Aires: Paidós, 1970.

———. *Conciencia y estructura*. 1969. Buenos Aires: Corregidor, 1980.

———. *Revolución en el arte: Pop-art, happenings y arte de los medios en la década del sesenta*. Buenos Aires: Edhasa, 2004.

Masotta, Oscar, et al., *Happenings*. Buenos Aires: Jorge Alvarez, 1967.

Massuh, Víctor. "Crónica del desastre." *Sur* 237 (November–December 1955): 107–8.

Mazzei, Daniel. "Periodismo y política en los años '60: Primera Plana y el golpe militar de 1966." *Entrepasados* 7 (1994): 27–42.

McCammon Martin, Edwin. *Kennedy and Latin America*. Lanham, Md.: University Press of America, 1994.

McLuhan, Marshall. *Understanding Media*. New York: McGraw-Hill, 1964.

Medhurst, Martin J., Robert L. Ivie, Philip Wander, and Robert L. Scott. *Cold War Rhetoric: Strategy, Metaphor, and Ideology*. New York: Greenwood Press, 1990.

Melville, Stephen, and Bill Readings, eds. *Vision and Textuality*. Durham, N.C.: Duke University Press, 1995.

Mena, Filiberto. *La opción analítica en el arte moderno: Figuras e íconos*. Barcelona: Gustavo Gili, 1977.

Merleau-Ponty, Maurice. *Fenomenología de la percepción*. Barcelona: Península, 1994 (*Phénoménologie de la Perception*. Paris: Gallimard, 1945).

Messer, Thomas. *Latin America: New Departures*. Boston: Institute of Contemporary Art and Time, 1961.

———. "Latin America: Esso Salon of Young Artists." *Art in America* 53, no. 5 (October–November 1965): 120–21.

———. "Introduction." In *The Emergent Decade: Latin American Painters and Painting in the 1960's*. Ithaca, N.Y.: Cornell University Press, 1966: xiii–xv.

Metzger, Gustav. *Damaged Nature, Auto-Destructive Art*. Nottingham: Russell Press, 1996.

Mitchell, M. J. T. *Iconology: Image, Text, Ideology*. Chicago: University of Chicago Press, 1986.

———. *Picture Theory: Essays on Verbal and Visual Representation*. Chicago: University of Chicago Press, 1994.

Molina, Enrique. *Costumbres errantes o La redondez de la tierra* (1951). *Obra poética*, 2 vols. *Obras completas*. Buenos Aires: Corregidor, 1987.

Monahan, Laurie. "Cultural Cartography: American Designs at the 1964 Venice Biennale." In *Reconstructing Modernism: Art in New York, Paris and Montreal, 1945-1964*, ed. Serge Guilbaut. Cambridge: MIT Press, 1992: 369–416.

Morero, Sergio. *La noche de los bastones largos*. Buenos Aires: Biblioteca Página/12, 1996.

Mudrovcic, María Eugenia. *Mundo Nuevo: Cultura y Guerra Fría en la década del 60*. Rosario: Beatriz Viterbo, 1997.

Nanni, Martha. "Obra pictórica 1922–1981." In *Antonio Berni*. Buenos Aires: Museo Nacional de Bellas Artes, 1984.

Neiburg, Federico. *Los intelectuales y la invención del peronismo*. Buenos Aires: Alianza, 1998.

Noé, Luis Felipe. "La pintura en Latinoamérica." *Hoy en la Cultura* 1 (November 1961): 14–15.

———. *Premio Nacional Di Tella 1963*. Buenos Aires: ITDT, 1963: 54.

———. *Antiestética*. Buenos Aires: Ed. Van Riel, 1965.

———. "Homenaje a Alberto Greco." In *Alberto Greco*. Buenos Aires: Galería Carmen Waugh, 1970.

———. "La llamada Nueva Figuración Argentina." Lecture at University of Texas, Austin, October 1989.

O'Brian, John, ed. *Clement Greenberg: The Collected Essays and Criticism*. Chicago: University of Chicago Press, 1995.

Ocampo, Victoria. "La hora de la verdad." *Sur* 237 (November–December 1955): 3–4.

O'Donnell, Guillermo A. "Estado y alianzas en la Argentina, 1956–1976." *Desarrollo Económico* 11, no. 64 (January–March 1977): 523–54.

Oteiza, Enrique. "El cierre de los centros de arte del Instituto Torcuato Di Tella." In VV.AA., *Cultura y política en los años '60*. Buenos Aires: Instituto de Investigaciones "Gino Germani," Facultad de Ciencias Sociales y Oficina de Publicaciones del cbc-uba, 1997: 77–108.

Pacheco, Marcelo. *Kenneth Kemble: La Gran Ruptura, obras 1956-1963*. Buenos Aires: Centro Cultural Recoleta, 1998.

Parpagnoli, Hugo. "Pintura y escultura: Hacia un arte de dimensión internacional." In *Argentina 1930-1960*. Buenos Aires: Sur, 1961.

———. "Dos pintores del concurso Di Tella." *Sur* 285 (November–December 1963): 117–19.

———. "Vanguardia Vital y Móvil." *3a Bienal Americana de Arte*. Córdoba, 1966.

Payró, Payró, Julio, E. *Pintura moderna*. Buenos Aires: Poseidón, 1942.

———. "Los pintores franceses y el estilo del siglo XX." *Sur* 147–49 (January–March 1947): 393–403.

———. "Exposición de arte español contemporeaneo." *Sur* 159 (January 1948): 119.

———. "De Manet a nuestros días." *Sur* 177 (July 1949): 82–86.

———. "Exposición en el Instituto de Arte Moderno." *Sur* 177 (July 1949): 86–87.

———. "¿Arte abstracto y arte no objetivo? Carte abienta a Guillermo de Torre." *Sur* 202 (August 1951): 91.

———. *Los héroes del color*. Buenos Aires: Poseidón, 1951.

———. "Exposiciones recientes y tendencia profunda en el arte contemporáneo." *Sur* 217–18 (November–December 1952): 143–47.

———. "Un panorama de la pintura argentina." *Sur* 219–20 (January–February 1953): 159.

Paz, Samuel. "Los últimos diez años de pintura y escultura argentina." In *150 años de arte argentino*. Buenos Aires: Museo Nacional de Bellas Artes, 1961.

Pellegrini, Aldo. *La valija de fuego*. Buenos Aires: Americalee, 1952.

———. "Arte surrealista y arte concreto." *Nueva visión: Revista de cultura visual* 4 (1953): 9–11.

———. "Fundamentos de una estética de la destrucción." In *Arte Destructivo*. Buenos Aires: Galería Lirolay, 1961.

———. *Nuevas tendencias en el arte*. Buenos Aires: Jacobo Muchnik, 1966 (*New Tendencies in Art*. New York: Crown, 1966).

———. *Panorama de la pintura argentina contemporánea*. Buenos Aires: Paidós, 1967.

———. *Para contribuir a la confusión general*. Buenos Aires: Leviatán, 1987 (1965).

Peluffo, Gabriel. "Instituto General Electric de Montevideo: medios masivos, poder transnacional y arte contemporáneo." In VV.AA., *Cultura y política en los años '60*. Buenos Aires: Instituto de Investigaciones "Gino Germani," Facultad de Ciencias Sociales y Oficina de Publicaciones del cbc-uba, 1997: 109–32.

Penhos, Marta and Diana B. Wechsler, eds. *Tras los pasos de la norma: Salones Nacionales de Arte en Argentina, 1911–1989*. Buenos Aires: Archivos del CAIA 2, El Jilguero, 1999.

Perazzo, Nelly. "Aportes para el estudio del informalismo en la Argentina." In *El*

grupo informalista argentino. Buenos Aires: Museo de Artes Plásticas "Eduardo Sívori," 1978.

———. *El arte concreto en la Argentina.* Buenos Aires: Gaglianone, 1983.

Peterson, Harold F. *La Argentina y los Estados Unidos*, vol. 2: *1914–1960.* Buenos Aires: Hyspamérica, 1985.

Pettoruti, Emilio. *Un pintor ante el espejo.* Buenos Aires: Solar/Hachette, 1968.

Piglia, Ricardo, "Literatura y sociedad." *Literatura y Sociedad* 1 (October–December 1965): 1.

Pisarello Virasoro, Roberto G. *Cómo y por qué fue derrocado Frondizi.* Buenos Aires: Biblos, 1996.

Poggioli, Renato. *Teorie dell'arte d'avanguardia.* Bolonia: Societá Editrice il Mulino, 1962.

Pogolotti, Graziella. "Conversación con Lea Lublin." *Casa de las Américas* 36–37 (May–August 1966).

Popper, Frank. *Arte, acción y participación: El artista y la creatividad de hoy.* Madrid: Akal, 1989 (*Art, action et participation: L'artiste et la créativité aujourd'hui.* Paris: Klincksieck, 1985).

Portantiero, Juan Carlos. "Economía y política en la crisis argentina (1958–1973)." In *Estado y sociedad en el pensamiento nacional: Antología conceptual para el análisis comparado*, ed. Ansaldi and J. L. Moreno. Buenos Aires: Cántaro, 1989: 301–46.

Potash, Robert A. *El ejército y la política en la Argentina: 1962–1973.* Buenos Aires: Sudamericana, 1994.

Puiggrós, Adriana, ed. *Peronismo: Cultura política y educación (1945–1955).* Buenos Aires: Galerna, 1993.

Ramírez, Mari Carmen, ed. *The School of the South and Its Legacy.* Austin: University of Texas Press, 1992.

———. "Blueprint Circuits: Conceptual Art and Politics in Latin America." In *Latin American Artists of the Twentieth Century*, ed. Waldo Rasmussen. New York: Museum of Modern Art, 1993: 156–67.

———. "Tactics for Thriving on Adversity: Conceptualism in Latin America, 1960–1980." In *Global Conceptualism: Points of Origin*, ed. Jane Farver et al. New York: Queens Museum of Art, 1999: 53–71.

Rapoport, Mario and Claudio Spieguel. *Estados Unidos y el peronismo: La política norteamericana en la Argentina: 1949–1955.* Buenos Aires: Grupo Editor Latinoamericano, 1994.

Rasmussen, Waldo, ed. *Latin American Artist of the Twentieth Century.* New York: Museum of Modern Art, 1993.

Read, Herbert. *Al diablo con la cultura*. Buenos Aires: Proyección, 1965.

Rebollo Gonçalves, Lisbeth. *Sergio Millet, crítico de arte*. São Paulo: Perspetiva-Editora da Universidade de São Paulo, 1992.

Restany, Pierre. "El Arte, virtud moral, al fin!" In *Premio Nacional Instituto Torcuato Di Tella 1964*. Buenos Aires: ITDT, 1964: 14.

———. "Buenos Aires y el nuevo humanismo." *Planeta* 5 (May–June 1965): 119–29.

———. *Yves Klein*. Paris: Chêne-Hachette, 1982.

Rivas, Francisco. "Alberto Greco [1931–1965]: La novela de su vida y el sentido de su muerte." In *Alberto Greco*. Generalitat Valenciana: ivam Centre Julio Gonzalez, 1991.

Rodríguez Lamas, Daniel. *La presidencia de Frondizi*. Buenos Aires: CEAL, 1984.

———. *La Revolución Libertadora*. Buenos Aires: CEAL, 1985.

Romero, Luis Alberto. *Breve historia contemporánea de Argentina*. Buenos Aires: Fondo de Cultura Económica de Argentina, 1994.

Romero Brest, Jorge. *El problema del arte y del artista contemporáneos*. Buenos Aires: Author's edition, 1937.

———. "Punto de partida." *Ver y Estimar* 1 (April 1948): 3.

———. "El arte argentino y el arte universal." *Ver y Estimar* 1 (April 1948): 4–16.

———. "Picasso el inventor." *Ver y Estimar* 2 (May 1948): 4–5.

———. "Alabanza de Portinari." *Ver y Estimar* 4 (July 1948): 41.

———. *Pintores y grabadores rioplatenses*. Buenos Aires: Argos, 1951.

———. *Qué es el arte abstracto*. Buenos Aires: Columba, 1951.

———. *La pintura europea, 1900–1950*. Mexico City: Fondo de Cultura Económica, 1952.

———. "Reflexiones sobre la historia del cubismo." *Imago Mundi* 1 (September 1953): 52–63.

———. "Palabras liminares." In *XXVIII Exposición Bienal Internacional de Arte de Venecia. Participación de la República Argentina*. Buenos Aires: Ministerio de Educación y Justicia, 1956: 7–8.

———. *4 evidencias de un mundo joven en el arte actual*. Buenos Aires: Museo Nacional de Bellas Artes, August 1961.

———. "L'art actuel del'Amerique Latine en Argentinie." *Art International* 8, no. 10 (December 1964): 27–28.

———. Introduction. *New Art of Argentina*. Minneapolis: Walker Art Center, 1964.

———. *Ensayo sobre la contemplación artística*. Buenos Aires: Eudeba, 1966.

———. "La imagen y el imaginar." *Américas* 12 (December 1966): 30–33.

————. *Semana del arte avanzado en la Argentina*. Buenos Aires: n.p., 1967.

————. *El arte en la Argentina: Ultimas décadas*. Buenos Aires: Paidós, 1969.

————. *Política artísticovisual en Latinoamérica*. Buenos Aires: Crisis, 1974.

————. *Rescate del arte: Ultimos cien años de pintura y escultura en occidente*. Buenos Aires: Gaglianone, 1980.

————. *Arte visual en el Di Tella. Aventura memorable de los años '60*. Buenos Aires: Emecé, 1992.

————. *La pintura del siglo XX (1900–1974)*. Mexico City: Fondo de Cultura Económica, 1994.

————. *Pensamiento en curso (inéditos 1972–1987)*. Buenos Aires: Corregidor, 1996.

Rose, Barbara. "Response to Crisis in American Art." *Art in America* 1 (January–February 1969): 24–35.

Rosenberg, Harold. "On the Fall of Paris." *Parisian Review* 7, no. 6 (November–December 1940): 440–48.

————. "Collective, Ideological, Combative." In *Avant-Garde Art*, ed. T. Hess and J. Ashbery. London: Collier-Macmillan, 1968.

Rostow, Walt Whitman. *The Stages of Economic Growth: A Non-Communist Manifesto*. New York: Cambridge University Press, 1960.

Rouquié, Alain. *Poder militar y sociedad política en la Argentina*. Buenos Aires: Hyspamerica, 1986.

Sacco, Graciela, Andrea Sueldo, and Silvia Andino. *Tucumán Arde*. Rosario: Sacco-Sueldo, 1987.

Sandler, Irving. *El triunfo de la pintura norteamericana: Historia del Expresionismo Abstracto*, Madrid: Alianza Editorial, 1996 (*Triumph of American Painting: A History of American Expresionism*. New York: Harper & Row, 1970).

Santantonín, Rubén. "Hoy a mis mirones." Buenos Aires: Galería Lirolay, 1961.

Sarlo, Beatriz. "Los dos ojos de Contorno." *Punto de Vista* 13 (November 1981): 3–8.

————. *Buenos Aires y una modernidad periférica: Buenos Aires 1920 y 1930*. Buenos Aires: Nueva Visión, 1983.

————. *La batalla de las ideas (1943–1973)*, Buenos Aires, Ariel, 1991.

————. "Victoria Ocampo o el amor de la cita." In *La máquina cultural: Maestras, traductoras y vanguardistas*. Buenos Aires: Ariel, 1998.

Sartre, Jean-Paul. *Imagination*. Translated by Forrest Williams. Ann Arbor: University of Michigan Press, 1962 (1936) (*La imaginación*. Buenos Aires: Sudamericana, 1973; *L'imagination*. Paris: Presses Universitaires de France, 2000).

————. "El pintor sin privilegios." In *Literatura y arte, Situations IV*. Buenos Aires: Losada, 1977: 281–98 (*Portraits: Situations IV*. Paris: Gallimard, 1964).

———. *What Is Literature?* Translated by Bernard Frechtman. Gloucester: Peter Smith, 1978 (*Qu'est-ce que le litterature? Situations II*. Paris: Gallimard, 1948).

———. "Situacion del escritor en 1947." In *What Is Literature?*, trans. Bernard Frechtman. Gloucester: Peter Smith, 1978 (*Qu'est-ce que le litterature? Situations II*. Paris: Gallimard, 1948).

Schlesinger, Arthur M., Jr. *The Vital Center: The Politics of Freedom*. Boston: Riverside Press, (1946) 1962.

Sebreli, Juan José, "El joven Masotta." In *Oscar Masotta. El revés de la trama*, ed. Marcelo Izaguirre, Buenos Aires: Atuel/Anáfora, 1999: 69–70.

Sigal, Silvia. *Intelectuales y poder en la década del sesenta*. Buenos Aires: Punto Sur, 1991.

Sigal, Silvia, and Oscar Terán. "Los intelectuales frente a la política." *Punto de Vista* 42 (April 1992): 42–48.

Slemenson, Marta and Germán Kratochwil. "Un arte de difusores: Apuntes para la comprensión de un movimiento plástico de vanguardia en Buenos Aires, de sus creadores, sus difusores y su público." In *El intelectual Latinoamericano*, ed. J. F. Marsal. Buenos Aires: Ed. del Instituto Di Tella, 1970.

Smulovitz, Catalina. *Oposición y gobierno: Los años de Frondizi*. Buenos Aires: CEAL, 1988.

Solá, Graciela de. *Proyecciones del surrealismo en la literatura argentina*. Buenos Aires: Ediciones Culturales Argentinas, 1967.

Sourrouille, Juan V. *El complejo automotor en Argentina*. Mexico City: ILET-Nueva Imagen, 1980.

Squirru, Rafael. *Primera Exposición Internacional de Arte Moderno*. Buenos Aires: Museo de Arte Moderno, 1960.

———. "Spectrum of Styles in Latin America." *Art in America* 52, no. 1 (February 1964): 81–86.

———. *MAM 10 años, 1956–1967*. Buenos Aires: Museo de Arte Moderno, 1967.

———. *Kenneth Kemble*. Buenos Aires: Gaglianone, 1987.

Stabile, Blanca. "Para una historia del arte concreto en la Argentina." *Ver y Estimar* 2 (December 1954): 15.

Stiles, Kristine. *Rafael Montañez Ortiz: Years of the Warrior 1960–Years of the Psyche 1988*. New York: Museo del Barrio, 1988.

Terán, Oscar. "*Imago Mundi*: De la universidad de las sombras a la universidad del relevo." *Punto de Vista* 33 (September–December 1988): 3–5.

———. *Nuestros años sesentas: La formación de la nueva izquierda intelectual en la Argentina 1956–1966*. Buenos Aires: Punto Sur, 1991.

Torre, Guillermo de. *Joaquín Torres-García*. Buenos Aires: Instituto de Arte Moderno, 1951.

———. "Respuesta a Julio E. Payró." *Sur* 202 (August 1951): 95.

Torre, Juan Carlos, ed. *El 17 de octubre de 1945*. Buenos Aires: Ariel, 1995.

Traba, Marta. *Dos décadas vulnerables en las artes plásticas latinoamericanas 1950–1970*. Mexico City: Siglo XXI, 1973.

Tzara, Tristan. "El surrealismo de posguerra" (lecture at the Sorbonne, April 11, 1948). In Dominique Bozo, *Andre Bretón y el surrealismo* (exhibition catalogue). Madrid: Museo Nacional Centro de Arte Reina Sofía, 1991.

van der Marck, Jan. Foreword. *New Art of Argentina*. Minneapolis: Walker Art Center, 1964.

———. "New Art of Argentina." *Art International* 8, no. 8 (October 20, 1964): 35–38.

Venturi, Lionello. *La Colección Torcuato Di Tella*. Buenos Aires: Centro de Artes Visuales, ITDT, 1965.

Verbitsky, Bernardo. *Villa miseria también es América*. Buenos Aires: Contrapunto, 1987 (1957).

VV.AA. *Argentina 1930–1960*. Buenos Aires: Sur, 1961.

———. *Arte Argentino contemporáneo*. Madrid: Ameris, 1979.

———. *Sobre Walter Benjamin: Vanguardias, historia, estética y literatura: Una visión latinoamericana*. Buenos Aires: Alianza-Goethe, 1993.

Wechsler, Diana B. "Buenos Aires, 1924: Trayectoria pública de la doble presentación de Emilio Pettoruti." In VV.AA., *El arte entre lo público y lo privado*. Buenos Aires: Centro Argentino de Investigadores de Artes, 1995: 231–40.

———. "Recepción de un debate: Reconstrucción de la polémica en torno a la formación de un 'plástica moderna' en la prensa de Buenos Aires." In *Arte y recepción*. Buenos Aires: Centro Argentino de Investigadores de Artes, 1997: 47–57.

Williams, Raymond. *Marxismo y literatura*. Barcelona: Península, 1980 (*Marxism and Literature*. London: Oxford University Press, 1977).

———. *Cultura: Sociología de la comunicación y del arte*. Barcelona: Paidós, 1981 (*Culture*. London: Fontana, 1981).

———. *Keywords*. New York: Oxford University Press, 1985.

———. "La política de la vanguardia." *Debats* 26 (December 1988): 7–15. In Edward Timms and Peter Collier, comps., *Visions and Blue-Prints: Avant-Garde Culture and Radical Politics in Early Twentieth-Century Europe*. New York: Manchester University Press, 1988.

———. *La política del modernismo: Contra los nuevos conformistas*. Buenos Aires: Manantial, 1997 (*The Politics of Modernism: Against the New Conformists*, ed. Tony Pinkney. London: Verso, 1989).

Wood, B. *The Making of the Good Neighbor Policy*. New York: Columbia University Press, 1961.

Wool, Robert M. "The Attraction of Magnet." In *Magnet: New York*. New York: Galería Bonino, 1964.

Zito Lema, Vicente. "Luis Felipe Noé: Conciencia de una aventura." *Crisis* 30 (October 1975): 72–74.

Index

Adams, Beverly, 7

Adrogué, Carlos, 57

Aizenberg, Roberto, 158

Alechinsky, Pierre, 153

Alliance for Progress, 5–13, 192–93, 199, 243, 288

Alloway, Lawrence, 138, 173, 176, 212, 223, 236, 293 n. 40

Altamira Escuela Libre de Artes Plásticas, 39, 300 n. 45

Altamirano, Carlos, 12, 95

American Assembly, 193–94, 344 n. 9

Américas (magazine), 170

Anderson, Perry, 9

Ángel, Félix, 11

Apollonio, Umbro, 212

"A propósito de la cultura mermelada" (Renzi), 264–66, 267, 272

Aragon, Louis, 253

Aramburu, Pedro Eugenio, 56

Argan, Giulio Carlo, 107, 204

Argentinean muralism, 365 n. 21

Arman, 138, 147, 165, 213, 263

Art: development and, 95; mass media and, 273, 279; politics and, 3, 6, 16, 21–22, 256–64; propaganda and, 40, 44; violence and, 275

Art autre, 76

Arte Concreto Invención, 25, 34–36

"Arte-cosa rodante" (Santantonín), 159–60

Arte generativo, 69, 312 n. 38

Artistic and intellectual constellations, 75

Artistic field, 11–12

Artistic images, 17–18, 19; as image-manifesto, 18, 29–30, 260; as "structures of feelings," 18, 329 n. 24

Artists, as committed intellectuals, 246–48, 254–56

Asociación Estímulo de Bellas Artes, 28, 87

Autonomy and heteronomy, 15, 255–56

Avant-garde, 6, 13–16, 92, 108, 142; aesthetic vs. political, 245, 248, 265–66; experience and, 161; first generation of, 128, 328 n. 18; insti

Greenberg, Clement, 1, 11, 14, 76, 85, 121, 167, 293 n. 40, 339 n. 3, 361 n. 150; "Avant-Garde and Kitsch," 176; jury for the ITDT Award 1964, 213–15, 354 n. 79; "Louis and Noland," 168; "Modernist Painting," 168; pop art viewed by, 179; Post Painterly Abstraction, 175

Grela, Juan, 264

Grilo, Sarah, 103

Guernica (Picasso), 52, 251–55

Guevara, Che, 93

Guggenheim Award (1964), 237, 362 n. 162

Guido, José María, 93

Guilbaut, Serge, 18, 302 n. 62, 303 n. 66

Guinovart, Josep, 125

Guston, Philip, 101

Habermas, Jürgen, 14

Hacia un realismo sin fronteras (Garaudy), 253–54

Hahn, Otto, 14

Halperín Donghi, Tulio, 93

Hantai, Simone, 76, 84

Herrera, María José, 22

Hlito, Alfredo, 34, 111

Howard, David, 339 n. 3

Humphrey, Hubert H., 201

Hunter, Sam, 239–40

Huntington Gallery of Modern Art, 195

IAFA, 21

Il Gesto (magazine), 75

Illia, Arturo, 198; coup d'état and, 225

Imagination, L' (Sartre), 169

Imago Mundi (magazine), 52, 305 n. 87

Imperialism, 256

Incendio del Jockey Club, El (Noé), 154, 337 n. 89

Independent Salon, 27–30, 295 n. 5

Informalism, 84, 87–89, 125, 316 n. 83

Institute of Modern Art, 19, 42, 44–45, 53

Inter-American Committee (IAC), 21, 195–96

Inter-American Development Bank, 192

Inter-American Foundation for the Arts, 21, 197

Inter-American Office, 31

Internationalism, 6–13, 21; artistic language and, 69, 74; Cold War and, 233; devaluation of, 223, 240–42; "forms" of, 282; institutions and, 69, 91; inter-Americanist, 200, 202; local tone and, 207–8; nationalist, 92, 111; as success and recognition, 113–17

Introducción a la Esperanza (Noé), 153

ITDT, 4, 17, 21, 92, 198, 323 n. 39; building of, 349 n. 45; financial support for, 364 n. 6; formation of new public and, 325 n. 56

Ivanissevich, Iván, 25, 40–42, 300 n. 53, 302 n. 60

Jacoby, Roberto: art of the media, 185, 269, 278; "Mensaje en el Di Tella," 370 n. 80

Jaguer, Édouard, 74–75

Jameson, Fredric, 2

Jockey Club, 71

Jorn, Asger, 153

Kaiser Industries, 92, 346 n. 26; American Art Biennials, 21, 347 n. 33; First Biennial, 198–202; Sec-

Rosa Blindada, La (magazine), 262

Rose, Barbara, 3

Rosenberg, Harold, 14, 76, 292 n. 24

Ruano, Eduardo, 269

Saint Phalle, Niki de, 155

Sakai, Kasuya, 105, 111

Salamander, 75, 77

Salgado, Susana, 166, 228

Salon d'Automne (Paris), 34

Salon des Réalités Nouvelles (Paris), 34

Sandberg, William, 206

Santantonín, Rubén, 20, 88, 120, 123, 139; "Arte-cosa rodante," 159–60; *Cosas*, 127–35; *La Menesunda*, 160–62, 165; phenomenology and, 330 n. 28

São Paulo Biennial: *1951*, 51; *1953*, 48, 197

São Paulo Museum of Modern Art, 197

Sarlo, Beatriz, 11, 342 n. 47

Sartre, Jean-Paul, 73, 130, 169, 246, 252, 329 n. 24

Selective tradition, 85, 140, 332 n. 56

Seuphor, Michel, 45

Shuster, George N., 194

Sidney Janis Gallery, 100

Sigal, Silvia, 3

Sívori Museum, 69

Soto, Jesús, 211

Soulages, Pierre, 111

Spoerri, Daniel, 147

Squirru, Rafael, 68, 82, 108–12, 121, 200, 218, 235; MAM and, 67–68, 311 n. 32

Stoppani, Juan, 166

Suárez, Pablo, 31, 266

Sur, 19, 25, 32–33, 36, 40, 42, 46, 93, 151, 152

Surrealism, 70–81

Sweeney, James Johnson, 204, 206, 218

Tapié, Michel, 76, 84

Tápies, Antonio, 107

Temps Modernes, Les (magazine) 246

Terán, Oscar, 3, 305 n. 87, 307 n. 6

Testa, Clorindo, 111, 212

Tinguely, Jean, 138

Tobey, Mark, 111

Toilette de Venus, La (Bouguereau), 173–75, 341 nn. 24–25

Torre, Guillermo de, 45–46, 303 n. 72

Torre, Juan Carlos, 296 n. 13

Torres-Garcia, Joaquín, 45–46, 106

Toyen, 72, 76

Traba, Marta, 7, 212

Tucumán Arde, 22, 243, 273–79, 371 n. 94

Tzara, Tristan, 73

Understanding Media (McLuhan), 273

Unión Panamericana, 94

Vailland, Roger, 73

Van der Mark, Jan, 216

Van Riel Gallery, 79, 127

Vega, Jorge de la, 89, 143, 154, 334 n. 63

Venice Biennial: *1956*, 61–64; *1964*, 352 n. 71

Venturi, Lionello, 94, 97–99, 125, 319 n. 17, 320 n. 18

Verbitsky, Bernardo, 88, 120

Ver y Estimar (magazine), 19, 26, 48–54, 106; award of, 269, 309 n. 20

Vietnam War, 259

Villanueva, Carlos Raúl, 224

ANDREA GIUNTA is a professor of art history at the Universidad de San Martin and an associate professor of art history at the Universidad de Buenos Aires. She has been awarded the John Simon Guggenheim Fellowship, the J. Paul Getty Postdoctoral Fellowship in the History of Art and the Humanities, the Rockefeller Senior Fellowship, and the Donald D. Harrington Faculty Fellowship at the University of Texas, Austin. Her publications include *Goeritz / Romero Brest: Correspondencias* (Instituto Payró, FFYL-UBA, 2000); editor, *Candido Portinari y el sentido social del arte* (Siglo XXI, 2004); coeditor, *Arte de posguerra: Jorge Romero Brest y la revista* Ver y Estimar (Paidós, 2005); coeditor, *Listen, Here, Now! Argentine Art in the Sixties: Writings of the Avant-Garde* (MOMA, 2004); and editor, *León Ferrari: Retrospectiva, 1954-2006* (Centro Cultural Recoleta-malba-Imprehsaoficial-Cosac&Naify, São Paulo, 2006). Currently, she is completing the book *El Guernica de Picasso: Arte, poder y guerra fría* (Paidós, forthcoming); she is the director of the Centro de Documentación, Investigación y Publicaciones (CeDIP) at the Centro Cultural Recoleta de Buenos Aires, and of the collection *Arte y Pensamiento* for the publishing house Siglo XXI.

PETER KAHN is a translator and Spanish-language instructor at the University of Massachusetts, Amherst.

Library of Congress Cataloging-in-Publication Data

Giunta, Andrea.

[Vanguardia, internacionalismo y política. English]

Avant-garde, internationalism, and politics : Argentine art in the sixties /

Andrea Giunta ; translated by Peter Kahn.

p. cm. Includes bibliographical references and index.

ISBN 978-0-8223-3877-2 (cloth : alk. paper) — ISBN 978-0-8223-3893-2 (pbk. : alk. paper)

1. Art, Argentine—20th century. 2. Art—Political aspects—Argentina. 3. Avant-garde (Aesthetics)—Argentina—History—20th century. 4. Argentina—History—1955–1983.

I. Title. N6635.G5713 2007

709′820904— dc22 2006102942